The Arts in the West since 1945

The Arts in the West
since 1945

ARTHUR MARWICK

OXFORD
UNIVERSITY PRESS

OXFORD
UNIVERSITY PRESS

Great Clarendon Street, Oxford OX2 6DP

Oxford University Press is a department of the University of Oxford.
It furthers the University's objective of excellence in research, scholarship,
and education by publishing worldwide in

Oxford New York

Athens Auckland Bangkok Bogotá Buenos Aires Cape Town
Chennai Dar es Salaam Delhi Florence Hong Kong Istanbul Karachi
Kolkata Kuala Lumpur Madrid Melbourne Mexico City Mumbai Nairobi
Paris São Paulo Shanghai Singapore Taipei Tokyo Toronto Warsaw

with associated companies in Berlin Ibadan

Oxford is a registered trade mark of Oxford University Press
in the UK and in certain other countries

Published in the United States
by Oxford University Press Inc., New York

British Library Cataloguing in Publication Data

Data available

Library of Congress Cataloging in Publication Data

Marwick, Arthur, 1936–
The arts in the West since 1945 / Arthur Marwick.
Includes bibliographical references and index.
1. Arts, Modern—20th century. I. Title.
NX456.M367 2001 700'.9182'109045—dc21 2001053097

ISBN 0–19–289266–5

1 3 5 7 9 10 8 6 4 2

Typeset in Imprint by RefineCatch Limited, Bungay, Suffolk
Printed in Great Britain by
Cox & Wyman Ltd.
Reading, Berkshire

Preface

This book is both very ambitious and very modest: ambitious in scope, modest in philosophy. It covers more than half-a-century of the most rapid and profound change ever to have taken place, discussing all of the main European countries outside Russia, and also the United States. It includes *all* the élite arts, and *all* the popular arts. My fundamental belief is that anyone, student or general reader, who is interested in the history of the West since 1945 is also likely to be interested in the most significant artistic movements and the most significant developments in popular culture in that period. My approach is historical and concerned with why, in certain conjunctions of historical circumstances, certain types of art tend to be produced; at the same time, I have sought to give full recognition to the particularities of artistic production, including personal factors. I have sought to set out the things I think readers may want to know. Did the Second World War have critical effects on painting, music, literature? Was American political hegemony reflected in artistic hegemony? Did the exuberance of the 1960s result only in the debasement of art? Have any achievements in film come near to equalling those in older art forms? What were the implications for the arts of the new sophisticated globalization of capitalism and of advanced information technology? What repercussions did the collapse of the Soviet empire have for the arts?

To arrive at informed decisions on such matters, readers need to be given the views of specialist critics, and I have borrowed heavily. However, it is another of my beliefs that readers can be intimidated by the weight of 'theory' interposed between them and the appreciation of the creative arts. This book says something about the central elements of Marxist, postmodernist, and cultural 'theory': for those who seek more, there are books abounding. I have set myself the positive purpose of trying to demonstrate that it is possible to learn a great deal about the arts and their relationship to society and to historical change without becoming involved in 'theory'. As history, as a discipline, has

continued to develop, and as interdisciplinary initiatives continue to be encouraged, students begin to find themselves moving not just into the fashionable realm of popular culture, but into the élite arts as well.

I do not believe in such concepts as 'the spirit of the age', 'discursive formations', or 'epistemes'. Others have seen the arts, or even the arts and society together, in any particular age as forming some metaphysical unity, made up of a number of definable characteristics. One can then take painting, literature, music, film, and so on all together, studying them holistically, perhaps taking each 'characteristic' separately and using it as a means of entry into the arts as one great entity. My fundamental principle of analysis, certainly, is that of periodization. Periodization is simply an analytical device of the historian and has no immanent reality. One defines a certain chunk of time as a period, because one feels that within it there is a certain interrelatedness, or integration, between different circumstances, social, economic, ideological, cultural, and so on, giving a kind of unity. I have divided my 'more than half-a-century' into three periods, and within each period I have sought to bring out the connectedness between the different art forms and between them and the historical context. But I also stress autonomy and difference: there is much that is fascinating in the differences between the different individual art forms. Of course, holistic generalizations can be stimulating and illuminating, but this book is aiming rather at providing basic knowledge: to satisfy my aims I need to provide a certain amount of detailed information, and that can only be furnished through taking painting and painters, novels and novelists, separately.

I have no great truths to unfold about the condition of the arts in late-twentieth-century society. If I were to examine politics, or social welfare, or class structure, I could make certain generalizations, but I would also have to note many contradictions. So it was in the arts: mixes of traditions and innovations, of convention and individualism, of state-sponsored training and private enterprise, of subsidy and censorship and the pull of the market, of the desire to shock and the desire to sell, the two sometimes, but not always, coinciding. One could speak of 'the art of mixed economies, all with an increasing market

orientation', but that would be to take us little beyond the obvious. In my own previous work on films and novels, I have stressed the importance of these middlebrow and popular art forms in revealing the unique characteristics of the societies within which they were produced. I have argued that certain films could have been produced only in France, others only in America; that certain novels could have been produced only in Italy, others only in Britain. In my *Class, Image and Reality* I used novels and films to create mappings of class as it actually existed, and was perceived, in the different countries. A serious question arises as to whether national differences are also apparent in the élite arts, or whether in fact the élite arts are necessarily more international in character than the popular ones. Is there a paradox here? Are the popular arts much more subject to the pressures of commercialization and standardization? These are the sort of issues my approaches explore.

If one were to make grand statements about the nature of the arts in the second half of the twentieth century, they would have to be comparative, they would have to contrast the arts in this period with the arts in the first half of the twentieth century, the arts in the nineteenth century, the arts in the Renaissance, and so on. Some knowledge of previous centuries is implicit in everything I have written. One cannot understand the visual arts in the 1940s and 1950s without an understanding of Surrealism, the movement in art that, developing from Dada, dominated art in the inter-war years. But, although Dada began as a multimedia activity, and Surrealism as a movement in literature, by the end of the Second World War Surrealism is not of great significance in regard to art forms other than painting and sculpture.

Given the unique scope of this book (it touches on dance as well as opera, children's books as well as video installations, critical technological changes in the production of gramophone records as well as the transmission of architectural ideas), combined with the finite number of pages at my disposal, much has been left out that I would have preferred to put in; what I have worked to ensure is that every piece of information mentioned, every connection suggested, contributes to illuminating the issues set out in my Introduction.

There is no one grand, unifying, idea to this book, save perhaps that the arts, both élite and popular, are of importance, that the manner of their coming into existence is far from straightforward, and that all of this needs to be discussed carefully and without mystification.

My hope is that readers will read some of the novels discussed, listen to some of the music, view some of the art and architecture. The Appendix contains a selection of websites where some of the most significant art of the period can be viewed.

For reading this book, and making many helpful comments, I would like to thank my colleagues, Professor Donald Burrows, Dr Robert Samuels, Dr Tony Aldgate, Dr James Chapman, and Dr Bernard Waïtes; also Professor Hagen Schulze of the German Historical Institute and his colleague Professor Benedikt Stuchtey. For typing the various drafts I would to thank Margaret Marchant, Sue Leyland, and Lorraine Brookman, with further thanks to Lorraine Brookman for preparing the final copy for handover to the publishers, and to Debbie Williams for keying in the very extensive final revisions. I wish to thank both my publisher, George Miller, and my agent, Michael Sissons, for invaluable support. The final version also owes much to conversations with my good friends, Pierre and Irène Sorlin.

Contents

Introduction: Assumptions, Themes, Contexts

Humans need food and shelter. They tend to want sex. To obtain these, they have, most of them, to work. Those who do not have to work, through good fortune or inheritance, have more leisure time than those who do. Leisured or not, humans are sociable creatures and naturally devote a certain amount of time to interacting with each other. The time that is left after work, after satisfying basic wants and attending to the normal interactions with family and friends, can be occupied in various ways. Playing games, or watching others playing games, for instance. Climbing hills or admiring waterfalls. But there is ample evidence that over the centuries human beings have put paintings on the walls of their caves, carved recognizable objects, played domestic keyboard instruments, or trombones in village bands, have danced round their own maypoles and watched itinerant dance troupes, listened to or read stories, recited rhymes, marvelled at mighty buildings and contemplated the paintings within, attended plays. Sometimes some of these activities were associated with religious practices, some with secular rituals, and some with the arousal and satisfaction of carnal appetites. Artistic impulses, whether to create, or to enjoy the creations of others, no doubt have been, and perhaps occasionally still are, mixed with other impulses, whether of religion or socially conditioned conformity, but the indications are overwhelming that human beings crave, at varying degrees of intensity, some or all of the following: colour, display, beauty, music, stories (however transmitted), that which stirs the subconscious and inspires the imagination, the familiar seen in unfamiliar ways, unexpected harmonies, disruptions of expected ones, the sense of penetrating through the surface to the profound. The words 'art' and 'arts' have changed in meaning over the years and have contested meanings today, but I am using the phrase 'the arts' to signify the practices and artefacts

that respond to these basic cravings. Some humans are gifted with special talents in regard to the production of these 'arts', most are not. Hence there has always been a division of labour between the minority of troubadours, storytellers, actors and their managers and writers, and the majority who have to earn their living in more mundane ways.

My approach is that of a historian. In studying the Western countries in the period since 1945 I might, in a different book, focus on their manufacturing sectors, assessing adaptation to change, quality of production, employment practices, etc., or on their welfare policies, perhaps measuring achievements against stated aims, and so on. In this book I shall be focusing on the production, consumption, reception, and status of the arts, trying to relate these, as I would any other topics, to the wider historical contexts. Apart from the artistic artefacts themselves, most of my sources are secondary; for a historian, primary sources (stating, for example, an artist's intentions or a critic's reactions) are particularly to be cherished, but they, even more than secondary sources, have to be subjected to careful assessment and evaluation. I frequently enlist the help of specialist art historians, musicologists, literary and film critics. Language has its ambiguities and imperfections, but if we work at it (and the work can be killing) we can use it to express ourselves precisely and explicitly. No one can rule that 'culture' or 'the arts' shall have this signification, rather than another. All I can do is make it clear how I am using the phase 'the arts'; 'culture' is a word with so many meanings and uses that I try to avoid it where possible.

I shall not get into detailed arguments over what is art and what is not art. I have sketched out the basic human needs that the arts exist to meet (and shall shortly develop this approach further): just as one can reject welfare policies that do not deliver, that fall below accepted standards, so we can rule out certain artistic forms and practices. One intriguing difficulty in the use of the words 'art' and 'arts' is worthy of comment here: it is established practice to refer to 'art films' and 'art music' when one means, respectively, 'non-commercial films aimed at the intellectual, "elite" audiences who frequent "art house" cinemas', and the contemporary version of what used to be known

as 'classical' music, distinguishing that from 'popular' music. There is, in fact, a widely recognized distinction between the élite arts and the popular arts. In part, the distinction is simply one of numbers, the élite arts being consumed by a relatively small minority, the popular arts by a large majority, but it is also one of intention, producers usually being fully conscious of what type of audience they are aiming at. The popular arts include both materials produced *for* the majority by the rich and powerful, and materials produced *by* the majority themselves, or, more accurately, by talented representatives of that majority (who are likely soon to become rich). In a work of history one must consider the enjoyments and preoccupations of the majority; but in a work focused on 'the arts', one must reject artefacts and activities that bypass the needs already outlined, that aim merely to pass the time, without presenting challenges or evoking responses, or that are merely 'exploitative'—that is to say, simply exploiting the public appetite for sex, violence, the occult, and the doings of the rich. It is a basic assumption of this book that some artistic products are of far higher value (by which, of course, I do not mean price) than others. Against that, there are two further assertions: first, art without audiences, art that does not strike up interactions and responses, is of little significance historically; and, secondly, genius is a limited commodity. Thus it is ridiculous to expect the bestseller lists, cinema releases, and television schedules to be stuffed with works of outstanding artistic quality.

Central to the postmodernist metaphysics that I reject is the notion that all forms of communication and expression share a common 'textuality'. My postulate is that the arts founded in the *imagination* are very different from that range of activities, founded on *evidence*, that runs from the most sophisticated scholarship to the simplest reporting of current events. Scholars and reporters have a duty to 'get it right' in the most literal sense; what they say should depend on carefully validated sources and logical thinking. Their language should be precise and explicit, as should any images they may deploy. Artists—I use the word to cover practitioners in all the different arts—will no doubt aim 'to get it right', or to represent reality according to their lights, but they have no obligation to base their work on

evidence or logical argument, and on the whole we will value it less as art to the extent that it is literal. We expect artists to give free licence to their imagination, to express their moods and feelings as strongly as they wish, to exploit or distort their medium for the achievement of particular effects. Unlike *responsible* academics and journalists, they are not communicating precise data, or information, or interpretations and conclusions based on careful analysis of all the relevant evidence. Unlike scholars and reporters, artists are fully entitled to exploit the resonances and ambiguity of language and image. In this book, I shall discuss television plays, crime series, soap operas, and sitcoms, but not television newscasts and documentaries. It is vital to us all that we remain sensitive to the distinction between the 'factbased' and the 'fictionbased', particularly in these days when the controllers of television seem determined, through docusoaps and other cut-price contrivances, to blur the distinction. The introduction of documentary elements into plays and novels can produce richer works of fiction, but it does not produce richer history. Works of scholarship that introduce fictional techniques simply cease to be works of scholarship.

I want now to identify the various modes of artistic communication this book is concerned with, distinguishing, where relevant, between élite, and popular, manifestations. The different art forms raise different questions about how and where they interact with audiences and how they are delivered to them. What should I include, what exclude? Frankly, my guidelines are taken from the newspapers of the period: what I discuss in this book is, in general, what was reviewed under the rubrics 'arts and entertainments', 'books', and, latterly, 'media' and 'pop music'. I start with 'art' as distinct from 'the arts', taking that to include painting, photographic art (self-standing or incorporated in 'photopieces' or installations), sculpture, assemblages, installations, and video art (often incorporated in installations). In the contemporary period, artists of high repute have tended to earn high incomes: that is certainly not a reason for excluding them. But there have also been artists, financially very successful, but of low repute, because banal, anecdotal, or basically exploitative. At the time of writing Scottish ex-miner Jack Vettriano was being described as 'Britain's most popular

living painter, better loved than Van Gogh, or Monet'.[1] Such 'popular' painters I exclude. 'Popular art' more properly refers to design and illustration, posters and advertising: because of their essentially functional applications these are also excluded. Painting, sculptures, installations will usually be exhibited first in a temporary exhibition, though they may be commissioned directly. Most usually, having been bought by some public authority or by a private patron, they will be exhibited in one of the many galleries open to the public. Art is paid for by a few wealthy patrons, public or private, supplemented by the manifold small contributions of those who visit art galleries. Architecture is very much in the public eye, though the public plays little or no part in the production process. Although there is an obvious distinction between, on the one hand, public housing, schools, and hospitals, and, on the other, the big prestige projects commissioned by public authorities, or increasingly, wealthy private ones, it is not usual to have a separate category of 'popular architecture'.

The opposite is very much the case with literature. Despite repeated prognostications of the death of the novel, the novel remains a staple of contemporary artistic consumption. While some novelists aim to be avant-garde, modernistic, or, more recently, postmodernist, a large number of novels (reviewed in the press and of considerable interest to us) are aimed at what can reasonably be termed a 'middlebrow' audience. Authors' incomes depend very much upon purchases by that audience. Massive advances from publishers (when offered) depend on an expectation of massive sales. In all Western countries (but least in Britain) there are book prizes, but these are important mainly for the stimulus they give to sales.

Playwrights depend upon their works being commissioned or bought by theatrical companies (many of the more adventurous ones being subsidized in some way or another), and then upon the willingness of a public (partly middlebrow, partly élite) to pay to watch their plays. A most important process, which I shall refer to from time to time, is that of the conversion of novels and sometimes plays into films—a most satisfactory process, financially, if not always otherwise, for authors. Poetry, appealing to the same mixed audience as plays, was not noted for

its money-making potential: a few poets did well, some subsidies were available, most poets had other jobs. Generally poems were marketed in the form of book collections or else in 'little magazines' devoted to poetry, though poetry readings had a vogue during the later 1950s and the 1960s.

The condition of music is both simple and very complicated. The distinction between 'art' music and popular music remains fairly obvious, though there have been many attempts at 'crossover'. Most art music listened to, whether in concert halls, on the radio, or on records, tapes, or CDs, is in fact classical music—that is, music of the seventeenth, eighteenth, and (above all) nineteenth centuries. Apart from discussing technological innovations that affected the distribution of all kinds of music, I shall be concentrating exclusively on music written since 1945. (The same principle, it may be noted here, will be applied to art, drama, and literature; however, the analogy does not hold out for television, where productions of past literary artefacts, whether plays or novels, formed a major part of the more ambitious television output.) Art music includes various types of symphonic composition, chamber music, and opera. At the end of the war, radio was extremely important in communicating new compositions, not least to other composers, while the expanding market for gramophone records depended significantly on technological developments. Within popular music there is the obvious distinction between stage musicals (which often became film musicals), and popular music produced for professional singers, bands, and groups. For both types but particularly the latter, record sales were an absolutely crucial part of the business.

As regards films, my concern is solely with feature, or fiction, films, not at all with documentaries. On examination, the distinction between 'art' films and 'popular' films turns out to be less salient than might be thought. What I include are films that attained critical acclaim or controversy; pretentious films operating in a vacuum are excluded along with the routine potboilers. Film, I believe, should be seen primarily as belonging to the arts, rather than to the mass media. With television, however, the opposite is the case. Only one element within what is transmitted falls within the domain of this book, since television

also serves the functions once the monopoly of newspapers. Much television, and on the whole that part with the greatest popular appeal, is financed by advertising. Clearly there is some motivation within commercial television to put on prestige productions, but that motivation is mainly to be found in those sectors financed by the state or by local subscription. It is obvious that I put television, in its creative aspects, at the bottom of my values scale, while recognizing that, since the 1960s, it has had the largest audiences.

Actually, examining those aspects of television programmes that do give them some standing in the arts helps to illuminate further the functions that we can expect the arts to perform. Our encounters with other people, with our environment, with the world are necessarily limited. Even through the meanest literature, the most simplistic television programmes, our experience may be extended. More certainly, we may find illumination on questions of individual psychology, relationships between individuals, and means of meeting the challenges and upsets of everyday life. We may be introduced to a variety of human motivations and compulsions, to belief systems, to the significance for others of religion and of ideology. We may be introduced to the humorous side of our own behaviour, or of those close to us, to the absurdity of authority, the comedy of convention.[2] We may be taken out of the stolidity of the everyday into the enchantment of fantasy. We may even, perhaps in a historical romance, or a production of some literary classic, be made aware of the profound significance to human beings of their past. We may be led to sense that what happened in the past governs what happens now, and much of what will happen in the future. We may be gripped with the feeling that people in the past were so like ourselves, and yet so different. We may begin to wonder at the relationship between past and present, and the relationship between individual memory, and those inklings of the past we all seem to share. These are big issues. They are addressed in one way by historians, and in a completely different way by certain works of art, and sometimes even—this was my starting point—by routine works of entertainment. The arts, to a greater or lesser extent, depending upon where they are on the value scale, should enlarge and deepen our view of the world,

introduce us to new ways of looking at things, stir our imagin-
ations, enhance our lives, give us experiences that go beyond
anything in everyday life, or at the very least make us pause and
think.

The ways in which the arts come into existence are complex.
From time to time in this book I shall pause to try to throw light
on specific examples. Some artists simply have a particular
talent that they do their best to exploit. Others clearly have very
powerful compulsions. The Orcadian poet George Mackay
Brown expressed his apparently very limited 'purpose' in the
prologue to his first collection of poems:

> For the islands I sing
> and for a few friends,
> not to foster means
> or be a midwife to ends.[3]

Other artists, of course, are driven by strong political, moral,
religious, or aesthetic obsessions. Others again have clear ideas
about the distinctions between art and mere entertainment.
Cesare Zavattini, a collaborator of the Italian film director Vit-
torio De Sica, wrote in December 1952 that the main objective
of film-making is not to entertain but to urge the spectator to
think, going on to declare that the cinematographer has a moral
responsibility 'to represent reality and avoid fantasy'.[4]

Much art comes into existence through private commission or
negotiation, or through the simple fact that publishers, film
production and television companies, commercial art galleries,
concert promoters exist, all requiring 'product', whether for
reasons of prestige or simply for commercial gain. There are
two possible roles for the state, one concerning censorship, the
other concerning direct patronage in the form of subsidies or
loans, or perhaps indirect support in the form of tax conces-
sions. Historically, the situation has been that the continental
European countries have been more amenable to the idea of
public subsidy for the arts than the 'Anglo-Saxon' ones. In
France, the system was very highly centralized, with the bene-
ficiaries being the big Parisian cultural institutions, whereas in
Germany there was a strong tradition of subsidy by the indi-
vidual states (*Länder*). In Italy, subsidies went mainly to

monuments and museums, which were vital components of the tourist industry. In all of the continental countries the idea of supporting cultural activities was closely entwined with education.[5] In Britain, it was under the pressures of a war that inspired the sense of a titanic struggle being fought to protect the treasures of civilization that the first major initiative in government support for the arts came in the form of the Council for the Encouragement of Music and the Arts, renamed the Arts Council at the end of the war.[6] America had nothing akin to the institutions existing in the European countries until the setting-up of the National Endowment for the Humanities in 1965. State support for the arts is not in itself an indisputable good, as the experiences of Nazi Germany and Soviet Russia demonstrate. In Britain, Arts Council subsidies and the state-funded art schools undoubtedly played an important part in the cultural efflorescence of the 1960s. At that time, the BBC was itself an important patron of new music. Whether declining state support since has really had a deleterious effect on the arts is difficult to determine. State support for film-making was strong in France, Germany, and Italy, practically non-existent in Britain (some gestures began to be made in 1999). On the other hand, in these countries state support was not generally forthcoming for films thought likely to be subversive of the civil and religious order, and such films were also liable to censorship. Most of the French 'New Wave' films were funded privately, because in fact they turned out to be good commercial prospects. In Britain, the basic problem was the general reluctance of private fund-holders to invest in film, so that from the 1960s onwards most of the great British film successes were in fact American financed. Censorship in all countries weakened considerably in the 1960s, and became practically non-existent in the early 1970s.

America has outstanding art schools, music schools, and drama schools, one in particular having been responsible for propagating method acting. These, like the great art galleries, the great symphony orchestras, and the great opera houses, are all privately funded. The dominance of America and of American-inspired market-led cultural policies is a constant source of concern among Europeans, and among many

Americans. Experience shows that the specialist education vital for budding artists, musicians, dramatists, and actors does require state funding. It is important too that the state should be there at the very least as a reserve patron in case artistic integrity becomes totally swamped in the forces of commercialism. The Western democracies, in general, are very imperfect. But none of their governments controls the arts for propaganda purposes, none imposes a crass or oppressive censorship. It is important that people have choices, and they do, even if commercial pressures make these choices more limited than they would be in an ideal world. To maintain good health, money has to be spent on the arts; it is, and the state is not necessarily a wiser spender than private individuals. All of the national governments in the continental countries are formally committed in constitutional statements to supporting 'culture', and this is true also of the separate German *Länder*.[7] Formal commitment is less secure in Britain and the United States. France from 1959 and Italy in the 1970s deliberately set out to decentralize cultural provision and enrich the provinces. What, if any, differences in artistic production and distribution resulted should emerge from the main text of this book.

The Historical Contexts

The more interesting question for historians may be that of how production of the arts responds to, or reacts against, historical developments. To assist that enquiry, I have divided the book into three periods: 1945–57, 1958–79, and 1980–2000. These, obviously, are not hermetically sealed blocks of time, with everything in the arts changing as we move from one block to another. We should think rather of a succession of waves, each wave adding in new elements to which the arts responded or reacted.

The Aftermath of War, 1945–1957

America, or rather myths about America, fascinated many European intellectuals and artists before the Second World War; and Hollywood films, which in themselves contributed to the myths, established certain basic conventions of film-making,

while also setting standards for people to aspire to in regard to fashion and behaviour; American popular music, too, was already very influential. Then the outcome of the war left America with a geopolitical ascendancy that strengthened its international position in both the élite and popular arts, it being part of the essentially international nature of the arts that influences pass readily from one country to another, though at different speeds for different art forms. Books pass fairly readily, save that there can be problems of translation. Films are quicker, dubbing or subtitling being less of an obstacle than wholesale translation. Popular music was largely transmitted through song sheets, classical music through scores, though there were recordings, and sometimes actual cross-border visits by orchestras and bands. Radio broadcasts could cross European boundaries, but not the Atlantic. Painting and sculpture were more difficult: it took time and money to organize travelling exhibitions (though there is the point that some leading painters in America were fairly recent immigrants from Europe). The exchange of photographs and reproductions was not very satisfactory; however, it did give artists in one country inklings of was going on in another. Buildings cannot be exported, though architectural drawings can.

The most obvious indications of a new American ascendancy were in the movement in painting known as Abstract Expressionism, very much an American invention, though a not dissimilar movement, *art informel*, did develop independently in Europe at roughly the same time. American claims bred strong resistance, many European intellectuals (for example, Jean-Paul Sartre) being both fascinated and repelled by America, while anti-Americanism was strong in intellectual circles all over Western Europe. Indeed, in the post-war period, when the Soviet Union had derived great prestige from its part in defeating Nazi Germany, many artists and intellectuals gravitated towards the Communist Party.

The effects of war, and of the Holocaust that accompanied it, pervaded almost all aspects of life and art, from technology to the human psyche. The needs of war had made radio practically an essential item in every home and had brought huge improvements in the quality of gramophone records. The

experience of war was a traumatic one for artists and intellectuals on the continent who lived through it, and for Americans and Britons who fought in it. The implications continued to be evident in novels, films, and even in art and music, for the rest of the century. For the defeated, particularly Germany, the situation was especially bleak: there are few artistic achievements to celebrate until, in the mid and late 1950s, intellectuals began to try to get to grips with the Nazi past. Americans enjoyed affluence throughout the war and after it, and affluence began to affect Europe in the 1950s. Some of the new resources went into artistic production; at the same time many intellectuals reacted against what they saw as growing consumerism, and growing Americanization. American artists often had the benefit of patronage by rich individuals and organizations, and also by the major cities, while the European countries in the immediate aftermath of war increased their patronage of the arts to symbolize their welcome for a world rid of Nazi obscurantism. Although America was the occupying power that left the strongest influence on West Germany, that country joined with Italy and France in endeavouring to replicate the British way (through the BBC) of sponsoring and controlling broadcasting by means of an autonomous state corporation (in the event the French and Italian systems were subject to much political interference).

The Cultural Revolution and After, 1958–1979

Growing affluence, and the very large number of young people in the various populations (the outcome of the wartime and immediate post-war 'baby boom'), laid the basis for the 'cultural revolution', which was characterized by attacks on authority and convention, and by a general frankness and permissiveness. There was also something of an intellectual revolution, mainly taking place in Paris, entailing the promulgation of structuralism and poststructuralism and the production of associated art forms.[8] In this general ambience, artistic innovation at times seemed to go to ultimate extremes. During the same period, the advent of rock/pop music brought about a transformation in popular music. Radical protest movements sought civil rights for blacks, and liberation for women and gays. The ugly fact of

the Vietnam War itself, the protests against it, and their suppression also had their repercussions, as did 'the events' of 1968.

German Metamorphosis and Global Capitalism, 1980–2000
The transformations of the 1960s and the consequences of the protest movements of 1967–9 were felt more strongly in West Germany than anywhere else, and out of them a new German participatory democracy did begin to replace the stuffy conservative society of the years since the economic recovery.[9] Yet the 1970s were a time of appalling civic violence, both there and in Italy, provoked by extreme left-wing terrorist groups. Reactions to this interacted in the 1980s with the new open democracy, including a new feminism, to inspire a potent reappraisal of Germany's contemporary situation, and its relationship to the Nazi past, the war, and the Holocaust. I open Part Three with this great German metamorphosis, one of whose side effects was the establishment of a kind of cultural axis between America and Germany. This is the period, too, when postmodernist ideas, which had germinated in the Paris of the 1960s, had their strongest impact on artistic production. Globalization, supranational organizations, resurgence of regional nationalism, renewed faith in market economics, and decisive technological advances in information technology, computerization, video recording, and the production of CDs created a multiplicity of influences. One obvious outcome was a boom in building development, creating distinctively postmodernist urban environments. In 1989 the Soviet Empire collapsed, entailing a further stage in German metamorphosis, involving unification and a degree of impoverishment, and the arrival from Eastern Europe of new influences on the arts in the West, particularly music.

Themes

From everything I have said so far, it is not surprising that, across the arts, certain themes recur: I propose to conclude this Introduction by looking at each in turn.

Modernism and Postmodernism

The terms we use to encapsulate the predominant artistic styles of past ages may apply to certain art forms but not to others, may mean different things when applied to different art forms, and may refer to general characteristics rather than specific ones, or vice versa. Examples of such terms are: 'romanesque', 'gothic', 'renaissance', 'mannerist', 'baroque', 'classical', 'romantic', 'neo-gothic'. 'Modern' and 'modernist' have a general rather than specific connotation: 'modernism' in the arts is usually thought of as beginning towards the end of the nineteenth century.

Among the characteristics of modernism (not all characteristics being displayed by all practitioners or all artefacts) are: a conviction that a new era of cataclysmic change demands a new art; a rejection of *mimesis* (imitation of the 'real' world), representationalism (direct representation of that world), and figurism (direct representation of human figures and of objects); the explicit and self-conscious recognition that the arts are an artificial convention or game consisting of words on a page, paint on a canvas, etc.; and the conviction that, instead of merely echoing 'reality', art should create a separate 'reality' of its own. This, in turn, led to some modernist works raising such questions as: 'what is art?', 'does art exist?'; 'can anything, in the right circumstances, be art?' Marcel Duchamp's presentation in 1917 of a urinal as a work of art entitled *Fountain* is well known. Other examples of modernism could entail quite shocking disruptions of the order, sequences, and harmonies of traditional forms—in music, for example, departures from tonality, extreme use of percussion.

In discussing the work of individual artists, or, indeed, individual works of art, it can be useful to assess the extent to which these are modernist. On the whole, because we expect a work of art to introduce us to new ways of seeing, or thinking about things, we tend not to rate highly a work of art that in form, content, and style merely imitates works of art of an earlier period. But this does not mean that a work of art in the twentieth (or twenty-first) century must be unrelentingly modern, and that every artist must strive to be more and yet more modern. The purpose behind being modern should be to surprise,

perhaps even to shock, certainly to extend horizons. But then a point can come when simply being routinely modern is to be unsurprising, conventional, reassuring. Within the framework of these rather obvious comments, all depends upon the particular aims of the particular artist, and how well these are achieved. The British artist of the 1960s and onwards David Hockney made a point of emancipating himself from contemporary theories about what modern art should be; but, in fact, there is nothing traditional about Hockney's painting, which, indeed, could scarcely have been produced before the 1960s. In reading evaluations by literary critics of the novels discussed in this book, the term I have come across most frequently, referring to non-English as well as English books, is 'Dickensian'. Likening a contemporary work to a nineteenth-century one would not usually be taken as complimentary; yet to suggest that a contemporary novel richly evokes character, place, period, the joys of language, of humour, the power of the subconscious, is to be very complimentary indeed. A novel can be both Dickensian and modern. But it need not strive officiously to be the latter: engaging with the world of today (which is very different from the one Dickens engaged with), its materiality, its morals, its practices, its languages, can be every bit as rewarding as engaging with the social world of early and mid-nineteenth-century England.

For some, however, the modern is already outdated. The contention of certain philosophers, critics, artists, and intellectuals is that we now live in a postmodern era, in, as some like to put it, 'a condition of postmodernity'. The basic contention with respect to the arts is that modernism has been pushed as far as it can go. Every extremity of innovation has already been tried; music, for example, reached the stage by the 1960s and 1970s where it was so 'pure' in respect of modernist theory that most listeners just could not relate to it. With no further stage in modernism to be reached, the thing to do was to be eclectic, to pick and mix from the styles and forms of earlier ages. Without doubt such eclecticism does characterize much of artistic production since the 1970s (above all, perhaps, in music and architecture). Such production (since labelling is an essential prop to academic endeavour) may, in this particular respect, be termed

'postmodern'. In summarizing the characteristics of modernism, I mentioned 'the explicit and self-conscious recognition that the arts are an artificial convention or game' and questioning about whether the arts actually exist. Such recognition and such questioning are often to be found at the heart of works described as 'postmodernist'. So, as a style, postmodernism can embrace both developed and more extreme forms of modernism, and reactions against some of the key tenets of modernism. One may, in a single work of art, identify characteristics that could equally well be described as modernist or postmodernist. Here we have an obvious echo of the way in which the structuralism of the late 1950s and early 1960s developed into the poststructuralism of the 1970s.

Stucturalism, like Marxism, of which it was in many ways a refurbishment, sought for the deeper structures allegedly underlying surface appearances. The primacy that Marx attributed to economic structures, the structuralists attributed to what they perceived as the ineluctable structures of language. The poststructuralist philosophers (of whom the most famous is Michel Foucault) retained this insistence on the central importance of language, and stressed what they saw as its ambiguities and slipperiness. A particular emphasis on language, and on the way in which, it is asserted (though scarcely proved), it serves as a power tool for the bourgeoisie, is therefore a distinctive feature of postmodernist philosophy, and sometimes also postmodernist style: words incorporated in paintings; poems in which the words have no meaning, thus defying bourgeois conventions about how words should be used.

Collages with everyday objects stuck in them, literary works incorporating actual historical documents—from the beginning of the century there was nothing very new about these. The same is true of the mixing of styles and the borrowings from other artists and from other ages; as we shall see in this book, artists are forever seeking examples and ideas from other artists and from other art forms. However, postmodernist works tend to be knowingly reflexive and self-aware about such practices; the philosophers of postmodernism have coined the technical term 'intertextuality'. While postmodernist philosophers generally follow Marx in having a metaphysical view of past

becoming present becoming future in a succession of stages, the 'feudal', the 'capitalist', or the 'bourgeois' era, and so on, some postmodernist artists reject the notion of change through historical time, and take up the synchronic stance that what historians see as different eras—such as, say, the Classical Age of the ancient Greeks and Romans or the twentieth century—in fact coexist simultaneously. The synchronic approach can produce very exciting literature—as, for example, in the novels of the Austrian Christopher Ransmayr or the Englishman Peter Ackroyd.

The approaches and devices of postmodernism as a style can, I have just suggested, be very exciting; they can also be formulaic and tedious. It is important to distinguish between postmodernism as the most distinctive avant-garde style of the last two decades of the twentieth century, and postmodernism as a philosophy claiming that we actually live in a 'postmodern age', in a 'condition of postmodernity'. This position has no foundation in serious historical *analysis*; it is simply the *assertion* of, principally, two latter-day French Marxists, Jean-François Lyotard (1924–98) and Jean Baudrillard (b. 1929). In his *The Postmodern Condition* (1979), Lyotard identified the 'postmodern age' as a specific phase of late capitalist development, a time of crisis and fragmentation of older certainties. He saw the 'condition of postmodernity' as being characterized by the breakdown, or rejection, of what he called *grands récits*, usually translated as 'grand narratives'. Actually, the only grand narrative that had broken down was Marxism. What the postmodernists wanted to assert, however, is that any story or narrative (about events in the past, for example) is as good as any other. That view can make for very resonant, challenging, works of art, but it makes for poor history (or journalism). Baudrillard, with reason, if scarcely superhuman insight, stressed the extent to which the contemporary world is shaped by the mass media, and particularly the electronic media. He then went on to the dubious argument that events assume reality only when they are refracted through the media: 'virtual reality' triumphs over what used to be regarded as the real world. He exposed the madness of his own position in claiming that the Gulf War of 1991 did not 'really take place', apart from its media representation.

Past and Present: Identity, Place, Memory

Past and present, identity, place, and memory, have, as I have already suggested, all long been staple concerns of artists. Postmodernists evinced a special interest in memory, its fallibility, its propensity for 'playing tricks'. Foucault, in particular, invented the notion of 'popular memory'. At best, since memory is an attribute of individuals, this phrase is a metaphor for 'views widely held among ordinary people about what happened in the past'. Foucault, Marxist in his fundamental beliefs about history and society, used the idea to make the case, subsequently taken for granted by postmodernists, that wicked capitalists were depriving ordinary people of their 'popular memory', which Foucault equated with 'radical politics'.[10] Postmodernist theorists have also been protagonists of the view that nineteenth-century 'bourgeois' novelists were wrong in believing that human beings have fixed identities: postmodernist plays in which male roles are taken by females, and vice versa, can be truly exhilarating, but the points they are postulating are scarcely ones upon which historical, political, or social decisions could be made. All of these issues go far beyond postmodernist fashion and crop up in many of the works of art we will be discussing right through the period since 1945.

The great, unique cities of the twentieth century often form central subject matter, New York, Los Angeles, Atlanta, Paris, London (sometimes as both a contemporary city and an eighteenth- or nineteenth-century one). Other works focus on the dreadful backwardness and superstitiousness of the countryside (in southern Italy, for instance), or simply on the mixed emotions of returning from city to home village. Artists have always been interested in historical change, in fashion and values, in the growing salience of technology, in the relationship between past and present: there are 'sociological' novels as well as 'modernist' and 'postmodernist' ones. Identity, of the Catholic, of the Jew, of the female—these are recurrent themes.

Wars and the Holocaust

Artists may be more or less unconsciously influenced by war, perhaps as much in style as in content, or they may very consciously choose to engage with war, its heroics, its horrors, its

absurdities.[11] One or two distinctive individual works excepted, Picasso's *œuvre* as a whole does not seem to have been greatly affected by war. Yet, interviewed in the late summer of 1944, he said: 'I have not painted the war, because I am not the kind of painter who goes out like a photographer for something to depict, but I have no doubt that the war is in these paintings that I have done. Later perhaps the historians will . . . show that my style has changed with the war's influence. Myself, I do not know.'[12] There is, obviously, *The Charnel House* (1945), highly reminiscent of *Guernica*, and there is the bronze *Tête de mort* (*Death's head*) of 1941: the photographer Brassaï asked, 'Is it the war that has brought forth this monolith in Picasso's work?'[13] There is no need for such uncertainty when we come to some of the works of the great Italian women novelists, Elsa Morante and Natalia Ginzburg, nor with the first novel I discuss in this book, *The Naked and the Dead* by Norman Mailer. As American memories of the world war faded, the Vietnam War became a major reference point for many writers and other artists. The understatement and indirection of Fautrier's evocations of the horrors of the German occupation may be puzzling, but the titles leave no room for doubt: *The Hostage, The Shot* (by firing squad), *Oradour* (scene of a Nazi massacre) (all 1944).

The Second World War document everyone knows is the diary compiled by the young German Jewish girl, Anne Frank, while in hiding from the Nazis in Amsterdam. The humour, the cheerfulness, the optimism are heart-breaking. The story of how the Nazis were fooled for two years, thanks to the incredible bravery of Dutch friends, is enthralling. Because of what we know about the Holocaust, because we know that the two families closeted in their hiding place in an Amsterdam warehouse were finally dispatched to concentration camps, all perishing save for Anne Frank's father, the diary becomes an almost unbearably tragic human document. Although Anne Frank hoped that her diary might become the basis for a later novel about her clandestine life in 'the Annex'—and the diary, when originally published in 1947 was given that title, *Het Achterhuis*—the diary itself is not a work of art in the sense that phrase is used in this book; it is a historical document that had the most profound historical ramifications.[14] There were

struggles over getting it translated into English and into German. There were struggles over getting it converted into a stage play. Holocaust-deniers have consistently challenged its authenticity. Eventually published in America and Britain as *Anne Frank: Diary of a Young Girl* (1953), it was then converted into a play by the Americans Frances Goodrich and Albert Hackett, with the title *The Diary of Anne Frank*. This premiered in New York on 6 October 1955, and in London on 29 November 1956. In between, on 1 October 1956, it was put on simultaneously in seven theatres in Germany, where in book form it had enjoyed only modest sales. There had been complaints that the play marginalized the specifically Jewish Holocaust elements of the diary, and leading British theatre critic Kenneth Tynan said of the New York production that it 'smacked of exploitation'. But his experience of the German production in Berlin was overpowering (though he described the experience as historical not artistic): 'At the Schlosspark I survived the most drastic emotional experience the theatre has ever given me. It had little to do with art, for the play was not a great one; yet its effect, in Berlin, at that moment in history transcended anything that Art has yet learned to achieve.' Then, after admitting that these comments were not those of drama criticism, he continued: 'Yet in the shadow of an event so desperate and traumatic, criticism would be an irrelevance. I can only record an emotion that I felt, would not have missed, and pray never to feel again.'[15]

I shall touch again on the diary, and on another renowned 'factual' work relating to the Holocaust (*If this is a Man* (1947), by Primo Levi (1919–87)); but the point I am making here is one of categorization. What we have is a historical document, not itself a work of art, which made a great historical impact, particularly when converted into a play, and, subsequently, in 1980, when presented as a telefilm, neither of those being of great artistic merit. The all-pervasive horror of the war and the Holocaust, as Tynan said, outweighs any work of art.

Consumerism

Many European intellectuals and artists, as I remarked, were anti-American. Many saw the advent of affluence and the consequent consumerism as Americanization. Many saw

consumerism as being responsible for blunting what they thought ought to be the destiny of the working class, adopting a radical or revolutionary stance. At the same time, for the artist as sociologist, consumerism clearly was a fact of contemporary society of such significance as to be worthy of recording in all its resonances and ambivalences. In the upshot, we find that many works of art seem both to celebrate and to criticize consumerism, this being particularly true of Pop Art and its French analogue, *nouveau réalisme*. The classic work is the novel with the very historical/sociological subtitle, Georges Perec's *Les Choses: Une histoire des années soixantes* (*Things: A Story of the Sixties*, 1962). Even Elsa Morante's massive *Storia* (*History*, 1987), running across two world wars, ends up with criticisms of consumerism and Americanization.

Civil Rights, Feminism, Permissiveness

In this book, there are more male names than female ones, many more whites than blacks. Still, the balance does still shift a little as the book proceeds. The American civil-rights movement dominated most of the 1960s, at the end of which decade the new assertive feminism emerged. If there are no blacks in Norman Mailer's *The Naked and the Dead* at the beginning of our period, the questions of black–white relations cannot be kept out of Tom Wolfe's *Bonfire of the Vanities* of the 1980s and *A Man in Full* of the 1990s. The greatest novel of black protest is James Baldwin's *Another Country*, from the early 1960s. This also contains a great deal of uninhibited sexual description and a frank account of a homosexual relationship. In fact, in the growing permissiveness within the arts from the 1960s onwards, women writers and artists played a significant role. Race relations are an issue that European writers, from the 1960s on, have to address. A key work is *Élise ou la vraie vie* by Claire Etcherelli, a gentle love story as recounted by the woman, featuring an Algerian factory worker and the indignities he suffers at the hands of the French police. It may, incidentally, be noted that this novel begins with memories of the German occupation of Paris during the war. Women's novels, essentially social records of an increasingly permissive society in the 1960s, by the 1980s had become much more fundamentalist. A genre attracting

much attention at the end of the century is that of postcolonial literature.

Religion and Nationalism

Religion and nationalism may seem highly inappropriate to the arts at the beginning of the twenty-first century, but in fact they appear with increasing frequency. They are related to the issues of identity and regional nationalism, to reactions (particularly in music) to the formalism and lack of emotion to be found in extreme modernism, and to the geopolitical transformation that came about after 1989, when both Russians and the peoples they formerly oppressed refound their religious beliefs as well as their national voices. National sentiment was often strongly apparent in much of the poetry that was not self-consciously postmodern. Some critics associated the Edinburgh-based detective stories of Ian Rankin with the resurgence of Scottish nationalism following upon devolution. All that apart, I do hope that it will emerge strongly from this book that, while the arts are international, they are often fine exemplifications of the individual characteristics of different nations. What will also emerge is the unique creativity of those belonging to Jewish minorities.

Part One

The Aftermath of War, 1945–1957

Introduction to Part One

I start from the fact of war, raising questions about its effects, and how far it marked a break in historical continuity. One cannot obliterate the cultural traditions of the European countries: Italy celebrated for art and music, Germany (despite the obscurantist interlude under the Nazis) for its music, Britain (and especially England) for its literature. Above all, Paris, before the war, was still the European, and, to a considerable extent, the world, centre of culture. Thus two quintessential facts need to be grasped right at the outset: the first, geopolitical, the utter ascendancy (in the West) of wealthy, powerful, victorious, and relatively unscathed America; the second, cultural, the continuance of the immense ('eternal' I call it, with deliberate exaggeration) appeal, artistic, intellectual, and emotional, of Paris, though in fact its position in art may already have passed to New York.

Throughout the book, I start each part with those developments that, for that particular subperiod, are most important with regard to: what they contribute to the characteristics of the subperiod considered as a unity; the extent to which, through the media in particular, they were known to wide sections of the population at the time; the influence they had on the other arts, or on non-artistic developments, and the ratings they have subsequently been allotted as being especially significant and valuable products of their time.

On that basis I start (though I cannot deal with both simultaneously) with Abstract Expressionism (almost exclusively an American phenomenon) and Existentialism (almost exclusively a Parisian phenomenon), principally as it affected novels and drama. In between I touch on what can be regarded as the Parisian version of Abstract Expressionism, *art informel*, which was directly influenced both by the war experience and by Existentialist ideas. Throughout all this there runs the important

historical issue of American relations with Europe. Abstract Expressionism actually owed a great deal to European Surrealism; in its turn, of course, it subsequently began to influence European art. An intriguing sub-issue is that of America's relationship with Britain. Whatever reservations we may have about the alleged 'common heritage' and 'special relationship', the fact of an (almost) common language is one that simply cannot be gainsaid, and is noteworthy because of the way in which it provided readily shared audiences for films and novels produced in both countries.

Now, there is one other quintessential fact almost comparable with the two I have already mentioned (greater with respect to popular influence, lesser—and that is what counts in my ordering of things—in respect to intellectual and cultural stature): the hegemony of Hollywood films. As I have already mentioned, a subtheme of importance is that of the way in which many films (and indeed television programmes) have their origins in novels. The last major topic of Chapter 1 is the Hollywood film of the period, but for reasons just given it seemed organically appropriate to include both British films, which, though responding to the experience of the war with some delightful national touches, were in many respects imitative of American examples, and the literature of both countries.

Chapter 1 deals with victors. The French, whose experiences of occupation crop up again and again throughout my book, were, in reality, only victors by the thinnest of margins, but they were officially accounted as such, and Parisian art and Parisian existentialism were openly paraded as the triumphant products of a victorious power. America had never had greater authority; the British stamped many of their artefacts with their (justified) obsession with having been 'the country that fought alone'. So Chapter 2 turns logically to the countries that were defeated, and most obviously suffered the extreme disasters of war. Such matters show up palpably in what was to be the characteristic medium for much of the era, film. One of the most prestigious of all art films, *Les Enfants du Paradis*, was made while France was still actually under occupation. Defeated, 'liberated', and thoroughly devastated, Italy also produced, in the neo-realist genre, works of great artistic repute, closely related to the war

and post-war experience. The turning here to a trilogy of Polish films, integrally associated with the war, is obvious enough. Since the one international rival to the Italian neo-realists and to Wajda was Sweden's Ingmar Bergman, I bring him in here for comparative purposes: his films depended on sales in West Germany, while the Italian films, denied the government support that went to films that were less austere and less critical of Italian society, depended particularly on sales in America.

The Holocaust is inescapable. The notion of 'both sides' may seem dubious, or perhaps even repugnant, but the point I am making is that, while that great and terrible man-made catastrophe indelibly marked those Jews who survived, or who were domiciled in safer parts of the world (for example, America), it also came to haunt much German artistic production. We examine the way in which defeated, and in many ways outcast, West Germany began tentatively, and perhaps rather inadequately, to try to deal in literature with Germany's immediate past. This leads to the most famous of all two-volume accounts of what it was like to be a survivor of Auschwitz, that by an Italian, Primo Levi. While concentrating on works that deal with the immediate past, I am anxious also to show how literary and dramatic works, particularly in the German-speaking regions of West Germany, Switzerland, and Austria, began to exploit revolutionary techniques (some having been pioneered in pre-war years by Bertolt Brecht), thus helping to open the way to the great cultural innovations of the 1960s. Experimental theatre is a minority taste and not, therefore, given the prominence I give to, say, Abstract Expressionism, yet one of the subthemes of my book is the intellectual power of what I have referred to as this 'mighty atom of change'. The Theatre of the Absurd, of Cruelty, and of Panic, is dealt with here again, partly as a bridge towards the 1960s.

Classical music is performed in concert halls and opera houses. However, its growing, if still fairly strictly delimited, popularity throughout our era was based very much on important developments in the production and reproduction of gramophone records. Just prior to the full realization of these developments, radio, because of its central role in the Second World War, achieved a position of near indispensability in all

the Western countries. Chapter 3 focuses on that fundamental transformation whereby entertainment in the home at the touch of a switch became a basic facet of everyday life. I start with the changes in the production and diffusion of music, both classical and popular. From there it is logical to move to the major providers of entertainment in the home, first radio and then television. My concern is with both how the industries were organized, and what artistic fare they actually provided. After the discussion about the music, including popular classics, which were being made increasingly widely available, it is then appropriate to turn, by contrast, to that interest with an even tinier following than experimental theatre, avant-garde art music. We have Boulez's own words for making the historical point that the war was a caesura offering a new beginning in the creation of minority classical music. Part One, then, goes from what is fairly widely known about, Abstract Expressionism, existentialism, and Hollywood films, to finish with that which was not much known about at the time, and still is not widely publicized today.

1 Ascendant America and Eternal Paris

Abstract Expressionism

The story goes that, when all the good artists had been chased out of Europe by Hitler in the 1930s, they created Abstract Expressionism, which led to New York usurping the position Paris had long held as the leading city in the world of art. In crucial details the story is not true. Armenian-born Arshile Gorky (1905–48) had settled in the United States as far back as 1920, while German-born Hans Hofmann (1880–1966) had moved to America in 1930, three years before Hitler came to power. Willem De Kooning (1904–97) had arrived from Holland three years before that. Mark Rothko (1903–70) was born in Russia, but had been brought to America before the First World War. Robert Motherwell (1915–91) and Jackson Pollock (1912–56) were American born and bred, Motherwell hailing from Washington State and Pollock from Cody, Wyoming. However, the notion of a transfusion of European ideas to America is not erroneous. Hofmann had worked with the Parisian giants from 1904 to 1914. Motherwell, very much an intellectual, was in close contact with both political and philosophical European ideas: he was deeply affected by the Spanish Civil War, and became involved with existentialist philosophy.

The term 'Abstract Expressionism' goes back to Germany at the end of the First World War, but became an accepted label applied to a recognizable school, 'the New York school', only at the end of the Second World War. An alternative label, 'Action Painting', came into existence in the early 1950s. In fact, one can make a broad distinction between the more aggressive and dynamic style (Action Painting), and the more contemplative, colouristic one.

It is important to be clear that the various 'isms' in art are not hermetically sealed off from each other: any one painting may

display elements of several different isms. Edward Lucie-Smith has described Gorky as 'perhaps the most distinguished surrealist that America had produced'.[1] He was strongly influenced by Picasso, Miró, and Tanguy, but also by the Chilean-born Surrealist painter Roberto Matta, who himself brought American artists into contact with American Indian art. The war did have the effect of cutting artists in America off from European influences, and it was during the war that Gorky developed a more intense, more personal style. *Water of the Flowery Mill* (1944) suggests a movement from Surrealism towards Abstract Expressionism. A famous interview in 1947 seems to show Gorky, in thought at least, moving towards the notion of a 'continuous dynamic', an important constituent of Abstract Expressionism:

When something is finished, that means it's dead, doesn't it? I believe in everlastingness. I never finish a painting—I just stop working on it for a while. I like painting because it's something I never come to the end of. Sometimes I paint a picture, then I paint it all out. Sometimes I'm working on fifteen or twenty pictures at the same time. I do that because I want to—because I like to change my mind so often. The thing to do is always to keep starting to paint, never finishing painting.[2]

Yet, one of his most famous paintings of the same year, the *Betrothal II*, continues to conjure up reflections of both Miró and Matta. Whether Gorky would have moved from being Surrealist supreme and precursor of Abstract Expressionism to being a leading Abstract Expressionist we will never know. In 1948 a highly destructive studio fire, a cancer operation, injuries sustained in a car accident that stopped him from painting, his impotence, and his wife's adultery drove him, at the age of 44, to commit suicide.

Hofmann almost had two separate careers. When he arrived in America he had already accumulated great experience as a teacher in Paris and Munich, and as a teacher in New York in the inter-war years he had great influence on the younger painters who were to form the core of Abstract Expressionism. Then in his sixties he began to paint in a style that was very much in keeping with the serene, colourist aspect of Abstract Expressionism, good examples being *Radiant Space* (1955) and *Rising Moon* (1964).

Motherwell, the intellectual, was also a traveller, and it is significant, in bringing out both Abstract Expressionism's origins in Surrealism, and the importance of native American art, that he made a trip with Matta to Mexico. His intellectual (and, indeed, organizing) activities are seen in his editorship of the magazine *Possibilities* (1947–8), and his founding in 1948 of the Arts Club on 8th Street, New York, which included fellow artist Mark Rothko and avant-garde musician John Cage. Very characteristically, *The Voyage* (1949) is a tribute to Baudelaire's poem *Le Voyage*, about modern art travelling into unknown territory, which was what Motherwell felt he and his colleagues were doing. Best-known are the series of *Elegies to the Spanish Republic*, running through from the early 1950s to the early 1960s. Lucie-Smith speaks of Motherwell's 'nostalgic rhetoric'. Motherwell, with perhaps a touch of the philosopher's perversity, declared that the *Elegies* were not political, but 'general metaphors of the contrast between life and death'.[3] Motherwell even half-opened the door to the pathway that much 1960s art was to take when, in 1951, he published an anthology of Dada painting and poetry.

Nowhere other than America, leader in the modern mass media, was the press more practised in whipping up sensations. Abstract Expressionism, and above all the most famous exponent of Action Painting, Jackson Pollock, became a sensation. Pollock came to New York in 1929, where the influences on him were ones we have already noted: Mexican painting and Surrealism. According to the guide to the 1990 Royal Academy exhibition, 'American Art in the 20th Century':

By the early 1940s some young American artists made the conscious decision to disconnect the line to Europe. They wanted to provoke and shock, to be the standard-bearers of the avant-garde in a specifically American way. This radical group of artists launched the revolutionary movement called Abstract Expressionism that by 1950 had successfully invented a new contemporary art vocabulary. And, for the first time in the history of Western art, the centre of the artistic avant-garde shifted away from Europe to America.

According to the guide to the Tate Gallery Jackson Pollock exhibition in the spring of 1999: 'Jackson Pollock is an inescapable

presence straddling Western art at the mid point of the twentieth century . . . an artist who is now seen as one of the most significant of his century.' I am not sure that either of these statements is totally true, but certainly Pollock is the first of several figures of this book to have achieved celebrity status. If a single artist can represent the 'new contemporary art vocabulary', it must be him. His life represents a mobility in American society not yet to be found in Europe. His career strongly illustrates the influence of mediators, critics, and patrons. Though to talk of him being completely cut off from European influences is nonsense, the all-American influences on him can be identified with particular clarity. Tall and handsome, born in a town named after Buffalo Bill, gentle and somewhat inarticulate in the manner of James Stewart's screen characters, but violently aggressive when drunk, he and his protagonists encouraged the myth of himself as the all-American lone hero as artist.

He was the youngest of five brothers, his father an unsuccessful farmer: yet three of the brothers actually set out to become artists. At the age of 16 Jackson entered the Manual Arts High School in Los Angeles, moving in 1930 to New York to join his elder brother Charles at the Art Students' League. Here Jackson's teacher was Thomas Hart Benton, than whose American Realist portrayals of the Midwest there could be nothing more American. As early drawings testify, Pollock achieved the highest standards of draughtsmanship; of his time with Benton he remarked that it was 'important as something against which to react very strongly, later on'.[4] He went on lonely hitch-hiking trips across America; he took a strong interest in contemporary Mexican painting, and also in Inuit Indian ritual masks and totem poles. His first paid employment was with President Roosevelt's 'socialistic' Federal Arts Project, where, despite outbursts of drunkenness and violent behaviour, he stayed between 1938 and 1943. The early paintings are both expressionist and Surrealist, and contain quite strong representational elements: I, personally, am reminded of Max Beckmann. *Birth* was painted in 1941, and included in an exhibition in New York in January 1942 called (note the internationalism) 'American and French Paintings'. This painting attracted the attention of Peggy Guggenheim, New York's wealthiest and most prestigious

collector, who in 1943 gave him his first solo show at her Art of this Century gallery. His cause was now taken up by the powerful art critic Clement Greenberg. Pollock was also sought after by the female artist Lee Krasner: their marriage took place in October 1945, and their married life attracted as much media attention as Pollock's paintings. This being New York, it was natural that Pollock's aberrant behaviour should lead to his employing an analyst. The analyst encouraged the painter to see his work as a direct outpouring of his subconscious. In the summer of 1943, Peggy Guggenheim commissioned Pollock to provide a massive canvas (*Mural*) for her house on East 61st Street. Guggenheim was a great collector of modern European painting, and there can be no question but that Pollock at this time was very aware of the work of Miró and, above all, Picasso. Reading *Mural* can take as long as reading a short book: 'Figures are still there, reduced to stick-like forms and engaged in some great dance, of life or death, or in some ritual procession . . .'[5]

The year of the birth of Action Painting was 1947. Pollock, now living out on Long Island with his wife, began tacking his unstretched canvasses to the floor, dripping and splattering paint onto them, together with small pebbles and other objects. Increasingly he used industrial paints and household enamels, sometimes pouring directly from the can. Many of these paintings, collectively known as 'the great webs', were simply given numbers, but sometimes he or a friend would provide a descriptive title, such as *Summertime*, of which there are ten or so versions. After surveying what he had produced, Pollock would trim his canvas in order that the finished painting should have some kind of coherence or structure. Everyone knows, or thinks they know, about Pollock's demonic and balletic methods of production, because, in the summer of 1950, a young neighbour, Hans Namuth, took hundreds of photographs and made two films of Pollock at work. In the films, it is easy to perceive Pollock as something of a poseur. And indeed a crisis of self-examination was provoked, turning the artist back towards the heavy drinking that he had managed to abandon for a few years. After a series of black paintings Pollock went on to do some final monumental ones, before ceasing to work altogether in 1954. To the delight of the media his relationship with Lee Krasner

began to break up: in the summer of 1956, while she was abroad, he began an affair with a young artist called Ruth Kligman. On 11 August 1956 Pollock fulfilled the role of rumbustious, but tragic artist, and, drunk, drove his car into a tree, killing himself and a girlfriend of Kligman's.

Nearest to Pollock as action man of Action Painting was De Kooning, who, however, almost always retained a very strong figurative element in his work. To begin with, Greenberg was a supporter of De Kooning, defining his figurative tendencies as being designed to recover 'a distinct image of the human figure, yet without sacrificing anything of abstract painting's decorative and physical force'.[6] But when, at his third one-man show in 1953, De Kooning exhibited the paintings *Woman I–VI*, he was viciously attacked by Greenberg for betraying the tenets of abstraction and decoration, while Harold Rosenberg, the critic who had coined the term 'Action Painting', defended him. *Woman I* was bought by the Museum of Modern Art, New York, and 'became one of the most widely reproduced paintings of the 1950s and at the same time a focus for pugnacious controversy . . . the general public was shocked by the gross grinning ugliness of De Kooning's presentation of a classical subject', the female nude. De Kooning, in a sentiment that in some ways anticipates the attitudes of the Pop artists, said: 'I seem always to be wrapped in the melodrama of vulgarity.'[7]

Rothko may be seen as representing the serene, contemplative aspect of Abstract Expressionism. He is, most assuredly, one of the giants of the New York school, but, given that his paintings are essentially composed of 'fields' of colour, at first sight resembling the late work of Hofmann, he is perhaps best regarded as the first of what were to be referred to as the 'colour-field' painters. The basic idea was that these flat fields of colour should induce meditation and mystic feelings in the beholder. Rothko declared himself in favour of 'the simple expression of complex thoughts', his:

rectangular canvases proffer, on an even-coloured ground or field, two or three rectangles of different colours, varying in width or in height but seldom in both, disposed precisely horizontal or vertical. There, however, precision ends, for the colour is washed or stained with shifting tones, shifting luminous intensities, while the edges of the

rectangles blur out of definition until the colour seems to float—and, so powerful and intense is the impression of mysterious radiance flooding from these great canvases, the spectator in contemplating them may seem almost to float, too.[8]

These effects are at their strongest when the viewer is surrounded by paintings, as in the Tate Gallery, and also at Harvard and at Houston, Texas. The Tate set of eight originally formed part of a commission for the Four Seasons Restaurant in the Seagram Building in New York, which fell through. There is a strong indication of Rothko's intentions in the fact that he was pleased his paintings were to share a gallery with the great mood-evoking series by J. M. W. Turner.

It is right to focus on Abstract Expressionism and its emergence in the United States, but quite wrong to believe that Paris was in any way eclipsed.

Art informel

These artists were the first American ones to become internationally famous. But there were European artists, all based in Paris, who were already international 'greats': Picasso, Miró, and Beckman—but also Braque, Matisse, Léger. The 'greats' were perceived as standing for Western civilization, which, finally, had triumphed over Hitler. In 1946, at the exhibition 'Art and Resistance' organized by the Veterans' Association of French Partisans at the National Museum of Modern Art, works by these famous figures were exhibited along with ones by lesser-known and younger artists. With the possible exception of Matisse, who produced his stunning *papier découpé* works out of pieces of coloured paper—for example, *The Snail* (1953)—the reputations of these artists are not thought to have been much enhanced by their post-war work. Picasso, who joined the Communist Party at the end of the war, produced some rather weak propagandist stuff, though, as we shall see, he enjoyed a final and influential burst of glory in that most stimulating of artistic periods, the 1960s. One of Picasso's paintings, exhibited at the Art and Resistance Exhibition, then fiddled with, but never fully finished, for several years thereafter, is *The Charnel House* (1945). There is some argument as to whether the

painting refers specifically to the Nazi concentration camps, photographs of which certainly became available to Picasso in 1945, or whether it is more broadly anti-war and anti-militarist. Tim Hilton has written:

Like Guernica, it is a black and white or grisaille painting, set in an indeterminate Cubist space and embodying a general symbolism of suffering. The complex weaving of black and white shapes, running patterns, interweaving of positive against negative areas, is more pronounced than in the earlier picture, though the palette is nearly identical and the iconography very similar.[9]

To me it is plain that both *Guernica* and *The Charnel House* stick out from the general development of Picasso's art; they are almost 'duty' paintings. Picasso, like Braque and Matisse, was too secure in his artistic purposes to be affected by 'events', even events as calamitous as total war. Whether or not the 'greats' continued to develop, their influence was overwhelming. Very important in the transmission of modernism were the exhibitions of Picasso and Matisse at the Victoria and Albert Museum, London, in December 1945, and of Braque and Georges Rouault at the Tate the following summer. At this time (in the *Nation*, 29 June 1946) it was still possible for Clement Greenberg to write:

The School of Paris remains still the creative fountain-head of modern art, and its every move is decisive for advanced artists everywhere else—who are advanced precisely because they show the capacity to absorb and extend the preoccupations of that nerve-centre and farthest nerve-end of the modern consciousness which is French art.

His reversal of this judgement, as he wheeled round behind Abstract Expressionism, eighteen months later, symbolically represents the theory (not necessarily a completely sound one) that ascendancy had passed from Paris to New York.

Much more interesting than Picasso's one-off, rather mechanical, reaction to the war is the work of Jean Fautrier (1898–64). Although Fautrier was painting throughout the 1930s, it seems to have been in 1940 that he perfected his distinctive method, paper placed on canvas, with *grumeaux* (clots) and *magmas* (heaps) of oil paint (delicate tints, blues, orange, or green) built up on the paper, and ink drawings scratched on these clots.

Fautrier, resident in France throughout the Occupation, was deeply affected by German atrocities, as is demonstrated by his titles: *Le Fusillé* (*Shot* [*by Firing Squad*]), *La Juive* (*The Jewess*), and the series *Les Otages* (*Hostages*), and *Oradour-sur-Glâne* (the town obliterated by the Nazis in 1944, the men shot, the women and children burned to death in the church). At first sight, these paintings appear charming: then one deciphers the lifeless faces inscribed upon the clot of paint. 'Hieroglyphics of suffering', these have been termed, and art critic Maurice Fréchuret has commented on those apparently gentle, but manifestly deeply felt paintings: 'Is not this the only response possible to a world become mad and upon which aversion which is merely horrified would exercise no grip . . .'[10] Fautrier is an important contributor to the post-war movement known as *art informel* (Informal Art)—that is to say, not 'casual art' but 'art without form'. As ever, there are a number of, usually overlapping, subsets—such as *art brut* (Unrefined Art) and *Tâchisme* (a *tâche* being a blob or splash of paint)—with some painters openly associating themselves with the philosophical movement of Existentialism.

The most successful of the younger French artists was Jean Dubuffet (1901–85). In 1947 he presented his exhibition of *art brut*, 'unrefined' works that he had collected by those whom he considered free of standard cultural preconceptions and constraints, 'naives', 'primitives', 'psychotics', 'eccentrics', and 'children'. Together with André Breton (1896–1966), the founder or 'Pope' of Surrealism, and the insignificant Michel Tapié (1909–87), Dubuffet founded the 'compagnie de l'Art Brut'. Its aims, according to Dubuffet, were: 'To seek out the artistic productions of humble people which have a special quality of personal creation, spontaneity and liberty with regard to convention and received ideas. To draw the public's attention towards this sort of work, to create a taste for it and encourage it to flourish'.[11] Dubuffet's own works, mainly of human figures within a thick paint surface broadly similar to that of the other Informal Art artists, seemed to echo the childlike qualities of spontaneity, liberty, and naivety, but were in fact highly sophisticated, and certainly extremely appealing. They can also be seen as visual expression of 'the Absurd'.

Tâchisme was the style developed by Nicolas de Staël (1914–55). The de Staël family were fugitives from the Russian Revolution, Nicolas having been born in St Petersburg. Between 1932 and 1934 he studied at the Royal Academy of Fine Arts in Brussels, installing himself in Paris in 1938. At first he painted portraits and still-lifes, having his first one-man show of these in 1944. Then he went through one of the sudden conversions not uncommon among artists: he found himself, he said in exquisite French, 'gêné de peindre un objet ressemblant' (embarrassed to paint something that looked like something). Now he almost sculpted with his knife, depositing thick, luminous blobs (*tâches*) of paint on the canvas. His aim, he said, was to 'achieve a harmony'—and some commentators (including myself) would say that, of all the abstract and informal painters of the time, including Rothko, de Staël was the most successful in this. He said: 'Regarding my painting, I know what lies beneath its appearances, its violence, its perpetual games of force. It is a fragile thing like love.' In 1952, just as suddenly as previously, he switched back to figurative painting, doing footballers, musicians, and landscapes. Clearly, deep stress lay behind the switches in style. He wrote, 'I do not have the strength to perfect my paintings.'[12] On 16 March 1955 he committed suicide by throwing himself over the ramparts at Antibes. Here again there would seem to be evidence that, while there is no single artistic personality, and while artists *can* be dull, they are certainly not mere depersonalized agents of bourgeois hegemony.

For those interested in the possible influences of events, as distinct from more profound historical 'forces', Alberto Burri (1915–95) is an important painter to consider. He is also an interesting example of a man whose sudden mission to paint leads him to abandon a perfectly successful professional career. Born in 1915 at Città di Castello in Italy, he was a doctor before joining the Italian army in 1940. Taken prisoner by the Americans, he was interned in a camp in Texas during 1943 and 1944. It was here that he turned for the first time to art. His highly distinctive works, mainly made of sacking and old rags, form an important contribution to Informal Art. Burri said that he had selected his materials because they reminded him of the

blood-soaked bandages he had seen in wartime. He spoke of his work as 'affirming liberty',[13] and, in his use of waste, or scrap, materials, he forms a bridge between the Informal Art of the 1940s and the 'art povera' of the 1960s—'art povera' (a mix of English and Italian) was the term originally coined by Germano Celant (b. 1940), but it is now usually corrected to 'arte povera'. The impact of Burri's paintings is an immensely powerful one.

Continental European artists still gravitated to Paris (Burri died in France). But one of the aims of this book is to shed some limelight on the creative spirits who worked in some of the less fashionable countries. The CoBrA Group, the name carefully chosen to represent the fact that the original members came from Copenhagen, Brussels, and Amsterdam, was founded in 1948, the leading members being Asger Jorn (1914–73) from Denmark, Corneille (b. 1922) and Pierre Alechinsky (b. 1927) from Belgium, and Karel Appel (b. 1921), from the Netherlands. CoBrA, which disbanded in 1951, is always referred to as 'short lived'; actually most post-1945 'isms' and groups were short lived, particularly from the 1960s onwards, as artists became more and more eager to assert their innovativeness rather than their solidarity. The CoBrA style was similar to that of the more emotional, gestural Abstract Expressionists, though it never resorted to the techniques of Action Painting. The only member of undisputed international stature was Appel, though, with reference to general cultural movements, some of the others are of considerable interest too. The violent, expressionist quality of Appel's work is echoed in his own statement: 'A painting is no longer a construction of colours and lines, but an animal, a night, a cry, a human being, it forms one indivisible whole.'[14] It 1950 he moved to Paris (probably a reason for the disbanding of CoBrA within a year), and in 1959 to New York. His career thereafter, based on both of these cities, exemplifies the international cultural exchange that becomes a prominent feature from the 1960s onwards. Jorn worked in Fernand Léger's Contemporary Academy in Paris in the late 1930s. He was an indefatigable theoretician and associated himself with most of the avant-garde movements of the post-war years. Naturally, he was present at the founding of the Situationist

International in Italy in 1957. (Situationism will be discussed in Part Two.)

Let us now turn to artists from two other less prominent countries. Descended from a well-connected family of the Anglo-Irish ascendancy, and born in Dublin, Francis Bacon (1909–92), worked as an interior decorator in the inter-war years, but never studied art. An exhibition at a private gallery in April 1945, which contained works by such leading British artists as Matthew Smith and Henry Moore, also included a large triptych by Bacon entitled *Three Studies for Figures at the Base of a Crucifixion*: this contained those ingredients by which Bacon was eventually to become well-known—malignant, ominous, twisted figures, part-human, part-animal. Art critic Frances Spalding has suggested that, 'to a postwar audience, these ghoulish celebrants of murderous acts were a horrific reminder of human bestiality'. Against that, one must put Bacon's own statement that he had 'nothing to say about the human condition'. Bacon also spoke of his aim to 'unlock the valves of feeling and therefore return the onlooker to life more violently'.[15] In his later interviews with the art critic David Sylvester, Bacon gave an interesting account of how he came to do a major work in 1946:

One of the pictures I did in 1946, the one like a butcher's shop, came to me as an accident. I was attempting to make a bird alighting on a field. And it may have been bound up with the three forms that had gone before [i.e. *Three Studies for Figures at the Base of a Crucifixion*], but suddenly the lines that I had drawn suggested something totally different, and out of this suggestion arose this picture. I had no intention to do this picture, I never thought of it that way. It was like one continuous accident mounting on top of another.[16]

In his standard *Movements in Art since 1945*, Edward Lucie-Smith refers to Alan Davie (b. 1920) as English. In fact, Davie was not only born and bred into a very separate Scottish tradition, studying at the Edinburgh College of Art between 1937 and 1941; he developed into much more of an international figure than any of his English contemporaries. Travelling to Venice in 1948 he there encountered the work of Jackson Pollock and Robert Motherwell. Concentrating thereafter on a form of Abstract Expressionism, he became associated also with

the CoBrA group. From the beginning of the 1950s strong fig-
urative elements entered his work, drawn from an enormous
cultural range, Celtic, African, Bhuddhist. Rather in the man-
ner of Jackson Pollock, he would put himself into a trance, then
let the paint run directly onto the canvas.

Finally, the odd man out. Balthazar Klossowski de Rola,
known as Balthus (1908–2001), belonging to a Parisian family of
artists, was something of a child prodigy. Balthus totally
rejected modernism, seeing himself as the inheritor of the great
masters. He returned time and again to the same topics: land-
scapes, moments from everyday life, interiors, cats, nude por-
traits of young girls and young boys. His human subjects, in the
words of French critic Pascale Le Thorel-Daviot, 'are situated
in a universe of nostalgic and timeless voluptuousness, appar-
ently just before or after making love, dreaming unawares'.
Despite the intense naturalism of his paintings, Balthus spoke
as the most confirmed modernist might: 'Painting is a language
which no-one can replace with another language . . . Honestly, I
do not know what to say about what I paint.'[17]

The main styles I have been describing (Balthus, of course,
excluded) continued to dominate Western art until the late
1950s. New modes, which I shall discuss later, began to appear
during the 1950s, culminating in the transformed configuration
of the 1960s.

Existentialism

On the international stage, Informal Art had to compete for
attention with Abstract Expressionism. Within Paris, it had to
compete with the philosophical movement Existentialism, with
which it was closely associated. The association brings us to our
first, and only, heterosexual celebrity partnership: Jean Paul Sar-
tre (1905–80) and Simone de Beauvoir (1908–86). Both were
brilliant students of philosophy and met at the Sorbonne in
1929. She was a handsome and imposing woman, he very small
and unimpressive in appearance. Modernism in philosophy
can be seen in the rejection of the optimistic notions of
Hegel (1770–1831) that humans are simply tiny fragments
in the total scheme of things, presided over by God, the

impersonal Absolute. In the nineteenth century the Danish philosopher and theologian, Søren Kierkegaard, challenged Hegel in stressing the separateness and loneliness of human beings, who have to make their own individual choices, their relations with God being inexplicable or 'absurd'. Developments towards what was to become known as Existentialism were taken further by two German philosophers, Edmund Husserl (1859–1938) and his pupil Martin Heidegger (1889–1976). The phenomenology of Husserl argued that philosophy must begin from an inspection of a person's own mental processes, removing all assumptions about their causation and wider significance. Heidegger said that the only certainty for humans is that of their own death; only in extreme states of mind is their situation in the world revealed. Sartre immersed himself in the philosophy of Husserl and Heidegger, for a time studying phenomenology at the French Institute in Berlin.

He was conscripted in 1939, taken prisoner in 1940, then released with the capitulation of France. While a prisoner he began his great work of Existentialist philosophy, *L'Être et le néant* (*Being and Nothingness*, 1943): nothingness is the condition of a human being before he or she makes the decisions creating his or her own being, and which is everyone's condition after death. An important Sartrean concept was that of 'bad faith': if, instead of forging your own decisions and acting upon them, you simply took refuge in conventions, in religion, in what was comfortable, then you were guilty of 'bad faith'. Sartre's vocation as an intellectual can be seen in his wartime membership of the *Comité national des écrivains*, a talking shop rather than an active resistance organization, but nonetheless an activity that could have got him into serious trouble with the German occupiers. Depression and hunger in the inter-war years, the rise of fascism, the atrocities of the Second World War, the desire for an intellectually coherent politics, led many intellectuals on the European continent (and some in Britain and America) to accept Marxism and its representatives on earth, the Soviet Union and the various Communist parties. Sartre strove to meld Existentialism and Marxism, even though there were some contradictions between the former's insistence on the individual's responsibility for his or her own destiny and Marxism's

insistence on the primacy of social forces. Another Sartrean watchword was 'commitment': he and de Beauvoir were committed to the struggle on behalf of the poor and the oppressed, and saw the Communist Party as the only effective instrument in that struggle. In post-war France, Sartre, abetted by de Beauvoir, was a leading intellectual, literary figure, political activist, delegate, committee man, revered by young people abroad as the apostle of individual action and commitment.

The other famous Existentialist was Albert Camus (1913–60). Like a number of French intellectuals, Camus was born to a white family in Algeria (in his case a very poor one). However, he studied philosophy at the University of Algiers and became a journalist in France. During the war he was active in the militant resistance group, COMBAT. To Camus is due the credit for popularizing the concept of 'the absurd'. His major Existentialist work, *Le Mythe de Sisyphe* (*The Myth of Sisyphus*, 1942), argued that human liberty could actually be enlarged by a frank acceptance of the meaninglessness of life. In the same year, he published *L'Étranger* (*The Outsider*): the outsider of the title commits a pointless murder (an Existentialist act that is also absurd) then refuses to conform to any of the usual norms of explanation, motivation, or remorse. This was the novel that, translated into English in 1946, brought him an international audience. He quickly became disillusioned with Communism, and *La Peste* (1947; *The Plague*, 1948), an allegory of the Occupation, showed a strong scepticism about political commitment. His utter rejection of Communism was revealed in *L'Homme révolté* (1951; *The Rebel*, 1953); this entailed a complete break with Sartre and de Beauvoir. Camus, with his creations of outsider, rebel figures, was also a great hero to the young in many countries. He lacked the self-advertising qualities of a Jackson Pollock (or even a Sartre), but perhaps grew in legendary power when he too met that specially twentieth-century death, being killed in a car crash in 1960.

For young people in all Western countries seeking a philosophy of life, Existentialism was that philosophy, maintaining its hold throughout the 1960s, even when in French intellectual circles it had been superseded by Structuralism. In the later 1940s, and for much of the 1950s, Existentialism, or what was

thought to be Existentialism, was treated as an important cult by journalists: its centre was to be found in the cafes and clubs of the Left Bank; its uniform, tight black sweaters and trousers; its music, jazz; its protagonists giving exaggerated displays of Existentialist angst in place of the normal conventions of social intercourse. Imitators could be found in most university cities throughout the West.

Sartre dabbled in film, but turned particularly to theatre, an art form that showed considerable resilience, and that enjoyed a great flowering in the 1960s. A particularly good example is *Les Mains sales* (*Dirty Hands*, though in Britain usually given the alternative French title *Crime Passionnel*), first presented in Paris in 1948. More, perhaps, than any other of Sartre's works, this highly effective piece of theatre combines Existentialist philosophy with a sense of the agonizing choices facing the European Left in the post-war years. Such was Sartre's fame that productions followed quickly in New York and London. London avidly welcomed this intellectual and dramatic experience, but New York was not interested in the dilemmas of the Communist Left. The political issues in the play are those of 1948, though it is actually set during the Second World War, among a group of people in a central European country who are resisting Hitler. Hugo is a young upper-class figure who is perhaps just not quite dedicated enough in his commitment to the Communist Party. However, perhaps in part to resolve doubts on that score, he accepts the job of shooting the Party's leader, Hoederer, who has been taking the pragmatic line of advocating collaboration with liberal and social democratic opponents of Nazism. Hugo carries out the assassination, but then finds that the Party line has changed, Hoederer's collaborative policy now being advocated. Hugo, himself, is now in danger of his life from the Party. He refuses to adjust to the new line, and it is clear that he is destined for execution. Is Hugo the brave individual in the face of the ruthless totalitarianism of the Party? Or is Hugo, who, having, after much hesitation, made one choice, now seems simply to be waiting for death and refusing to face up to the necessity of constantly making difficult choices, guilty of 'bad faith'? There is a profound, and fascinating, ambiguity at the heart of the play: fascinating for (some) audiences, but also

mirroring the ambiguity in Sartre's position as he attempted to straddle both Existentialism and Marxism.

There is a nice comparison and contrast to be made with Camus's play *Les Justes* (*The Just*, 1940). Communist critics were extremely critical of both plays. *The Just* seems to cover similar issues, though it is set in the terrorist milieu of nineteenth-century Tzarist Russia. Kaliayev, one of a group of terrorists plotting to assassinate the Grand Duke Serge, draws back from his first attempt because it would involve killing children. The play contains a wide range of debates over the legitimacy of political assassination. The case is made that assassination achieves nothing, and leads only to the execution of the assassin. However, the character Stepan defends indiscriminate violence in furtherance of the cause. Kaliayev now goes through with the assassination. He refuses to express repentance, and is executed. As the play ends, the group are planning a new attempt.

Sartre's speeches are plain and straightforward, and all the more effective for that. Camus's are much more passionate and rhetorical. Camus, it was said, was interested in people, interested in their emotional turmoil, while Sartre was interested in abstractions, in people's intellectual turmoil. Whatever his final position, if he had one, Sartre clearly makes the case for total obedience to a ruthless Communist Party. Camus seems to suggest criticisms of violent actions justified by nothing more than revolutionary theory.

In his work of political analysis *L'Homme révolté* (*The Rebel*, 1951), Camus recognized some of the positive aspects of Marxism, but mounted a devastating attack on Marxist faith in historical inevitability, and the atrocities that this led to in Marxism in practice. In May 1952, Sartre's own journal *Les Temps modernes* published an attack by Francis Jeanson accusing Camus of being too fastidious to take part in the struggle against social injustice. Sartre invited Camus to reply, but then added rebuttals from both Jeanson and himself. This debate was important in France, and, to a lesser extent, in other parts of continental Western Europe. Already in Britain, George Orwell (1903–50) had published his desperately bleak novel *Nineteen Eighty-Four* (1948), a devastating account of totalitarian society, of which

Soviet Russia was then the main exponent. In Britain and America defenders of Communism were tiny minorities. However, Marxism, in the broadest sense, continued to be an all-permeating world outlook in France, and Sartre, as we shall see, felt bound to go on wrestling with the problem of the incompatibility between Existentialism and Marxism, in his *Critique de la raison dialectique* (*Critique of Dialectical Reason*, 1960). He was far more appealing in another magnificent play, *Les Séquestrés d'Altona* (1959)—presented in English as *Loser Wins*, though an accurate translation would be *The Prisoners of Altona*—in which prisoners in the north German town of Altona (adjacent to Hamburg) further explore the great issues of the Resistance, violence, and torture.

Simone de Beauvoir published a major novel, *Les Mandarins* (*The Mandarins*, 1954), based on the intellectual and political developments at the end of the war, Sartre being split into two separate characters. Her autobiography, *La Force des choses* (*Force of Circumstances*, 1963), is both a fine literary effort and a vital source. However, her most important work was *Le Deuxième Sexe* (*The Second Sex*, 1949). There are strong Existentialist elements in it, which perhaps contributed less to its continuing popularity among young women right through the 1960s, than it did to prolonging their preoccupation with Existentialism. Beauvoir denied the existence of the essentialist concept of 'the eternal feminine'. She was the first to give currency to the idea of women, as they existed in a man's world, being defined, as against men, as 'The Other'. She was also at the beginning of a major new tradition in claiming that the role of women was not biologically determined, but constructed by society: 'One is not born a woman, one becomes one.' On her final page she wrote:

To emancipate woman is to refuse to confine her to the relations she bears to man, not to deny them to her; let her have her independent existence and she will continue none the less to exist for him *also*; mutually recognizing each other as subject, each will yet remain for the other an *other*. The reciprocity of their relations will not do away with the miracles—desire, possession, love, dream, adventure—worked by the division of human beings into two separate categories; and the words that move us—giving, conquering, uniting—will not lose

their meaning. On the contrary, when we abolish the slavery of half of humanity, together with the whole system of hypocrisy that it implies, then the 'division' of humanity will reveal its genuine significance and the human couple will find its true form.

While she declared herself not to be a feminist, because she did not wish to distract attention away from what she regarded as the all-important class struggle, she was attacked by the Communists for doing that very thing. Anyway, the significance of her book transcends the kind of debate held between Sartre and Camus.

Existentialism was a multimedia, multidisciplinary movement. Jean Fautrier (1898–1964) was closely associated with it, as was Robert Motherwell in America and, even more so, Wolfgang Schülze (1913–51), German-born Paris denizen, who, existentially, created his own name, Wols. He was the perfect specimen of the existentialist artist, nonconformist and alcoholic: his work is distinguished by thick paint and mysterious forms, as, for example, in *The Blue Pomegranate* (1946).

Anglo-Saxon Film and Literature

'Anglo-Saxon' is a word continental Europeans often use to describe the combined cultural production of the United States and the United Kingdom. When we talk of the 'influence' of one country's cultural production we have to be very clear in specifying influence over *what*. American Abstract Expressionism, when exhibited, say, in Venice, or in the last room of the 'Modern Art in the United States' exhibition in London in 1956, interacted with not dissimilar European developments, and undoubtedly influenced some European artists (a tiny minority within European populations). A rather different influence has been attributed to American films, which certainly formed a substantial part of the films viewed in the European countries. The best and most successful European films were distinguished by being distinctively non-Hollywood, but Hollywood films certainly provided audiences with images of lifestyles in the world's most advanced, most affluent, consumerist society. In the post-war years the Americans were in a particularly strong position to influence customs and

behaviour in Italy and Germany; recent work has challenged the more simplistic accounts of a general Americanization of Western Europe.[18] America in the late 1940s and early 1950s had something of a mythical status, fascinating to many, but certainly not imitated by all. No one even suggested that Britain had anything like this kind of influence. A popular genre, which also intrigued certain continental intellectuals, was the thriller/ crime novel or film, often linked to the concept of the American tough-guy private eye, such as Lemmy Caution—but Lemmy Caution was actually the creation of British novelist Peter Cheyney (1896–1951).

In both America and Britain there are films and novels related to the war and its aftermath. Then, in America, the Cold War and the persecution of those held to be anti-American had their effects; in Britain the main trend was merely towards various celebrations of Britishness. Hollywood, as film critics see it, was the home of 'classical' cinema (continental Europe that of 'modern' or 'art' films). The classical genres continued: social-problem films, thrillers, comedies, Westerns, and musicals (I deal with all of these in Chapter 3).

The English-language novel of the Second World War widely regarded as the greatest was American, *The Naked and the Dead* (1948) by Norman Mailer (b. 1923), based on the author's own experiences in the Pacific war. The finest representation of the aftermath of war was the British film *The Third Man* (1949), but this had two American stars, Orson Welles and Joseph Cotten, demonstrating that British cinema often seemed to belong to an American colonial outpost. For the student of the relationship between war and cultural production, the third great artefact is the American film *The Best Years of our Lives* (1946), whose director, William Wyler (1902–81), had many of his basic assumptions shaken by the war experience.

William Wyler was born in Alsace, his father being German and his mother Swiss. He came to the United States in 1920. His seriousness of purpose as a Hollywood director, and commitment to imaginative use of the camera, can be seen in his film of Lillian Hellman's play *The Little Foxes* (1941). He directed two war documentaries, *Memphis Belle* and *The Fighting Lady* (both 1944), as well as the feature film *Mrs Miniver* (1942),

much mocked since as a very Hollywood (and specifically, per-
haps, MGM) vision of an English family at war, but highly
successful in its gently propagandist aims. Wyler was in great
demand as a director, and for *The Best Years of our Lives* he
returned to Samuel Goldwyn, producer of *The Little Foxes*
(1941). *The Best Years of our Lives* is an extremely earnest film
about the transition from war to peace as experienced by three
servicemen returning to the same American small town. An
intense naturalism is aimed at through the photography of
Gregg Toland, 'using long takes, a moving camera, and deep
focus, with objects and people photographed in relation to each
other in different planes of depth within the frame'.[19] An ama-
teur, Harold Russell, who had lost both his hands in the war,
plays the sailor who has been fitted with prosthetic devices. The
film conveys the sense that, after the atrocities of war, America
ought to be a better place. That sentiment keeps encountering
harsh reality, as we see the different fates of the bank official
(played by Fredric March), who had been no more than an army
sergeant, and the drugstore assistant (played by Dana
Andrews), who had been a fighter pilot. Even in length—nearly
three hours—the film makes no comfortable concessions. Wyler,
who, with John Huston, established the Committee for the First
Amendment, to defend film-makers' artistic freedom (not very
effectively) against the attentions, from 1950, of the House Un-
American Activities Committee (HUAC), reckoned that only a
few years later it would not have been possible to make the film.

 The notion of a film set perhaps in post-war Vienna, perhaps
in post-war Rome, came from Britain's most powerful producer/
director, Alexander Korda (1893–1956), himself Hungarian
born.[20] He put the idea to novelist Graham Greene (1904–91),
who had been working with Korda and director Carol Reed
(1906–91) on the film eventually released as *The Fallen Idol*
(1948). Greene was already working on a story about a dubious
character, 'Harry', who had been buried but who subsequently
reappeared. Greene went to Vienna and there a young Intelli-
gence officer introduced him to 'underground Vienna', consist-
ing of a massive sewerage system that completely undercut
the rigid division of Vienna into four occupied zones, British,
American, French, and Russian, and told him about the deadly

racket that was going on in adulterated penicillin. 'Harry' became Harry Lime, the murderous racketeer who apparently returns from the grave; the friend who comes to seek him is a pulp Western writer, Rollo (later Holly) Martins; the central character of British officer, Major Calloway, is created, and he becomes the narrator of the film that became *The Third Man* (1949). Korda had done a deal with David O. Selznick (producer of the all-conquering *Gone with the Wind*), giving him most of the distribution rights in the United States of any Korda–Selznick films, in return for dollars and access to Selznick's stars. Selznick was keen on the idea of both Lime and Martins being American, though actually his first firm casting move was to get his young protégée, the Italian Alida Valli, in as Anna, Lime's girlfriend. Eventually Joseph Cotten, who was under contract to Selznick, was selected for the role of Martins. It was Reed who was eventually successful in signing up Orson Welles, who was not under contract to Selznick, to play Harry Lime.

Apart from the yet-to-be completed *The Fallen Idol*, Reed had also recently made another greatly admired and highly successful film, *Odd Man Out* (1947), about a wounded IRA man on the run. Reed had clear ideas about how the war had affected British cinema audiences: 'Today, audiences the world over are more conscious of the phoney and stock film situations than they were pre-war. People who were plunged into war were so immersed in reality that nowadays they expect it in both the living theatre and pictures. It is a natural reaction.' He also believed that: 'Instead of trying to make pictures for a country we don't understand (i.e. America), we must make pictures our way.'[21] Receiving suggestions, and even instructions, from all directions, Reed adopted them, shaped them, rejected them, setting his own seriousness of purpose upon the eventual film, *The Third Man*. The most famous adoption was of the speech Welles, plagiarizing the painter James McNeill Whistler, produced for Harry Lime: 'You know what the fellow said: In Italy for thirty years under the Borgias they had warfare, terror, murder, bloodshed; they produced Michelangelo, Leonardo da Vinci and the Renaissance. In Switzerland they had brotherly love, five hundred years of democracy and peace, and what did they produce? The cuckoo clock.'

As cameraman, Reed chose Robert Krasker (1913–81), an Australian of French and Austrian parentage, whose dark photography and expressionist lighting techniques had brought distinction to *Odd Man Out*, and were to do so again with *The Third Man*. It was Reed, too, who chose Viennese zither-player Anton Karas for the absolutely unique, and infinitely haunting, music for the film (Korda had wanted to get rid of that).

Anna is Czech and Calloway offers to do his best to try to stop her from being reclaimed by the Russians, but the big game he is after is Lime. Eventually he persuades Martins to betray Lime, who, after a chase through the sewers, is in fact shot by his old friend. The sense of shabby, divided Europe, of the intimidating Russian presence, of the dispossessed rich colluding with the evil Lime, is overwhelming. In Greene's original screenplay there was a conventional happy ending, with Martins and Anna walking away arm in arm. Such an absurdly contrived ending was rightly rejected by Reed, and in this he eventually won the support of Selznick. *The Third Man* did not meet with immediate critical acclaim, but was commercially successful on both sides of the Atlantic. Most significantly, it won first prize at the Cannes Film Festival and was enormously successful throughout Europe. Today it is universally recognized as one of the greatest of films.

'Nobody could sleep. When morning came, assault craft would be lowered and a first wave of troops would ride through the surf and charge ashore on the beach at Anopopei. All over the ship, all through the convoy, there was a knowledge that in a few hours some of them were going to be dead.' So begins *The Naked and the Dead*, which then continues for over 700 pages. Anopopei island, 300 miles long, almost 150 miles across at its widest, is occupied by the Japanese. It is the task of the invading American army division, under the command of Major General Edward Cummings, to clear them out. We read not only about individual soldiers in and out of combat (brilliantly evoked), and their past lives and present thoughts (mainly about previous sexual encounters); we also have the entire campaign explicated, with the peculiar life of Cummings set out so precisely that we grasp the point that any man who becomes a general must be a bit peculiar. Mailer tells us that the most profound influence on

him at the time of writing was that of Tolstoy: during the fifteen months in 1946 and 1947 when he was writing this first novel he would often read *Anna Karenina* in the mornings before turning to his own writing: 'Tolstoy teaches us that compassion is a value and enriches our life only when compassion is severe, which is to say when we can perceive everything that is good and bad about a character but are still able to feel that the sum of us as human beings is probably a little more good than awful.'[22] Most of the individual soldiers, whom we come to know well, are pretty awful, particularly in their attitudes towards women—fully justifying what Simone de Beauvoir was writing in *The Second Sex* at just about the same time.

There is attack and counter-attack across the Japanese defensive Toyaku Line. Cummings realizes his career will be in jeopardy if he does not achieve the eviction of the Japanese planned by his chiefs. He is refused naval support. Thus he decides to disembark a platoon on the other side of the island and have them work across the mountains to take the Japanese in the rear. This, the most famous part of the novel, and one of the tensest adventure stories in literature, with the men battling nature as much as the Japanese, begins only when we are nearly two-thirds of the way through the book.

The moist ferny odors, the rot and . . . the wet pungent smell of growing things, filled their senses and loosed a stifled horror, close to nausea. 'Goddam, it stinks,' Red muttered. They had lived in the jungle for so long that they had forgotten its odor, but in the night, on the water, their nostrils had cleared; they had forgotten the oppression, the intense clammy weight of the air.

'Smells like a nigger woman,' Wilson announced.

Brown guffawed nervously. 'When the hell'd you have a nigger?' But he was troubled for a moment; the acute stench of fertility and decay loosed a fragile expectation.

This was the one hint of the routine racism (not an issue in the book) of men who scarcely ever encountered blacks. The final phrase is one of Mailer's most resonantly economical.

The depleted platoon fail to make it and return, shattered. It then transpires that the Japanese are infinitely weaker than Cummings's (practically useless) intelligence had told him. The advance now proceeds unchecked: wherever helpless Japanese

soldiers are encountered, they are slaughtered on sight. The novel ends with Major Dalleson, another human oddity, setting up a rigorous training programme, to prepare the troops for their next hazardous campaign.

None other of Mailer's books had quite the resounding success of *The Naked and the Dead*, but he was henceforth able to set himself up as *the* commentator on episodes and changes in American life, writing both documentaries that employed the devices of fiction and fiction with strong documentary elements.

There is another great English-language novel about the war, which, today, has been almost forgotten, though the author, Romain Gary (b. Roma Kassef, Moscow, 1914; comitted suicide, Paris, 1980), writer, heroic aviator, diplomat, playboy, film-maker, friend of de Gaulle, husband (for a time) of film star Jean Seberg, was a celebrity for nearly forty years. The novel, *Forest of Anger* (1944), a series of episodes, some of them extremely brutal, set in occupied Poland (where Gary had been educated), was actually written in French, while Gary was based in England and flying dangerous sorties over occupied France. It was handed to the Cresset Press in 1943; they had it translated into English, and brought it out in 1944. Only in 1945, the year in which Gary was invested with the Légion d'Honneur under l'Arc de Triomphe, was the original French version *L'Éducation européenne* published to enormous acclaim. The first title refers to the forest in which the Polish partisans are hiding. The second to the 'education' of a whole generation in evil and human resilience provided by the war. Gary is a writer of particular interest to historians, his military, and then his diplomatic and political career, interacting closely with his literary one. His life also tells us much about the special characteristics of the creative process: for example, he communicates his own direct apprehension of the enormities of war, but is not merely autobiographical—he was never with the partisans in a Polish forest, in a concentration camp, or part of the French Resistance. In ranging from Eastern Europe to France to America, he represents a particular form of globalism. Some of his novels were weak, too declamatory, too obvious, and were rightly spurned (genius cannot be turned on like a tap); some he himself wrote in English; most were written in French, then became

particularly successful in the United States. *Les Racines du ciel* (1956; *The Routes of Heaven*, 1958), unites war and ecology: Morel survives his concentration camp by concentrating on his passion for elephants; after the war he dedicates himself to their protection. The posthumously published *Les Cerfs-volantes* (1980; *The Kites* (never translated)) centres on the Resistance.

In the immediate aftermath of the war a number of other rather muted films were made in the social criticism tradition established by Warner Brothers in the 1930s—for example, *Crossfire* (Edward Dmytryk, 1947), in which an anti-Semite is identified as the 'baddie' who, in a too horribly American way, is shot dead by the 'goodie' police officer. An altogether more substantial film, with something of a 'background', was *On the Waterfront* (1954). Elia Kazan (b. 1909), the director, had been a pioneer in America of the 'Method' acting of the Russian Konstantin Stanislavski (1863–1938), an introspective style in which the actors use their own experiences to 'live' their parts, and he had founded the Actors Studio in New York in 1947. Among its products were Marlon Brando, Rod Steiger, Eva Marie Saint, Montgomery Clift, and James Dean. The first three of these all appeared in *On the Waterfront*. But Kazan, along with Budd Schulberg, writer, and Lee J. Cobb, who played the racketeering boss of the corrupt unions portrayed as controlling the New York waterfront, had all testified before the HUAC, naming colleagues as Communists. In the film, the young dock labourer, played by Brando, after at first believing that he must at all costs show loyalty to the union, is finally persuaded to testify against the racketeers. The film won eight Oscars, the reward, liberals said bitterly, for collaboration. Yet, this is a powerful film, important testimony to the effectiveness of 'Method'. Photography—more evidence of American absorption of European talent—was by Boris Kaufman, who had worked with French director Jean Vigo. The end of the film, when a desperately beaten-up Brando finally manages to walk unsupported into work, does not make sense, but critics and audiences accepted the heavy symbolism.

'The West', the moving frontier, was unique to America, and the Western was a unique American genre. Because it has certain distinctive features and (fairly) consistent conventions, it

has been much used in esoteric analyses of the relationships between Hollywood film and American society. Fruitful observations can be made, but the point always to be kept in view is that of Hollywood as a manufactory of entertainment and a conservatory of attendant myths, many of them the myths that so intrigued Europeans. The central myth of the Western is that of the rugged individualist, often bitter and obsessive, somewhat existentialist, though, of course, no intellectual, who performs some great service for the community, either then becoming integrated into community life, or, more likely, continuing on his lonely way (seen at its most powerful in *Shane* of 1954, when Alan Ladd's eponymous hero, despite the entreaties of the boy he has befriended, rides off into the mountains). The dominant figures by the end of the war were John Ford (1895–1973), the director responsible for anchoring the fundamental conventions of the genre, and the actor John Wayne (1907–79). Other prestigious directors and established actors turned to the Western; James Stewart, gentle hero of Frank Capra's pre-war political tables, emerged as archetypal tough loner. A more complex, 'psychological' Western, or 'super Western', developed, the prototype being the independent production by veteran director Howard Hawks (1894–1977) of *Red River* (1948), his own first Western. The context is a cattle drive, of the sort that, historically, made the beef of the West available to the markets of the East, to the profit of all concerned. The 'psychology' lies in the relationship between the autocratic Texas rancher, played by John Wayne, and the gentler, but more perspicacious, orphan he adopts as almost a son, played by Montgomery Clift, who eventually ousts the older man and takes over the drive (hence the—unhelpful—references by some critics to Bligh of the Bounty). At the end the rancher is spoiling for a gunfight, which the younger man declines. Suddenly we are in conventional territory. There is a fistfight. The young man's girlfriend fulfils the female stereotype by preaching reconciliation. Through conflict, there is resolution. America's diverse traditions stand unified once more. The new acting range Wayne had revealed was exploited by Ford in his 'cavalry trilogy', *Fort Apache* (1948), *She Wore a Yellow Ribbon* (1949), and *Rio Grande* (1950).

Another new development was the Western that referred allegorically to current events. Most famous of these was *High Noon* (Fred Zinnemann, 1952). The distinguished screenwriter (and later director) Carl Foreman (1914–64) wrote this film, about a lawman deserted by his fellow townsfolk when a gang arrive determined to kill him, as a demonstration of the need for civic loyalty. Because Foreman had himself been called before the HUAC, some critics equated the cowardly townsfolk with Hollywood's own capitulation to the Committee. As with *On the Waterfront*, however, the film can stand on its own, almost painfully suspenseful, and brilliantly carried by a grizzled Gary Cooper. Foreman refused to cooperate with the HUAC and was subsequently blacklisted by the American film industry.

The tough loner also tended to appear in what may variously be described as *film noir*, gangster movies, or crime thrillers (often based on the novels of Dashiel Hammett, Raymond Chandler, James M. Cain, or Micky Spillane), and was most famously played by Humphrey Bogart. One of the greatest Bogart vehicles, with the wonderful Lauren Bacall, was the almost incomprehensible *The Big Sleep* (1946), directed by Howard Hawks. Just as the Western became more ambitious, so did this genre. German émigré Fritz Lang (who had arrived in America in the 1930s) brought bleak, expressionist overtones to *The Big Heat* (1953), starring Glenn Ford, with the unforgettable scene in which hoodlum Lee Marvin throws scalding coffee over the face of his moll, played by English-born actress Gloria Grahame. For what may be regarded as the culminating opus in the *film noir* movement, *Touch of Evil* (1958), Universal Studios brought back the former *enfant terrible* and feared genius, Orson Welles, who had not directed a film in America for ten years, to star as well as direct. As Robert Sklar puts it, the making of this film 'sheds light on the relation of individual artistry to industrial practice'.

Recognized as a gifted collaborator as well as a one-man show, Welles worked with the studio's regular talent in cinematography, art direction, set decoration, and costumes, and created a dark, foreboding *mise-en-scène* quite unlike the studio's brightly lighted, spacious, wide screen color pictures on which his collaborators usually worked. Set in the Mexican–United States border, the film brings racial themes into film

noir, along with a self-reflective concern with vision, spectatorship, and voyeurism in the Hitchcock manner.[23]

Alfred Hitchcock (1899–1980), an Englishman who had made films in Britain before the war, was a formidable figure, whose 'voyeuristic' and 'spine-chilling' films, and their influence, cannot be ignored, whether one likes them or not. *Dial M For Murder* (1954) was made in the stereoscopic process known as three-D, a would-be sensational innovation that flopped within three years. The film itself had many of the characteristics of the 'well-made' West End detective play. *Rear Window* (also 1954), was quintessentially voyeuristic, its action, the carrying-out of a murder, being essentially that seen through the window by a photographer (James Stewart), temporarily confined to a wheelchair. *North by Northwest* (1959) moves out into the open spaces, its most famous scene that of Cary Grant being hunted by a crop-duster aeroplane, in fact occupied by evil enemy agents. *The Macmillan International Film Encyclopedia* neatly places the man some have called the greatest of all British-born directors:

Although he chose to limit his thematic range to the genre of suspense-ful melodrama and has disappointed some high-minded critics with his lack of seriousness or interest in important social issues, Hitchcock is without question among the few most gifted directors who ever worked in the film medium. A supreme technician and stylist with an unmistakable personal imprint and a great visual artist, he is impossible to dismiss as just the 'Master of Suspense', as he has been frequently described.[24]

The greater ambitiousness of Hollywood movies, the (failed) introduction of three-D, were in large part responses to the wide diffusion of television ownership throughout American society in the 1950s. But the new difficulties of the industry were not insurmountable, and, in any case, for the time being Hollywood still continued to be a considerable international cultural influence, though eventually replaced by American-made television series. Apart perhaps from news coverage, the general quality of American television was not high, though the 1950s, as we shall see, was perceived as a golden age of the television play. Two plays by highbrow dramatists made a particular mark, Paddy

Chayevsky's *Marty*, and Reginald Rose's *Twelve Angry Men*. As filmed, *Marty* (Delbert Mann, 1955) demonstrated Hollywood's total inability to deal with issues of personal appearance. Both protagonists are supposed to be ugly, which Ernest Borgnine, playing a butcher, certainly is, but Betsy Blair, the wallflower he picks up at a public dance, is quite certainly the opposite, and is not even made up in such a way as to hide her natural good looks. *Twelve Angry Men* (1957) is about how a single juror, an architect, eventually converts his eleven fellow jurors into acquitting a youth from a deprived Hispanic background of murder. Sidney Lumet's film, with Henry Fonda as the architect, was boring to many in American audiences, and was not a great commercial success, though it did achieve quite a high reputation abroad. The usual critics (that is, the Marxist ones) define the film simplistically as an attempt to legitimate the American system and the 'corporate consensus' of the 1950s.[25] It is true that the film does have that irritating American habit (seen in *Red River*) of having everyone make up at the end. But what is surely much more important is that the film is a testimonial to the importance in America of the legal and constitutional concept of 'due process', something that, as an actual social reality, was to prove important (if still often traduced) in restraining the authorities in their dealings with civil rights and anti-war protestors in the 1960s. And the exposure of a very recognizable bigotry makes its own point. The reactionary, self-made businessman, played by Lee J. Cobb, addresses the architect: 'You come in here with your heart bleeding all over the floor about slum kids and injustice. Everyone knows the kid is guilty. He's got to burn.'

Among the American novelists of the 1950s, there appeared two sharply contrasting figures: one a glittering success who quickly retired into deliberate privacy, his one major work remaining both a cult and a canonized text; the other, a very public figure who was to go on, with a steady stream of books throughout the succeeding decades, to be a Nobel Prize winner and, the media agreed, America's greatest contemporary novelist. J. D. Salinger (b. 1919), created, in the adolescent boy Holden Caulfield, one of the most memorable of fictional characters, the central figure and narrator in *The Catcher in the Rye*

(1951). The colloquial, intense, humorous first-person narrative of the boy who runs away from boarding school in Pennsylvania to New York shows an almost exquisite sensitivity and disgust, which adolescent readers could recognize in themselves or their fellows, a 'nausea', you might say, over the 'phoniness' of adults, their 'bad faith', indeed. Salinger wrote *Franny and Zooey* (1961), and several long short stories, before disappearing into a jealously guarded retirement. Saul Bellow was born in Canada in 1915 of Russian-Jewish parents, but brought up in Chicago. I have touched on the astonishing contribution to American (and other) culture of people of Jewish origin. But this, of course, is only of significance where it led to the discussion of specifically Jewish themes. In the case of Hollywood producers and directors, it did not, as it did not with Salinger, Mailer, Arthur Miller, and hosts of others. Bellow's novel *The Victim* (1947) is concerned with relationships between Jews and Gentiles. The grand-scale *The Adventures of Augie March* (1953) seems to be deliberately invoking comparisons with Mark Twain's *The Adventures of Huckleberry Finn*. Bellow's novel is a picaresque account of Augie's progress from boyhood in Chicago on to Mexico and Paris. 'I'm an American', the book begins, '. . . and go at things as I have taught myself, free-style . . .'. Later protagonists, as in *Herzog* (1964), *Mr. Sammler's Planet* (1970), and *Humboldt's Gift* (1974), are self-consciously Jewish.

Tennessee Williams (1911–83), born in Mississippi, achieved success with his play *The Glass Menagerie* (1944), which is based on memories of his mother as a Southern belle in grimly reduced circumstances. Williams's was a distinctive voice, 'gothic and macabre', but 'with insight into human passion and its perversions, and a considerable warmth and compassion'; 'voluble matrons nag timid offspring: callous or thuggish men shrug off the possibility of intimacy with women, for whom their appetite is temporary, their distaste permanent'.[26] In Williams, Southern romanticism figures as a debased gentility. His Southern belles, breaking the lady-like stereotype, slip into promiscuity, or in middle age vainly seek suitors for unloved daughters. In 1947 came *A Streetcar Named Desire*, followed by *Cat on a Hot Tin Roof* (1955) and *The Night of the Iguana* (1961). *Death of a Salesman* (1949) by Arthur Miller (b. 1915),

which comments critically on contemporary society by present-
ing the life, and ultimately suicide, of salesman Willie Loman,
established Miller as Williams's main rival as chief post-war
American dramatist. Miller's most famous play, *The Crucible*
(1952), was a reaction to the McCarthyite witch hunts, making
use of the Salem witchcraft trials of 1692 to create a very power-
ful and moving drama. In an era characterized by a great variety
of genres of experimental theatre, Miller has concentrated on
the practical realities of life, deploying a meticulous craftman-
ship in presenting believable characters in striking situations.
He is the pre-eminent chronicler and analyser of the problems
and issues of post-war society: materialism, dehumanization,
and the decline of the family, and the struggle for human rights.

Of British novelists of the time, the one with the highest
reputation abroad was Graham Greene (1904–89), whose work,
in addition, embodies many of the puzzling relationships
between artistic autonomy, integrity, intention, and commercial
success. From what would seem to be the very depths of his
being he drew a passionate commitment to left-wing causes that
never abated; from his Catholicism, an obsession with funda-
mental evil and fundamental good; from his incredible nose for
public affairs, a gift for setting his novels in troubled parts of the
world almost before they hit the headlines. Greene's tautly con-
structed plots are never less than thrilling, their sense of place
and time is always impeccable. *The Heart of the Matter* (1948) is
set in a West African colony as British colonialism is coming to
an end; *The End of the Affair* (1951)—based on a love affair of
his own—directly evokes the blitz and wartime London; *The
Quiet American* (1955) offers its own insights into the unfolding
of the Indo-China tragedy in the Cold War era. Greene had
made a distinction between his thrillers, which he termed 'enter-
tainment', and his more serious novels. The dropping of the
'entertainment' label after 1958 was significant: all of his novels
were thrilling; all of them addressed serious issues.

Literary movements are not common in Britain; however, in
the 1950s a group of poets and novelists formed themselves into
'The Movement', initially in protest against what they per-
ceived as the rhetorical excesses and voluble romanticism of
such writers as the Welsh poet Dylan Thomas (1914–53) and

the novelist Gerald Durrell. Thomas's (mainly) verse play specially written for radio, *Under Milk Wood*, was broadcast in 1954 and subsequently given in the form of both solo readings by the author and full-dress stage presentation. The most notable product of The Movement was *Lucky Jim* (1953) by Kingsley Amis (1922–95), the first of the 'campus' novels, subsequently an important genre on both sides of the Atlantic. Amis, whose first allegiance was to poetry, had a highly distinctive style, informal, very contemporary, but absolutely precise and extremely funny. For forty years his novels were (most of them) hailed as shrewd and caustic commentaries on the changing social scene in Britain. Meantime, a very different novelist wrestling with the deepest problems of existence, achieved international fame, William Golding (1911–93). *The Lord of the Flies* (1954) placed a group of boys on a deserted island and watched them lapse very quickly from civilization to violent primitivism.

British films, mainly through the productions of Ealing Studios, did enjoy a minor golden age during and after the war, celebrating a kind of essential Britishness. Two of the best, *Passport to Pimlico* (1947), directed by Henry Cornelius, and *Whisky Galore* (1949), directed by Alexander Mackendrick, are both stories of local people defying bureaucracy. *Kind Hearts and Coronets* (1949), directed by Cambridge graduate Robert Hamer, in which an Edwardian shop assistant proceeds to a dukedom by killing off an entire aristocratic family, is wickedly stylish and witty. Completely unique was the partnership of Michael Powell (1905–90) and Emeric Pressburger(1902–88). Their *The Red Shoes* (1948) was most unusual in featuring both ballet and the composing of a contemporary opera, and in weaving conflicts of love and artistic dedication into the tragic fable of the red shoes that will not stop dancing.

This chapter has focused on the countries that emerged from the war congratulating themselves on being on the winning side. The most striking and strident developments were taking place in America, while France led in philosophy and manifested a continuing development in art. If British novels and films were most notable for their Britishness, not all were parochial, and some addressed matters of universal, or at least global, significance.

2 The Disasters of War and their Repercussions

'All post-war German literature', British critic Martin Seymour-Smith wrote, 'is, naturally enough, one form or another of reaction to Nazism and its disastrous end'.[1] German cultural production, right up to the end of the century, was characterized by an introspective analysis of the immediate past, or of contemporary events (such as the terrorist attacks of the 1970s), with a view to dissecting their connections with that past. Nazi control and then wartime destruction had a devastating effect on the German film industry. But perhaps literature and drama thrive on low resources and adversity. Certainly a little German-speaking literary world of West Germany, Austria, and Switzerland came into being, out of which sprang two or three of the dramatic masterpieces of post-war Europe. But only at the very end of the 1950s did the literature of the Federal Republic of West Germany begin to achieve major international attention. The major work recording elements of the Holocaust was actually written by an Italian, Primo Levi—not fiction, but such a major work of 'letters' as to require a place in this book. Readers might like to reflect on the relative statuses of Anne Frank's *Diary*, Primo Levi's Auschwitz memoirs, and, indeed, Carlo Levi's non-fiction account of archaic life in the Italian South. What of Italy, torn to shreds in the war? Under Fascist dictator Mussolini it was a partner (inferior) in the Axis with Germany. Invasion from the South by the American and British Allies brought German occupation of the North, encouragement for the anti-Mussolini partisans, an official switch to the side of the Allies, and a situation of civil war taking place within an international war. Yet under Mussolini, Italy had preserved a relatively free film industry; just as soon as the war had ended, an astonishing series of cheaply produced neo-realist films attracted international attention. However, I am going to start with France, and another of

the greatest of all films, released in 1945, but actually made during the German occupation, *Les Enfants du Paradis* (*Children of 'the Gods'*—that is, the theatre balcony).

Non-German Reactions

Before the war the poetic realism of French films had given them a certain international status, and the Germans were keen that occupied France should continue to be a centre of film production, with all films, naturally, being closely scrutinized: were these films upholding Nazi values, or were they, in coded language, supporting the Resistance? The Germans found *Children of 'the Gods'*, product of two major pre-war figures, director Marcel Carné and screenwriter Jacques Prévert, baffling, as it was filmed in bits and pieces under their noses, mainly in Nice. Prévert's setting is in early nineteenth-century Paris, among theatre folk and criminals of various degrees. The principals in this three-hour-long masterpiece are: Baptiste (played by leading actor-manager Jean-Louis Barrault), a brilliant mime who becomes the hero of the populace in 'the Gods' (hence the title of the film) and who falls idealistically in love with the courtesan Garrance (the famous star Arletty), spurning his devoted wife and son, while Garrance eventually becomes the mistress of the powerful and sadistic Count; the actor Lemaître (yet another famous actor, Pierre Brasseur); and François, thief and murderer, who at the end assassinates the Count in a Turkish bathhouse—existentialist act, or rough justice for a Nazi, or both? Are the actors and criminals, outcasts in their own day, symbols of resistance to occupation? But the film goes much deeper than contemporary politics, being about right and wrong, illusion and reality, different kinds of love. And it is a continuous joy to watch, funny and dramatic. When released, the film was lauded as a celebration of French spirit and popular tradition, which the Occupation had been powerless to suppress.

Two younger directors established themselves in the years after the war. Jacques Becker (1906–60) was relatively conventional, but his comedies of social class are acute and subtle. *Antoine et Antoinette* (1947) portrays a working-class couple

who lose, then recover, a winning lottery ticket. Édouard in *Édouard et Caroline* (1951) is a middle-class pianist, humiliated before Caroline's upper-class uncle, M. Beauchamp (he has a camped-up aristocratic accent, and the contrast between his lavish establishment and their small flat is well made). But a rich American recognizes Édouard's musical talent, so that he both makes his fortune and holds on to his wife. Robert Bresson (b. 1907) was more innovative, making use of non-professional performers, with voice-overs in the manner of a diary, rather than extensive dialogue. Most famous are *Journal d'un curé de campagne* (*Journal of a Country Curate*, 1950) and *Un condamné à mort s'est échappé* (*A Condemned Man has Escaped*, 1956), again set during the Occupation, and explicating in meticulous detail the escape from prison of a Frenchman about to be executed by the Germans. And then there was Jacques Tati (1908–82), who, as director, scriptwriter, and principal performer, introduced the world in 1953 to the tall, thin, ill-coordinated M. Hulot, in *Les Vacances de Monsieur Hulot*—followed in 1958 by *Mon Oncle*.

There was a direct link between the Italian neo-realist films and the war experience, and these films had a direct influence on the subsequent history of Western cinema. One of the magnificent band of directors, Vittorio de Sica (1902–74), declared:

The experience of war was decisive for us all. Each felt the mad desire to throw away all the old stories of the Italian cinema, to plant the camera in the midst of real life, in the midst of all that struck our astonished eyes. We sought to liberate ourselves from the weight of our sins, we wanted to look ourselves in the face and tell ourselves the truth, to discover what we really were, and to seek salvation.[2]

The neo-realists sought to replace the shameful falsities of Fascism with uncompromising truths, through location shooting, lengthy takes, unobtrusive editing, natural lighting, a predominance of medium and long shots, injection of elements of contemporary social criticism, an uncontrived, open-ended plot, working-class protagonists, a non-professional cast, and dialogue in the vernacular. These formal elements were all part of a deliberate philosophy, though some, in fact, were enforced

by the circumstances of the time. Mussolini's great studio complex, Cinecittà, was being used by the Americans as a refugee camp, so that location shooting, as well as being desirable, was necessary. Further 'realism' was attained by filming silently, without the apparatus and planning needed for sound recording, the sound being dubbed on later. In fact there was a considerable tradition in Italy of dubbing American films into Italian. Now necessity created another virtue.

The precursor of neo-realism was *Ossessione* (1942), directed by Luchino Visconti (1906–76): this dark and even rather sordid film happily illustrates the American literary influence and, in this case, that of the crime thriller—it is based on a French translation of James M. Cain's *The Postman Always Rings Twice*, loaned to Visconti in 1940 by the French film director Jean Renoir. In 1945 came the great and noble war film *Roma, città aperta* (*Rome, Open City*—technically, an open city is one that is not defended, and therefore, in theory, should not be attacked).

The Nazis occupied Rome from September 1943 until the Allies drove them out in June 1944. In the spring of 1944 a wealthy patroness suggested to film director Roberto Rossellini (1906–77), who had made propaganda films for the Fascists, but who was now a founding Christian Democrat member of the cinema workers' branch of the Committee of National Liberation (a Resistance organization), that he make documentaries about, respectively, a Roman priest, Don Morosini, who had been shot by the Germans, and the resistance activities of Roman children. These ideas, together with other actual historical events, were combined into plans for a full-length feature film, which went into production almost immediately after the departure of the Germans. The film features: the Gestapo chief, Bergmann, who is hunting the Resistance leader, Manfredi; the lovers, Francesco and Pina; a gang of Roman boys who sabotage Nazi installations; the priest, Don Pietro, who aids the Resistance; Manfredi's mistress, Marina, a drug addict, who eventually betrays the patriots to the Gestapo agent, Ingrid. Francesco is arrested and Pina is machine-gunned down when she attempts to follow him. Manfredi is tortured to death, Don Pietro sent before a firing squad. As he goes to his death,

another priest, there to administer the last rites, tells him to have courage. Don Pietro's last words are: 'It's not difficult to die well. The difficult thing is to live right.'[3]

After all that violence and excitement, Vittorio de Sica's *Ladri di biciclette* (*Bicycle Thieves*, 1948) seems slow and uneventful. In a time of mass unemployment in Italy at the end of the war (the film is set in 1946), Antonio Ricci is lucky enough to get a job as a bill-poster. But Ricci has had his bicycle, an essential for the job, stolen. With his young son, Bruno, he sets out to track down the thief, but even when he finds him he is unable to get the bicycle back. Later, Ricci tries to steal another bicycle. Pedalling off on it, he is caught. However, despite the vengeful shouts of the crowd, the owner simply says: 'I don't want to make trouble . . . not for anyone . . . Let's just forget it.' The directions for the ending of the film are as follows:

Pan down to BRUNO *looking up to his father. He is unhappy about what has happened and miserable because he can do nothing about it . . .* RICCI *tries to hold back the tears in his eyes . . . close-up of* BRUNO *walking next to his father still looking up at him. Big close-up of* BRUNO's *hand slipping into his father's . . . Shot of* RICCI *walking on and crying;* BRUNO *holding his father's hand. Big close-up of their hands. Long shot from behind them, as they move away and disappear into the gathering crowd.*[4]

According to an interview he gave in *Le Monde*, of 4 March 1955, De Sica was offered millions by an American producer, on condition that Cary Grant played the part of Ricci. The part, in fact, was taken by a steelworker, Lamberto Maggiorani. Pedants point out that the film was far from being without artifice: that the story was very subtly structured, and accompanied by very effective music; that because Maggiorani's working-class accent was not easy to follow, an actor was actually used in the post-production dubbing. So what? None of the arts is without artifice.

While *Les Enfants du Paradis* (*Children of 'the Gods'*) was a celebration of eternal France, the neo-realist films, which also include *Paisà* (1946), *La terra trema* (1948), *Riso amaro* (1949), and *Umberto D* (1952), were deeply pessimistic testaments to the desire to break with the bombast of the Fascist past. Although the Italian government was keen to limit the number

of American films being shown, and to encourage Italian production, it joined with the Catholic Church in denouncing these films as subversive and damaging to Italy's image abroad, refusing to subsidize them. State subsidy of the arts is not an automatic good in itself; much depends on what is being subsidized. As this little clutch of post-war 'art' films passed into cinema lore, there emerged one of the celebrity figures of the international art cinema circuit, Frederico Fellini (1920–94), who had been a co-scriptwriter on *Rome, Open City* and on *Paisà*.

But first some films, typically Italian, but not well-known internationally. Exactly contemporaneous with the neo-realist wave is a spate of filmed operas, filling a gap while opera houses struggled with conditions of extreme scarcity. Given the general use of dubbing, established film actors could be used. Playing Nedda in *I pagliacci*, Gina Lollabrigida was dubbed by opera *diva* Renata Tebaldi (a heavenly partnership one might think), while Anna Magnagni actually had a good enough voice of her own. Three major productions of 1946 were *Il barbiere di Siviglia* (Mario Costa), *Lucia di Lammermoor* (Piero Ballerini), and *Rigoletto* (Carmine Gallone). Thereafter the two most popular genres were vehicles for the comic actor Totò (real name Antonio De Custis) and what Italian film historians call *neo-melodrama*. The best of the former was actually directed by De Sica, *Miracolo a Milano* (*Miracle in Milan*, 1951), while the latter included: *Tormento* (*Tormented*, Raffaello Matarazzo, 1952), *Maddalena* (Augusta Genina, 1954), and *Pietà per di cade* (*Pity for the Fallen*, Mario Costa, 1954).[5] We should also note another significant interconnection between popular novel and popular film. The notion of Italy as post-war battleground between Communism and Catholicism was charmingly and humorously caught in Giovanni Guareschi's stories of local rivals, Communist mayor, the Honourable Peppone, and Catholic priest, Don Camillo. The rivalry had resonance in France also, and the first film, *Don Camillo* (1952), was directed by Frenchman Jean Duvivier. There followed *Don Camillo e l'onorevole Peppone* (Carlo Gallone, 1955).[6]

Fellini remained broadly within the parameters of neo-realism with *I vitelloni* (1953), a film concerning the Italian equivalent of the British 'teddy boys', very explicitly set in the

Tuscan seaside resort of Viareggio. It is *La strada* (1955), another of the great cinematic masterpieces, that moves out of the precise locations, and away from specific social or political references, of neo-realism into universals—religious ones, some critics thought. Directly related to that universalism is the fact that the title was not usually translated for American or British audiences (literally it means 'The Road', but since it concerns characters in an itinerant circus, the best translation would probably be 'On the Road'). Cary Grant was not in contention, but, in regard to both international cultural exchange and the international character of cinema, it was most significant that two brilliant American character actors, Anthony Quinn and Richard Basehart, played the leading roles of, respectively, Zampanò, the strongman, and Il Matto (The Fool). The third main character, the waiflike chaplinesque clown, Gelsomina, bought from her mother by Zampanò, was played by Fellini's wife, Giulietta Masina (1920–94). Gelsomina is treated brutally by Zampanò, and befriended by Il Matto, who is killed by Zampanò, who then abandons Gelsomina. Years later, he learns of her death, and alone on a beach cries for her. Does Il Matto represent Christ and Gelsomina the Virgin? Whatever, it is a wonderful film of brutality, humour, and pathos.

For Western intellectuals addicted to art cinema, Fellini was the man, save that he had a rival from Sweden. To pay their way Swedish films needed at least to have distribution in Germany; to keep the Swedish film industry afloat there had to be the occasional worldwide success. Originally a screenwriter, Ingmar Bergman (b. 1918) achieved that kind of success as a director with *Summer with Monica* (1953), an intense story of adolescent love that at first seems idyllic, but then turns to tragedy. However, *Smiles of a Summer Night* (1955) is irresistibly stylish and witty, a kind of cosmopolitan counterpart of *Kind Hearts and Coronets*, which somehow reminds us of Sweden's history as a great European power. Gloom returned with *The Seventh Seal* and *Wild Strawberries* (both 1957). Eric Rhode speaks of 'a governing intelligence involved in the process of self-discovery', this sense being intensified by Bergman's habit of limiting himself to the same small group of actors and to only two cameramen.[7] The first of these two films is an allegory of life and death

set in medieval times. In *Wild Strawberries* an elderly medical professor is on the way to collect an honorary degree. His thoughts are narrated in voice-over and he has various dreams, some symbolic, some about events that happened during his youth. Intellectual audiences in the West loved it (or said they did).

From another cold, 'minor' country, Poland, came another international success, which takes its place with *Rome, Open City* and *The Third Man*, in a trilogy of masterworks about the war in Europe, its end, and its aftermath. Actually, *Ashes and Diamonds* (1958) was part of the Polish trilogy by Andrzej Wajda (b. 1924), which had included *A Generation* (1954) and *Kanal* (1956). The war has ended, and the action takes place against the context of civil celebration, a banquet, and fireworks. The endearing young protagonist, Maciek, who has a brief romance with a stunningly beautiful barmaid, has been instructed by his right-wing partisan group to assassinate the returning Communist leader. Maciek carries out the assassination, and is then himself shot: two agonizing deaths, lingeringly filmed. The camerawork by Jerzy Wojcik, in its daring drama, was said to emulate that of Welles's *Citizen Kane*. Zbygniew Cybelski, as Maciek, was, in many of his mannerisms, reminiscent of James Dean.

Modernism, war, post-war: the novel that enfolds all three, translated into many languages within a few years of publication is *La luna e i falò* (*The Moon and the Bonfires*, 1950), by Cesare Pavese (1908–50). In size, *The Moon and the Bonfires* contrasts very sharply with *The Naked and the Dead*: it is barely 50,000 words—almost a prose poem. Pavese was a student, and translator, of American literature; elements of Walt Whitman have been detected in his poetry; he was imprisoned by the Fascists; he joined the Italian Communist Party at the end of the war; his earlier novels have affiliations with the neo-realists. *The Moon and the Bonfires*, at first, seems simply to be the account of the return from years spent in America to his native territory of the former Piedmontese peasant, known as 'Anguilla' ('Eel'). Pavese, it may be noted, never actually visited America. Questions are raised about identity and the nature of country life: the moon apparently symbolizes immutable nature,

the lighting of bonfires—burning the rubbish and fertilizing the soil—the beginning for the peasantry of a new year. But then echoes and undertones of the war and the Resistance begin to intrude upon the personal exploration, mainly through conversations with Nuto, an old friend who had lived through these events. Then we become aware of the female character, Santa (which also means saint), who sleeps with the Germans, fights alongside the partisans, but apparently also, we learn in the very last pages, betrays them. An existentialist figure, perhaps: 'I've always worked for myself—no-one has ever kept me . . .'. Santa is sentenced to death by the partisans, and in fact is machine-gunned down trying to run away. Her body is burned, leaving a mark, 'like the bed of a bonfire'—the last words of the novel. For the reader, the work is open to various interpretations. For Pavese, it was a culmination of all he had to say: 'if it succeeds', he wrote in his diary, 'I have reached my goal. I have completed the historical cycle of my own times.'[8] But he did not wait for its worldly success. Pavese is yet another of our cultural producers, so intense, so tortured (perhaps over what he saw as the failure at this time in Italy of the Left and of Resistance ideals) that he committed suicide (shortly after the publication of the novel).

Fascism, the war, the Holocaust: the writer one thinks of immediately is Primo Levi (1919–87). Fascism, the war, the deprived, backward state of southern Italy: the writer one thinks of immediately shared the same surname; and Carlo Levi (1902–75) came to the attention of the world first. A doctor (as was Burri), he became a painter and a writer. Born in Turin in 1902, he died in Rome in 1975. In the late 1920s he moved between Turin and Paris, always involved in liberal and anti-conformist cultural politics. In 1935 he was arrested by Mussolini's Fascist police, and sentenced to live in Lucania in Italy's deep South. He was conscious of being a member of the conquering Piedmontese race, prisoner among the conquered, the inferior Italians of the South. His account of his experiences (again 'letters', not fiction) was published in 1945 as *Cristo si è fermato a Eboli*—the title is explained in the second paragraph of the book: ' "We are not Christians," they say. "Christ stopped at Eboli.". Christian, in their language, means man . . .'. Eboli, on the Salerno coast, is where the road and the railway turn

inward into the desolate land of Lucania. The Lucanians were themselves saying that they did not live as humans, but as animals. As well as exposing the archaic conditions of the people among whom he had lived, Levi also revealed an extraordinary peasant culture. Italo Calvino, the novelist, commented: 'the uniqueness of Carlo Levi consists in this: that he testifies to the existence of another epoch in the midst of our own epoch, and he is the ambassador from another world situated in the midst of our own world.'[9]

Both Sides of the Holocaust

Since reunification, German scholars have been remarking that, though technically united, Germany is still two societies: forty years of Communist rule could not be easily sloughed off by Germans in the East. So, too, with the part of Germany occupied by the Western powers after 1945. Under Hitler, the entire German people were brainwashed by his propaganda machine and were terrorized by Allied bombing. Most of the leading cultural figures had gone into exile.

This was true of Germany's two most famous pre-war playwrights: Bertolt Brecht (1898–1956) and Carl Zuckmayer (1896–1977). Brecht, who lived in the United States until 1949, has had an absolutely crucial influence on twentieth-century theatrical developments. Theatre should not, he argued, seek to create the illusion of reality; many of his works called for highly stylized acting; his deliberate 'alienation effect' made audiences aware that they were watching something contrived, not 'reality'; his theory of 'epic theatre' ran directly counter to the idea of the well-made play, with its tight organization and dramatic climaxes—Brecht's plays are often in the form of loosely connected sketches, with songs commenting on the action. The two major plays that call for comment here were both written in America. *Der aufhaltsame Aufstieg des Arturo Ui* (*The Resistable Rise of Arturo Ui*, 1941) confronts a Hitler figure (Ui) with the strongly Marxist didactic anti-capitalism that Brecht had developed at the end of the 1920s; *Der kaukasische kreide Kreis* (*The Caucasian Chalk Circle*, 1948), the story of two mothers both claiming the same child, is of an overpowering human

intensity. Brecht returned to East Berlin in 1949, where he set up one of the most prestigious of all theatre groups, the Berliner Ensemble, to demonstrate his dramatic precepts. The visit of the Berliner Ensemble to London in 1956 was one element in provoking the striking emergence of experimental theatre in Britain during the 1960s.

Carl Zuckmayer (1896–1977) was a rugged, picaresque figure, who had turned his hand to many jobs before achieving success as a playwright. As it happened, both he and Brecht began as play-readers with the Austrian producer Max Reinhardt, who influenced both of them, though in rather different ways. Zuckmayer achieved fame at the age of 29 with *Der fröhliche Weinberg* (*Happy Weinberg*, 1925), a recreation of his own community in the Rhineland, under a fictional name. Among the characters was a laughably militaristic and jingoistic student. This brought down upon Zuckmayer the wrath of the growing Nazi Party, who also hated *Der Hauptmann von Köpenick* (*Captain von Köpenick*, 1931), set just before 1914, in which an unemployed cobbler exploits all the pomposity of the military caste to pose as an army captain. Zuckmayer married a Viennese actress and settled down near Salzburg. The Nazi takeover in 1938, which he referred to as 'the revolution of greed, envy, bitterness, blind and most malicious vindictiveness', forced him to flee to London.[10] In this book I have deliberately chosen to foreground film as a key twentieth-century cultural form: it is significant that Zuckmayer had already written scripts for two very important German films, *Der blaue Engel* (*The Blue Angel*, 1930) and *Rembrandt* (1936), so that on his arrival in London he was given work by Alexander Korda. Zuckmayer moved to Switzerland, then, after being deprived of his German citizenship in 1939, to the United States, where for a time he worked as a scriptwriter with Warner Brothers. He took a remote farm in Vermont, and in early 1942 began writing the play that has to be central to any discussion of cultural developments in post-war Germany: *Der Teufels General* (*The Devil's General*). Zuckmayer's political importance can be seen from the way in which, at the end of the war, the American government sent him on a tour through Germany to collect information on German attitudes. 'The Devil's General' is a hard-living, hard-drinking,

highly popular *Luftwaffe* general, Harras, an expert in the technology of aircraft production. He dislikes the Nazis, but personal ambition has driven him upwards to this eminent position. It is late 1941, just before the American entry into the war, and German aircraft and pilots are subject to mysterious crashes. He is given a week to track down their cause: the Gestapo suspect him, and he refuses to allay suspicions by joining the Nazi Party. In fact, the sabotage is the work of Oderbruch, a cold, dedicated engineer, who believes it is his duty to do everything to bring down the evil Nazi regime, even if it means that his own friends are dying in the plane crashes. This is a play of moral dilemmas in an epic context. The full evils of Nazism are represented in Kulturleiter Schmidt-Lauistz, but as Harras is himself, despite his views, thoroughly implicated in sustaining the regime, he is indeed 'The Devil's General'. His only way out is suicide.

The play had its première in Zurich in December 1946 and was received with enormous acclaim. But, despite Zuckmayer's work for the American government, the play was banned in occupied Germany (the very topic itself was inflammatory, while the treatment of it, as in any top-quality work of art, was not without its ambiguities and odd resonances). However, less than a year later, the ban was lifted in the Western part of Germany, though it continued in the Russian zone. Presentations in Frankfurt and Hamburg in November 1947 were outstandingly successful, and these successes were subsequently repeated throughout what was now emerging as the Federal Republic of Germany. The British première took place at the Edinburgh Festival on 17 August 1953, with the by-now famous film actor Trevor Howard playing the part of Harras. A German film of the play was released in 1954.

No one could doubt Zuckmayer's anti-Nazi credentials, and his play was the very opposite of pro-Nazi propaganda. Yet so strong and complex were (and still are) the emotions of guilt and revulsion against the older generation in Germany that the play was subject to attack from younger and more leftist critics. Zuckmayer himself could be represented as being too closely associated with American capitalism, and the play could be seen as a vehicle for evading responsibility for Germany's immediate past. If audiences identified with Harras, and saw his death as

noble, so the argument ran, they were simply adopting a super-
ficial and false anti-Nazism, without contemplating the reality
of their own complicity. In addition, against Zuckmayer it could
be argued that his dedicated resister, Oderbruch, was actually
represented as a rather unsympathetic character. As we move
into the new era in which, as we shall see, more determined
attempts began to be made to engage with the German past,
Zuckmayer (in 1963) withdrew his play from the public domain.

In Germany, more than in any other developed country,
theatre really mattered. (London theatre, very quickly booming
in the post-war years, and much liked by American tourists, was
middle aged and middle class in its appeal, and dominated by
the 'well-made' plays of such as Terence Rattigan.) The Ger-
man statistics, which, in turn, reflect the long tradition of
theatres associated with the nobility or petty royalty, are impres-
sive. With 37 per cent destroyed and most of the rest severely
damaged because of the war, theatres nonetheless began reopen-
ing in the autumn of 1945. In the season of 1947–8 there were
133 active theatre companies. The stringency entailed in the
currency reform brought a reduction, but then a further expan-
sion gave Germany 'the greatest density of theatre anywhere in
the world'.[11] Neither subsidy nor devolution is automatic; but it
should be noted that the majority of theatres were run by the
Länder (the local states within the federal system), who gener-
ally also granted subsidies to commercial theatres. The list of
the four most-produced dramatists throughout the 1940s–1960s
shows a nice balance between traditional and modern classics,
and between the British and the German: in order, it reads,
Shakespeare, Schiller, Shaw, and Brecht; Zuckmayer achieved
twelfth place. The most genuinely avant-garde play, and the one
that most powerfully anticipated what was eventually to become
a central theme in German cultural production, *Vergangenheits
bewältigung* (*Conquering, or Getting to Grips with, the Past*), was
the neo-expressionist *Draussen vor der Tür* (literally *Outside the
Door*, usually translated as *The Man Outside*, 1947) by Wolfgang
Borchert (1921–47). It was withdrawn after only a few perform-
ances; Borchert then died at the tragically young age of 26. The
very left-wing novel *Der Ruf* (*The Call*, 1947) by Hans Werner
Richter (b. 1908) was banned by the Americans, leading to

Richter joining with other leftist literary figures in founding the important Gruppe 47 (Group 47). Heinrich Böll (1917–85) published 'soul-searching tales about the dehumanizing effects of the war'[12]: *Der Zug war pünktlich* (*The Train was on Time*, 1949) and *Wo warst du, Adam?* (*Adam, Where Art Thou?*, 1951). Then, in 1953, there came a major novel of the Second World War, focused, significantly, on one arm of the German military machine of which it was still possible to write in traditional heroic tones, the *Luftwaffe*, and its desperate battles as it faced annihilation: *Die sterbende Jagd* (literally *The Deadly Hunt*), published in English, first as *The Falling Leaf* (1956), then as *The Last Squadron* (1960).

In the mid-1950s, the dominant figures, who quickly established international reputations, were the two Swiss dramatists Max Frisch (1911–91) and Friedrich Dürrenmatt (1921–90). Frisch was working as an architect in Zurich when, in 1945, he tried his hand at a play about individual guilt during wartime, *Nun singen sie wieder* (*Now you can Sing*). Several plays followed, culminating in a work that, interestingly, was actually written for radio, *Biedermann und die Brandstifter* (*Biedermann and the Fire-Raisers*, 1958). Biedermann represents the complacency of the modern bourgeois who, though given plenty of warning by the arsonists themselves, fails to prevent them from setting his house on fire. Always translated as *The Fire-Raisers*, this play, after initial success in Germany, became an international hit. Literary critics see it as contributing to what was soon to be christened 'Theatre of the Absurd'. The grotesque black comedies of Dürrenmatt, concerned with hypocrisy, cruelty, greed, and, apparently, indictments of the breakdown of community values in modern society, are also allocated to this theatrical movement. To him, tragedy was no longer appropriate to the modern 'upside-down world', only the dramas of absurdity. His plays include: *Der Blinde* (*The Blind Man*, 1948) and *Der Besuch der alten Dame* (*The Visit of the Old Lady*, 1956—always rendered in English as simply *The Visit*). This and *Die Physiker* (*The Physicists*, 1962) worked most effectively in the theatre, and were very warmly received in both London and New York.

The year of breakthrough in German literature written by

Germans came in 1959, very truly a time 'of arrival and departure' as we move into the beginnings of the cultural revolution: Gunther Grass published *Die Blechtrommel* (*The Tin Drum*) and Heinrich Böll published *Billard um halb zehn* (*Billiards at Half-Past Nine*). Both had been associated with Gruppe 47. I return to these works in Part Two.

The first of Primo Levi's two-volume account of what it was like to be a survivor of Auschwitz (the concentration camp that he always refers to as 'the Lager'), *Se questo é un uomo* (*If this is a Man*), was published in 1958. This volume, the dark story of existence in Auschwitz, and its lighter successor, the story of the author's return home, *La tregua* (*The Truce*, 1963), are an incredible, superhuman achievement, yet, of course, they cannot represent the full horror of the Holocaust. As Levi's own Preface to *If this is a Man* explains:

It was my good fortune to be deported to Auschwitz only in 1944, that is, after the German Government had decided, owing to the growing scarcity of labour, to lengthen the average life-span of the prisoners destined for elimination; it conceded noticeable improvements in the camp routine and temporarily suspended killings at the whim of individuals.

As an account of atrocities, therefore, this book of mine adds nothing to what is already known to readers throughout the world on the disturbing question of the death camps. It has not been written in order to formulate new accusations; it should be able, rather, to furnish documentation for a quiet study of certain aspects of the human mind. Many people—many nations—can find themselves holding, more or less wittingly, that 'every stranger is an enemy'. For the most part this conviction lies deep down like some latent infection; it betrays itself only in random, disconnected acts, and does not lie at the base of a system of reason. But when this does come about, when the unspoken dogma becomes the major premise in a syllogism, then, at the end of the chain, there is the Lager. Here is the product of a conception of the world taken rigorously to its logical conclusion; so long as the conception subsists, the conclusion remains to threaten us. The story of the death camps should be understood by everyone as a sinister alarm-signal.

Primo Levi was born in Turin in 1919, and trained as a chemist. In 1943 he helped to form a partisan group that it was intended to affiliate with the Resistance movement 'Justice and Liberty'.

But at the end of the year he was captured by the Fascist militia and sent to a detention camp at Fossoli. Then on 21 February 1944 it was announced that all Jews in the camp would be setting out the following day for, as it transpired, Auschwitz. When the Germans fled from Auschwitz in January 1945, they took the healthy inmates with them, almost all of whom perished. But Levi, ill with scarlet fever, was left behind, eventually being released by the Russians. Here there is space only for a few words on what had gone before:

. . . because the Lager was a great machine to reduce us to beasts, we must not become beasts; that even in this place one can survive, and therefore one must want to survive, to tell the story, to bear witness; and that to survive we must force ourselves to save at least the skeleton, the scaffolding, the form of civilisation . . .

. . . everyone knew mysteriously that the selection would be today.

The news arrived, as always, surrounded by a halo of contradictory or suspect details: the selection in the infirmary took place this morning; the percentage was seven per cent of the whole camp, thirty, fifty per cent of the patients. At Birkenau, the crematorium chimney has been smoking for ten days. Room has to be made for an enormous convoy arriving from the Poznan ghetto. The young tell the young that all the old ones will be chosen. The healthy tell the healthy that only the ill will be chosen. Specialists will be excluded. German Jews will be excluded. Low numbers will be excluded. You will be chosen. I will be excluded . . .

It is lucky that it is not windy today. Strange, how in some way one always has the impression of being fortunate, how some chance happening, perhaps infinitesimal, stops us crossing the threshold of despair and allows us to live. It is raining, but it is not windy. Or else, it is raining and it is also windy: but you know that this evening it is your turn for the supplement of soup, so that even today you find the strength to reach the evening. Or it is raining, windy, and you have the usual hunger, and then you think that if you really had to, if you really felt nothing in your heart but suffering and tedium—as sometimes happens, when you really seem to lie on the bottom—well, even in that case, at any moment you want you could always go and touch the electric wire-fence, or throw yourself under the shunting trains, and then it would stop raining.

The journey home involved going deep into Russia, then returning through Romania, Hungary, Germany, and Austria.

As I wandered around the streets of Munich, full of ruins, near the station where our train lay stranded once more, I felt I was moving among throngs of insolvent debtors, as if everybody owed me something, and refused to pay. I was among them, in the enemy camp, among the *Herrenvolk*; but the men were few, many were mutilated, many dressed in rags like us. I felt that everybody should interrogate us, read in our faces who we were, and listen to our tale in humility. But no one looked us in the eyes, no one accepted the challenge; they were deaf, blind and dumb, imprisoned in their ruins, as in a fortress of wilful ignorance, still strong, still capable of hatred and contempt, still prisoners of their old tangle of pride and guilt.

At last the train crossed the Brenner pass into Italy.

We felt in our veins the poison of Auschwitz, flowing together with our thin blood; where should we find the strength to begin our lives again, to break down the barriers, the brushwood which grows up spontaneously in all absences, around every deserted house, every empty refuge? Soon, tomorrow, we should have to give battle, against enemies still unknown, outside ourselves and inside; with what weapons, what energies, what willpower? We felt the weight of centuries on our shoulders, we felt oppressed by a year of ferocious memories; we felt emptied and defenceless. The months just passed, although hard, of wandering on the margins of civilization now seemed to us like a truce, a parenthesis of unlimited availability, a providential but unrepeatable gift of fate.

These two quotations from *The Truce* take me a little beyond my current chronological limits. Levi's great transmutation of his experiences into literary works comes still later: *Il sistema periodico* (*The Periodic Table*, 1975), *La chiare a stella* (*The Wrench*, 1979), *L'altrui mestiere* (1980; *Other People's Trades*, 1985).

Theatre of the Absurd, of Cruelty, and of Panic

The Theatre of the Absurd existed before a name was put on it, in 1961, by the British critic Martin Esslin. We have already touched on elements of the Absurd, in, say, the plays of Max Frisch. What is usually recognized as the first example of Theatre of the Absurd, *La Cantatrice chauve* (*The Bald Prima Donna*, 1950), by the Romanian-born French playwright Eugène Ionesco (1909–94), was very absurd indeed, being, in

conventional terms, effectively meaningless. The play had its origins in the author's reading of English phrase books. In *La Leçon* (*The Lesson*, 1951) a girl is killed by the *word* 'knife', in *Les Chaises* (*The Chairs*, 1952) the stage is dominated by a large number of empty chairs, and in *Amédée or How to Get Rid of It* (1954) two lovers are obsessed by the idea that there is a huge dead body in the next room. *Le Rhinocéros* (1960) seemed to have a clear anti-Fascist message: finding that all his friends are turning into rhinoceroses, the protagonist is forced into making the choice between undergoing the same transformation for the sake of conformity, or rebelling. Ionesco is often associated with another naturalized French dramatist from Eastern Europe. Arthur Adamov (1908–70) was born in Russia. After the earlier plays, such as *The Parody* (1950) and *Le Professeur Taranne* (1953), his plays become more specifically anti-capitalist satires—for example, *Ping-Pong* (1955) and *Paolo Paoli* (1957).

Theatre of Cruelty drew its inspiration from the French actor, director, and theoretician Anton Artaud (1896–1948), who set out his ideas in *The Theatre and its Double* (1938). Artaud argued that theatre, returning to its origins in ritual and spectacle, should be deliberately shocking and violent in order to induce catharsis in the audience. The most important practitioners in the post-war period were Jean Genet (1910–86), Fernando Arrabal (b. 1932), and, as theatre director and manager, Jean-Louis Barrault (1910–94), the mime artist in *Children of 'the Gods'*. Genet, native-born Frenchman, but illegitimate and abandoned as a child, and for his first thirty years continually in and out of reformatory or prison, deals obsessively with sexual perversion, violence, and corruption. *Les Bonnes* (*The Maids*, 1946) presents a ritual game that culminates in murder, *Haute Surveillance* (*Prime Surveillance*, always translated as *Deathwatch*, 1949) draws upon his prison experiences to explicate the relationships that develop between fellow-prisoners, *Le Balcon* (*The Balcony*, 1956) is set in a brothel where the fantasies that the clients act out serve as attacks on the conventional (and, the implication is, false) values of society, and *Les Nègres* (*The Blacks*, 1959) is an exposure of racial prejudice and exploitation. Arrabal, a Spaniard born in Morocco but living in Paris and writing in French, coined for his deliberately shocking

grotesque comedies the label *théâtre panique* (Theatre of Panic). *Theatrical Orchestration* (1959) contains no dialogue at all. In 1946, Barrault established the Renaud–Barrault company with the actress Madeline Renaud in the Théâtre Marigny, where, apart from the classics, they put on performances by Ionesco and Samuel Beckett.

Beckett (1906–89) was born in Dublin, and settled in Paris in 1927, where he became a close friend of James Joyce, who greatly influenced him. He played an active part in the French Resistance and earned the Croix de Guerre. *En attendant Godot* was presented in Paris in 1953, having an enormous influence on British theatre after being presented at the Royal Court in London in 1955 as *Waiting for Godot*. Beckett asks, in effect, whether at any time life is worth having, and he presents this, not as a question for debate (which would be pointless), but as a permanent doubt. There is grotesque humour in the conversation of the two tramps awaiting the arrival of the mysterious Godot, who never shows up (God in French, of course, is Dieu). *Fin de parti*, later translated as *Endgame*, was first performed in French at the Royal Court in 1957; this features blind Hamm and his attendant Clov and Hamm's relatives who spend the action in ash cans. *Krapp's Last Tape* (1958), whose eponymous central character plays to himself recordings made in his earlier life, was written for the Irish actor Patrick Magee.

Beckett, in particular, was an enormous influence on subsequent theatre, while the theatres of the Absurd, Cruelty, and Panic led very directly into the experimental theatre that is a major characteristic of the 1960s.

3 Home Entertainment at the Touch of a Switch

Production and Diffusion of Music

In this chapter I am particularly concerned with the critical swing towards being able to listen to music (and enjoy other entertainments) in the home at the touch of a switch, which took place during the war and its aftermath. Music is the art form with fewest referential elements, the most remote from historical circumstances, yet it was the art form upon which the war had the greatest effects. But the new classical music was arguably the art form of least relevance to most ordinary people. Popular music in the meantime remained notably unchanged, with existing modes, indeed, being strengthened through the use of popular music and popular singers to entertain the troops on both sides, and to bind together fighting and home fronts. Across all types of music the sorts of interrelationships we have discussed in the Introduction in passing are particularly marked. The war experience affected musicians; the needs of war brought technological innovation; technology affected the distribution, and perhaps even the production, of music. Increasingly during the inter-war, and then the war years, music was broadcast on the radio, either 'live' or in some pre-recorded form—broadcasting companies could use their own recordings, or they could use the same kind of gramophone records as were available in shops. The necessities of war gave radio an enormous boost, so that everywhere possession of a radio became almost a domestic necessity. The primary function was in the realm of information (or disinformation): millions depended on the radio for the latest war news; the BBC brought reliable information, and hope, to occupied Europe; radio was a prime propaganda medium; partisans and Resistance units made great use of it. While news was the cutting edge, radio also brought music and entertainment to fighting men and to domestic workers.

Music was distributed, communicated, or consumed in different ways. Musical scores (for classical music), or sheet music (for the more popular forms), were bought by orchestras and bands, and, though to a declining extent in the later twentieth century, individuals. Live performances were given in concert halls and other venues by orchestras, bands, groups. Operas could be listened to (and watched) in opera houses, popular musicals in theatres, and then, transformed into films, in cinemas. From the beginning of the century, possession of a gramophone, and purchase of shellac records, enabled people to listen to four minutes of music at a time, single songs or dances; or a stack sufficiently high could be worked through to reproduce a whole symphony, piece by piece. By the Second World War there had been some improvements in the material out of which the discs were made, but the sound produced was still rather thin and tinny, subject to surface noise, and, in time, scratches; the risk of breakages remained high. Enter war as broker of technological change. Early on, RAF Coastal Command asked the British Decca Record Company if it could provide a training record that would illustrate the different sounds made by German and British submarines. Existing gramophones and their records simply could not produce the frequency range required, so intensive work was undertaken, directed by Decca's chief engineer, Arthur Haddy. The upshot was the development of a new recording technique providing for what Decca called full frequency range reproduction, 'ffrr', adopted as a trade mark by Decca in 1945. As Roland Gelatt, historian of the 'phonograph', puts it, Decca records were henceforth 'brilliant and incisive in the treble, full and resonant in the bass, with a heightened sense of presence and room tone never before encountered on a phonograph record to such stunning effect'. The first important release in the new mode, Stravinsky's *Petrouchka* conducted by Ernest Ansermat, came in June 1946; the trade journal *Gramophone* spoke of 'a new and very exciting page of gramophone history'.[1]

Meanwhile the American record industry was undergoing some very American challenges and responses. The American Federation of Musicians had a particularly vigorous president, James Caesar Petrillo, who was perfectly relaxed about records

being used in the home, but worried by their use in juke boxes and radio broadcasting. From 31 July 1942 Petrillo's members were prohibited from participating in music recording, until such time as the recording companies agreed to pay an appropriate royalty on every record sold. The companies held out for over a year, simply selling off their stockpiles, but in September 1943 the American Decca Company (a separate organization from the British one, whose own records were shortly marketed in America as 'London Records') agreed to Petrillo's terms. During the First World War the British record industry had found a lucrative new market in original-cast recordings of wartime musicals; wartime restrictions, war weariness, the limited number of shows on offer, and difficulties in getting to theatres had all contributed to this phenomenon. This now repeated itself, to even greater effect, in America in the Second World War.

In his book *Green Grow the Lilacs* (1931), Lynn Riggs (1899–1954) had written about the customs and habits of both whites and Indians in his native Oklahoma. The middle of a war in which attention was focused on down-home values was the perfect time for two of America's most skilled producers of musical comedy, Richard Rodgers and Oscar Hammerstein, to confect *Oklahoma!* (1943) out of Riggs's work. America's most successful wartime musical, this subsequently appeared in Europe in both theatrical and film versions. Decca, temporarily in a monopolistic position, seized the opportunity to record an album of *Oklahoma!* hit songs, sung by the original cast. Sales rose to an unprecedented 1,300,000. In November 1944 the two other major companies, Columbia and RCA Victor, accepted Petrillo's terms, and resumed production. Towards the end of 1946 full frequency range reproduction arrived from Britain. American record sales were already booming (275 million in 1946), rising to 400 million in 1947. A classic case is that of RCA Victor's new version of Bach's *Goldberg Variations* by harpsichordist Wanda Landowska. Released in January 1946, it was expected to sell between 2,000 and 3,000; in fact it sold over 40,000.[2]

During the war British and American intelligence officers monitoring German radio broadcasts were astonished at their

quality. In September 1944, Radio Luxembourg, which had fallen under German control, was captured, and the secret was revealed: with respect to making magnetic recordings of material for broadcasting, the Germans were far ahead of the Allies. But, while the equipment was fine for studio use, it was too massive to be practical for home reproduction. In 1947 the Minnesota Mining and Manufacturing Company, makers of the famous 'Scotch' tape, went into full-scale production of magnetic systems for prerecording radio programmes. They had, as we shall see shortly, a crucially influential customer in the person of America's most popular crooner and top radio star, Bing Crosby (1901–77). There was a 'landslide' towards the use of magnetic tape in recording for radio, but as yet no product that could be marketed for home use.[3] Columbia sought, not to abandon the traditional disc, but to transform it, and in 1948 its team, directed by Hungarian-born Peter Goldmark, came up with a non-breakable, micro-groove disc, operating at 33 revolutions per minute (as opposed to the old 78 revolutions per minute), with a playing time of twenty-three minutes per side. This 'LP' was introduced to the press in June 1948. The 33 rpm record was obviously ideal for symphonies and operas. RCA Victor, meantime, developed the smaller, shorter, 45 rpm as the perfect mode for popular music.

For top-quality reproduction the only appropriate way forward appeared to be through magnetic tapes. First high fidelity (hi-fi) reproduction was developed, followed nearly ten years later in 1955–6 by stereophonic reproduction. For a brief period genuine musical enthusiasts, as well as those determined to keep up with the Joneses, sported machines with large wheels over which stereophonic tapes were spooled. This latest development was seized upon by smaller and newer companies. Mercury Records, for example, taped the different elements of Tchaikovsky's *1812 Overture* in three separate locations: the musical score was recorded in Minneapolis under the musical direction of Antal Dorati; the tolling bells were those of the Harkness Memorial Tower in New Haven, and were taped there; the cannon fire was that of a 1761 brass cannon at West Point, so the recording truck went there too. Finally the three sets of tapes were melded into one master tape at the Mercury

Records' New York studio and the completed product was marketed from March 1956. The first attempts to market stereo discs came in 1958, but, compared with tapes, the quality was very low. Once more a vital advance is attributable to the British Decca Record Company Limited. Wagner's massive opera *Das Rheingold*, the first in the Ring Cycle, had never been recorded before. For the British Decca production in Vienna, under the baton of Georg Solti, producer John Culshaw had the platform marked out in squares, into which the singers, including the celebrated Kirsten Flagstad, had to move at appropriate moments. Culshaw voiced his aim as 'that of recreating in the studio an environment as close as possible to the theatre, with singers acting their parts in a production almost as elaborate as the real thing'.[4] The issue of this carefully constructed recording in August 1959 marked the decisive victory of the stereo LP over the open-reel tape.

American musicals continued to have enormous success at home and abroad, first on stage, then on record and on film. Particularly noteworthy are Columbia's *South Pacific* (Rogers and Hammerstein, 1949) and *My Fair Lady* (Lerner and Lowe, 1956). The latter, based—loosely—on Bernard Shaw's *Pygmalion*, had unprecedented, and unsurpassed, sales of 6 million.

Radio and Television

The war experience confirmed the belief of British politicians and publicists that they were right to have radio broadcasting firmly in the hands of a public corporation, the BBC. If further confirmation were needed, that was provided by the awful example of the American system, dominated by advertisers presenting sponsored programmes, often of low quality, though generally of considerable appeal to mass audiences. State control was adopted in Belgium, Norway, Denmark, France, Greece, and Italy. Generally, the example of the BBC was felt to be a good one, though from the moment the war ended there were battles on behalf of total or partial private control of radio stations; and, in fact, direct government control was exercised in France and Italy. Television, which I return to at the end of this section, was important in America—20 million sets in

1953—though still second to radio until the early 1950s. It was of much less importance in Britain—one million sets at that time, and really only of very minor significance in Italy— 100,000 sets, and France—60,000 sets.

At the end of the war, the radio services monopolized by the BBC were reorganized into three: the Light Programme, the Home Service Programme, and the Third Programme. The audience research that the BBC had pioneered shortly before the war treated the audiences for these three services as synonymous with working class, middle class, and upper-middle and upper class, respectively. The most successful radio soap opera was *Mrs Dale's Diary*, set in a distinctly upper-middle-class milieu and broadcast on the Home Service for a middle- and upper-working-class audience. The Light Programme was the main medium for the transmission of popular music, largely in the form of programmes that played numbers requested by listeners—with the BBC, however, taking it upon itself to make sure that no single record got too much exposure: several bands were employed for live broadcasts ranging from light music to swing. Swing music was very much American dominated, Ted Heath being a rather pale imitation of the American swing bands, as Vera Lynn (b. 1917)—the wartime 'forces' sweetheart' —and Donald Pears were of crooners and ballad singers Bing Crosby, Guy Mitchell, and Doris Day. Public dancehalls formed the other main outlet for popular music, with the more famous singers and bands also sometimes appearing at the still-thriving variety theatres.

The most significant phenomenon was the success of *Saturday Night Theatre* on the Home Service, with an audience at the end of the 1940s equivalent to one-third of the entire adult population. The Third Programme was devoted to serious talks, serious plays, and classical music—its function in respect of the distribution of classical music being second only to the direct sale of records. Taking all of these developments together, we have in radio the precursor of the hegemony of television soon to come: music, drama, and all other types of entertainment available in the home at the touch of a switch. This is a key development for the contemporary world—and it was the war that made a radio in every home a necessity. Television broad-

casting, only just beginning at the end of the 1930s, had been brought to an end by that same war; it grew only slowly in the post-war years. In order that it might not become an addiction, nor distract children from their studies or adults from their duties, television broadcasting was confined to a limited number of hours per day—very much in keeping with the BBC ethic. The first debate over the BBC's position took place in 1954, when, against the convictions of senior Conservatives, the Act was passed which led to the setting-up of a separate commercial television channel. But Britain, and the other European countries, remained, as John Ellis puts it, in a television era of 'scarcity', which lasted until the 1980s or 1990s.[5] Only in the era of 'availability', and on the edge of the era of 'plenty', do the perennial complaints about television as destroyer of the arts begin to have substance.

Resistance workers in France had a radio station all ready in a small hotel in the Latin Quarter for the moment of Liberation. It played the music of Debussy, Saint-Saëns, Fauré, Franck, and Milhaud (the last-named being banned by the Germans as too decadently modernistic), and from 10.30 on the evening of 22 August 1944 began broadcasting calls for Parisians to rise up against the Occupying Power. The leading figure was Jean Guignebert, and, when the state broadcasting authority RTF was set up on 25 October 1944, he was appointed first Director General. When he was promoted to the Presidency of the Council of Governors, he was succeeded by Claude Bourdet of the Resistance organization COMBAT. But the state monopoly was not total. The commercial company Radio Luxembourg, founded in 1925, had in the 1930s won the support of French governments, anxious for a strong French presence in the propaganda war against Germany, and been encouraged to establish a studio in Paris. After the liberation of both Luxembourg and Paris, Radio Luxembourg went into operation again as a prime purveyor, among the advertisements, of swing music and ballads on the American pattern. Two of RTF's greatest popular successes were *Pêle-mêle*, which began in October 1944, and *On chante dans mon quartier* (*Singing in my Neighbourhood*), first broadcast on 5 December 1945. The former was a variety show, presenting stories, comedians, games, and a large

orchestra; it had two stars, a Monsieur Champagne, who adjudicated over a quiz show between different schools, and a comic singer Bourvil, who handled the continuity. The latter was purely a music show. For each broadcast it visited a different town, where the local singing stars (previously selected at public performances held on Sundays in Paris) would sing, backed by a chorus made up of ordinary local people. 'Ploum ploum' was the popular name for the programme, derived from its signature tune. Writing in 1966, Louis Merlin, a leading producer and entrepreneur, remarked that it was already impossible to imagine such a simple, and even naive, programme being successful: he attributed its enormous success in the post-war years to the fact that for five years of war the French and Belgian populations had been 'deprived of the right to assemble on the day and at the time they wanted and to come and go at will'. ' "Ploum ploum" was', he concluded, 'a logical outcome of the Liberation'.[6]

Denied increases in incomes and resources, the principals in both programmes defected in 1948 to Radio Luxembourg, the music programme being formally renamed *Ploum ploum tra la la*, joining Radio Luxembourg's other major product, game shows, such as *Quitte ou double* (*Quit or Double*), *100 francs par seconde* (*A Hundred Francs a Second*), *Seul contre tous* (*Alone against Everyone*), etc. RTF showed its serious side, and its emulation of the BBC, in two programmes broadcast, respectively, at 8.00 p.m. on Mondays and Tuesdays: *L'Heure théâtrale* and *L'Heure symphonique* (a theatrical hour and a symphonic one). It also sponsored, as we shall see in a moment, experiments in *musique concrète* and electronic music.

On 1 January 1955 a number of experts and entrepreneurs from France and other European countries, including Louis Merlin, founded Europe No. 1 in the Saar region, at that time part of France, but on the point, after a referendum, of being returned to Germany. Like Radio Luxembourg, Europe No. 1 had an office and studios in Paris. It quickly became famous for its relaxed, direct style, and, above all, its appeal to young listeners, and was thus one of several developments of the 1950s that form a bridge into the cultural revolution of the 1960s. RTF, bedevilled by accusations that it was subject to undue political

interference by whatever was the government of the day, sourly decreed that none of its journalists or producers could work for Radio Luxembourg or Europe No. 1. But it should be noted that, across state and commercial radio, and in a thriving industry of live performance, France manifested a deep-rooted tradition of native popular music, featuring such performers as Edith Piaf, Tino Rossi, Maurice Chevalier, Yves Montand, Charles Bécaud, Pierre Brassens, les Frères Jacques, and les Compagnons de la Chanson.[7] The same was true of Italy, where there was a well-established popular music industry, independent of the American one, and bolstered by the San Remo Festival founded in 1952, with the active participation of the state-run radio system, RAI. An early and distinctive success for RAI was the show, launched on 4 January 1946, *Botta e risposta*, which privileged very quick repartee, and which might best be translated as 'Battle of Wits'.[8]

When radio and television have large audiences as news media, this usually means that they also have large audiences as music and entertainment media (large audiences, obviously, do not necessarily entail high quality). In 1946, 63 per cent of Americans sampled said that radio was their prime source of news. It was also a fairly general American practice for radios to be fitted in cars. There were some respectable drama productions, including, on CBS, the classic radio play about war and peace, Norman Corwin's *On A Note of Triumph*. NBC had some of the most popular stars, singers, and comedians. Their *Kraft Music Hall* (sponsored by the famous cheese manufacturer) starred Bing Crosby. He got tired of doing the show live, but such was the state of the technology that the attempt to prerecord the shows during 1947 was not outstandingly successful. Then came the breakthrough using magnetic tape, enthusiastically adopted by Crosby and the *Kraft Music Hall*. Competition between the radio companies was genuinely cutthroat, and in 1948 CBS lured from NBC some of its top stars: Jack Benny, Edgar Bergen, and Charlie McCarthy (it seems astonishing now that a ventriloquist and his dummy, whose 'magic' one would presume would have to be seen in vision, were actually highly popular on radio), Amos and Andy, Red Skelton, and Burns and Allen. Several of these were, in 1950, to

move to television; this crossing was also made by the successful audience participation show *Truth or Consequences*.[9]

The type of crime thriller developed in the inter-war years as a basic source for film and popular theatre, was also popular for radio and then television. The Perry Mason novels of Erle Stanley Gardner (1889–1970) form a case in point. Gardner was a practising attorney in southern California, who published his first novel, *The Case of the Velvet Claws*, in 1933; his famous central character was a crime lawyer who, with his assistants, went in for a great deal of complex sleuthing in what was by now becoming the conventional style. Within the space of four years Warner Brothers turned out seven Perry Mason movies—none being very successful. Where film failed, radio thrived. From October 1943 to December 1955, soap manufacturers Proctor and Gamble sponsored the very popular Perry Mason radio series. Then Gardner formed his own production company, selling the well-known and widely exported series, starring the Hollywood character actor Raymund Burr, to CBS, who ran it from September 1957 to May 1966.[10]

In mentioning a couple of television plays converted into Hollywood films I referred in Chapter 1 to the widely accepted description of the 1950s as America's 'Golden Age of TV Drama'. The plays, which were broadcast live, brought new stars and new directors to the fore, most of whom subsequently became major figures in the film industry—for example, Rod Steiger, Joanne Woodward, and Paul Newman. The McCarthy episode dulled the urge to address controversial topics, and with the advent of video prerecording the excitement and immediacy of live performance was lost. The golden age ended when television drama production moved from New York to Hollywood, and the attempt to put on plays of authenticity and integrity was abandoned as the need to seek out mass audiences became paramount.[11]

The Caesura of War and the Musical Avant-Garde

In a lecture given on 13 May 1968, entitled 'Where Are We Now?', Pierre Boulez (b. 1925) (by this time undisputed tsar of the musical avant-garde) declared:

Immediately after the war there were great hopes for a generation (and especially for the generation that had realized the failings and weaknesses of its predecessors and immediately marched ahead, full of enthusiasm), to make its own discoveries on what amounted to a *tabula rasa*. I must first remind you that in 1945–6 nothing was ready and everything remained to be done: it was our privilege to make the discoveries and also to find ourselves faced with nothing—which may have its difficulties but also has many advantages ...

The discoveries we made between 1945 and 1950 were comparatively easy: it was simply the primary effort needed to lay the foundations of the new language, starting from the existing sources, which we had chosen afresh for ourselves ...[12]

Son of a wealthy steel manufacturer of Montbrison in central France, Boulez studied maths, engineering, and then music. He was 19 at the time of the Liberation, and he was one of the creative spirits who felt most strongly that, with the ending of the war, there must be a total break with the past and all the mistakes and compromises of his forebears, and a new, utterly uncompromising, beginning. Just what *precisely* is due to the experience of war is impossible to calculate, but there can be no question that there was a new post-war music, involving integral serialism (composition based entirely on the twelve notes of the chromatic scale), *musique concrète* (music that depends on natural sounds), electronic music (in which the sounds are generated entirely electronically), and the aleatoric (incorporating chance), in which Boulez was a leading spirit, along with Karlheinz Stockhausen (b. 1928) in West Germany, Nono and Berio in Italy, and John Cage (1912–92) and Milton Babbitt (b. 1916) in America. Arnold Schoenberg (1874–1951), from the early 1920s onwards, had been the pioneer of serial, or twelve-tone, music, but Boulez regarded the great Viennese master as insufficiently rigorous, too inconsistent. In February 1952 he published a deliberately provocative essay entitled 'Schoenberg Is Dead':

We must resist regarding Schoenberg as a sort of Moses who died facing the Promised Land, after having brought down the Ten Commandments from a Sinäi which many obstinately wished to confound with Valhala (all the time, the dance round the Golden Calf is in full swing). We are, in all truth, indebted to him for *Pierrot lunaire* ...; and

several other works which are much more than enviable. With all due
deference to the surrounding mediocrity, it is very specious to attribute
this havoc solely to central Europe.

It has become essential, however, to abolish a misunderstanding full
of ambiguity and contradiction; it is time to reverse the failure. Gra-
tuitous boasting and smarmy fatuousness have no place in this, but a
rigour which forswears feebleness and compromise. Also let us not
hesitate to write, without any wish for stupid scandal, but without
prudish hypocrisy or useless melancholy:

<div align="center">Schoenberg Is Dead[13]</div>

Boulez spoke more highly of Schoenberg's Austrian con-
temporary Anton Webern (1883–1945), and of his fellow
Frenchman Olivier Messiaen (1908–92). Asked, in the early
1970s, about their influence, Boulez made this comment about
creative processes:

I think there are influences one undergoes and at the same time rejects.
If one is gifted with a sort of creative instinct (basically a thing that
cannot be precisely explained) this kind of reaction is natural: it means
that you assimilate what attracts you and what is necessary, while reject-
ing constraints that don't seem fruitful enough. This would describe
my attitude to Messiaen and Webern at that time. But there is more to
it than that: when you first encounter such works—Messiaen's just as
much as Webern's—you don't quite grasp their scope, nor probably
their logic. There's a difference of age. For instance, looking at music
composed by Webern when he was about fifty, it is very difficult for a
nineteen- or twenty-year-old to assimilate it as a total object. When you
are young you are like a bird of prey, seizing on what suits you and
leaving aside what doesn't.[14]

In his compositions Boulez strove to do some or all of the
following (not always consistently throughout an entire work):
eschew all subjective or emotional elements; follow strict math-
ematical formulae (so that the music would to some extent write
itself 'automatically'); apply what *he* perceived as the rules of
twelve-tone music in a *total* way—that is, to note values, volume,
and density of note sequence as well as pitch, rhythm, and col-
our; to be constantly innovative, as in the deployment of *musique
concrète* and electronic music, the incorporation of chance (the
'aleatoric'); the incorporation of elements and ideas from non-
Western musical sources. One has only to hear a few seconds of

music by Boulez to appreciate that indeed this is new music for a new age. In his May 1968 lecture Boulez went on to admit that: 'Some of our solutions were no doubt exaggeratedly strict in character.'[15] One has to be a musician of considerable talent to be able to follow the (different) rules and intellectual principles on which Boulez's music is based.

Boulez's reputation is unassailable. Let us quickly note the main works upon which it rests. *Structures I* (1949) is a milestone in the evolution of integral serialism. *Polyphonie* (1951), incorporating *musique concrète*, created a sensation when presented at the Donauschingen Festival on 6 October 1951. *Le Marteau sans maître* (*The Hammer without a Master*, 1954) consists of nine pieces, operating in three cycles, and is scored for contralto, and a group of instruments bringing in non-Western sounds, xylorimba, vibraphone, flute in G, viola, guitar, and an exotic range of percussion. *Poésie pour pouvoir* (*Poetry for Power*, 1958), again a sensation at the Donauschingen Festival, combines electronic sounds on tape with the sounds of two synchronized orchestras led by two conductors.

If the music of Boulez was the caesura of war incarnate, the innovativeness of John Cage seems to have been an entirely personal internal compulsion. His earliest important works were composed during the war, but do not seem to have been influenced by it. What is of historical significance is the 'alliance' Cage and Boulez formed in the promotion of post-war avant-garde music. Cage explained his own compulsions:

I'm devoted to the principle of originality. Not originality in the egotistic sense, but originality in the sense of doing something which it is necessary to do. Now, obviously, the things that it is necessary to do are not the things that have been done, but the ones that have not yet been done. This applies not only to other people's work, but seriously to my own work; that is to say, if I have done something, then I consider it my business not to do that, but to find what must be done next.[16]

Among his early ideas were those of concentrating on percussion without melody, and introducing completely new sounds. Thus his *Third Construct in Metal* (1941) uses rattles, drums, tin cans, cow bells, various other percussion instruments, and includes a lion's roar. In 1949 at the Artists' Club (founded by

Robert Motherwell) he gave a 'Lecture on Nothing', which, he said, was 'written in the same rhythmic structure I employed at the time in my musical compositions'. Having been asked by Dr Wolfgang Steinecke, Director of the Internationale Ferienkurse für Neue Musik (International Holiday Course for New Music) at Darmstadt, to discuss his *Music of Changes*, he decided to give a lecture within the time length of that work, so that, whenever he stopped speaking, the corresponding part of *The Music of Changes* itself would be played.

This is a lecture on changes that have taken place in my compositional means, with particular reference to what, a decade ago, I termed 'structure' and 'method'. By 'structure' was meant the division of the whole into parts; by 'method', the note-to-note procedure. Both structure and method (and also 'material'—the sounds and silences of a composition) [pause] were, it seemed to me then, the proper concern of the mind (as opposed to the heart) . . .; whereas the two last of these, namely method and material, together with form . . . were equally the proper concern of the heart. Composition . . . I viewed . . . as actively integrating the opposites, the rational and the irrational . . .

 In the case of the *Sonatas and Interludes* which I finished in 1948, only structure was organized . . . the method was that of considered improvisation . . . the materials, the piano preparations, were chosen as one chooses shells while walking along a beach . . .[17]

The importance of chance operations, Cage went on to explain, greatly increased in *Music of Changes*, all the elements of which were chosen using charts derived from *I-Ching*, the Chinese Book of Changes. Throwing the pair of Chinese dice determined which elements to use and how. Cage saw this as imposing 'rational control'.[18] Boulez, who spent a considerable amount of time in the United States, and Cage were close friends, and their correspondence is an important source for their ideas. Boulez has stressed the enormous significance of the United States in his musical development.

 The older man who had great influence over the new post-war generation, but continued himself to be a composer of great stature, was Olivier Messiaen. Antoine Goléa has described the story of the composition and the first performance of *Quatuor pour la fin du temps* (*Quartet for the End of Time*, 1941) in a German prisoner-of-war camp, before an audience of 5,000

prisoners, as 'one of the great stories of twentieth-century music'.[19] Messiaen has resisted any attempt to interpret this work as a reaction to war or imprisonment, emphasizing its dependence on the imagery of the apocalypse contained in the Revelation of St John the Divine, though Paul Griffiths comments that 'imprisonment may have played its part in directing Messiaen's thoughts towards the eschatological'.[20] From a series of interviews Messiaen has left this in response to the question 'Why do you compose?':

I have often been asked that question, and I find it very unprofitable; indeed it seems to me that a composer writes music because he must, because that is his vocation and he does it very naturally, as an apple-tree bears apples or a rose-bush roses.

It is certain that since childhood I felt an irresistible and overwhelming vocation for music. [21]

He was encouraged by his parents, his father being a teacher of English and translator of the complete works of Shakespeare, and his mother, as he put it, 'a great poet of motherhood'. Questioned about his well-known incorporation of bird song in his works, he responded: 'I've addressed myself to bird song, because that, finally, is the most musical, the nearest to us, and the easiest to reproduce.'[22] In 1944 he published his *Technique de mon language musical*, in which he made the following remarks:

music should be able to express some noble sentiments (and especially the most noble of all, the religious sentiments exalted by the theology and truths of our Catholic faith).

Supremacy to melody! the noblest element of music, may melody be the principal aim of our investigations.

Plainchant is an inexhaustible mine of rare and expressive melodic contours ... Hindu music abounds in curious, exquisite melodic contours ...

Paul Dukas used to say, 'Listen to the birds. They are great masters.' I confess not to having awaited this advice to admire, analyse, and notate, some songs of birds.[23]

Messiaen began a new experimental phase in 1949, most fully expressed in his *Quatre études de rythme* (*Four Studies in Rhythm*), played at Darmstadt in 1951.

The only true rival to Boulez among younger composers was

Karlheinz Stockhausen. First he was associated with the RTF group experimenting in *musique concrète* and electronic music, and then with a rather similar experimental group at the West German radio headquarters in Cologne. His earliest compositions at the Cologne studio, *Study I* (1953) and *Study II* (1954), were among the first examples of pure electronic music. Stockhausen's most important achievements belong to the period of the cultural revolution, and I shall discuss them in Chapter 7 along with the works of Nono and Berio.

The works I have just been discussing were not works that record companies rushed to market. Again, rather like Cubism, much of the experimental work did not in itself seem to achieve much, though at the same time it was colossally influential in presenting new elements of which other composers had to take cognizance. It was, in any case, the great classics of the eighteenth and nineteenth centuries that made up the bulk of concert repertoires, and that were the basis for radio broadcasts and the better-selling classical records. Modern works that did do well eschewed the rigour, and the extremism, of a Boulez or Stockhausen.

Benjamin Britten (1913–76) had in 1930s Britain been a bright young intellectual, associated with the group that looked to W. H. Auden for leadership. Despairing of British society, Britten, together with his close friend, the tenor Peter Pears, left for America in August 1939. However, though pacifists, they were not deserters, and in early 1942 they voluntarily returned to embattled Britain, where they were given exemption from military service on condition that they gave recitals for the recently established, state-sponsored, Council for the Encouragement for Music and the Arts. Much of Britten's creative energies were devoted to composing an opera based on a poem by George Crabbe: as conscientious objectors and homosexuals, and therefore to a degree outsiders, Britten and Pears identified with the strangely independent and stubborn character of Peter Grimes. If the founding of the Edinburgh International Festival of Music and Drama in 1947 was one impressive testimonial to the new spirit of internationalism, sanity, and reconciliation released by the war, the fact that it was Britten's opera *Peter Grimes* that was chosen to reopen the

Sadler's Wells Theatre on 7 June 1945 was another. However, the major work to which I wish to give attention is the *War Requiem*: this combines nine of Wilfred Owen's First World War poems with the Latin Mass for the Dead, and thus brings together the two world wars in one great testament to the tragedy of all war and to the necessity for reconciliation (the work was dedicated to four friends killed in the Second World War). The immediate context was the building of the new Coventry Cathedral, to replace the one destroyed in the blitz. The first performance took place in the new Cathedral on 30 May 1962. It was, as these things go, immensely popular, then and since, registering an acceptance of 'the Modern' by the British concert-going, and record-buying, public, though the 'Modernism' was that of Europe in the inter-war years, not of the contemporary avant-garde.

Part Two

The Cultural Revolution and After, 1958–1979

Introduction to Part Two

Part Two, in its four separate chapters, is concerned with pinning down the essential features of the great period of transformation between 1958 and 1973, 'The Cultural Revolution', and its aftermath up to 1979, discussing the manner in which the Cultural Revolution manifested itself in the different art forms. With regard to the widely expanding sphere of popular culture, embracing all activities involving the young and the would-be young, the central feature is undoubtedly the arrival of rock music. However, I put this topic, and associated developments in film and television, as secondary to certain governing social developments, summarized as permissiveness, relaxation of censorship, and feminism. For such historical phenomena, the best, least-mediated, artistic sources are still novels. The basic purpose then of Chapter 4 being to drive home as quickly as possible the most culturally and artistically significant features of this time of change, it concentrates on novels, drawn from all the main countries, but divided up into three categories. First, novels that most obviously deal with permissiveness and sexual liberation; then novels by women writers, all of them in some way or another feminist in philosophy; finally, novels that are not so obviously 'realist' or 'programmatic', but that are much more obviously modernist, showing preoccupations with the past and memory, or consumerism, or demonstrating that modernistic *mélange* of realism and fantasy that, originating in South America, has been termed 'magic realism'.

The matters dealt with in Chapter 4 affected large sections of the population. This hierarchy of numbers continues with Chapter 5, focusing on the rock revolution, and on films and television. Chapter 6 turns us towards minorities, but also to ideas of tremendous potency. This book is not concerned with works of philosophy or political or social ideas, so the main

features of the structuralism, poststructuralism, and post-modernism that developed mainly in France in the 1960s and 1970s are only briefly summarized. Structuralist ideas were provided with their most obvious artistic outlets in the *nouveau roman* and in the writings of Italian neo-avant-gardism, and this short chapter concludes with a discussion of these. The *nouveau roman* received a certain amount of publicity, and even notoriety, partly because of its implication in film-making. Continuing down my hierarchy of numbers, I come (in Chapter 7) to those art forms that might seem most remote from popular influences, but that nevertheless do very strongly reveal many of the characteristics that I have identified as central to the Cultural Revolution. Throughout, of course, I am interested in questions of the relationships between élite and popular art. Attempts at 'crossover' are very much part of 1960s cultural practices, and this phenomenon can be seen in all of the artistic activities I take in turn throughout this chapter: art music, paintings and assemblages, poetry, experimental theatre, architecture. Particularly evident here, too, is the blurring of the boundaries between different art forms. Art music incorporates popular elements; paintings come to be more than two dimensional, as indeed does poetry; theatre incorporates song, dance, and film; architecture becomes highly eclectic and is one of the first art forms to be given the label 'postmodernist'.

4 Permissiveness, Censorship, Feminism

The Literature of Permissiveness

In the minds of the vulgar, as represented by the popular press, modernism, from its beginnings, had been associated with an undue emphasis on sexuality. The novels of James Joyce (1882–1941), the works of D. H. Lawrence (1885–1930) (including his paintings, scarcely dry before being seized by the police), and the surrealist works of, say, Juan Mirò (with bits of genitalia appearing all over the place) had seemed to provide ample witness to this. There were nearly always sexual passages in the novels of such widely-selling authors as Ernest Hemingway (1899–1961), Alberto Moravia (1907–90), and Graham Greene, though nothing really in the way of anatomical explicitness. A new kind of permissiveness in life and in fiction lay at the heart of the Cultural Revolution. Authors themselves felt emboldened to move into new territory; censors sensitive to the way in which society was changing began to dismantle the barriers preventing entry into this territory. A new wave of feminism, triggered after the Second World War by de Beauvoir, came to a new intensity in the early 1960s, and burst out explosively at the end of the decade. Women novelists insisted that sexual experience was no longer to be treated almost exclusively from the male point of view. Middlebrow novels were still the medium that responded most immediately to changing social attitudes and mores—reflecting them, defining them, extending them, legitimating them—and it is on such novels that this chapter will mainly concentrate, along with the question of literary censorship—leaving films and film censorship to Chapter 5. Feminism, of course, must be treated as a serious issue in its own right. Literature and film more properly related to other aspects of 1960s development will be discussed in Chapters 5, 6, and 7.

With regard to permissiveness in literature, three trends are

discernible in both America and Britain in the final years of the 1950s and the early 1960s. A number of new novels were published that were perceived by contemporaries as breaking former taboos in the frank and daring way they dealt with sexual matters. Almost at the same time, though, if anything, after a slight delay, changes in literary censorship made possible not only a continuation and exaggeration of the trend but also the publication and circulation of older books that had previously been banned. The third trend was that both kinds of book (which if confined to limited hardback editions might not have excited the authorities too much) were appearing in paperback for a mass market—for the 1960s 'paperback revolution' had already begun. Certain branches of French literature had long been perceived in the Anglo-Saxon countries as being much more daring than anything permitted in home products; the great controversial English-language books of the inter-war years, *Lady Chatterley's Lover* (1928) by Lawrence and *The Tropics* books of Henry Miller (1891–1980) (*Tropic of Cancer*, 1934; *Tropic of Capricorn*, 1939), were available in Paris (in the euphemistically titled 'Travellers' Companion Library', profitable invention of the stalwart pornographer Maurice Girodias and his Olympia Press). But arguably there was also a new sexual note in some of the more distinctive novels of the 1950s, that note being very evident in *Bonjour tristesse* (*Good Morning Sadness*, 1954) by 18-year-old Françoise Sagan (b. 1935). Literary censorship in France, apparently quiescent, could be arbitrary, and, if anything, was applied with greater vigour under the Gaullist regime after 1958—this cuts two ways, however, since attempted censorship brought the issue into greater prominence. In Italy, strictest control was mirrored by least change. Developments in Germany echoed those in America. What is very worthy of note is the attention French, Italian, and German journals gave to the (as they saw it) profound changes taking place in Britain, long perceived as the model of staid decorum.

With reason, one might add: in 1955 a shopkeeper in a lower-class part of London was sentenced to two months in prison for having in stock *Lady Chatterley's Lover*.[1] This is the book that almost simultaneously became the subject of crucial legal

actions in both Britain and America. In Britain the essential prerequisite was an actual change in the law. Credit for the new Obscene Publications Act, which allowed 'literary merit', as vouched for by acknowledged experts, as a possible defence against prosecution for obscenity, goes to the then backbench Labour MP Roy Jenkins. Jenkins had shown great pertinacity and skill in making use of his luck in winning a Private Members' ballot, which provides the fortunate backbencher with the rare opportunity to introduce legislation. Without, however, wide recognition in governing circles that Victorian taboos could not be upheld in the late 1950s, it would not have succeeded in getting through all its parliamentary stages during the year 1958; the new law came into effect in July 1959. In America an important criterion was whether a book was pure enough to be sent through the post, thus giving the American Post Office an important role; in the end decisions lay in the hands of the courts, and depended upon how they interpreted the First Amendment to the American Constitution, guaranteeing freedom of speech. A case of 1955–7 established that the notion of 'redeeming social importance' might be used as a defence, and indeed this was the defence used in the 1957 trial in San Francisco of Allen Ginsberg's long poem *Howl*. Deciding that it too would make use of this defence, Grove Press of New York brought out an unexpurgated edition of *Lady Chatterley's Lover* in the spring of 1959, when it was at once challenged by the Post Office. 'If this book is not filth', asked the Postmaster-General, 'pray tell me what filth is'.[2] The book was duly banned; however, Grove Press took immediate counter-action to restrain the Postmaster-General from preventing distribution. In the US District Court, Southern District of New York, Judge Bryan ruled on 21 July 1959 that *Lady Chatterley* could be shipped through the mail, noting: 'the record . . . indicates general acceptance of this book', and concluding: 'The trends appear in all media of public expression, in the kind of language used and the subjects discussed in polite society, in pictures, advertisements and dress, and in other ways familiar to see. Today such things are generally tolerated whether we approve or not.'[3] This is the argument that is applied also in film censorship: people's attitudes are changing, thus

interpretations of the law must change also. A self-reinforcing process, of course: people become more open, more explicit, less ashamed, less clandestine, in what they read and watch and in what they do.

It was in the latter half of 1959 that Penguin Books, an infinitely more reputable and respectable organization than Grove Press, decided to mark the thirtieth anniversary (falling in the following year) of Lawrence's death and the twenty-fifth of Penguin's birth with eight Lawrence titles, including an unexpurgated *Lady Chatterley's Lover*. Of this 200,000 copies were printed, but held back while a dozen copies were sent to the Director of Public Prosecutions. Although the DPP, showing some recognition of changing attitudes, had recently decided not to prosecute the British edition of *Lolita* (1959), he did decide to prosecute the Lawrence, which, in contrast to the elegant euphemisms of Nabokov (1899–1977), was loaded with the four-letter words that sections of the British public found deliriously exciting in print, but that by a widely accepted convention were held to be beyond the pale of civilized life. Thus it came to pass that the most celebrated and illuminating show trial of this critical time of change was held at the Old Bailey during five days in November 1960.

Some of the statements of the expert defence witness read comically today: he was at pains to stress that *Lady Chatterley's Lover* is 'hygienic' and 'wholesome'; it was a book 'Christians ought to read'. But such comedy was nothing to the ludicrous opening address to the jury by the prosecution barrister Mervyn Griffith-Jones, which aroused great hilarity at the time and which has continued to do so ever since:

You may think that one of the ways in which you can read this book, and test it from the most liberal outlook, is to ask yourselves the question when you have read it through, would you approve of your young sons, young daughters—because girls can read as well as boys—reading this book. Is this a book that you would leave lying around in your own house? Is it a book that you would even wish your wife or your servants to read?[4]

Unwittingly, poor, befuddled Griffith-Jones had stumbled on the fact that, while formally proceedings were about how far

explicit descriptions of sexual acts could be published, and, therefore, discussed, this trial also had a class dimension. After the jury had acquitted *Lady Chatterley* of obscenity, Penguin printed hundreds of thousands of new copies (two million were sold within the year), adding a blurb referring triumphantly to the trial: 'it was not just a legal tussle, but a conflict of generation and class.' In the spring of 1961 Grove Press published a hardback edition of *Tropic of Cancer*. Again there came the automatic response from the US Post Office, but on 13 June the attempt to ban the Miller novel from the federal mails was abandoned.

At the beginning of the 1960s there was a spate of serious novels, in no way pornographic in intention, that dealt with sexual matters in such an explicit way that a few years earlier the attentions of the censors would have been attracted. Now they passed almost unnoticed in that quarter. Excellent examples are provided by the work of John Updike (b. 1932). Updike was very much the white Northern Protestant, the son of a mathematics teacher, born and brought up in Pennsylvania. He studied at Harvard, where he majored in English, but also displayed great talent as a graphic artist and cartoonist; he spent a year in Oxford studying at the Ruskin School of Drawing and Fine Art. For nearly two years he worked on the *New Yorker*, subsequently bringing to his novel writing the keen and cynical eye of a successful contributor to that journal. At the same time he had a deep commitment to Protestant religious morality. He published one collection of poems prior to his first short novel *The Poorhouse Fair* (1959), which is marked by a strong element of social commitment.

Rabbit Run (1960) introduces 'rabbit' Angstrom, 26 years old, six-foot-three inches tall, formerly a star basketball player, who has a wife who drinks, a 2-year-old son, a too-small flat, and a job as salesman for a kitchen gadget called the MagiPeel Peeler. He is feckless, disorganized, but with a certain appeal for women. His own sexual experiences, those of his wife, and those of a woman he consorts with are meticulously detailed. *Couples* of 1968 neatly records a critical development of the intervening years: 'They deftly undressed, she him, he her. When he worried about contraception, she laughed. Didn't Angela [his wife]

use Enovid yet? *Welcome, she said, to the post-pill paradise.'*
Couples is, of course, about much coupling.

Another Country (1962) by James Baldwin (1924–87) had the
same sexual explicitness, but was infinitely more audacious in
that much of the sex was inter-racial and that homosexuality
and bisexuality are openly recognized. Baldwin, born into the
black community in Harlem, New York City, in 1954 had pub-
lished a successful first novel, calling upon his experiences as a
boy preacher in Harlem, *Go Tell it on the Mountain* (1953). His
second novel, *Giovanni's Room* (1955), confined to white
characters, had broached the question of homosexual love.
Baldwin's purposes were deeply serious: 'the artist', he
declared, 'cannot allow any consideration to supersede his
responsibility to reveal all that he can possibly discover concern-
ing the mystery of the human being'.[5] *Another Country* presents
a fascinating interweaving of themes, only just beginning to
announce themselves as Baldwin was writing, which we now
recognize as being among the most distinctive of the entire
period up to the beginning of the 1970s. First, of course, is race
relations—continuing hurts and *visions of change*. Baldwin was
to become increasingly active in the civil-rights and black-
liberation movements. The notion of the need to subvert what
Baldwin referred to as an 'anti-sexual' country lies at the heart
of vast tracts of *Another Country*, and accounts for the
complaint of one critic that there is 'something offensive for
everyone'.[6] If the barriers and indignities of race form one
encompassing theme, the other is of the paramouncy of sex, of
the absolute legitimacy of sexual activity at all times, in all cir-
cumstances, and of all types and combinations. Heterosexual
couplings are described in intimate anatomical detail. Interest-
ingly, the homosexual ones resort to the unspecific purple prose
that until this time had often been deployed for heterosexual
love making.

Gore Vidal (b. 1925) is a true aristocrat, a member of the
American upper class, a man of prodigious energy and talent, a
patrician critic of American society, active in politics but too far
to the Left to secure any elected post. He knew Hollywood
intimately, and in the 1950s wrote both films and television
plays. In the 1960s he began to concentrate on writing novels,

particularly a famous, naturalistic historical series, running from *Burr* and *Lincoln* to *Washington DC*. *Myra Breckinridge*, however, is a modernist satirical fable, written, the author says, as a deliberate spoof on the French *nouveau roman*.[7] Myra had previously been Myron, who had deliberately willed the sex change. The book is more liberated in sexual matters than the ones by Updike and Baldwin already cited. It is Myra's set purpose to crush and humiliate the handsome and sexually successful student, Rusty. In a protracted and thoroughly explicit sequence, on the pretext of giving him a medical examination, she brutally handles his genitals, jeers at their size, and then thrusts an enormous dildo up his anus. But this is also a hilarious and penetratingly accurate satire on all aspects of American society in the 1960s, from the fetishism of automobiles and freeways to phoney (as Vidal sees it) student protest.

William Styron (b. 1925), a Southern Protestant who served in the Marines in 1944–5 and briefly in Korea in 1951, seems to stand a little apart from the other novelists I have discussed. There are semi-autobiographical elements in a late novel, *Sophie's Choice* (1979), where the narrator tell us: 'I have always been attracted to morbid themes—suicide, rape, murder, military life, marriage, slavery.' Certainly murder, rape, and, in fact, evil incarnate dominate *Set This House on Fire* (1960), Styron's third novel. *The Confessions of Nat Turner* (1967), based on the testimony of the historical figure who had led a slave revolt, raises the vital issue of the distinction between history and fiction, which I return to in Chapter 7. *Sophie's Choice* (filmed, with Meryl Streep, in 1982) was set in the post-war period, when racist atrocities were very common in the American South: one question raised is—should the young Southern narrator bear some of the guilt? Sophie is an Auschwitz survivor, but a Polish gentile. The third main character is an accusatory and often angry American Jew who has himself escaped all the sufferings of the Holocaust. The moral dilemmas are electrifying, but the novel is heavily padded, with long and tedious extracts from the book reports the narrator wrote as a publishers' assistant, and from his first attempts at novel writing. Fortunately the brilliant slimmer novel inside struggles free of the all-too-typically corpulent one.

Portnoy's Complaint (1969) by Philip Roth (b. 1933) might have been designed to anticipate the complaints feminists were beginning to make about men, around that time. Portnoy (a fictional character, we must remember) has the same obsession with his own sexual needs and contempt towards women as is seen in the semi-autobiographical works of Henry Miller. The novel is in the form of confessions by Portnoy, in his thirties, to a psychiatrist, but, of course, it is shaped by the wit and critical mind of Roth himself. As an adolescent Portnoy is a compulsive masturbator; as an adult he treats women as sex objects, giving them names like 'Pumpkin' and 'the Monkey', then callously abandoning them. He forces 'the Monkey', a model and actress, into an act of troilism with an Italian prostitute: 'Boy, was I busy! I mean there was just so much to do. You go here and I'll go there—okay, now you go here and *I'll* go there alright, now she goes down that way, while I head up this way, and you sort of half turn around on this . . . and so it went, Doctor, until I came my third and final time.' Roth was brought up in a strict Jewish lower-middle-class family, and the novel is pervaded by Portnoy's sense of his Jewishness. There is also a touch of that class awareness that, as we shall see again, came, with other kinds of frankness, into American discourse in the later 1960s: one of Portnoy's women is an 'aristocratic Yankee beauty' whose upper-class pursuits and mannerisms he mocks. Twice, in humiliating circumstances, Portnoy fails to achieve erections. The second time is in Israel—where he finds it almost impossible to believe that 'in this country, everybody is Jewish'— where he gets his come-uppance from a six-foot, idealistic ex-national-service woman. Roth extended his reputation as the frank and explicit expounder of the erotic with such novels as *The Breast*, the story of a man who turns into a female breast, and *The Professor of Desire*.

From Doris Lessing to Hélène Cixous

The contemporary feminist or women's liberation movement began during and after the events of 1968. But the first stirrings in a new phase in the history of feminism, the beginnings, one could say, of the self-conscious 'Women's Movement', def-

initely came in the early 1960s. There are two hallowed names, that of Betty Friedan (b. 1921) in America, and that of Doris Lessing (b. 1921) in Great Britain. Friedan published a kind of political tract in 1963, *The Feminine Mystique*. This was actually a year after Lessing had published a large, complex, and modernistic novel, *The Golden Notebook*. The impact of Friedan's book was probably more immediate. Friedan herself was an activist, and played a leading role in the establishment the National Organization for Women (NOW). At a meeting of 300 men and women in Washington in October 1966, NOW declared that 'The time has come for a new movement toward free equality for all women in America, and toward a truly equal partnership of the sexes, as part of the world-wide revolution of human rights now taking place within and beyond our national borders'. Friedan had carried out her researches into what she termed 'The problem that has no name' between June 1957 and July 1962: 'There was a strange discrepancy between the reality of our lives as women and the image to which we were trying to conform, the image I came to call the feminine mystique.'[8] *The Feminine Mystique* was an account of the frustrations and unhappiness of educated American women unable, as 'good wives and mothers', to use their education and stretch their intelligence—'the problem that has no name'—and a criticism of the way in which American society forced women into the exclusive role of home-keepers, carers, and sexual foils to men— this role embodying what Friedan called 'the feminine mystique'. Her book was an inspiring plea for genuine equality between the sexes, in both the home and the workplace.

There was no overt programme in Lessing's *The Golden Notebook*: the influence it had became clearly evident only in the outburst of a more militant feminism at the end of the decade. The novel is modernist in that it is made up of conventional narrative with the ironic title of 'Free Women', together with four experimental notebooks kept by the main protagonist, Anna Wulf, a writer, each written in a different style. Wulf is wrestling with crises in her domestic and political life, and she comments on these through different modes, fiction, parody, political documentation, and a naturalistic setting-down of everyday events. She undergoes a breakdown, the structure of

the novel replicating her sense of fragmentation and the way she feels the need to keep the different aspects of her life in separate compartments. Recovery comes when she meets up with an American lover. We now learn that the first sentence in the conventional narrative of *The Golden Notebook* has been suggested by him.

Actually, many of the ideas of *The Feminine Mystique* had been foreshadowed in a novel published in the same year as Lessing's, less successful at the time, though its author, Alison Lurie (b. 1926), later became a bestseller.[9] Emmy in Lurie's *Love and Friendship* is a highly educated, upper-class, university wife, with no job, though the often vexatious task of bringing up her beloved 4-year-old son, Freddy. She has fallen out of love with her worthy husband Holman, and soon becomes involved with the college womanizer, Will. The descriptions of sex from, as it were, below, are unprecedentedly frank and funny: they could not have been published a year or two before: 'she realised that here she was with her husband, in the very act, imagining another man. She went stiff all over for another moment, but Holman seemed to take no notice. He went on with what was today a rather long-winded and monotonous performance, and at last brought it to a conclusion.'

She is in Will's tiny sports car: 'Well, anyhow, we can't possibly do it now here in the car, was her last mistaken, coherent thought.' Suspicions aroused (though he suspects entirely the wrong man), Holman has taken to spying on Emmy's diaphragm, and, as she doesn't have a spare, Will has to resort to other means:

'Oh, I am so wet.'
'Here.' Will passed a handful of leaves over his shoulder.
'Thank you. Golly. It didn't break, did it?'
'No. That's all you.'

Only once is there a comment more notable for anatomical explicitness than sly wit: 'I like it at the end when you get bigger and bigger and I can feel myself slowly exploding and nothing can be done about it.'

In the end, Emmy does not go off with Will: 'I don't have to marry him. I belong to myself. I haven't decided yet, and

nobody can make me.' Emmy is the autonomous, existential woman. She does stick with Holman, but not because of social pressures, but because it is her independent decision. Much of the novel is about the uninhibited pleasures of sex, uninhibitedly expressed. This was an aspect of Lurie's work that was increasingly to be featured in blurbs, playing a part in spreading the gospel of the permissive society. But there is a sense in *Love and Friendship*, too, of good sex as a dangerous drug for a woman, an idea appearing at that time in the novels of French author Christiane Rochefort, and one that was to be increasingly propagated by the new wave of feminists at the beginning of the next decade. Katherine, in Lurie's *The Nowhere City* (1965), is another highly educated, upper-class woman, a virgin at the time of her marriage, who has come to Los Angeles because that is where her husband has got a job. She hates this city—there are brilliant descriptions of Beat culture—but, once she has become sexually emancipated, she makes the existential decision to stay on there, while it is her husband who goes back to the East.

The novels trace moves that Lurie herself actually made. *Love and Friendship* is set at a fictional Amhurst College, where her husband got his first job; the bestseller, *The War between the Tates* (1974), at Cornell University, where Lurie finally settled. Most of the events take place in 1969, a climactic year of hippies, student protest (particularly against the Vietnam War—deliberately echoed through the title of, and the family conflict in, the novel), and feminist organization—from which the upper-class, virginal Erica is rather detached. However, many feminist points are made: 'It is true, Erica thinks: men run the world, and they run it for their own convenience.' Erica's worthy husband, who, we learn in a typical piece of Lurie frankness, has very small genitals, has an affair with a hippy student who throws herself at him. For a time, both Erica and the activist feminist, Danielle, have to manage without their husbands:

'And I really don't like masturbation,' Danielle confides in a lower voice. 'I tried it a few times, but I could never get much out of it. I couldn't come or anything; I just always felt nervous and silly, you know?'

'Mm', repeats Erica, who has had the opposite experience.

It is the fully liberated Danielle who triumphs as an existential individual, while the reconciliation between the Tates (Erica and her husband) is presented as a classic conflict resolution in which individual autonomy has to be compromised.

Lurie's novels, which continued to be published throughout the 1970s–1990s, are usually characterized as 'comedies of manners'. It is also worth noting their 'reflexive', almost 'post-modernist', character. There is much reflection on the nature of academic work and its purposes. In *Real People* (1969), there is a fictional novelist and a fair amount about the nature of novel writing and also about the construction of contemporary art.

The real shocker was *The Group* (1963) by Mary McCarthy (1912–89), which was coolly funny in its treatment of sex. Not only was the author a woman, but, at the age of 51, she was a long-established member of the liberal literary establishment. *The Group* is not by some young newcomer, nor is it about the contemporary youth or beat scene. It is not, in its essence, time specific at all, though formally it deals with what happens in the seven years after 1933 to a group of graduates from the upper-class women's college Vassar. There is nothing strongly feminist about the novel, though the telling point is made about the doctor husband of one of the young women that he gives no help whatsoever in the matter of their son who, at the age of $2\frac{1}{2}$, was not able to control his bowels. The young women all tend to innocence, and look towards men to initiate them into what have remained the mysteries of sex. The hilarious, downbeat, and anatomically explicit account of how Dottie brought about her own seduction, which comes as early as Chapter 2, still has the power to shock: it ranks as the classic gateway to 1960s candour, explicitness, and simple joy in sex, without the purple passages and romantic posturing. The next chapter includes an uninhibited, thoroughly explicit, and extremely funny description of Dottie being fitted up with a contraceptive diaphragm.

The Group was denounced publicly by many critics. A Mid-South middlebrow thirty-something woman expressed her revulsion in a letter to her parents: 'I read the first 50 pages, was so nauseated by its dirt for dirt's sake that I took it right back to Doubleday [booksellers] . . . It's shameful that Vassar has to be the butt of such a work.' A lady novelist in California took a

more profit-oriented view, writing to a friend: 'I don't think we need books of this sort, but if Mary McCarthy can do it, then I should at least try for these lovely $ that seem to be under that manure.'[10] But it was a book that people read as well as denounced—presumably because it was indeed a book women could identify with. It reached the American bestseller list, and in the same year came out in Britain, followed in 1964 by paperback publication.

Christiane Rochefort was 41 in 1958 when she published her first novel, *Le Repos du guerrier* (*The Warrior's Rest*), she came from a militant working-class family (her father served for three years with the Republicans fighting against Franco), and she earned her living from journalism and public relations. *The Warrior's Rest*, a frank but, by the standards of the books I have just been discussing, scarcely explicit account in first-person narrative of an *adult* woman's infatuation with a drunken ne'er-do-well, enjoyed a *succès-de-scandale* and by 1961 had sold 265,000 copies, becoming, under the original title, the popular Roger Vadim–Brigitte Bardot film of 1962. It presents an early version of the perception, a commonplace among feminists ten years later, that the sexual attractiveness of certain men is a dangerous drug, a terrible trap.

Les Petits Enfants du siècle (1961, *The Little Children of the Century*, though actually misleadingly translated as *Josyane and the Welfare*) is also a first-person narrative, this time recounted by a working-class girl (Josyane), living in an appalling multi-storey housing estate on the outskirts of Paris, who by the end of the story is 17, but who gives a child's-eye view of family life with two parents and eleven children, from the time of her going to school onwards. Among many other things, *Les Petits Enfants du siècle* is a protest against working-class women being treated as mere breeding machines. Josyane, still pre-pubescent, has one absolutely transporting experience (cunnilingus, it is perfectly clear from the text) with Guido, an Italian labourer on a local building site. Josyane's cold-eyed appraisal of the stupidities of adults and, as she grows older, of how to turn to her own advantage the sexual exigencies of the boys around her, is chillingly accurate and chillingly funny (from one boy she demands cunnilingus as a precondition for full sex). She meets a more

cultured youth—but he is killed in the Algerian War. At 17 she falls in love, gets pregnant, and marries. She has swallowed the drug, fallen into the trap. With respect to the eventual explosion of feminism, *Les Petits Enfants* really is quite revolutionary: apart from the cunning and intelligence of the girl narrator herself and the feebleness of most of the male characters and their refusal to play any part in domestic chores, the central position given to cunnilingus could be said to be the 'myth of the vaginal orgasm' seven years *avant la lettre* (Anna Koedt's famous tract not being written until 1968).

Rochefort's next novel, *Les Stances à Sophie* (*Sophie's Stanzas,* 1963—the American translation of 1965 was crassly titled *Cats don't Care for Money*) was a disillusioned story of a marriage and a divorce. The strong note of protest is apparent in the opening paragraph: 'The thing about all of us poor girls is that we are never told anything. We land right in it without accurate information ... because we are ruled by our own unfortunate confusion, we show a weakness which addles our mind and throws us into contradictions if not into total imbecility.'

Rochefort was very active in the new feminist wave at the beginning of the next decade; we will hear more of her in Part Three.

Élise ou la vrai vie (*Elise or Real Life,* 1965) by Claire Etcherelli (b. 1934) is very different from any of the other books by women authors that I discuss. It begins with memories of the war and the German occupation, but then settles down in the working-class ambience of the Citroen factory in Paris, where many of the workers are North African—*bicots* (wogs) they are called by the racist French workers. It is at the height of the crisis in the Algerian War in 1957–8, and so the Algerians are constantly under threat of the brutal attentions of the police. Élise, an intelligent, self-taught woman of 28, works on the assembly line. Her brother Lucien is an activist in the anti-war movement. She is looking for 'real life' to begin. She forms an attachment to an Algerian worker a few years older than herself, Arezki. There is absolutely no overt sex in this novel, and as they meet and travel, and walk all over Paris, occasionally having tea in cafés, one is almost reminded of the pure love of the

English film *Brief Encounter*. There is nowhere they can go to be alone. Then Arezki begins to say that they must find a room together. After a while it is Élise who says this. Arezki does manage to secure a room in an Arab quarter of Paris. They are, rather shyly, alone together, when the police raid the place. Humiliatingly, and with tragic irony, they force Arezki to strip in front of Élise, making a vulgar comment when they finally whip off his underpants. Then they leave. It does become clear that the couple do make love, this being concentrated into the words of Élise, the discreet and modest narrator throughout: 'I knew the pleasure of giving pleasure.' Arezki is harassed by the police, and at one point arrested and briefly imprisoned. But now Élise finds a room and they have some idyllic moments, again only hinted at in the most discreet way. Lucien is injured in a demonstration, and when trying to escape from hospital is killed in a stupid traffic accident. Arezki disappears: imprisoned, dead? Élise does not know. She withdraws 'into a kind of burial', but, drawing upon her own reserves, she will survive. Attempts to make a film of this brave novel were discouraged by the Gaullist regime, but eventually, in 1970, *Élise ou la vraie vie*, directed by Michel Drach, appeared; it was a prize-winner at Cannes that same year.

Questioned about the directly autobiographical character of her novels, Marie Cardinal (b. 1929) somewhat disingenuously responded that 'All novels are autobiographical'.[11] *Les Mots pour le dire* (*The Words to Tell it with*, 1976), the story of the seven years during which she underwent psychoanalysis, is explicitly termed 'an autobiographical novel'. *La Clé sur la porte* (*The Key in the Door*, 1971) is not so described, but the narrator clearly is Cardinal herself, a 40-year-old mother living with her three children in an apartment in Paris, taking them to visit her husband in Canada each summer. The novel is about her relationship with her children, her attempt to give them as open an upbringing as possible, to which end she allows their friends to drift in and out of the flat, even residing there for considerable periods at a time, and about late-1960s youth culture. *La Clé sur la porte* became a film, directed by Yves Boisset, in 1978.

Two women novelists in Italy were already receiving critical acclaim before the beginning of the 1960s, while another one

had achieved international celebrity status by the end of that decade. Most Italian novels, like French ones, are short, almost no more than novellas. That is generally true of the novels of Natalia Ginzburg (1916–91), which have a delightful lightness and informality though often carrying painful memories of the Fascist and wartime years. Though born as Natalia Levy, in Palermo, Sicily, Ginzburg spent almost all of her first twenty-three years in Turin, where her father was a Professor of Anatomy at the university. She and her husband, the academic Leone Ginzburg, were strongly anti-Fascist, and were confined to internal exile in the malaria-infested village of Gagliano in the Abruzzi in the deep South. On the fall of Mussolini, Professor Ginzburg returned to Rome, but he was arrested by the Germans and in February 1944 tortured to death. In a long novel, *Tutti i nostri ieri* (*All our Yesterdays*, 1952; translated as *Dead Yesterdays*, 1956), Ginzburg discusses the impact of Fascism and war on two Italian upper-middle-class families. The human understanding, the lightness of touch amid tragic events, is perhaps best exemplified in a number of short quotations. As Italy enters the war and gas masks are issued against the threat of British air attacks:

Mammamia went down into the cellar to see if they could take refuge there in case of air raids . . . Mammamia was always sniffing the air and thinking she felt a strange smell, an asphyxiating smell.

At the fall of Mussolini:

Italy had had quite enough of Fascists with big muscular torsos and athletic processions and had a great longing for white-haired, mild old gentlemen with crooked, trembling knees.

The book ends:

. . . they were pleased to be together, the three of them, thinking of all those who were dead, and of the long war and the sorrow and noise and confusion, and of the long, difficult life which they saw in front of them now, full of all the things they did not know how to do.

Lessico famigliare (*Family Lexicon*, 1963; translated as *Family Sayings*, 1967) is about Ginzburg's own family, about her mother and father, and the three brothers and one sister all older than herself. Many of Italy's most famous intellectuals, all

friends of the family, including Carlo Levi and Cesare Pavese, appear in its pages. In her author's preface, Ginzburg writes: 'The places, events and people in this book are all real. I have invented nothing. Every time that I have found myself inventing something in accordance with my old habits as a novelist, I have felt impelled to destroy everything thus invented.' She explains that the names are real also, for she could not have endured having it otherwise. There are many omissions, because she is limited to her own perceptions as a growing girl. 'Although this book is founded on reality, I think it should be read as though it were a novel and, moreover, read without demanding of it either more or less than what a novel can offer.' Much of the essence of the book, perhaps most clearly expressed in the English title, consists of the sort of phrases that, coined accidentally by members of the family, become cherished by them. The stern father was always castigating what he referred to as 'Niggers'—crude, ill-educated people. Her mother was for ever saying: 'It is like the Dreyfus affair.' Her brother liked the children's ritual of reciting a children's phrase, in which the vowel was changed with each repetition. Thus what started out as 'Il baco del calo del malo' (the sign of the defeat of evil) ended up as 'Il buco del culo del mulo' (the hole of the arse of the mule). There is little about Ginzburg herself. Here is how the book refers to the death of her husband:

The Publisher [Giulio Einaudi] had a portrait of Leone on the wall in his room. It showed his head a little on one side, his spectacles low down on his thick mane of black hair, the deep dimples on his cheeks, and his feminine hands. Leone had died in prison, in the German wing of the prison Regina Coeli, during the German occupation, in an icy February.

The relationship between autobiography and literary creation has been touched on once or twice. What Ginzburg said about *Family Sayings* can be compared with her note on *Le voci della sera* (1961; *Voices in the Evening*, 1963):

The places and characters in this story are imaginary. The first are not found on any map, the others are not alive, nor have ever lived, in any part of the world.

 I am sorry to say this having loved them as though they were real.

This short novel, almost entirely in dialogue, presents the story of a young woman who gets engaged and then ends her engagement.

Elsa Morante (1918–85), author of novels that are immensely long, and densely poetical and psychological, has been regarded as the first European writer to dabble in 'magic realism'—a not very rigorously defined term that is sometimes applied to certain writings that appeared across several countries in the 1960s, and became more common in the 1980s, mixing fantasy and realism, and highly poetic in their use of language. The term was originally applied to Spanish American writing, which enjoyed something of a boom in the 1950s.[12]

Morante's title *Menzogna e Sortilegio* (*Lying and Witchcraft*, 1948; translated as *House of Liars*, 1951) certainly suggests some of the qualities of magic realism. However, the novel also incorporates the techniques of another kind of modernism—alienation, anti-illusionism, and directly addressing the reader. The first section of the 700-odd pages is headed 'Introduction to the History of my Family', and the first chapter begins: 'Before beginning to write my family chronicles it seems opportune to describe my home town, and to present my family as I rediscover it in my first memories of my childhood.' This search into the past is often darkly Gothic, but with descents into the deliberately mundane. We are in a world of invented stories, fantasies, and lies, where the characters' inability to cope with reality leads to suffering and mental breakdown. Practically at the end of the book we learn that the narrator, called Elisa, craved a cat, and was given one, though she was told that a cat was of no monetary value. This cat died of old age, and its successor was killed in an accident. Finally she got the cat that she now possesses as an adult, Alvaro. Then the book comes to an end:

At this point, oh reader, nothing remains but to say goodbye to you. But before taking leave of you, I must ask pardon for the lack of tact and discernment in my neglect right up to the end of the most loveable and important personage, I mean the Cat Alvaro. So here is, both in compensation and as a farewell, the

SONG FOR THE CAT ALVARO . . .

The next page-and-a-half are taken up with this poem. Self-indulgent? Perhaps. In this kind of novel the reader probably has to become complicit in the self-indulgence.

I would say this was also true for *L'isola di Arturo* (1957; *Arturo's Island*, 1959). There is magic in the very remoteness of the island. Arturo's father neglects him, going off to the mainland for long periods. Arturo is left with his father's young second wife. The novel is in the form of Arturo's recollections of all these things, as he progresses through adolescence; it is interspersed with poems. Arturo falls in love with the young wife, but has a sexual relationship with another young woman on the island; he is completely ruthlessly and logically aware that he is not in love with *her*, and seems the very prototype of the young man behaving badly.

Morante's most famous novel, which indeed went on to become the best-selling Italian novel of the century, was *La storia: Romanzo* (1974; *History: A Novel*, 1977). This is one of the truly great novels of the twentieth century; the title and the table of contents indicate its ambitious nature. The first chapter is entitled '. . . 19—' and consists of short historical summaries of world events from 1900 to 1940, leading into a fictional section that takes place in January 1941. We meet a German soldier who is in Rome, and the sad, sick, middle-aged schoolteacher, Ida, who is in fact Jewish by ancestry, a widow with a son, Nino. The soldier rapes Ida. The succeeding chapters have titles '. . . 1941', '. . . 1942', right through to '. . . 1947', with the last, very short, chapter, again being titled '. . . 19—': this is a summary of world events from 1948 to 1967, taking a very left-wing view and emphasizing the evils of America, of colonialism, of consumerism. Throughout there are brief historical summaries. If these are simplistic, this complex novel of war, of the inner world of the ill-favoured Ida, of Nino the partisan, of war's effects on people both ordinary and odd, of Ida's dreams and nightmares, of the aftermath of war, certainly is not. I suppose the label we have to reach for, in addition to that of magic realism, is that of 'postmodernism'.

Marguerite Duras (1914–96) achieved fame through her association with the *nouveau roman*, and still more for her screenplay for the film *Hiroshima mon amour* (*Hiroshima my*

Love, 1959). By the 1970s she was becoming a more overtly feminist writer, declaring in 1975:

I think 'feminine life' is an organic, translated writing . . . translated from blackness, from darkness. Women have been in darkness for centuries. They don't know themselves. Or only poorly. And when women write, they translate this darkness. Men don't translate. They begin from a theoretical platform that is already in place, already elaborated.

The novel *L'Amour* (1971) is usually taken as marking the change of emphasis in Duras's work. The openly declared lesbian writer Monique Wittig (b. 1935) wholeheartedly adopted the postmodernist notion, strongly advocated also by Julia Kristeva (b. 1941), that (transformed) language would be a powerful force for changing women's lives. Wittig's *Les Guérillères* (1969) is a typically postmodernist title, being a constructed word combining the words for both warriors and guerrillas. The text is certainly highly experimental, being set between two poems and including a number of visual symbols—circles, for example, symbolizing the female sex organ. It concerns young girls in a world of their own. It is openly didactic:

The women say, unhappy one, men have expelled you from the world of signs . . . They say, the language you speak is made up of signs that rightly speaking designate what men have appropriated. Whatever they have not laid hands on, whatever they have not pounced on like many-eyed birds of prey, does not appear in the language you speak.

Most famous of the French feminist novelists is Hélène Cixous (b. 1937), founder in 1974 of the Centre d'Études Féminines (Centre of Feminine Studies) at the new University of Paris campus at Vincennes, which she also directed. She was the inventor and leading exponent of what she called *écriture feminine* (feminine writing). As with the Wittig novel there is a punning double meaning in her title *Prénoms de personne* (*Personal Pronouns*, 1974). *Souffles* (*Breaths*, 1975) is about the mental and physical experiences of an anonymous female narrator who is never situated or described; there is a constant presence and mingling of masculine and feminine elements, and an almost Joycean manipulation of words. With regard to femininity, Cixous declared:

we have almost everything to write: about their sexuality, that is about the infinite and mobile complexity of their eroticization, about the dazzling ignitions of such a minute-immense region of their body, not about destiny, but about the adventure of such a drive, trips, crossings, progressions, sudden slow awakenings, discoveries of some formerly shy, now surging . . . write yourself, your body must be heard. Then the immense resources of the subconscious will spring out.[13]

The East German writer Christa Wolf (b. 1929) became part of the great controversies in Germany that I shall discuss in Chapter 8. During the 1960s her novels were popular in the West, but criticized in the East. The events of 1961, when the Berlin wall was erected, form the background to the story of a disintegrating relationship in *Der geteilte Himmel* (*The Divided Heaven,* 1963). *Nachdenken über Christa T.* (*The Quest for Christa T.*, 1968) is in the form of a biography of the fictional Christa T., a romantic outsider in East German society. There were genuine autobiographical elements in *A Model Childhood* (1976), a reconstruction of Wolf's own Nazi childhood, which seemed to question the official East German claim to have come to terms with the Nazi past.

In comparison, women writers in the British Isles seem very modest in their aims, though usually there is the same absence of modesty in dealing with sexual matters that we found in the American novels. The novels of Edna O'Brien (b. 1936) were, in fact, banned in her native Ireland. By the time of her third novel, O'Brien herself, like her main character Kait, had moved to London, the setting for most of her later works. *The Country Girls* (1960) seems totally innocent, and *The Lonely Girl* (1962; published in America, and in the Penguin paperback of 1964, as *The Girl with Green Eyes*) a little less so. The most striking aspect of the sexual preferences of Kait and her friend Baba, and one that did echo the way in which one aspect of sexual relationships was to develop in the permissive Sixties, is that they associate entirely with older men. The whole of the latter part of the second novel is taken up with Kait's first complete love affair, with a documentary film-maker called Eugene. The novel is utterly frank in making it clear that she is completely overwhelmed by him, completely helpless in his presence. But she is frightened of sex, and when she does lose her virginity (a

full account, incorporating what was still the novelty of a female record of female experience, by a female, with the inevitable foregrounding of male tumescence and detumescence), she does not like it very much: 'I felt no pleasure, just some strange satisfaction that I had done what I was born to do.' Although it makes her desperately miserable, she comes to see that parting from Eugene is inevitable. By the end of the novel she is sharing a bed-sittingroom in Bayswater, in West London, with Baba, and at night is studying English at London University (she is on the fringes of that young London that, though not classless, was characterized by a mixing of classes). *The Girl with Green Eyes* was made into a film with the central part being taken by Rita Tushingham.

The Pumpkin Eater by Penelope Mortimer (1918–99), about a woman with an uncontrollable urge to have babies, was also published in 1962; *My Friend says it's Bullet-Proof* (1967) was about a woman who had had a breast removed in a cancer operation. Margaret Drabble (b. 1939) wrote of the female experiences of young upper-middle-class females in *A Summer Bird Cage* (1964), *The Millstone* (1965), and *The Waterfall* (1969). The greatest stir was created by a work of non-fiction, *The Female Eunuch* (1970) by Australian-born Germaine Greer (b. 1939). Greer sought to shake her readers out of their illusions by warning them that they did not realize, as she put it, 'How much men hate women'. Much of the essence of her arguments and style come through in the statement: 'A woman should not continue to apologise and disguise herself, while accepting her male's pot-belly, wattles, bad breath, farting, stubble, baldness and other ugliness without complaint.' Greer recognized the very deep fear that existed among women over doing anything as drastic as abandoning their compulsive male-serving activities. Women must accept the existence of risk when they 'refuse to accept the polarity of masculine–feminine'.[14]

Along with such American publications as *Sexual Politics* by Kate Millett (b. 1934) and *The Dialectic of Sex: The Case for Feminist Revolution* by Shulamith Firestone (b. 1945), Greer's work heralded the advent of the new extreme feminism. This was accompanied, particularly in America, by novels of still

more extreme sexual explicitness, presenting men as dangerous, because of either the appeal of their sexuality, or their inherent viciousness, and advocating separatist existences (that is, separate from men) for women. Most notorious were the novels of Erica Jong (b. 1942), beginning with *Fear of Flying* (1972), whose British paperback publishers said it did 'for the novel what *The Female Eunuch* did for non-fiction', while novelist John Updike said it 'belongs to, and hilariously extends, the tradition of *Portnoy's Complaint*'. Critically acclaimed were those of Judith Rossner (b. 1935). We know from the police confession with which her *Looking for Mr Goodbar* (1975) starts that Theresa is going to be murdered by the guy she picks up in a singles bar, but this story of man's inhumanity to woman has an intense, suspenseful power throughout; it was an international bestseller and was turned into a film. A third author of bawdy novels of women's liberation was Lisa Alther, who published *Kinflicks* in 1976 and *Original Sins* in 1981. *The Women's Room* (1977) by Marilyn French (b. 1929) is, to quote the paperback blurb, the story of 'a wife of the Fifties who becomes a woman of the Seventies'.

The black civil-rights movement, going back to the 1950s, was in full flood long before the beginnings of the new feminism. Many articulate black women were contemptuous of what they saw as a white, middle-class movement. A special black protest, and a special feminism, are combined in the novels of Toni Morrison. Morrison was born Chloe Anthony Wofford in Lorain, Ohio, in 1931. Both her parents were from Southern families; her maternal grandparents were from Greenville and Birmingham, Alabama, and had moved first to Kentucky, where her grandfather had worked as a coalminer, before coming on to Lorain.[15] Her father had come to Ohio, taking a job as a shipyard worker in Lorain, to escape the racial violence of Georgia. In the 1930s Lorain was basically a steel mill town, population 30,000, with a small port on Lake Erie. Apart from a heavy enough job in the shipyards, her father, for seventeen years, took a couple of part-time jobs, so that he was able to send his daughter to the prestigious, though highly traditional, all-black Howard University in Washington. Because people there had difficulty with her name, she changed it to Toni. Discrimination

was obvious enough in Lorain, but there was no full-scale seg-
regation and no ghetto: it was while out on the road with the
touring theatrical group, the Howard University Players, that
Morrison came into direct contact with the vicious reality of
segregation in the South. A brilliant student, she was able to
profit from the absence of overt prejudice in Northern edu-
cational circles, and take an MA in English Literature at classy
Cornell University in New York State. She went back to teach
at Howard, and while there experimented with colleagues in
the production of a short story. Her basic idea came from the
memories of a little girl she had known back in Lorain who
had claimed she knew God didn't exist because she had
prayed for two years for blue eyes without any effect. Thus,
the book which eventually became *The Bluest Eye* got its
vague beginnings around 1961 or 1962. She married a young
black architect from Jamaica, and in the summer of 1964 went
to Europe with her husband and two sons. But she returned
without the husband, and so had to go back to her parents in
Lorain.

She got a job with an educational publisher in Syracuse, not
far, as it happened, from Cornell. Here, without ever having
thought of that as a possible career, she turned, because of lone-
liness and absence of anyone to converse with, to trying to turn
her short story idea into a novel. Very conscious of, but not
directly active in, the civil-rights movement, she believed that as
an editor of school textbooks she could use her position to
change the ways in which blacks were presented in them. In one
delightful indication of changing times, she had a white 'maid'
to look after her sons. She has described the impetus for getting
The Bluest Eye written as the desire 'to write a book about a kind
of person that was never in literature anywhere, never taken
seriously by anybody, all those peripheral little girls. So I
wanted to write a book that—if that child ever picked it up—
would look representational.' It was to be a book about 'the
whole business of what is physical beauty', a topic that was
actually very much at the centre of a whole new way of thinking
and behaving in the 1960s.[16] Such was the drive to follow the
ideas once they had formed themselves that, Morrison has said,
even if 'all the publishers had disappeared one night' she would

have continued until she produced a book she was satisfied with, and then would have xeroxed it and passed it around among her friends.

The Bluest Eye is set in Lorain, and she has commented: 'I was clearly pulling out of what autobiographical information I had', at the same time expressing what was obviously a strong emotion: 'I never felt like an American or an Ohion or even a Lorainite. I never felt like a citizen.'[17] The little girl that Morrison wanted to write about emerges in Pecola Breedlove, who has two little childhood friends, Claudia (who is the main narrator of the novel) and Freida MacTeer. The novel is modernistic in presenting different narrative standpoints, and it eventually becomes apparent that Claudia is telling her parts of the story retrospectively from the standpoint of adulthood. But, much more than this, the main narrative is counterpointed throughout by a simple children's reading book that tells the story of a happy white family. This was the kind of book, with its imagery of a little golden-haired girl with blue eyes, that was also presented to black children. After first being printed clearly and correctly, the extracts from the reading book become typographically confused and scrambled, to echo the confusion of black children as they find that this image of external white civilization does not coincide with their own reality. Pecola is raped by her own father, Cholly, and gives birth to her own father's child. There are no overt moral judgements, though the language is powerful and resonant. Pecola goes insane, but not, apparently, so much because of her traumatic experience but because of her persistent wish to have the bluest eyes. Nothing is overtly stated, but from the form as well as from the narrative it is clear that we are meant to understand that white society and what it has done to blacks is the source of the tragedy. Just apparent is the influence of such French intellectuals as Barthes and Althusser, particularly with reference to the invincibility allegedly given to white bourgeois power through its control of language.

The eponymous protagonist of *Sula* (1973) is another young black girl, but dynamic and individualistic. As a child her closest friend is Nell, but then Sula follows her own wayward and uncompromising path, which contrasts with Nell's opting for

conventional married life. Breakthrough to success came with *Song of Solomon* of 1977, which won two prestigious awards and sold very well.

History, Consumerism, and Magic Realism

Earlier I pinned the label 'magic realism' on Elsa Morante, and also mentioned her criticisms of consumerism. Many of the other novels of the later 1960s, whether foregrounding permissiveness or not, do show a preoccupation with consumerism; many have the modernistic quality for which magic realism is perhaps the best, if still imperfect description.

If, in Morante, we see hints of magic realism allied to historical analysis, that combination is presented in stunning array by the German, Günther Grass (b. 1927). At the heart of *Die Blechtrömmel* (1959; *The Tin Drum*, 1962) is the incredible creation, Oskar, fully mentally developed at birth, but who as a child makes a conscious decision to stop growing on reaching the height of three feet. He plays a tin drum and has a voice that can break glass. Through the picaresque adventures of Oskar we go on a satirical tour of the whole of German history from the beginning of the century, through the Nazi period, through the war, to the economic miracle (and consumerist excess). Here is Oskar, aged 19, in occupied Paris (Oskar's glass-shattering voice is a metaphor for German, and particularly Nazi, destructiveness):

In collaboration with other groups, we put on colossal programmes at the Salle Pleyel and at the Théâtre Sarah Bernhardt . . . No longer did I waste my vocal prowess on common German beer bottles; here, in the city of light, I shattered graceful, invaluable vases and fruit bowls, immaterial figments of blown glass, taken from French castles. My number was conceived along historical lines. I started in with glassware from the reign of Louis XIV, and continued, like history itself, with the reign of Louis XV. With revolutionary fervour I attacked the crockery of the unfortunate Louis XVI and his headless and heedless Marie Antoinette. Finally, after a sprinkling of Louis Philippe, I carried my battle to the vitreous fantasies of the Third Republic.

Of course the historical significance of my act was beyond the reach of the field-grey mass in the orchestra and galleries; they applauded my shards as common shards; but now and then there was a staff officer or

a newspaper man from the Reich who relished my historical acumen along with the damage.

The sexual descriptions in *The Tin Drum* broke one of the major taboos of the Adenauer era. Grass was represented in the press as a wicked Bohemian, while Hans Magnus Enzensberger, an attender at Gruppe 47 meetings, who published a volume of poetry *Verteidigung der Wölfe* (*Defence of the Wolves*) in 1957, was given the role of Germany's own angry young man.

This was an important moment in German literature. Heinrich Böll (1917–85), who had already published a couple of novels—'Soul-searching tales about the dehumanizing effects of the war'[18]—came out in the same year with *Billard um halb-zehn* (*Billiards at Half-Past Nine*, 1959). A younger man, Uwe Johnson (1934–84), who had fled from the East in order to be able to publish, joined in with *Mutmassungen uber Jakob* (*Speculations about Jacob*, also 1959). In the following year, there appeared *Halbzeit* (*Half-time*) by Martin Walser (b. 1927). While Grass continued to develop his modernist, magic realist, style, delving back to the early years of the century in *Cat and Mouse* (1961) and *Dog Years* (1963), and covering the whole history of male domination of female in *The Flounder* (1977), Böll concentrated on the moral weaknesses of post-war Germany, writing in a highly traditional way. *Der Clown* (*The Clown*, 1963) is the moving story of a professional comic, which along the way criticizes the politics of the Adenauer era and the collaboration of Church and State in suppressing the guilt of the Nazi past. *Group Portrait with Lady* appeared in 1971 and *The Lost Honour of Katharina Blum* in 1974; in between, in 1972, Böll became the first post-war German writer to win the Nobel Prize for Literature. These are novels stressing the crucial importance of the individual human conscience; *Katharina Blum* also attacks the irresponsibility of the press (the Axel Springer Press became notorious in the 1960s).

The first part of the title *Les Choses: Une histoire des années soixante* (*Things: A Story of the 1960s*, 1965) suggests some relevance to the question of the purchase of consumer goods; the second suggests a definite interest in the 1960s as a specific historical period. The author, Georges Perec, was born in Paris

in 1936, the son of Jewish immigrants from Poland: his father died in 1940, fighting in the French army, his mother in 1943, after being deported. It is clear that much of the success of the novel at the time depended upon its perceived sociological accuracy, a large swathe of upwardly mobile, middle-class young adults identifying with the characters and their milieu. As a literary artefact, it is a kind of friendly parody of Flaubert's *L'Éducation sentimentale*. Another governing influence was *Mythologies*, by Roland Barthes, published in 1958; Perec was to declare that the main idea of the book was to explore the way 'the language of advertising is reflected in us'.[19]

The question of memory, its nature, the 'tricks' it seems to play, became very much a preoccupation of intellectuals in the 1960s and can be seen as an important component of the postmodernist outlook. Giorgio Bassani (b. 1916) is generally considered the most important Italian protagonist of the novel of memory; he was also Jewish, and most of his novels concern the travails of the Jewish community in Ferrara. Most famous is *Il giardino dei Finzi-Contini* (1962; *The Garden of the Finzi-Contini*, 1965), the story of unrequited love between two Italian Jewish youths of different social backgrounds. The secluded life of the Finzi-Continis, an aristocratic Jewish family, is shattered by war and persecution; their walled garden becomes a symbol of lost innocence and the fragility of happiness.

Alberto Bevilacqua (b. 1934) was a poet as well as a novelist. His most famous novels, lyrical evocations of the city of Parma, belong to the 1960s: *Un città in amore* (*A City in Love*, 1962) and *La Califfa* (1964; *Califfa*, 1969). Califfa in the dialect of the Po Valley signifies a beautiful, aggressive young woman. This one 'crosses the bridge', as the author puts it, from humble origins to great riches.

The great modernist novelist of the 1950s, and more especially the 1960s, in Italy was Italo Calvino, and I shall return to him in Chapter 6 when I discuss the philosophical experimentation of the cultural revolution, and the way it spilled over into certain fictional works. I want now to focus on two authors who suddenly came to the fore in the 1960s, whose unique qualities dazzled the Italian literary scene, but for whom Italian literary critics have never been able to find adequate labels. Because

their work is in some way related to the Italian economic miracle, they are sometimes referred to as 'industrial' or 'commercial' novelists. But such terms are deeply inadequate, since both writers go far beyond the naturalism of the traditional novel. They are Lucio Mastronardi (1930–79)—his *Il calzolaio di Vigerano* (*The Shoemaker of Vigerano*) and *Il maestro di Vigerano* (*The Schoolmaster of Vigerano*) were both published in book form in 1962—and Luciano Bianciardi, whose *La vita agra* (*The Bitter Life*) was also published in 1962 (an American translation, *It's a Hard Life*, appeared in 1964). Some critics referred to Mastronardi's style as 'grotesque'. I would certainly term him 'modernist', while both he and Bianciardi are in some ways almost postmodernist. I am very tempted again to invoke the phrase 'magic realism', implying a dynamic inventiveness in expressing moral and social truths that goes far beyond realism. These books, at any rate, were highly original in form, yet what they wrote was palpably related to current social change.

One of my aims is, where the information is accessible, to try to bring out how individual creative works come to be produced and marketed. A most influential literary figure of the time, arbiter of taste and 'mediator' (as the cultural theorists would say), was Elio Vittorini. Towards the end of January 1956 Vittorini received a letter that included the following: 'I am a young man of twenty-five and from at least the age of ten have been interested in literature . . . Verga, Pirandello . . . Hemingway and Steinbeck, the Americans . . . For five years I have been writing and reading, reading and writing. Writers are born, but they also need to be developed, they say.'[20]

In letters, and in the occasional meeting, Vittorini encouraged the young Mastronardi to get down to writing a novel. What was to become *The Shoemaker of Vigerano* was begun in the winter of 1956–7. Vittorini, together with Calvino, was planning to bring out a new literary magazine, *Il menabò* (the Italian word for the dummy, or preliminary mock-up, produced by a printer or editor), which was launched in 1959. Vigerano, Mastronardi's home town, is a place of 50,000 inhabitants in Lombardy, on the borders between the rich agricultural lands of the Lombardy plains and the industrial areas developing around the city of Milan. Mastronardi was a primary school teacher there.

The helping hands Vittorini and Calvino were offering to Mastronardi became an almighty shove when, in the very first issue of *Il menabò*, they published the complete text of *The Shoemaker*, a short novel of about 132 pages. Mastronardi continued to work on *The Schoolmaster of Vigerano*. Like most of the Italian writers and film-makers of the time, he was Marxist in his basic assumptions about how societies operate and develop. The third-person narrative introduces 'Nicca', who comes from the town's oldest family of independent shoe-makers. The theme is of rapid industrialization and commercial expansion, and the desperation of almost everyone to share in this, at whatever cost to health, love, and private life. It was widely accepted that the 'economic miracle' Mastronardi was attacking was the economic miracle of the late 1950s, though in fact the novel is set in the period from Fascism through to the end of the Second World War. Mastronardi is presumably making the point that, as between the Fascist period and the 1950s, nothing had really changed. The improvement in Nicca's living standards is described with the heavy irony and crude comedy that are among Mastronardi's characteristics: 'he had soup made of the arses of four different animals, three not being enough, so that he also included the arse of a piglet; he washed in milk, and did the washing with soap; he took colour photographs . . .'.

The Schoolmaster is very firmly set in the contemporary period: towards the end of the book the narrator, the schoolmaster, is in a café where he selects *Volare* on the jukebox: 'the voice of Modugno expanded into the air.' The book is in a kind of diary format, though without any precise dates; documents and mathematical symbols are inserted into the text in postmodernist style. Ashamed of the lethargy at his school, the narrator is bitten with enthusiasm for the economic miracle all around him. He lets his colleagues know that he intends to leave to become an industrialist. However, the only way he can get a job is by taking one in the factory owned by his wife's brother. His wife is unfaithful to him, and he beats her to death with a hammer; but, surrealistically, no consequences follow from this act of murder. The novel ends with the narrator contemplating a marriage that will bring him a substantial sum of money.

Mastronardi completed a trilogy with *Il meridionale di Viger-ano* (*The Southerner of Vigerano*, 1964). The complete trilogy was unusual, but part of a movement just then developing in Italy, in that the characters express themselves in local dialect, exactly as they would if meeting each other in the street (the pocket edition containing the entire trilogy has a glossary extending to eight closely printed double-column pages). Each volume sold about 30,000 copies, and *The Schoolmaster* was turned into a film directed by Elio Petri and starring the popular idol Alberto Sordi and the distinguished English actress Claire Bloom. None of the books has been translated into English.

Bianciardi's *La vita agra* is an extremely funny novel, and had a considerable popular success. The opening pages make the mode of writing very clear. The author says he is combining a 'linguistic mélange', which, it turns out, includes not so much dialectics from different parts of Italy, but dialects from differ-ent eras in Italian history, and a traditional novel. The novel, in fact, is very loosely constructed, consisting of episodes from the author's life and various external events. There are references to the economic miracle and to the Common Market. However, the narrator visualizes the end of the modern civilization of con-sumerism, with the latter being replaced by sex: 'The only need would be that of coupling, of discovering the hundred and seventy-five possibilities of connecting up a man and a woman, and inventing a few more.' There are lavatorial as well as sex jokes. While the novels of Alberto Moravia had over decades been well known for bringing in illicit sex, this was never described in any detail: the vulgar, hilarious, disrespectful treatment of sex by Mastronardi and Bianciardi was completely new, something that can be quite positively identified with changes in the wider society.

Goffredo Parise (1929–86) was brought up in extreme poverty, though he was able to get a sound education after his mother married a journalist. He had some success with naturalistic works in the 1950s, and he associated with such film-makers as Rossellini and Fellini: he wrote one episode for *Boccaccio '70* and collaborated on *8½*. *Il Padrone* (*The Boss*, 1965) is a parable, akin to *The Schoolmaster of Vigerano* and *It's a Hard Life*. Nevertheless, it won the Viareggio prize, and

enjoyed considerable commercial success. Vast sections of the book are in the form of long dialogues of a quasi-philosophical character, putting one in mind of the theatrical tradition of Pirandello and Dario Fo. The enterprise in which the young narrator (who remains anonymous throughout) gets a job is a most peculiar one, run by the strange Doctor Satturno, and his son, 'Doctor Max'. He decides that he must find another job, but, since his bosses also own all other suitable enterprises, his prospects are not great. Dr Satturno's wife wants him to marry her ward, a girl suffering from Down's syndrome. He agrees, his hope being that his son will not be like himself, a man with some glimmerings of reason, but happy like his mother in the pure attitude of existing. This is perhaps a structuralist novel, an expression of revulsion against modern society in general. Parise himself spoke of the mode being 'non-naturalistic' and of 'a total absence of the individual psychology (though not the feelings) of the characters'.[21]

Of all the novelists discussed in this section, Leonardo Sciascia (b. 1921 in Sicily) achieved the greatest all-round fame. Moving away from the Communist Party, to join the Radical Party, he became both an Italian and a Euro MP. His series of four detective novels with a difference continued to be bestsellers into the twenty-first century, and have had a strong influence on a number of younger Italian authors. The series consists of *Il Giorno della civetta* (*The Day of the Owl*, 1961), *A ciascuno il suo* (*To Each his Own*, 1966—but rendered in the American translation of 1968 as *A Man's Share*), *Il contesto* (*The Context*, 1971), and *Todo modo* (1974; *One Way or Another*, 1989). All of these 'detective stories' concern the corruption of Sicilian life and the central role of the Mafia in business and politics; in none of them is a murderer ever brought to justice. Sciascia has made it clear that he used this genre in order to grab the attention of the reader; the opening of chapter 7 of *A ciascuno il suo* contains a disquisition on the unreality of the conventional detective story in which everything is neatly solved. In this novel, a pharmacist and his friend, Dr Roscio, are gunned down on the first day of the hunting season. The local secondary school teacher, Laurana, a dull pedant and timid bachelor, decides to play private detective. He discovers that the real target was Dr Roscio, who

had been involved in a web of political and business corruption. Laurana is himself bumped off; the wicked continue to prosper.

The most obtrusive memorials of the Cultural Revolution are the rock music, the pop art, the new wave films, the poetry readings and happenings (carefully preserved on film), the ugly uncomfortable buildings, and the treatises of the structuralist philosophers. But for insights into the changes in behaviour, in attitudes, in manners, and in morals, there are few better sources than the novels we have been studying in this chapter.

5 The Rock Revolution and the Influence of Youth

Rock Music

When we speak of the influence of youth on popular culture, and, to a significant but lesser extent, on high culture, we have in mind several different age groups. Those producing some of the most innovative cultural artefacts were notably younger than their predecessors in the post-war, and earlier, periods had been—broadly, they fall into the category of 'under-thirties' (a popular counter-cultural slogan was 'Don't trust anyone over 30'). However, the most potent new market for cultural arte-facts, in particular rock music, was that provided by 'teenagers', though sometimes this term was stretched to include those not yet married and/or those in tertiary education. At the same time, young married couples, and particularly young married women, were important contributors to the greatly accelerating consumerism of the 1960s.

In these days, when it can be seen quite clearly that there is absolutely no possibility of revolution on the Marxist model, the word 'revolution' gets applied to all sorts of other aspects of life. I don't think there is much point in protesting about this. Anyway, the term 'rock revolution' does seem particularly thor-oughly justified. Any comparison of the popular music of the 1940s and 1950s with that of the late 1950s onwards will make the point. Just about everything that was so awful about the older popular music is summed up in the tedious tune and excruciating refrain of: 'Love and marriage go together like a horse and carriage.' Rock was easier to play, and required fewer performers, than sophisticated big-band swing. It opened the way to relatively poorly educated young people coming into the business and having at least their fifteen minutes of local fame (Andy Warhol's famous phrase was that *everyone* would have their fifteen minutes: not true by a long chalk, but nonetheless

reflective of one aspect of 1960s culture), or, in some cases, make a lot of serious money. Rock, listened to on portable transistor radios (when the family was watching television), became at first a secret language of the young, detested by their elders. But in the 1960s there was no conflict of generations: many older people liked the ease and informality of dancing to rock music.[1] That same dancing, many have attested, played its part in the sexual, and general, liberation of younger women. The advent of rock meant a lasting revolution in popular music, and contributed to transformations elsewhere in society. Young rock musicians mostly composed their own music and wrote their own words: the great days of the composer and song-writer were coming to an end. Rock brought an intensely participatory element, first in the small dance venues, then later in the mass pop concerts. Rock's main medium of transmission was the 45 rpm record, played at home, listened to on the radio, or enjoyed at a disco. In deciding which records to buy, teenagers exercised choice as never before.

Tennessee born-and-bred former truck driver Elvis Presley (1935–77) was the key figure, young, beautiful, and sexy, succeeding the famous early protagonists of rock 'n' roll, Bill Haley and the Comets, who were not only old, but looked it. There has been much argument about 'authenticity', about the white 'purloining' of black music, and so forth. What needs to be stressed above all is that the new music was a product of exchange, of mixing of traditions, of very new influences acting upon quite old practices. In its own forms, the new music sought avidly by white teenagers (though not by them alone) was more authentic, more open, more honest, than the white popular music it began to supplant. In all cases, certain key elements lie in black America. But the popular music that had dominated the twentieth century so far had been very much a white-contrived exploitation of what were indisputably black origins. Rock 'n' roll was definitely black music. Bill Haley's 'Shake, Rattle and Roll' had been written by black musician Joe Turner. 'Hound Dog', the song with which Elvis Presley made his breakthrough in 1956, had been released three years earlier by the black singer Willie Mae Thornton. But a whole vital dimension of the critical changes taking place is missed if it is not realized that, for

example, Presley also brought the authentic tradition of white country music, not to mention a conviction and attack of his own, to his performances and recordings. The TV programme *American Bandstand*, broadcast nationwide by the ABC TV Company on Saturday mornings from 1957 onwards and bringing the full range of musical styles to over twenty million viewers, was an important transmission agent. Historically, it is absolutely true that it needed white performers to secure white listeners for music that had its origins with such black performers as Chuck Berry, Fats Domino, Little Richard, and Bo Diddley.[2]

Rock 'n' roll gave way to less monolithic, more sophisticated rock music (or 'beat'—the term was short lived, but featured in the name of the leading British group, the Beatles). The British product was at first openly imitative of the American, but then did, within its largely working-class ambience, develop a distinctive character of its own. Perceptions and, therefore, to a considerable extent realities of class do not coincide with the rules laid down by Marx, or even Weber. To those definitely outside the working class—that is, those in the middle class and above—the Beatles quite definitely seemed working class. In background, George Harrison (b. 1943) and Ringo Starr (b. 1940) very definitely were, Paul McCartney (b. 1942) was in the upper fringes, and John Lennon (1940–80) in the lower middle class.[3] All had accents and manners that placed them firmly among the popular classes, as against the élite classes earlier responsible for so much of the production of popular culture. In 1960 Lennon and McCartney, together with George Harrison and Pete Best, had formed the Silver Beatles to play in such Liverpool clubs as the Cavern and Jacaranda, where they began to evolve a personal style, partly imposed by the line-up of three guitars and drums. During a visit to Hamburg (venue for a number of British bands) the group were persuaded by their German impresario to introduce an element of dramatic performance into their show; they also adopted mop-top hair cuts and collarless suits. At the beginning of the 1960s the Beatles, as they were now calling themselves, were the most popular and successful group within the Liverpool beat scene, but scarcely known elsewhere in Britain (there were no local radio companies

to broadcast them, no local record companies to record them). Thoroughly deserved but utterly unpredictable good fortune arrived in the form of the 27-year-old gay Jewish manager of the local record shop in his father's chain, Brian Epstein. Epstein put himself forward as manager for the group. He had a clear conception of how best to project their talents; more, as a big seller of records, he was someone the record companies felt bound to listen to. Even so, five record companies turned the Beatles down before Epstein persuaded the Parlophone subsidiary of EMI, where staff man George Martin recognized the genuine musical skills of the group, to take them on. Part of the group's following was due to the sexy good looks of drummer Pete Best. But Best was replaced by the brilliant but less well-favoured Ringo Starr before 'Love Me Do' was recorded and released in October 1962. It was a hit in the sense of making the lower reaches of the top twenty. 'Please, Please Me', which followed, reached second place. Epstein was then able to persuade EMI to take on several of the other south Lancashire groups he now represented: the 'Mersey sound' had arrived. By this time, all records aimed at the mass market were subject to the wonders of double and multiple-track recording. The Beatles brought with them the directness of their live performances.

By late 1963 the phenomenon of 'Beatlemania' was firmly established in Britain. When 'I Want to Hold your Hand' was released in the States on 26 December, Capitol put a full-strength publicity campaign behind it. The LP *Meet The Beatles!* was issued on 20 January 1964, and a re-release of 'Please, Please Me' ten days later. In 1964 the Beatles were involved in the making of their first film; in 1965 they gave up touring and live performances. From 1966, in an indispensable alliance with George Martin, they made increasingly complex recordings dependent on the most sophisticated studio resources. A Beatles' song was always instantly recognizable, yet the variety of styles they essayed seemed almost endless. Of three 1965 hits, 'Help!' was fairly reminiscent of the earlier Beatles, 'Ticket to Ride' was psychologically deeper than anything they had yet recorded and, with respect to 'sheer sound . . . extraordinary for its time—massive with chiming electric guitars, weighty rhythm, and rumbling floor tom-toms', while

'Yesterday' has been described by Charlie Gillett as 'a tritely sentimental ballad'—a judgement that must be balanced against the fact that classical composer Peter Maxwell Davies thought highly enough of it to arrange it as a guitar solo.[4] It is in part because of their very variousness that the Beatles have so often been spoken of as the voice of the age—while the Americans Bob Dylan and Joan Baez were much more closely identified with the civil-rights and student-protest movements. With Beatles songs, direct links between lyrics and current events are not easy to find. In general, it was a case of music and lyrics together constructing—constantly changing—moods that apparently never failed to evoke responses in large numbers of listeners of the day. The song that most directly expressed the new class-defying tide of individualistic enterprise in Britain is 'Paperback Writer' (released in America on 13 May 1966 and in the UK on 10 June), whose lyric alludes to current trend-setting writers, film stars, and fashion designers. The Beatles had a marihuana period and an LSD and psychedelic period. The effects of pot-smoking were apparent in 'Paperback Writer', in 'If I Needed Someone', which was also strongly influenced by George Harrison's interest in Indian music, and, most notably, in 'The Word'. The LSD period coincided with a series of increasingly complex singles—notably 'Strawberry Fields Forever' and 'Penny Lane', released, in one of the great bargains of all time, on opposite sides of the same record, in February 1967—and the great LPs, above all *Sergeant Pepper's Lonely Hearts Club Band* (1967). A 'dramatic cycle' rather than 'simply a chain of songs',[5] it uses a full symphony orchestra, draws upon Indian influences, and in its totality is an expression of drug-expanded consciousness. Further LPs followed, and also one of the most memorable of all singles, 'Hey Jude' (1968).

The only real rivals to the Beatles were the Rolling Stones. When this group was founded, its lead singer, Mick Jagger (b. 1943), was a student at the London School of Economics, and two other members were at the Sidcup Art School. In order to distinguish them from the endearing Beatles, their manager Andrew Oldham encouraged them to project a wild and anti-social image. Oldham took them to America to record, and both their first British number one, 'It's All Over Now', and their

first American top-ten hit, 'Time Is On My Side', were recorded in Chicago. Their most powerful records, from 1965 onwards, were made in the RCA studio in Hollywood: 'Satisfaction', 'Paint It Black', 'Honkytonk Woman'. Importantly, the Rolling Stones, like the Beatles, had stamina; the latter lasted till 1970, the former apparently forever. At one time the Animals, with lead singer Eric Burdon, looked like challengers, but the group began to fall apart in 1966. The Who aimed at a wilder image similar to that of the Rolling Stones. With their guitarist and song-writer Pete Townshend, they, along with the Kinks, with singer and song-writer Ray Davies, specialized in explicit comment on the contemporary scene. An interesting insight into the strength of the British position in pop music is given by the way in which two Americans, P. J. Proby and Jimi Hendrix, came to be presented as essentially British stars. Hendrix, a black born in Seattle in 1942, was talent-spotted in Greenwich Village by Chas Chandler, bass player with the Animals, who recruited him to London, and managed him in a partnership with the Animals' manager Mike Jeffreys. Hendrix was a brilliant guitarist, singing songs that seemed closely related to the protests of the time. He made his name in Britain (where, with two white musicians, he formed the Jimi Hendrix Experience). He died of a drugs overdose in 1970. Proby was the embodiment of the aggressive rock soloist, crowning his act by bursting out of his tight-fitting trousers.

At the age of 13, blind black prodigy Stevie Wonder (b. 1950) had topped the American charts playing harmonica and singing the jazz soul song 'Fingertips Part Two'. His 'Uptight' (1965) and his version of Bob Dylan's anti-war song 'Blowin' in the Wind' (1966) were hits in the UK as well the USA. With Hendrix, he stands out as a classic exponent of the multiculturalism inherent in rock/pop, his 'A Place in the Sun' (1966) being influenced by the Beatles as well as by Dylan.

The most remarkable sign of direct British influence in rock/pop music was the deliberate creation in the United States of the Monkees, designed to project the fetching, playful qualities associated with the Beatles—not that this prevented them from producing one of the most memorable hits of the later 1960s,

'I'm a Believer'. But if we can talk of an American dominance in the 1950s and a British pre-eminence through most of the high 1960s, we have to recognize also a whole new wave of innovative American groups from California, and particularly the Bay Area, in the later 1960s, groups to which the Beatles, in their eclectic way, were instantly responsive, and which also had a strong influence on the Rolling Stones. One of the main bastions of American resistance to conquest by the Beatles, prior to the fabrication of the Monkees, had been the Beach Boys (founded in 1961), who extolled the semi-drop-out lifestyle of the south California beaches. In the later 1960s, bands deliberately at odds with the slick presentation of conventional rock/pop radio openly smoked grass while producing the music proudly related to the local hippie scene in the Haight-Ashbury district of San Francisco: the Grateful Dead (lead singer Jerry Garcia), Jefferson Airplane, Mother Earth, and Big Brother and the Holding Company, featuring Janis Joplin.

In France and Italy during the 1950s American influences on popular music and popular culture had generally been noteworthy; British ones were practically non-existent. But it is the British groups that are most praised in the youth magazines. The only performers to hold out against foreign influences in France were Johnny Halliday (in fact born in Belgium) and Sylvie Vartan (in fact born in Hungary); in Italy there was Domenico Modugno, whose style was essentially pre-rock, and who had had an astonishing worldwide hit in 1958, 'Volare', Bobby Solo, whose style was heavily sentimental, and the deliberately wild and violent Adriano Celentano. The American influence continued to be strong in West Germany, where rock music began to have a distinctive effect in the general liberation of young women, and then in the student protest movements. An event of immense importance in both the history of rock and the history of the German extraparliamentary protest movement was the *Internationalen Essener Song Tage* (International Song Day at Essen) in September 1968.

Big-band ballads were blasted nearly into oblivion; old-style musicals took heavy blows. Rodgers and Hammerstein had one more hit with *The Sound of Music* (1959) based on Maria Augusta Trapp's memoir, *The Trapp Family*: governess

befriends children of autocratic Austrian, father falls for her, and all escape from the Nazis. *Fiddler on the Roof* (1964) was, according to leading authority Gerald Bordman, the 'last of the great masterworks of the era'.[6] However, one stunningly original new talent had emerged, greatly admired by many classical music lovers, Stephen Sondheim (b. 1930), whose first hit was the musical *A Funny Thing Happened on the Way to the Forum* (1962). By the end of the decade a new genre of rock musicals had become established, such as *Tommy* (1969), by Pete Townshend and the Who, and, above all, *Hair*, which originated in 1967 as the New York fringe show *American Tribal Love-Rock Musical*. *Hair* is the great symbol of the power of youth, and of a burgeoning multiculturalism—in one number black girls sing the praises of white boys, while white boys sing the praises of black girls. An equally potent symbol was *Jesus Christ Superstar*, a paradigmatic example of the way the music, on record, now came first, the stage show very much second. Andrew Lloyd Webber (musician, b. 1948) and Tim Rice (lyric-writer, b. 1944), both British, were in their twenties when in October 1969, with Murray Head and the Grease Band, they produced the rock single, 'Superstar'. Success in America, following failure in Britain, led to the LP, *Jesus Christ Superstar* (June 1970), designated a 'rock opera' by Decca. The LP, flopping in Britain, popular in the USA, led to the stage show, masterminded by Tom O'Horgan, who had directed *Hair*, opening on Broadway on 12 October 1971.[7]

Films

In French cinema there was *la nouvelle vague*; in Italian, *La dolce vita* and the other modernist films of Fellini and of Antonioni; in British, the British New Wave; in German, the beginnings of a new experimentalism. And America? First, mirroring general changes in attitudes, a new frankness and explicitness, along with a loosening up of presentational techniques; later, manifest borrowings from European art films. Few Hollywood films of the 1960s were of outstanding quality on an international scale, but almost all are instantly recognizable for a particular, slightly mannered stylishness, usually apparent at once in the opening

credits (not utterly unrelated to developments in 'alternative' or 'underground' graphics), well illustrated in the divided-screen technique used at the beginning of *The Thomas Crown Affair* (Norman Jewison), and for a quality of sheer enjoyability. There were no biblical epics and, as suggested above, not too many musicals, though Robert Wise's film version of *The Sound of Music* (1965) was the most commercially successful film of the decade. Villains were often given great allure, and sometimes came out on top (Steve McQueen as Thomas Crown); there were heist films whose outcomes were villains coming off best or colossal cock-ups; there were comedy Westerns; much humour, much down-to-earth cynicism. Throughout, without any risk of overstatement and in a very relaxed way, movies bore evidence of the society changing around them. Both love and violence became more realistic. Blacks began to appear in key roles; other ethnic minorities were treated with a new sensitivity; women got more assertive parts; films aimed at independent, self-aware youth began to appear, sometimes with explicit references to counter-cultural developments.

In Britain from the late 1950s, John Trevelyan administered the British film censorship in a manner thoroughly sensitive to the changing standards of society outside. In America, somewhat later in the day, the equivalent figure was Jack Valenti, a former special assistant to President Johnson, who in 1966 became head of the Motion Picture Association of America, the organization responsible for the censorship system. As a result of his efforts, the code was replaced in 1968 by a rating system, analogous to that operating in Britain and other European countries. As amended, the 1968 ratings (since altered many times) were: G for general audience; PG for parental guidance; R for restricted, persons under 16 years being admitted only with an adult; and X for no one under 16 being admitted. Censorship could still hit hard in France and Italy, where the Catholic Church attempted to maintain its iron grip. Notoriously, *La Religieuse* (*The Nun*, Jacques Rivette, 1965) was banned for its 'blasphemous' approach. In both countries the events of 1968 forced on the authorities a thorough reappraisal of all their most basic instincts: there was a collapse in almost all surviving censorship.

Returning to the topic of the influence of youth, taken this time to signify those under 30, we should note that the leading protagonists in the *nouvelle vague* qualify, and that the term itself was actually originally coined in 1958 by Françoise Giroud, editor of that great barometer of progressive middle-class opinion, *L'Express*, for what she perceived as a new, *youthful* spirit pervading France. What the leading protagonists in the *nouvelle vague* as cinematic movement also had in common was a theory, or theories, about how a film should be made, or, to put it better, they shared in that reflexiveness that was a characteristic of 1960s thought and aesthetics. In addition, some 'new-wave' films were touched by the sexual explicitness I have already discussed, and also by the structuralist and *nouveau roman* ideas that I discuss in the next chapter. The 'new wave', in full flood, appeared in two very different manifestations, Truffaut's *Les Quatre Cent Coups* (*The 400 Blows*) and Resnais's *Hiroshima, mon amour* (*Hiroshima, My Love*) in 1959, and was ebbing by 1963. Over a longer period, one can break the wave into three distinctive wavelets. First, we have what I shall call the 'fundamentalists', whose origins lie in film criticism. At their core was a group of young critics writing in the 1950s for the newly founded *Cahiers du Cinéma*, François Truffaut (b. 1932), who was the most vociferous, Jean-Luc Godard and Claude Chabrol (both b. 1930), Jacques Rivette (b. 1928), and also Eric Rohmer (b. 1924). They analysed the work of certain Hollywood directors whom they admired; they criticized French films of the time for being too dependent on literary sources and for failing to achieve a distinctive filmic language; in their famous advocacy of a *politique des auteurs* (rather inadequately translated into English as '*auteur* theory'), they were claiming that a film director must be an 'auteur' ('author'), controlling every aspect of the making of a film, being a single directing creative spirit. This *could* mean that a film could become a very personal, private odyssey, autobiographical or an expression (rather in the manner of Jackson Pollock) of the director's subconscious. The move (I almost said 'retreat') from the universal to the highly personal is a strong feature of some modern and postmodern art, and can come over as a weird, perverted version of the romantic notion of the independent genius.

Secondly, we have the 'structuralists', linking laterally to structuralist writing and the *nouveau roman*, and flatly contradicting '*auteur* theory' in having highly verbal screenplays written by *nouveau roman* writers (interestingly, though, the *nouveau roman* writers subsequently went on to direct their own films). Thirdly, we have what I am going to call the 'proto-*nouvelle vague*' films, which as films, as distinct from criticism or theory, actually appeared first, and without the obsessive fundamentalism exhibited particularly by Truffaut and Godard. I start with them.[8]

Et Dieu créa la femme (*And God Created Woman*, 1956) is really pre-*nouvelle vague* rather than proto. It certainly combines the youth and sex themes, being directed by a new 28-year-old director, Roger Vadim (b. 1928), and presenting for the first time a new star, Brigitte Bardot (b. 1934), whose whole function in the film was to project an image of contemporary, available, teenage sexuality. This film also alerted production companies in the ailing French film industry that a young director could make lots of money. A year later, another young director, Louis Malle (b. 1932), came out with a thriller *Ascenseur pour l'échafaud* (*Lift to the Scaffold*, 1957), which was imaginative though not especially successful. But his *Les Amants* (*The Lovers*, 1958), taking still further the opening to sexual frankness, certainly was: Jeanne Moreau (b. 1928), another newcomer who achieved immediate international stardom, plays a society woman who acts out the roles of a variety of uninhibited female characters. Meantime Chabrol had made *Le Beau Serge* (*Handsome Serge*, 1958), which made him so much money that he was able to set up his own production company. Some critics regard this as the first new-wave film, though it probably relates more closely to Chabrol's own aesthetic trajectory as revealed in his later films dedicated to the particularities of rural France. *Handsome Serge*, about a young student in the provinces attempting to redeem a childhood friend, now an alcoholic, at the cost of his own health, is meticulously and lovingly photographed. In so far as these three directors chose to set their own daring subjects and then implement them, they are *auteurs*.

Truffaut, as a teenager a delinquent film fanatic who dropped

out of school at 13, was the most abusive in his criticisms of current French cinema. *The 400 Blows* had no straight narrative line, and used moving camera shots and long takes to create an open fluidity; it is a cinema fanatic's account of his own life. The young boy in the film (played by Jean-Pierre Léaud) is imprisoned in a centre for delinquent minors for stealing a typewriter. He escapes, and sets out with a determination to see the sea. The film concerns his encounters with the harsh adult world; he reaches the sea and the film concludes with a freeze frame of his face. Although an *auteur*, Truffaut did not do his own camerawork: like Godard, he tended to use either Henri Dacaë or Raoul Coutard, whose work contributes much to what is most distinctive about certain *nouvelle vague* films.

For his next two, and most highly acclaimed films, *Tirez sur le pianist* (*Shoot the Pianist*, 1960) and *Jules et Jim* (*Jules and Jim*, 1962), Truffaut employed Coutard, who had been cameraman on Godard's *A Bout de Souffle* (*Out of Breath*, but always translated as *Breathless*, 1960); in basing both films on novels, he seems to be breaking his own rules, but in the first he was certainly being true to his fascination with Hollywood gangster films in using a thriller by David Goodis. He worked both with and against the flowing camerawork, with extensive use of voice-overs, deliberately breaking the illusionism of traditional film narrative: in *Shoot the Pianist* (*Shoot the Piano-Player* in American English), we hear the character's innermost thoughts; in *Jules and Jim* there is a monologue telling us the basic story. 'These uses of language', according to Robert Sklar, 'gave the films a contemplative atmosphere, lulling and distancing the spectator into a false sense of ease just as the narratives turn toward violent action'.

This capacity for incongruous juxtaposition was a hallmark of Truffaut's style. *Shoot the Piano Player* has bumbling criminals and corny jokes. A crook is telling a tall tale about his scarf being made of metal and says, 'I swear on my old lady's head. May she die if I lied.' Immediately there is a shot of a woman keeling over (unusually shaped as an oval iris to give it the look of a silent comedy gag). Yet our laughter at this comic death is undercut by knowledge of senseless deaths that have occurred in the narrative, and the possibility of the crook's murderous intent.[9]

Jules and Jim are rivals for Catherine (Jeanne Moreau). Enthusiasts, of whom there were many, admired the film for its charm, psychological realism, poetic dialogue and literary allusions, accurate portrayal of bourgeois customs, and emotional power—Catherine dies at the end, as indeed does Lena in *Shoot the Pianist*. *Jules and Jim* seems to incorporate much of the literary quality that Truffaut had previously attacked: still, these two films *are* very different from mainstream French films of the 1950s—they are also very French.

In Godard's *A Bout de Souffle*, the male star, Jean-Paul Belmondo, at 27, was not especially young, but, as a new fashionably ugly figure, he became a hero to young people, rather as James Dean, had done earlier in America, Jean Seberg was 22: together they played a couple of young people searching for authentic roles in life. In keeping both with current philosophical ideas about the importance of texts and 'intertextuality', and the fascination of what were held to be *auteur*-directed films, there were open references to American *films noirs*. Belmondo imitates the mannerisms of Humphrey Bogart. The film's most obvious technical device was that of the jump cut—a sharp break in continuity running against all the traditions of smooth editing, leaving a (sometimes puzzling) gap in time. Belmondo is a petty criminal, who, in the perfect arbitrary existentialist crime, murders a policeman. Like pop art and *nouveau réalisme*, the film referred absolutely to contemporary, consumerist society. Like the *nouveau roman* (discussed in Chapter 6), it had no obvious narrative line. If you find yourself in tune with *A Bout de Souffle*, Godard creates mood and meaning purely by filmic means. If you don't, then, like so many works of art produced partly to exemplify a theory and partly to fulfil the personal visions of the creator, it can be a bore. The fact that the screenplay was by Truffaut is less a qualification upon Godard's claim to be an *auteur* than an affirmation of the close bond between the core protagonists of new-wave ideas. In this same year Godard's *Le Petit Soldat* (*The Little Soldier*, 1960) was among ten other films banned by the French authorities, in this case because Godard showed the French using torture against prisoners in the Algerian War. The ban was

lifted in 1963, by which time de Gaulle had brought the war to a close, granting independence to Algeria.

The 400 Blows has a separate importance in connection with both state support and commercial profit taking. It was one of the first films to benefit from a new government scheme offering young film-makers interest-free loans, but then enjoyed enormous commercial success, largely because of its appeal to the new young audiences. Its very commercial success made production companies (for a time) eager to invest in *nouvelle-vague* films. A kind of mid-1960s climax to Godard's new-wave style can be seen in *Pierrot le fou* (*Crazy Pierrot*, 1965). Ferdinand (Belmondo), having by chance met one of his former girlfriends, Marianne (Anna Karina), leaves his family, drives southwards with her, and settles on a small island. Such a summary, says French historian, Pierre Sorlin, is 'useless':

The audiences are shown some aspects of the French countryside . . . But these pictures are displayed lazily as if they were the pages of a Tourist Brochure. There is often no contrast or complementarity between the frames, whose junctions seem to be made at random. . . . The fiction is constantly interrupted by images which slow down the rhythm of the story. Some of these images are perfectly external to the plot. For example, at the outset we see two women playing tennis; we will not see them again, and nobody will play tennis in the rest of the movie. Other pictures are mere repetitions of what has already been screened. . . .

Finally, there are a lot of flash shots—posters, drawings, paintings, advertisements, comics—introduced in the middle of many scenes.

Sorlin notes that all this is part of the efforts of new-wave directors to remind audiences that they are looking at an artificial work not life, but Godard's aim is wider than this:

an attempt was made to enlarge the film and make the spectator's mind slip from the story to developments which were not included in the plot but which could have been developed as well as the central story. Instead of preventing viewers from trying various readings, which would have been achieved by focusing their attention on the details directly linked to the plot, *Pierrot le fou* seldom induced the audience to concentrate upon an object or an action. Spectators were allowed to let their attention linger on small details, and the film helped them to follow the story in a casual way by suggesting that the story could be

different, that there were many manners of going out of a building, that any scene could be understood as a part of either a love story, or a gangster film, or a comic-strip and so on.[10]

Now for the 'structuralists'. Alain Resnais (b. 1922) was an older figure, who had up to now been a documentary-maker, using long tracking shots and tight close-ups. This was the style he brought to *Hiroshima, mon amour* (script by *nouveau roman* author Marguerite Duras). Emmanuelle Riva plays a French actress in Japan to appear in a film about the dropping of the first atomic bomb on Hiroshima. She has an affair with a Japanese man played by Eiji Okada. In the course of this cryptic film, the woman remarks that: 'The art of seeing has to be learned', driving home that this is a film about perception, and about questions of individuality and identity. Somewhere, too, the film is criticizing America and its deployment of nuclear weapons. For his second film, *L'Année dernière à Marienbad* (*Last Year at Marienbad*, 1961), Resnais turned to the leading proponent of the *nouveau roman*, Alain Robbe-Grillet. A man and a woman are staying at the same hotel; he insists that they had met the previous year at Marienbad and made passionate love; she has no recollection of this, but as he gives his version she begins to form images of herself with him in Marienbad until, in a moment of awareness, she realizes that the place in her mind is the place where she is at present. Examining issues of memory and perception within an abstract, anti-realist visual and narrative style, *Last Year at Marienbad* was a great success in France and a cult film abroad, winning the 1961 Golden Lion at Venice.

Agnès Varda, only the second woman film director in French film history, had previously made one feature film, *La Pointe Courte* (*The Short Point*, 1955). *Cléo de 5 à 7* (*Cleo from five o'clock to seven o'clock*, 1962) covers two hours in the life of a pop singer, who is waiting to hear the results of tests for cancer, and in its visual style expresses the restlessness created by her fear and anxiety. She meets a soldier about to return to fight in the Algerian War: fear of death brings them together. *Le Bonheur* (*Happiness*, 1965), showing the two successive *ménages* of a young carpenter, is a feminist film. On a television screen we

hear a man saying: 'Happiness may be submitting to the order of nature.' Happiness, we see, is created for men by women submitting to them and doing all the boring household duties.

Traditional cloak-and-dagger (*de cape et d'épée*) films reached a peak of popularity in the early 1960s then went into decline, *nouvelle vague* director Philippe de Broca making a better fist of the genre with *Cartouche* (1962) than veterans Abel Gance and René Clair with, respectively, *Cyrano et d'Artagnan* (1964) and *Les Fêtes galantes* (1966). The audience for this kind of film, described scathingly by film historian Jean-Pierre Jeancolas as 'women, the aged, provincials', were among the first to switch to television.[11] In July 1964 the television series *Le Chevalier de Maison-Rouge* by Claude Barma came out in the Paris cinemas—a very rare occurrence at this early stage. From 1968 onwards cloak-and-dagger films were the ones most often rebroadcast on television, the Marxist critic Michel Capdenac remarking contemptuously that: 'the cloak and dagger film is to France what the western is to America.' With the great success of *007 contre doctor No*, issued in France in the spring of 1963, cloak-and-dagger producers switched to pseudo-Bonds—for example, *O.SS 117 se dechâine* (*O.SS 117 Escapes*, Audré Hunebelle, 1963), from the novels by Jean Bruse. Best in the genre were *Coplan ouvre le feu à Mexico* (*Coplan opens fire in Mexico*, 1960), directed by the Italian Riccardo Freda, with a screenplay by future director Bernard Tavernier, and *Coplan sauve sa peau* (*Coplan Saves his Skin*, 1962), Yves Boisset's first film. Both were from the Coplan novels by Paul Kenny. The film of contemporary life is referred to by Jeancolas as 'le mélo social-cochon' ('pigsty melodrama', 'melodrama in a sordid environment').[12] However, there was an interesting literary phenomenon in José Giovanni, self-styled 'child of the war' (that is, the Second World War), who frequented 'les gens de la pègre' (people of the underworld), whose stories provided the basis for such sordid but critically successful films as *Le Trou* (*The Hole*, Jacques Becker, 1960) and *Le Deuxième Souffle* (*The Second Breath*, Jean-Pierre Melville, 1966). With respect to international success, all of these were overshadowed by *Un homme et une femme* (*A Man and a Woman*, 1966), an immensely popular but much criticized evocation of consumer happiness, a

luxurious, optimistic, filmic analogue of *Les Choses*. Another international success was *Le Boucher* (1970) directed by Claude Chabrol, in which a murderous butcher operates within an intense recreation of the physicality and social manners of the Périgord—there is a wonderful cross-cultural comparison to be made of the wedding with which this film begins and that in the British film *The Family Way* (Boulting Brothers, 1966).

At the beginning of the 1970s international attention was captured by two stylish, relaxing, highly verbal films by Eric Rohmer, *Ma nuit chez Maud* (*My Night with Maud*, 1969) and *Le Genou de Claire* (*Claire's Knee*, 1970). In an era of rumbustious fumbling and coupling, Jean-Louis (Jean-Louis Trintignant) does not actually have sex with Maud (Françoise Fabian) during his night with her. The film is sophisticated and satisfying to watch: it is about that great double subject, physical beauty and sexual attraction. In *Claire's Knee* we see a lot of the beautiful legs and sweetly enticing face of Laurence de Monaghan (Claire); her admirer achieves sexual satisfaction by rubbing her knee.

In an article published in the summer of 1960 the Italian critic Morando Morandini wrote that Italian film producers in 1959 'began, timidly enough, to embark on a slightly bolder policy largely as a result of the French example. This year films are being made in Italy which two or three years ago could not have been attempted. Fear of censorship is an issue which no longer holds water . . .'[13] Actually, in the remarkable renaissance that Italian film-making enjoyed from 1959 into the middle 1960s, two different movements coexisted. Neo-realism, we saw, had been the mode of the Italian films that achieved international success in the years immediately after the war, and neo-realism emerged transformed in two films by Visconti: the historical *Il gattopardo* (*The Leopard*, 1963), the film of the famous novel (1958) set in the time of the Risorgimento by Giuseppe Tomasi di Lampedusa (1896–1957); and *Rocco e i suoi fratelli* (*Rocco and his Brothers*, 1960), a film located among the newly arrived southern immigrants in the suburbs of Milan (the date being precisely established in the film as October 1955). But two other films announced the arrival on the Italian screen of the director as autonomous *auteur* totally driven by his own

psyche: *La dolce vita* (*The Sweet Life*, 1959) by the already well-established Federico Fellini, and *L'aventura* (*The Adventure*, 1960) by the less well-known Michelangelo Antonioni (b. 1912). Taking these four films together, one could very reasonably conclude that 1959–60 was a watershed year in Italian film-making. In its particular form of realism, *Rocco* is operatic in quality and the story quickly veers away from the basics of working-class life to the boxing exploits of Rocco (Alain Delon)—nonetheless it played a substantial part in the process of making the working class visible. The enduring images from *Il gattopardo* are of the cruelties, not the heroism, of war (in particular a military execution in the centre of a small town), and, above all, of the jars full of urine, an inescapable adjunct to an elegant aristocratic ball. Both films tell lucid and dramatic stories. The other two films are completely 'modern', and episodic, lacking narrative structure, following through the internal thought processes of the director, evocative in mood, never making direct statements, full of striking images whose significance is not immediately graspable. *La dolce vita* begins with such an image: a statue of Christ being towed by a helicopter. The central figure, Marcello (played by Marcello Mastroianni, 1924–96), is an alienated journalist, without faith in anything: international star Anouk Aimée is la Maddalena in the film, with all the ambiguity and resonance that name implies (the biblical Mary Magdelene, of course, was a former prostitute); we see Marcello in his disordered and apparently promiscuous personal life, and then in a kind of random odyssey through the world of the Roman aristocracy, including night clubs, house parties, and an orgy.

La dolce vita could appropriately be called 'permissive'. There were no explicit scenes of sexual intercourse, but the orgy scene certainly looked thoroughly decadent, and a number of other scenes were highly suggestive. For the traditionalist Catholic there was much that seemed blasphemous. The cast list features a character Paparazzo, immediately followed by three more characters who are simply identified as 'second, third, and fourth photographer'. In the film Paparazzo and his rivals are intrusive, sensation-seeking, and generally a confounded nuisance to ordinary citizens. 'Paparazzi' quickly became an

international term for intrusive newspaper and magazine photographers.

The main protagonist in *L'aventura* is a young woman, Claudia, who, as played by Monica Vitti, comes over as a strong and sympathetic character. Her best friend Anna has a sexual relationship with Sandro, but refuses to marry him (very different from the traditional women in the traditional Italian film). Early on Anna and Claudia go together to Sandro's luxurious flat on the tiny Tibertina island in the middle of the Tiber. While Claudia waits in the street outside, Anna suddenly makes a passionate assault on Sandro. 'But your friend is down there, waiting for you', Sandro protests feebly. 'She'll wait', says Anna coldly. As they go into a clinch, there is a cut to Claudia pacing up and down outside. Anna's father is a diplomat, and it is clear that she and Sandro, and the various friends who now go off on a yacht trip to a desolate volcanic island off the west coast, belong to the same upper class as is featured in Fellini's film. Claudia, who accompanies them, seems rather out of place, much more full of life and joy than the others, who are constantly fractious. On the island, Anna disappears; the rest of the film ('the adventure') concerns the fruitless search for her. Claudia takes it very seriously, and is determined to follow up every lead that the police come up with. Sandro simply tags along, supine rather than predatory. She tries to reject him several times, but he simply clings. Following up a particular lead, they end up in Noto in Sicily.

Antonioni was not interested in presenting a well-made story: his concern is with the reactions of the characters, which he attempts to observe dispassionately. There is an empty factory and a deserted town, then the bustling town of Noto. The contrasts between Rome, the desolate island, Noto, and Sicilian seascapes are very striking. 'In this film', as Antonioni himself put it, 'the landscape is a component of primary importance'.[14] Despite herself, Claudia feels physically drawn to Sandro, who, it transpires, has given up being a creative architect for much more lucrative work as an architectural accountant: as the main upper-class protagonist, he is to be seen as decadent in this respect as well as in his readiness to exploit every sexual

opportunity without apparently showing any real passion or commitment.

The scene that some critics were to characterize as one of the most erotic ever filmed is headed in the screenplay 'The Road to Noto and Abandoned Village'. Their car stops and Sandro and Claudia get out. The script then runs as follows:

> She turns to look at Sandro and it is she who kisses him. When they break apart, they stretch out on the grass. Sandro begins to kiss Claudia, once, twice, three times, violently.
> Mix.
> Claudia lazily awakens from the embrace in which sleep had gathered her up . . . they are both a little dishevelled. They begin to move but only to take up more comfortable positions. Meanwhile, languorously, she utters little feminine moans.[15]

That's it. Once again it's a case of sex with all the clothes on (even if a little dishevelled). But certainly there can be no question as to the enormous sexual charge Monica Vitti puts into what is really quite a short scene. The last sequences of the film take place at an elegant weekend party. Claudia has become so involved with Sandro that she recognizes that, despite herself, she now hopes that Anna will never be found. Sandro, it is clear, will not go back to being an architect, but will continue as accountant to his powerful boss. Claudia goes early to bed, and comes down the following morning to find that Sandro has been unable to refuse the offer of a casual sexual encounter, and is stretched out on a couch with the woman he has picked up (both again fully clothed!). The final scene takes place out of doors. Sandro is on a bench, slumped in guilty gloom. It is Claudia who makes the gesture of forgiveness, touching his hair as the film ends. She might seem to be the conventional put-upon loving woman, but in this deeply moving conclusion we see how she is the individualist, the person capable of making decisions, the noble figure in contrast to Sandro who does little more than let things happen to him. Antonioni proceeded with further modernistic experiments in, for example, *La Notte* (*The Night*, 1960) and *L'eclisse* (*The Eclipse*, 1962), as did Fellini, in *8½* (1962) and, say, *Fellini Satyricon* (1969).

Some Italian films of a more conventional nature also achieved great acclaim. Pietro Germi had made neo-realist

films, openly Marxist in their message, and had shown a particular fascination with Sicily and its antiquated aristocratic class structure. His celebrated *Divorzio a l'italiano* (*Divorce, Italian Style*, 1961) is first of all hilariously and scabrously funny, and secondly an uncompromising satire on the corruption and immorality of the Sicilian nobility; the idea that it is a campaigning film on behalf of the right to divorce is unfounded—that campaign did not get started for another half-dozen years. The opening titles come up against a photograph that deliberately mocks the odd couple, Baron Fefe Cefalu and his dowdy wife. Then we see the Baron (the inevitable Marcello Mastroianni) travelling in a train, almost as if in a Western, through the Sicilian countryside, consumed in a sensual reverie: 'the serenades of the south, the gentle warmth, the enervating nights of Sicily. During all the time I have been away, the memory of these nights—or rather of one night—has filled my hours with regrets, with nostalgia.'[16] That one night was with his beautiful cousin, Angela, twenty years younger than he is. To enable him to marry Angela, Cefalu manoeuvres his wife into a situation where she is caught with a lover, and he, in keeping with Sicilian morality, kills her. As Pierre Sorlin writes: 'Cefalu is not a hero, he is a selfish, decadent dabbler whose fussiness makes him prepare a murder like a business deal. The final wedding is not an end. The last image makes it obvious that Cefalu will soon be cuckolded—maybe eliminated by his second wife.'[17]

Another side-splitting, but seriously-edged comedy, *Pane e cioccolata* (*Bread and Chocolate*, Franco Bruscatti, 1973), was an even greater international success. The Italian immigrant Garafoli (played by the brilliant comic actor Manfredi), desperately seeking work in snooty Switzerland, is the repeated victim of Swiss snobbishness and, indeed, racism; this is Charlie Chaplin recreated in a world exhibiting the negative aspects of the cultural revolution.

By the early 1970s Italian films were free of old-style Italian censorship and became truly and scandalously sexy. Bernardo Bertolucci (b. 1940) led the way, followed by two of the leading female directors now coming to the fore in Italy. Bertolucci's *Ultimo Tango a Parigi* (*Last Tango in Paris*, 1972) was an Italian–French co-production, featuring American megastar

Marlon Brando as a man who forsakes his nagging wife for lashings of sex of all types with a young woman (Maria Schneider); being an independent woman, she kills him.

Lilianna Cavani (b. 1936), a graduate of the University of Bologna and then subsequently of Rome's *Centro Sperimentale di Cinematografia* (Centre of Experimental Cinema), established herself through making documentaries and features for Rai. *Il portiere di notte* (*The Night Porter*, 1974) is about the sadomasochistic affair between an opera conductor's wife and a hotel porter, whom she recognizes as the former commandant of a Nazi concentration camp, in which she had been brutalized and raped. Almost as sensational was a film released the following year, *Pasqualino Settebellezze* (1973—the title in English always being cut to *Seven Beauties*) by the immensely colourful Lina Wertmuller (b. 1928). Daughter of a Roman lawyer, she was expelled from a dozen Catholic schools on the way to becoming a teacher, a graduate of Rome's Theatre Academy, a puppeteer (who toured Europe), and an actress, playright, and theatre director. She worked as an assistant to Fellini on *8½*, then formed her own production company with another of these magnificent Italian comic actors, Giancarlo Giannini, who starred as Pasqualino in *Seven Beauties*. This is a horrific, and also intensely amusing, film, in which Pasqualino survives a hideous existence in a Nazi concentration camp by pretending to have fallen in love with the horridly masculine female concentration camp guard—one scene shows the enormous difficulty he has in mustering an erection. Neither of these films is feminist: what they show is a female sensitivity to love of an almost grotesque kind.

Most notable among films for domestic consumption were a series of films in the style of Leonardo Sciascia, crime stories with a social conscience. From Sciascia's own *Il giorno della civetta* (*The Day of the Owl*) came the film of that name in 1968. Italy's most popular actor Alberto Sordi directed himself in a slightly oblique tribute to 'Swinging London', *Fumo di Londra* (*London Smoke*, 1965). And the Italian-made 'Spaghetti Westerns', which brought fame to Clint Eastwood, and international fortune to their makers, must not be omitted. Borrowing inspiration from *The Seven Samurai* (1954) by Japanese director Akira Kurasawa, Sergio Leone (adopted name of the son of wealthy

Italian producer Roberto Roberti) led the way with *Per un pugno di dollari* (1964—literally *For a Fistful of Dollars*, though the 'for' is always dropped in the English-language version).[18]

The key film in initiating the transformation in British cinema (sometimes referred to as 'The British New Wave') was *Room at the Top* (1959), the conversion of John Braine's high-selling novel of 1957 into a popular film carried out by Romulus Films (a company with a profitable specialization in 'problem' films for minority audiences). Romulus employed three competent professionals, Jack Clayton to direct, Neil Paterson to write the screenplay, and Mario Nascimbene to produce the musical score, and one very distinguished one, cameraman Freddie Francis. As was the custom, the film was planned throughout in consultation with the British Board of Film Censors. What becomes utterly clear from the censorship correspondence is that, influenced by wider trends in British society, the censorship was itself changing its views as to what was now acceptable to British audiences. Where it did put up a fight (usually over words like 'bitch' and 'lust'), it nearly always gave way in the end.[19] By concentrating, altering, and frequently developing material in the novel, the film presents two major preoccupations (or 'meanings'): class power, class rigidities, and the possibility of social mobility; and sex, frankly presented and still more frankly discussed. As a visual medium, the film gives very strong representations of the physical differences in social environments. While Joe Lampton in the novel was fastidious and self-questioning, Joe Lampton in the film (played by Laurence Harvey) is straightforwardly predatory, a figure much more likely to impact strongly on mass audiences. Almost every sequence of the film makes a clear statement about class or about sex, and sometimes both; no such comment could be applied to the chapters of the novel.

As we move into the 1960s, it becomes clear that British cinema was taking up a new central role, not just living off literature, but developing and bringing together new sources of talent. Early successes brought prestige; prestige brought American investment. But the new sources of talent were entirely native; novelists, playwrights, and actors with provincial and/or working-class backgrounds, beneficiaries of new educational

opportunities and, sometimes, of the expansion of provincial theatre. Three influences percolated through the written and spoken word and into film: provincial realism, social criticism, often explicitly socialist, and the non-naturalistic psychological exploration of the dynamics of personal relationships. Among the 'provincial realists' one can number Alan Sillitoe (b. 1928), Willis Hall and Keith Waterhouse (both b. 1929), Stan Barstow (b. 1928) and David Storey (b. 1933), and Shelagh Delaney (b. 1939). The leading socialist dramatist was Arnold Wesker (b. 1932), whose first success, *Chicken Soup with Barley* (1958), was presented at the Belgrade Theatre, Coventry, which was also responsible for the first productions of *Roots* (1959) and *I'm Talking about Jerusalem* (1960), these three plays forming a trilogy involving an East London left-wing Jewish family and farm labourers in Norfolk over a period of thirty years. Most original, and ultimately most influential, was Harold Pinter (b. 1920), son of an East London Jewish tailor who, after grammar school, became a professional actor. Pinter, manifestly influenced by Beckett, used the banal, everyday repetitions of language to explore the ways in which power relationships between human beings can shift, often quite frighteningly. His first play, *The Room*, was presented in 1957. Old-guard metropolitan critics nearly killed *The Birthday Party* (1958), but Pinter's distinctive voice quickly gained recognition among theatre audiences around the country, and in the quality and popular press. There followed *The Caretaker* (1960), *The Lover* (1963), *The Homecoming* (1965), *Old Times* (1971), *No Man's Land* (1975), and *Betrayal* (1978).

Alan Sillitoe was born into the highly deprived family of a tannery labourer. He left school in 1942 and went to work first in the Raleigh bicycle factory in Nottingham, then with a plywood manufacturer, and subsequently with an engineering firm. As had been the case with John Braine, the war had a considerable effect on the development of his career. Sillitoe became a cadet in the Air Training Corps, seizing the unique opportunity to study new skills. As soon as he was old enough, he joined the RAF and, in the immediate post-war years, was sent out as a radio operator to Malaya, where he contracted TB. He was in hospital for a year in 1948, and tried his hand at various pieces

of writing. Sillitoe, now, was certainly no typical representative of the working class: with his RAF pension he deliberately established himself as a writer, working briefly in Nottingham, then in south-east France, and finally in Majorca. The theme of the irresponsible hedonism of Saturday Night and the slow, ineluctable patterns of life, represented by Sunday Morning, had fascinated him for some time. Ten years after its first publication, Sillitoe wrote that 'the greatest inaccuracy was ever to call the book a "working-class novel" for it is really nothing of the sort. It is simply a novel . . .'.[20] On the other hand, of course, working-class figures were the figures he knew; the working-class milieu was the proper setting for his story—in that sense *Saturday Night and Sunday Morning* was a working-class novel.

Sillitoe's novel appeared in October 1958, just three months before the film of *Room at the Top*. Although reviewers of the latter did not refer to *Saturday Night and Sunday Morning*, it was itself far more radical than Braine's novel and played its part, in the more restricted circles of novel readers, in the growing acceptance of the importance of hitherto neglected geographic and social sections of British society, and also of a particular sexual frankness. The screen rights were bought by Woodfall Films, the new company founded by John Osborne and Tony Richardson, ostensibly to allow the voices of anger, kitchen sink, provinces, and working class to be heard, but backed by Canadian producer Harry Saltzman, who made no secret of his wish to turn an honest penny or two out of the new fashions. The director was Karel Reisz, who had been a leading figure in the 'New Cinema' documentary movement of the 1950s. Sillitoe himself was commissioned to write the screenplay. A poet and writer, Sillitoe had no affinity with cinema, and the final script, as ever in the *auteur*-less world of British film, was a team effort, with, of course, the British Board of Film Censors playing their part.

Much of the poetic ambivalence is lost, and the element of boy (Arthur Seaton, played by Albert Finney) meets girl (Doreen, played by Shirley Anne Field) greatly strengthened. Nonetheless, the essential, and novel, ambience of the film is firmly established in an important pre-credit sequence where we

see Arthur at his lathe. The censors objected to four things in the original screenplay: 'the slap-happy successful termination of pregnancy'; 'language'; love scenes that were 'too revealing'; and the violence of Arthur's beating-up. In the film finally released, the alteration in the abortion episode is the most obvious single change: we are left in no doubt that the attempt with hot water and gin has failed. Bert, only one of many colourful and vicious characters in the novel (educated in remand homes and Borstal), very much cleaned up, becomes Arthur's boon companion. The violence and the villainy are played down, so that essentially we are in the realm of the respectable working class (with which, of course, mass audiences could readily identify): a class point is therefore made much more clearly, the sense of working-class awareness and identity coming through all the more strongly.

A Taste of Honey (1961), in which a teenager expecting a mixed-race baby is befriended by a homosexual, was from Shelagh Delaney's play, as *A Kind of Loving* (marking the directorial debut of John Schlesinger) was based on Barstow's novel, the story of an office worker whose high cultural aspirations are destroyed as he finds himself lumbered with a marriage that represents no more than 'a kind of loving'. *This Sporting Life* (1963), about the pain and pride of that very working-class, but of course, not typical figure, the rugby league footballer, was an outstanding film, directed by left-wing but upper-class Lindsay Anderson, from David Storey's astonishing novel.[21]

The films of the 1960s have quite properly been accused of what later became known as male chauvinism, yet one should not overlook the emancipated young woman played by Julie Christie in *Billy Liar*, her amoral *Darling* (1965), and her spirited Bathsheba in *Far from the Madding Crowd* (1967) from the classic Hardy novel, all directed by John Schlesinger; nor the sophisticated (and lustful) Joan Greenwood in Tony Richardson's rumbustious (and permissive) representation of Fielding's *Tom Jones* (1963—again featuring Albert Finney). To these should be added full-blooded performances by Rachel Roberts in *Saturday Night and Sunday Morning* and *This Sporting Life*, the leading parts played by Rita Tushingham and Dora Bryan in *A Taste of Honey*, the self-contained Lesley Caron deciding

on her own to have her illegitimate child in *The L-Shaped Room* (a 1962 Romulus film directed by Bryan Forbes from the novel by Lynne Reid-Banks), and the ruthless Charlotte Rampling happy to abandon her child, the sturdy Lynn Redgrave ready to adopt it, in *Georgy Girl* (1966).

Alfie (1966, directed by Lewis Gilbert from the radio play, which became a stage play, by Bill Naughton) epitomized the cheerful amoral working-class swinger, played by Michael Caine, and the whole atmosphere of permissiveness. *Catch us if you Can* (1965) featured the rock/pop group the Dave Clark Five, and marked the film debut of television director John Boorman, very much a man of the cultural revolution in that he clearly thought of himself as at home on both sides of the Atlantic. It took the American-born Richard Lester to capture the surrealistic humour of top rock/pop group the Beatles in *A Hard Day's Night* (1964), an original combination of documentary and musical, clearly betraying the influences of the *nouvelle vague*, and *Help!* (1965). *Smashing Time* (1967), directed by Desmond Davis, incorporated the clothing revolution of Carnaby Street and featured the visit to London of two young provincial girls.

Save for the occasional elements of surrealism, the overwhelming number of such films were naturalistic in presentation. It is part of the Pinter mode to appear naturalistic, save that through the naturalism there penetrate the menaces, the ambitions, the lusts, of the subconscious. Clive Donner's film of *The Caretaker* (1963) was very different from anything that had yet appeared on the British screen. Almost immediately the American director Joseph Losey, domiciled in Britain as a refugee from McCarthyism, made *The Servant* (1963), a 'Pinteresque' drama about a gentleman's gentleman gaining the upper hand over his rich gentleman: the screenplay in fact was by Pinter. By 1967 Britain was ready for *the* film of the London-centred international cultural revolution of the 1960s, *Blow Up*, by Italian director Antonioni. Made in England with an entirely British cast, it had behind it the wealth and power of Metro Goldwyn Mayer. According to MGM's press release: 'The story is set against the world of fashion, dolly girls, pop groups, beat clubs, models, parties, and above all, the "in"

photographers who more than anyone have promoted the city's new image'.[22] Within a visually rich series of images operating on many levels and raising questions about the nature of reality, the dialogue itself is very effective: it was largely written by another playwright making his name on the London stage, Edward Bond.

Another distinctive talent was that of Ken Russell, who, from the documentary style of his TV film about Elgar, moved to the lavish, expressionistic *The Music Lovers* (1970), based (loosely) on the life of Tchaikovsky. Ken Loach's *Kes* (1969), telling the story of an underprivileged boy in the north-east and his relationship with a kestrel, was in some ways a reversion to gritty social realism; but it was also highly poetic.

One figure who commanded international attention was Nicholas Roeg, who had been cameraman on *The Caretaker*, *Nothing but the Best*, Truffaut's *Fahrenheit 451* (his British film of 1966 with Julie Christie), and *Far from the Madding Crowd*. In 1968 Roeg collaborated with painter and writer Donald Cammell, author of the original script for *Performance*, in directing the film with that title. An art film, full of complex allusions, interesting themes of identity, masculinity, and homo-eroticism, and consciously aiming to emulate Bergman and Antonioni, *Performance* faced enormous difficulties in finding producers and distributors, and was not indeed released until late 1970. Backing from the American Warner Brothers was secured only because of the commitment of rock star Mick Jagger to playing the leading role of Turner. The film was based on a novel by American science-fiction writer Ray Bradbury (b. 1920). In Britain both science fiction (top man, J. G. Ballard, b. 1930) and *verismo* espionage stories (prime exponent, John Le Carré, b. 1931) were among the most vibrant literary genres of the 1960s.

There could be no account of British film-making in this period without reference to the James Bond films and the famous horror films produced by Hammer. With regard to these, and certain other films, which could not unreasonably be described as escapist and, indeed, in large measure exploitative, three points can be made. First, one area in which the British film industry did indisputably lead the world at this time was

that of special effects; these films called upon that superiority to a spectacular degree. Secondly, there were, in most of the films here being considered, elements of humorous self-mockery. Thirdly, and largely consequent upon these two other points, the British fantasy films of the time can definitely lay claim to a certain stylishness.

Ian Fleming's novels about secret agent 007 James Bond were extremely popular towards the end of the 1950s, and for the next thirty-odd years. They are full of sex (or implied sex), violence, and a snobbish knowingness about the luxuries of life. In 1961 Harry Saltzman combined with the American producer Albert 'Cubby' Brocoli in buying the options on all the Bond novels except *Casino Royale*, which Fleming had already sold, and set up a six-picture contract with United Artists. Three suave screen heroes were considered for the part of James Bond: Patrick McGoohan, Richard Johnson, and Roger Moore. But Brocoli had taken a liking to Sean Connery (b. 1930) in, of all things, the 1959 Disney film *Darby O'Gill and the Little People*. Fleming's reaction to Connery was that he 'was looking for Commander James Bond, not an overgrown stuntman'.[23] Connery spoke with a marked Edinburgh accent, one which, however, is slow and easy to follow, and suggests a kind of mid-Atlantic quality. Film director Terence Young undertook to induct Connery into the patrician sensibilities of Commander Bond; Connery chose to play the role tongue-in-cheek and with a light irony. But what got the biggest laughs from the largest cinema audiences in Britain in this period was the series of very traditionally British vulgar comedies the *Carry On* films: from *Carry on Sergeant* (1958) to *Carry on Emmanuelle* (1978) there were twenty-seven.

At the end of February 1960 the American magazine *Life* was introducing its readers to 'the bold and risky world of "adult" movies', citing such recent films as *Suddenly Last Summer*, *Anatomy of a Murder*, *The Best of Everything*, *A Summer Place*, *Blue Denim*, *It Started with a Kiss*, and *North by North West*, in support of its contention that there was 'a general awareness that American movies have suddenly become more "frank", "adult", or "dirty"'. But, it added, 'the populace . . . hasn't seen anything yet'.

The production schedule for the months ahead bodes a full diet of films that would not have been permitted even a year ago. Two of John O'Hara's most libido-centred novels, *Butterfield 8* and *From The Terrace* are now being shot. Director Billy Wilder's new film, *The Apartment* is the story of a young man who rises swiftly in his firm by lending his apartment to his bosses for their dalliance after the working day . . . even *Lolita* will go into production this spring. Stanley Kubrick will direct filming of Vladimir Nabokov's wildly controversial novel about an older man and a 12-year-old girl touring the country motels together—surely the epitome of that ancient movie blurb, 'the picture they said couldn't be made!'.[24]

Lolita as actually made could scarcely be described as an 'explicit' film, though, as with the other films mentioned by *Life*, the implications of the actualities of human behaviour were quite clearly spelled out. The striking characteristic of the Hollywood films of 1959 and after was the portrayal of shocking events in shabby environments, as in *Anatomy of a Murder*. However, the most memorable film of 1959 was the hilarious and sophisticated *Some Like It Hot* (Billy Wilder, b. 1906), featuring the greatest female star of the time, Marilyn Monroe (1926–62), as a member of a female band that is joined by Jack Lemmon and Tony Curtis in drag ('Every girl in my band', the unsuspecting band leader tells them, 'is a virtuoso, and I intend to keep it that way').

With reference to censorship relaxation in Johnson's 'Great Society', a good film to consider is *Sunday in New York* (1966). This had its origins in a play by Norman Krasna that film critic Thomas Kiernan not unfairly describes as 'a minor trite Broadway sex comedy', continuing: 'It was transformed for the screen by director Peter Tewkesbury into a stylish but still trite Hollywood sex gambol—a bit more daring than similar comedies of previous years, but cut from the same cloth'.[25] But it was very funny, and immensely believable, even though the characters go to enormous lengths to avoid pronouncing the word 'virgin'. The virgin is Jane Fonda, a Mary Quant dolly-bird, warm and adventurous. Rod Taylor has picked her up; she takes him back to her brother's flat; he has to pretend to be her brother; her brother (played by Cliff Robertson), an airline pilot, is also cheerfully predatory. It is Fonda's serious, prudish fiancé who

comes off worst. Most of the residual delicacy had gone by the time *Carnal Knowledge* was released in 1970, one of the first general release films to get the new X certificate: it 'flirted deliberately with areas that until the last few years were unmentionable except among men in private'; and it had the 'first onscreen unsheathing of a condom in a major American movie'.[26]

The transformation in the portrayal of blacks in American films came in 1967, with two films, each of which had just one central black character, portrayed (both times by Sidney Poitier) as a highly successful, highly intelligent, middle-class member of American society. In Norman Jewison's *In the Heat of the Night*, Poitier plays a detective from the north who is assisting the local police chief (played by Rod Steiger) of a southern town in a murder investigation. The film centres on how, within an ambience fevered with segregationist sentiment, the two men accommodate each other. This was no minority film; it won the 1967 Academy Award for best picture. The other film, *Guess who's Coming to Dinner*, directed by Stanley Kramer, was in box-office terms the second most successful film of the year. A progressive Californian couple (played by Katherine Hepburn and Spencer Tracey) have to confront the fact that their daughter has got herself engaged to a distinguished black scientist who works with the United Nations. We also encounter the Sidney Poitier character's parents: from a lower social class, they are shown to share some of the basic values and, in reverse, the same prejudices as the white couple. This is a sensitive (though we do have the black father telling his son that it is highly appropriate that a husband should be considerably older than his wife—a notion that would seem unacceptably male chauvinist within a few years), polished, intelligent, enjoyable, and relaxed film—very much of the 1960s (and regarded with contempt by black activists).

The films usually selected as having a high quotient of youth appeal are *The Graduate* (1967), directed by Mike Nichols (b. 1931), about an affair between a student (Dustin Hoffman) and an older woman, the first Hollywood film openly to discuss contraception, and the second greatest box-office success of the decade; *Bonnie and Clyde* (1967), directed by Arthur Penn (b. 1922), the story of two 1930s gangsters, sympathetically

portrayed (by Warren Beatty and Faye Dunaway) as two youthful rebels against conventional society; and *Easy Rider* (1969), about two young drug-dealers (Dennis Hopper and Peter Fonda) riding across America on their motorbikes, encountering a drunken civil-rights lawyer and a hippie community—Hopper (b. 1936) directed while Fonda (b. 1940) was producer. *Midnight Cowboy* brings together a number of themes. It was a Hollywood film directed by a star of the British film supremacy, John Schlesinger (b. 1926). Its fundamental theme is sexual, in that it features a young Texan (played by Jon Voight) who, sure of himself as a 'stud', comes to New York expecting to make a good living from rich women; in fact he ends up performing a homosexual act for a crippled New York derelict, Ratso (Dustin Hoffman), with whom he then establishes a kind of relationship. Cult status, among the young in particular, was achieved by Stanley Kubrick's *2001: A Space Odyssey* (1968)—science fiction backed by spectacular special effects, and including a psychedelic sequence. The script was by Kubrick (1928–99) and Arthur C. Clarke (b. 1917), the film being based on a short story by the latter, British-born doyen of science-fiction novelists, resident in Sri Lanka.

Only one film at this time dealt overtly with the Vietnam War, John Wayne's *The Green Berets* (1968)—crude jingoism, in which the Vietcong are portrayed in the same racist way that traditional Westerns had portrayed the Indians. *M*A*S*H* (1970), debut film of Robert Altman, a central figure in the renaissance of American films, which developed and intensified in the 1970s, is important for that reason, and several others. It is the first Hollywood movie fully to deploy the 'art film' techniques of European cinema—alienation, non-realistic sequences, overlapping sound, and bleeding of sound from one image to another. Vulgar, irreverent, sexually explicit, and very funny, *M*A*S*H* is about a mobile army surgical hospital, ostensibly during the Korean War, though nobody could be in any doubt that the classical, senseless war being portrayed was the current one in Vietnam. *Little Big Man* (1970), directed by Arthur Penn, was one of the most important of the Westerns to treat Indians sympathetically, and to indict their brutal treatment by American whites.

Penn's Indians were made up to look very like Vietnamese. Nobody missed the point.

At the beginning of the 1970s, there was an explosion in pornographic and exploitation films, but also a remarkable continuity in the revival of serious American film-making, leading to what the doyenne of American film critics, Pauline Kael, has described as Hollywood's 'authentic golden age', including such films as *The Godfather* (Francis Ford Coppola, 1972), *American Graffiti* (George Lucas, 1973), *Chinatown* (Roman Polanski, 1974), *Nashville* (Robert Altman, 1975), *Taxi Driver* (Martin Scorsese, 1976), and *The Deer Hunter* (Michael Cimino, 1978). The intense realism of the new generation of directors (and actors, including James Caan, Robert De Niro, and Meryl Streep), often violent and sordid, completely buried the old Hollywood of polite evasions. Based on the best-selling novel by Mario Puzo, the first film on my list concerns the rise and rise of the Corleone family during the New York Mafia wars of 1945–55; the *New York Times* described it as 'one of the most brutal and moving chronicles of American life ever designed within the limits of popular entertainment'.[27] The reach of this 'authentic golden age' can be appreciated if I add that the last film starts with a delicate recreation of working-class life in a Pennsylvania steel town before proceeding to the drug-sodden trauma of the Vietnam War.

In France, Jean Poiret's stage play centring on a gay relationship, *La Cage aux folles* (*The Cage for Madmen*, 1978), was greatly admired. The film, directed by Edward Molinar, was taken in America as marking the gay liberation aspect of the 1960s' sexual revolution. However, Paris had had its own shocks in June 1975, when *Exhibition* (directed by Jean-François Darcy) arrived fresh from causing a stir at Cannes. According to Jeancolas: 'The audience were stupified: for the first time they had in front of their eyes, magnified to the size of the screen, sexual organs in action. France discovered what the Americans for several years have been calling "hard core".'[28]

Of all Western countries, Germany was the slowest to respond to the cultural revolution, though, in the end, it was probably the most profoundly transformed. There were major developments in the novel, as we saw in Chapter 2, and in

drama, as we shall see in the next chapter, but film began to stir into life only in the middle of the decade, the massive developments coming later; indeed, they form the starting point for Part Three of this book. At the Berlin Film Festival of 1961 the submissions were so feeble that the Federal Minister of the Interior decided that no federal film prize would be awarded.[29] Younger film-makers, specializing in producing short films, were running their own festival at Oberhausen in the Ruhr. At the Eighth Oberhausen Festival, in February 1962, twenty-six of them issued what became known as the 'Oberhausen Manifesto':

The collapse of the conventional German cinema finally removes the economic basis from an attitude of mind that we regret. With it, the new cinema has a chance of coming to life.

German short films by young *auteurs*, directors, and producers have in recent years received a large number of prizes at international festivals, and have met with approval by international critics. These works and their success show that the future of the German cinema lies with those who have shown that they speak the new language of the cinema. As in other countries, so too in Germany the short film has become both training ground and laboratory for the feature film. We declare our object to be the creation of the new German feature film.

This new cinema needs new freedoms. Freedom from the customary conventions of the trade. Freedom from the influence of commercial partners. Freedom from the tutelage of vested interests. We have a concrete notion of the production of the new German cinema at the intellectual, formal, and economic levels. We are collectively prepared to take economic risks. The old cinema is dead. We believe in the new one.[30]

Actually, only one of the twenty-six signatories did emerge as a major feature-film maker, Alexander Kluge. In 1966 he released his first feature film, *Abschied von Gestern* (literally, *Taking Leave of Yesterday*); this won eight prizes at the Venice Film Festival, and became Germany's first post-war international success under the title *Yesterday Girl*. The girl, played by Kluge's sister Alexandra, was a bewildered East German refugee, whose experiences of the West are bleakly amusing.

Television

It was widely accepted that Britain provided the model for how television ought to be organized; but undoubtedly America led when it came to questions of what should be made, and how it should be made. There were some outstanding productions in the main European countries (not yet including Germany), and some British programmes earned respect and audiences everywhere, achieving transmission in America either in the original or in adapted form. But the broad trends of television fashion were established first in the United States. In the post-war years the comedy variety show had dominated, but by the late 1950s this was on the way out, to be replaced directly by situation comedies ('sitcoms'), and by an increasing number of 'soap operas', series featuring a regular cast of characters, but dramatic rather than comic. The most popular American television show of all time, when continuing repeat sales all around the world for decades afterwards are taken into account, was *I Love Lucy*, which was itself based on the 1940s radio series *My Favorite Husband*. Both shows starred Lucille Ball as a wacky, loveable housewife, devoted to her husband, and, of course, in no sense a liberated woman. *I Love Lucy*, indeed, is the paradigmatic television series of the conventional, stereotyped Fifties, against which one can judge innovation in the Sixties. However, it did establish one technical convention that for a long time was to characterize the sitcoms that began to appear in the 1960s: the show was recorded in front of a live audience, whose laughter was then broadcast with the show. *I Love Lucy* ran on CBS from 15 October 1951 to 24 June 1957. Repeats were broadcast in most European countries throughout the 1960s. It was a particular and enduring characteristic of American television shows that the title featured the main star (rather than using the names of the fictional characters). Thus, the prototype of the new sitcom was *The Dick Van Dyke Show*, first broadcast on 3 October 1961, and chronicling the comic adventures of the Petrie family (Mary Tyler Moore being Mrs Petrie) through till 1966.

It is possible also to identify the two series that did most to establish the conventions for the many police and crime shows

that proliferated on both sides of the Atlantic: *Dragnet*, very traditional in its cop—the unambiguous, uncompromising, but always righteous, Sergeant Jo Friday—but increasingly adventurous in technique, using close-ups and cinema montage during its run from 1951 to 1970 on NBC; and *The Fugitive*, whose protagonist, the doctor wrongly accused of murdering his wife (played by David Janssen), spawned many imitators during and after its run from 1963 to 1967 on ABC. *Perry Mason* (mentioned earlier) was succeeded by *Ironside* (CBS, 1967–75), a series strongly inflected with 1960s liberalism in which Raymond Burr took the role of a sensitive San Francisco police chief confined to a wheelchair.

Slightly behind what was happening in film, the many Western series become more sophisticated, tending towards the psychologically alert. First in this genre was *Gunsmoke* (CBS, 1955–75). Others were: *Wagon Train* (NBC/ABC, 1957–65); *Maverick* (ABC, 1957–62), which introduced the wry, comic talents of actor James Garner; *Rawhide* (CBS, 1959–66), the showcase that brought recognition to Clint Eastwood; and *Bonanza* (NBC, 1959–73), featuring three motherless sons and an over-compensating father. The great prototype of the 1960s soap opera, and a medical one at that, was *Dr Kildare* (1961–6), doing for Richard Chamberlain what *Rawhide* did for Clint Eastwood. The nearest television came to the permissiveness beginning to be seen on the big screen was the soap opera of adultery, imagined if never graphically represented, *Peyton Place*, lurid certainly, and considered shocking at the time. The science-fiction imaginings of the day, apparent in novels and films, had their expression in what can perhaps be described as the cult series, *Star Trek* (NBC, 1966–9). *Star Trek* was to be revived, its original cast distinctly showing the signs of age, and then revived again with new characters. However, Rowan and Martin's *Laugh-In*, a revival for a completely new age of the old comedy variety show, was in its irreverent, stuttering, slightly surrealistic style, so much part of its age, the late 1960s, that it did not outlive its five-year run (NBC, 22 January 1968–14 May 1973). President Richard Nixon appeared on it briefly, endeavouring to show himself as a good guy who could take a joke.

The most potent sign that some of the changes detectable in film did also affect television was the series *M*A*S*H*, beginning on 17 September 1972 on CBS, and derived from the daring, satirical, and scabrous film already discussed. Three cops-and-robbers series attracted cult followings in America and Europe, largely because of their principal protagonists: *Columbo* (NBC, 1971–7), starring Peter Falk; *Kojak* (CBS, 1973–8), starring Telly Savalas; and *Starsky and Hutch* (1975–9), starring David Soul and Paul Michael Glaser. The effects both of black civil rights and the successes of British television began to show. *The Jeffersons* and *Good Times* were rather routine sitcoms, the black families portrayed still not being highly successful, or even mainstream. *Sanford and Son* had British ancestry, as we shall see shortly.

In the first years of British independent television, the commercial companies had gone through perilous times. However, the second generation of regional franchise holders, Granada, Associated, and Scottish, made large and rising profits, leading Lord Thompson of Scottish Television to declare his franchise 'a licence to print your own money'.[31] When the time came for the new franchises to be awarded by the Independent Television Authority in 1967, the companies were held to have totally sacrificed quality to profits. New companies were formed, featuring personalities with high cultural status, and swearing allegiance to the highest artistic standards. Meantime, a couple of critical changes had taken place at the BBC. In 1960 Hugh Greene, an upper-class figure, like Trevelyan at the British Board of Film Censors, but also like him sensitive to changes taking place in society, became Director General. In April 1964 a second channel (BBC2), designed to develop the BBC's more serious output, came on the air.

Where, in the 1950s, the BBC had panel games (*What's My Line?*, running from 1951 to 1963, was immensely popular), ITV had quizzes (with substantial prizes, something frowned upon by the BBC)—most popular were *Take Your Pick* and *Double Your Money*. In July 1955 the BBC began *Dixon of Dock Green*, the plodding police series that well encapsulates the naive pre-1960s British television world. But should the American soap opera be imitated? While BBC chiefs thought not, Associ-

ated Television came up with a winner—ITV's first twice-weekly serial, *Emergency Ward 10*, as much about romantic entanglements as hospital emergencies. To Granada Television belongs the credit for a sort of analogue of the British new-wave-novels, plays, and films. *Coronation Street* was firmly set in the sort of traditional working-class streets celebrated by left-wing educationalist Richard Hoggart in his *The Uses of Literacy* (1957). Its cast consisted of obscure north-western repertory actors and its first episodes (beginning on Friday, 9 December 1960) were broadcast to local audiences only. From the following spring it was given national networking, and became a national institution. Its creator, 23-year-old actor Tony Warren, has said: 'In 1960, the Northern resurgence was happening in the theatre and in films. I wanted to bring it to television. I wanted to see something written from the heart, acted by genuine Northerners.'[32]

The prototypical popular music programme was the BBC's *Six-Five Special*, launched in 1957, and providing exposure for such performers as Adam Faith and Tommy Steele. *Juke Box Jury*, launched in June 1959, was based on the playing of new record releases. *Top of the Pops* (a programme based on record sales, but including a number of featured performers) went out for the first time on New Year's Day 1964. It had been preceded, by almost a year, by *Ready, Steady, Go!* on ITV.

By 1962 the liberalizing influence of Sir Hugh Greene was beginning to be apparent. From the makers of the news and current affairs programme *Tonight* there emerged the first ever programme genuinely satirizing current affairs, *That was the Week that was* (produced by Ned Sherrin, presented by David Frost). At the beginning of the same year, also on BBC, came *Z Cars*, the cops-and-robbers series set in a fictionalized Liverpool, which, paying as much attention to the complex and fallible personalities of the cops as it did to the excitements of detection and chase, marked a definite break from Dixon. Ray Galton and Alan Simpson, script-writers of the first successful TV comedy show (a transfer from radio) *Hancock's Half Hour*, came up with *Steptoe and Son*, the first of a genre in which comedy sprang out of character (in this case a culturally aspiring rag-and-bone man and his decrepit father) yet embraced

issues that touched the feelings of intelligent audiences, while employing the street language that some still found shocking. Most of the point was lost in the American adaptation, *Sanford and Son*, in which the protagonists were black. The new genre achieved its ultimate form in *Till Death us do Part*, 'television's most controversial comedy series ever',[33] written by Johnny Speight, which mocked racism and reactionary attitudes by featuring the absurd ultra-conservative working man Alf Garnett. It was regularly viewed by over 17 million ordinary people, and was enthusiastically commented on by the critics. American audiences, of course, would not be expected to take this meaty stuff: the adaptation was a very feeble version of the original.

The standards of middlebrow drama, and sometimes more, were maintained by the BBC's Wednesday Night Play. *Up the Junction* (1965), from the novel of the same name (1963) by Nell Dunn, presented young women factory workers as the predatory sex, and caused an outcry for its abortion scene (as a film, it was top money-maker of 1968). Another important Wednesday Play author was working-class, but Oxford-educated, Dennis Potter, whose *Vote, Vote, Vote for Nigel Barton* took a working-class lad through Oxford into Labour politics. However, the sensation was *Cathy Come Home* (November 1966), written by Jeremy Sandford and directed by Ken Loach (b. 1936), the story of a young mother moving from one squalid lodging to another, then into a hostel for the homeless, before finally being evicted and having her children taken away from her. Thus, BBC Television established itself as the home of high-quality, 'serious' television; in the 1970s it was joined by some of the ITV companies. Internationally, what created the almost mythic status of British television was the BBC's last black-and-white drama series, *The Forsyte Saga* (1967), fashioned from the distinctly middlebrow novels of John Galsworthy, but with a brilliant cast of actors. All in all, by the early 1970s, television was occupying the central cultural function served by film ten years earlier: it was, for instance, in 1973 that Stan Barstow's Yorkshire novel of 1964, *Joby*, finally reached the screen—the television screen.

One of the best of all sitcoms, embracing nostalgia without sentimentality, *Dad's Army*, was first presented on BBC in 1968,

and grew in popularity, without loss of quality, throughout the 1970s, thanks to the way in which script-writers David Croft and Jimmy Perry allowed situations to develop naturally, without ever forcing the humour. The BBC was also the home of a comedy series of an entirely different cast: *Monty Python's Flying Circus*, with its zany humour and appalling bad taste, held together by weird animations, was first presented in 1969. In 1971 London Weekend Television broadcast the first episodes of *Upstairs Downstairs*, a series based on the careful delineation of the hierarchy existing within an aristocratic Edwardian household, and, in international fame, the true successor to *The Forsyte Saga*.

For the student of popular culture, perhaps the most rewarding British television series of the 1960s is *The Avengers*. Beginning, 'live' and in black and white, in January 1961, it ended, filmed and in full colour, six seasons and 161 episodes later in mid-1969. A crime thriller series, it started in a low-key, realist mode, but quickly moved to a more flamboyant, colourful, and fantastic style strongly influenced by the pop art and fashion of the time. Dr James Chapman, referring to the 'slick, witty and sophisticated entertainment' that developed after 1963, 'when it abandoned any pretence of realism or seriousness', has credited it with being the first 'postmodernist' TV series,[34] though that is a word to be used only with extreme caution.

Certainly there was nothing postmodernist about Italian television, which evolved its own peculiar Italo-American mix of quiz and popular music (Italian popular music in the 1950s was far superior to American), wonderfully expressed in the title *Canzonissima*, which was used in 1958–62, and again in 1968–75, with slight variations being tried out in the intervening period, the basic show never being taken off. Television historian Aldo Grasso speaks of an 'obsession' with American megashows and with great singing stars, compounded with an Italian megalomaniac passion for song and a desire for a sense of 'gladiatorial competitiveness'. In the beginning there was an American television presenter, Mike Bongiorno, who returned to the land of his fathers to present the initial run of the quiz show *Lascia o raddopia* (*Double or Quits*) from November 1955

to 1959. Two years behind came the Italian version of the music quiz, *Name that Tune*, that NBC had been running since 1954, *Il musichiere* (*The Music Quiz*). Then came something entirely Italian, the annual telecast of the San Remo Music Festival, held in January–February. The main rival to San Remo was the song competition at Capadanno, which spawned the radio show *Le canzoni della fortuna* (*Songs of Fortune*) beginning in 1956. It was from Capadanno via the radio show, and influenced by the Italian imitations of American programmes, that *Canzonissima* was born. The first *Canzonissima* ran between 22 October 1958 and 4 January 1959 (upstaging San Remo): second prize was won by Claudio Villa singing *Arrivederci Roma*, which became a great hit. In 1964–5 the same singer won with *O sole mio*. Beginning in November 1959, there was a slightly more up-market quiz show, *Campanile sera* (*Evening Clock Tower*).

Italian television began as the sole responsibility of the state-run corporation Rai. However, advertisements were introduced from 3 February 1957, though in a peculiarly Italian way—the Italians were just as determined as the British not to follow what was seen as the disastrous American path of sponsorship and commercialism. Instead a special, self-contained vehicle for advertisements, *Carosello*, was broadcast for ten minutes every evening, consisting of four short variety items, and thirty seconds of advertisements. It featured famous producers and famous actors, and gave rise to famous characters and famous catchphrases, such as 'Inspector Rock', who declared, 'I too have made a mistake, I have never used Linetti brilliantine'. Most famous and enduring was the phrase 'Basta la parola' (That's enough chat).

On the whole, Italian television has had a deserved reputation for low-quality, exploitative shows. However, from the later 1960s there were a number of high-prestige productions. Most important was the filming in colour, in eight episodes, of the famous nineteenth-century work usually seen as the foundation stone of the modern Italian novel: *I promessi sposi* (*The Betrothed*). Audiences of over 18 million mustered on Sunday evenings throughout January and February 1967. Direction was by Sandro Bolchi, with Nino Castelnuovo playing Renzo and Paola Pitagora playing Lucia. This classic series was in the top

ten for 1967, holding third place—top place being held by the XVII San Remo Festival.

The follow-up, a seven-episode presentation of Homer's Odyssey, *Odissea*, directed by Franco Rossi, was very much of its time in being a co-production with French and German television, under the aegis of the mighty Italian producer Dino De Laurentiis. *Odissea* made sixth place in the 1968 top ten: places one and two were taken by *Canzonissima 68* and the XVIII San Remo Festival. Another important co-production with the French and the Bavarians was *Le avventure di Pinocchio* (*The Adventures of Pinocchio*), which also reached sixth place in the top ten, reaching audiences of 21,300,000 during the seven episodes broadcast in April and May 1972. Other prestigious productions, all of which were subsequently presented as cinema films, were, in 1970, *I clowns* by Fellini and *La strategia del ragno* (*The Spider's Strategy*) by Bernardo Bertolucci (b. 1940), and, in 1977 and 1978 respectively, *Padre Padrone* (*Father Boss*) by the Taviani brothers (based on the autobiography of an illiterate Sardinian shepherd who became a linguistics expert), and *L'albero degli zoccoli* (*The Tree of Clogs*) by Ermanno Olmi. Both of these last two won prizes at Cannes.

France had its television game shows as well, the most notable being *La Tête et les jambes* (*The Head and the Legs*). The 1960s were marked by the ascendancy of the soap opera, eclipsing more prestigious drama productions. In 1966 *La Prise du pouvoir par Louis XIV* (*Louis XIV's Seizure of Power*), by—yet another indication of international cultural exchange—Rossellini was successful, but *Marie Tudor*, by the veteran French film-maker Abel Gance, was not. A second ORTF programme was established in 1964, and then, in 1968, came commercial television. The years 1968–70 were noteworthy for, in the aftermath of the events of 1968, programmes about everyday and in particular working-class life, such as *L'Usinier un jour* (*A Day at the Factory*, 1968) and *De la belle ouvrage* (*About a Job Well Done*, 1970). These oddly anticipated the docusoaps of thirty years later. The intellectual fashion for the structuralists and poststructuralists was greatly helped by the exposure that the leading figures were able to get on French television. In 1975 there began the 'intellectual' series *Apostrophes*, fronted by

the philosopher-become-media-star Bernard-Henri Lévy, in romantic coiffure and Yves Saint-Laurent silk shirts.

I want to end this chapter by referring to a much-cited interview given by Foucault in *Cahiers du Cinéma* of July–August 1974. Foucault answered questions concerning certain recently released films of a historical character relating to the Second World War, including *Lacombe Lucien* (Louis Malle, 1973), and the documentary-style television programme, *Le Chagrin et la pitié* (Marcel Ophuls, 1970). Foucault assumed French society of the time to be divided exclusively between 'la classe dominante' (the dominant class) and 'les classes exploitées' (the exploited classes). The protagonist of the Louis Malle film is a young French Fascist and Nazi collaborator, while the Ophuls television programme presented the French as having largely been willing collaborators during the German occupation. Foucault claimed that films of this type were deliberate attempts by 'la classe dominante' to deprive 'les classes exploitées' of what he called their 'mémoire populaire'—that is to say, their 'memory' of what, according to him, was the essentially radical character of their history. This interpretation, to me, is most unpersuasive; 'memory' is actually an individual attribute, the phrase 'popular memory' at best a metaphorical one, at worst a complete abuse of language.

Structuralism and After

Marxism and Structuralism

The enormous and enduring significance of Marxism as an intellectual system, in some cases also a belief system, cannot be doubted. Throughout the period studied in this book, it has been elaborated, extended, and qualified. Clearly it has exercised an enormous attraction for men and women of goodwill and imagination, variously possessed of desires to reform the world and to penetrate the deepest mysteries of all aspects of human behaviour. Very many of the most important intellectual and creative figures in the West since the Second World War, to go back no further, have in some way or another been strongly influenced by Marxist ideas. The universally admired British historian of today Eric Hobsbawm (b. 1917) remains a member of the British Communist Party; the scholar most widely recognized as the most distinguished historian practising in the West since 1945, Fernand Braudel (1902–85), often revealed profoundly Marxist attitudes—for example, in the celebrated *The Mediterranean and the Mediterranean World in the Age of Phillip II* he criticized bourgeois elements for seeking accommodation with the nobility, rather than opposing them, as, according to Marxist theory, they ought to have done. Braudel's associates in what is usually known as the second generation of the famous *Annales* school of historians shared his fundamental Marxist assumptions, though many of the third generation, particularly François Furet (1927–97), were quite aggressively hostile to Marxism.

Herein lies a central difficulty: while some intellectuals, such as Hobsbawm, proudly confirm their Marxism, declaring, with some plausibility, that the latest developments in global capitalism are exactly fulfilling Marx's predictions, many others who would appear to be at least as Marxist as Braudel go out of their

way to deny that they are Marxists. This denial is both hard to explain, and confusing, when one is seeking to analyse intellectual affiliations. Thus, the word 'Marxisant', signifying 'Marxist-influenced' though not necessarily committed to Marxist principles of political action, has come into use. I shall stick to 'Marxist', by which I simply mean holding to a broad theory of history and society by which the past has become the present through a serious of distinct 'stages', in which class struggle has been the central force of change, and according to which we are still in the 'capitalist' or 'bourgeois' stage, living in a bad, repressive society, where power is maintained, in particular, through the control of ideology—the struggle for right-thinking people should be to overthrow this society so that it will be replaced by a better, alternative one. For the purposes of this book, those who believe something along these lines are 'Marxists'; those who (like myself and, I would think, the majority of historians working in the West today), do not share Marxist assumptions about class, about revolution, about periodization, about the nature of bourgeois society, are not Marxists. Marxist theory, I have said, continues to have great appeal.

Sartre, in his beliefs, in his politics, in his creative activities, in the existentialism that was very much the fashionable philosophy of the post-war years, was quite definitely a committed Marxist. The structuralists and poststructuralists of the late 1950s and 1960s came from within the same broad Marxist framework. That did not for one moment stop the intellectual debates between the Sartreans and the structuralists being extremely bitter. There was the further complication that most intellectual Marxists, of whatever persuasion, were subject to attack by, and were often themselves contemptuous of, the official French Communist Party. Sartre was a 'humanist': he believed that, through commitment and action concerted through a Marxist political programme, he could bring about real change. Among the structuralists, there were those, most notably Louis Althusser (b. 1918), who viewed Sartre's enthusiasm as a romantic perversion of the austerity and scientific rigour of Marx's thought: humanism, he declared uncompromisingly, is alien to Marxism, the real subjects of history being, not human beings, but the structural relationships between

productive forces¹ (a central tenet of 'structuralism'). The structuralist anthropologist Claude Lévi-Strauss (b. 1908) was above all concerned to see the philosophical position behind his *Anthropologie structurale* (1958) replace that of Sartrean existentialism; his *La Pensée sauvage* (*The Primitive Mind*, 1962) contained an open attack on Sartre. In a venomous piece of personal criticism, Lévi-Strauss declared that: 'Whatever meaning and movement history displays is imparted and endowed not by historical actors, but by the totality of rule systems within which they are located and enmeshed.' Sartre and de Beauvoir continued to have enormous influence, particularly in Britain, where acquaintance with the newer fashions coming to eclipse existentialism remained patchy. But in Paris, structuralism rose and rose through prestigious university connections, the higher journalism, literary prizes, intellectual journals, public lectures, and reviews. Sartre made his bid to re-establish the primacy of humanist Marxism through *La Critique de la raison dialectique* (*Critique of Dialectical Reason*, 1960). Michel Foucault (1926–84), fêted as the most brilliant and charismatic of the structuralists, described the book as 'the magnificent and pathetic effort of a nineteenth-century man to conceive of the twentieth century. In this sense, Sartre is the last Hegelian, and even, I would say, the last Marxist.'² The interview in which Foucault made this comment was given the title 'Man, is he Dead?'. Notions of 'the end of the human subject' or of 'the last Marxist' were very much central to structuralism as it was represented at this time. Foucault's *Les Mots et les choses: Archéologie des sciences humaines* (*Words and Things: Archeology of the Human Sciences*, 1966; published in English in 1970 as *The Order of Things*, a title that Foucault actually preferred) was about how 'knowledge', which Foucault saw as a product of bourgeois culture, comes into existence. Foucault attacked the bourgeois notion that any significance attached to the individual human 'subject' or historical actor. Only the modern 'human sciences' put the individual human 'subject' at the centre of things; Foucault suggested that this had not always been so, and would not long continue to be so. The concluding paragraph of the book contained two particularly striking sentences: 'As the archaeology of our thought

easily shows, man is an invention of recent date. And perhaps one nearing its end.'

Whether Foucault and such other figures as Roland Barthes (1915–80) really saw structuralism as replacing Marxism is not altogether clear: what is clear is that both went on using the standard language of Marxism ('capitalist ideology' and so on), and that Foucault, as he and others like him moved to the extreme Left and to Maoism, quite explicitly restated his fundamental belief in Marxism. Foucault was one of those who acknowledged Marx as one of the great intellectual giants on a level with, say, Newton or Darwin.

Five Key Concepts of Structuralism and Poststructuralism

As my Introduction made clear, it is integral to my form of historical analysis that the various domains of knowledge (the sciences, philosophy, history, and so on) be regarded as separate from the domains of the creative arts. There is, therefore, no room in this book for the discussion of philosophers, anthropologists, scientists, or, indeed, historians. It is also one of my basic claims that appreciation of the arts is not dependent on the latest, or any, theory, but solely upon literacy, visual, and aural discrimination, intelligence, and open-mindedness, perhaps aided by a little explication and contextual information. However, just as supplying the context for Part One of this book required some account of existentialism, so preparing the context for the remainder of this book requires some account of structuralism, poststructuralism, and what eventually came to be referred to generically as 'postmodernism'. I take the five key concepts in turn.

1. The Transgression of Boundaries

The structuralists and their associates, often in an exhilarating way, worked outside and across the conventional disciplines. Foucault moved from psychiatry into medical history into what he called the 'archaeology of knowledge', into language, into the history of crime and punishment, into the history of sexuality. Barthes and Jacques Derrida (b. 1930) worked in literature,

language, grammar, with Barthes concentrating more and more on the signs, symbols, and representations (in the form both of language and of visual imagery) by which we are surrounded, developing the new subjects of semiology and semiotics. The *Annales* school cultivated a history that was overtly interdisciplinary. All around, in the creative arts the distinctions between painting and sculpture, between words, images, and music, between poetry and solid form, between popular and elite culture, were being broken. The structuralists and poststructuralists (unlike me) saw no distinction between the imaginative arts and evidence-based scholarship—everything was interpretation, or ideology, or text.

2. Decentring of the Human Subject
One or two quotations have already given the general idea: our lives are governed by structures and codes, in which individual human agency plays no part. The proper focus for attention, whether in works conventionally seen as scholarship or as art, is the system of interrelationships, not the individual human subject. This outlook was highly congruent with the history of Braudel and the *Annales* school, which stressed the importance of long periods of imperceptible change, *la longue durée*, and of cycles of change (*conjonctures*), in population, prices, etc., while discounting the influence of events or human agency.

3. The Centrality, and the Indeterminacy, of Language
On the flyleaf of his critical postmodernist analysis of the way historians produce history, *The Content of the Form: Narrative Discourse and Historical Representation* (1987), Hayden White prints this quotation from Barthes: 'Le fait n'a jamais qu'une existence linguistique' (The fact has never anything but a linguistic existence)—in effect, the full structuralist and poststructuralist contention that nothing has reality outside language, but that everything is constructed *within* language. This position is stated by different authors with different degrees of totality. At the very least, the contention is that there is no secure correspondence between any actual reality and the attempt to represent that reality in language. The basic idea put forward by the Swiss linguist Ferdinand de Saussure (1857–1913) earlier in the

century, and adopted as a central tenet of structuralism, was that the meanings of words do not lie in any intrinsic relationship between them and what they signify, nor are they determined by the intentions of those who utter them. Words derive their meanings from an entire system of structures of difference. Various conclusions were drawn, at various levels of intensity, but all denying to human beings complete control over the deployment of language. Demonstrating again his heavily Marxist heritage, Barthes, in his first book, *Le Degré zéro de l'écriture* (*Writing Degree Zero*, 1953), advanced the proposition that all current writing was contaminated with bourgeois values and that, to get back to 'degree zero' or true objectivity, that contamination would have to be scraped away. The notion that certain modes of language, or forms of discourse—for example, diplomatic language—help to determine the actual content of what is being said or written is certainly a fertile one. One argument (which, again, has a good deal of plausibility) was that it is impossible for one human being to communicate one exact meaning to another human being. Everything that is in fact written or spoken will contain several possible meanings. This is what is meant by 'the indeterminacy of language'. Structuralists believed that, if the key to human and social behaviour was to be found anywhere, it was to be found in the codes and structures of language. Much attention was paid to the nature of literary forms, and theories developed about the rules governing 'narrative', 'emplotment', and so on.

4. Discourse and the Discursive

These concepts concern the relationship between knowledge and power, whether that power resides entirely in some impersonal structure, or whether it is in the hands of the bourgeoisie. Discourses are cultural formations related to particular structures of power obtaining at particular points in time. The word 'discursive' refers to the way in which all cultural products, knowledge, texts, and so on are imbricated within the prevailing power structure. Foucault spoke variously of 'discursive formations', 'discursive practices', and 'epistemes', the last of which may be defined as 'comprehensive bodies of organized knowledge (conceptions of the world, sciences, philosophies,

etc.) characteristic of a social group and an era'. The basic notion that in any historical period there are clear limits upon what can be known or believed is one that would find broad sympathy with professional historians. The conclusion to which theories of the discursive tended, however, was that of the relativity of all knowledge: postmodernist theory rejects the belief that there can be any objective science, or any objective history.

5. *The Death of the Author*

This slogan is very much in keeping with the apocalyptic nature of some of the pronouncements we have already encountered and with notions of the indeterminacy of language and the relativity of cultural forms. The most explicit statement appears in the essay entitled 'The Death of the Author' by Barthes. The author is situated within a broadly Marxist historical period, being presented as the purveyor of capitalist ideology:

The author is a modern figure, a product of our society in so far as emerging from the Middle Ages with English empiricism, French rationalism, and the personal faith of the Reformation, it discovered the prestige of the individual or, as it is more nobly put, the 'human person'. It is thus logical that in literature it should be this positivism, the epitome and culmination of capitalist ideology, which has attached the greatest importance to the 'person' of the author.

The essay ends with the following dramatic statement, stressing that with regard to the meaning of a text, it is the reader who is all-important: 'a text's unity lies not in its origins but in its destination . . . the birth of the reader must be at the cost of the death of the author.'[3]

Postmodernist Novels in France and Italy

Contemporaneously with structuralism, and closely related to it, there emerged the *nouveau roman*. Sartre was a novelist and playwright as well as a philosopher; the writers of the new novel, who saw themselves as in revolt against Sartrean humanism and commitment, produced theoretical treatises as well as novels. Among the leading early proponents of the new novel

were Nathalie Sarraute (1902–99), Claude Simon (b. 1913), Marguerite Duras (1914–96), Robert Pinget (1919–97), Alain Robbe-Grillet (b. 1922), and Michel Butor (b. 1926); almost inevitably the modishness and sectarianism that is one of the less fetching aspects of creative extremism led, just as structuralism was to be supplemented by poststructuralism, to the later version being termed the *nouveau nouveau roman*. The critical point about the new novelists (and still more the new 'new new' novelists) is that, like all of the other intellectuals discussed in this chapter, their driving force was radical hostility, Marxist or neo-Marxist, to existing society: the enemy was the bourgeoisie, bourgeois 'liberal humanism', and in this particular case 'the bourgeois novel', which was seen as having achieved its apogee in the mid-nineteenth century. The fundamental aim of the new novel was to deny everything that went to make up the traditional novel: there would be no linear narrative, no plot, no suspense, no characters with defined identities; events would be recounted in the arbitrary mode of the human mind, stretched, abridged, repeated; meaning would come, not from individual passages of realism, but from the work as an entity (parallels with some of the *nouvelle vague* films are self-evident and with the notion of an overarching *structure*). Openly welcoming the theories of Barthes, the new novelists strove for a 'degree zero' free of bourgeois contamination. From the structuralism of Lévi-Strauss, they took the notion of *bricolage*, literally 'cobbling together', the incorporation in their novels of bits and pieces of myths and cultural stereotypes.[4]

As we saw in the previous chapter, this was a particularly welcoming time for young genius, and Paris could certainly be very kind to the young, especially those with the right background and the right backing. Philippe Jayause was born at Bordeaux in November 1936, into a factory-owning family with the suitably upper-class preoccupations of hunting and shooting. In 1957, at the age of 20 and under the name of Philippe Sollers, he published the brief work (thirty-five pages), *Le Défi* (*The Challenge*). In 1958 this was awarded the literary prize, the Prix Fénélon, just as Sollers published his first novel, *Une curieuse solitude* (*A Curious Solitude*). The critical acclaim was led by two established literary figures, Émile Henriot and Louis

Aragon.[5] A number of other senior figures now joined with Sollers in founding the new journal that perhaps best expressed the distinctive intellectual trends of 1960s Paris, *Tel quel*. The first number, published in the spring of 1960, uncompromisingly declared its faith in Marxism, structuralism, and a self-proclaimed puristic commitment to literature.

Only briefly associated with *Tel quel*, Robbe-Grillet remained the major theorist on behalf of the new novel, as well as its leading practitioner. Born in 1922 in Brittany, he came from a right-wing, anti-Semitic anglophobe bourgeois family. He trained as a scientist and originally embarked on a career in agronomy. Completed in 1949, his first novel, *Un régicide*, was not published until 1978, well after his name had become established. His *Les Gommes* (*The Rubbers*) of 1953 won the 1954 Prix Fénélon, which helped to pave the way to his becoming literary director of the important publishing house Éditions de Minuit. In 1955 his *Le Voyeur* was attacked by most critics, who deemed it unreadable. But in the intellectual world he attracted much attention with his 1958 essay, 'Nature, Humanisme, Tragédie' in the *Nouvelle revue française*, for two reasons: in the manner of Barthes, he attacked the use of metaphor and warned about the hidden values encoded in language, while along the way he managed to attack two of the great literary landmarks, *La Nausée* by Sartre and *L'Étranger* by Camus. The publication of *Dans le labyrinthe* (*In the Labyrinth*, 1959) is said to mark the transition from the *nouveau roman* to the *nouveau nouveau roman*. Broadly the change meant still more of the same, with a heightened emphasis on the autonomy of the text, the absence of the author, arbitrary shifts in the use of pronouns, and 'indeterminacy' (a key notion in all the arts at this time, here implying a fundamental role for the reader in selecting meaning), together with a more aggressive eroticism (challenging bourgeois morality of course, but in fact also part of the 'permissiveness' identified in Chapter 4).

Meantime, that gentle leader of, and guide to, taste among aspiring young middle-class couples, *L'Express*, had commissioned Robbe-Grillet to write a series on the new novel. This was reprinted in book form in 1963 as *Pour un nouveau roman*. Robbe-Grillet wrote:

Story-telling, as it is understood by our academic critics—and, following them, many readers—represents an orderly world. That order, which is perceived as being natural, is tied to a whole system, rationalist and systematic, whose expansion corresponds with the taking of power by the bourgeois class. In that first half of the nineteenth-century, which saw the apogee—with *La Comédie humaine* [by Balzac]—of a narrative form which for many remains a paradise lost of the novel, several important certainties held sway: in particular a confidence that the arrangement of things was both just and universal.[6]

It was that confidence, of course, that the new novel set out to subvert. It must, he said, be primarily literary, but it may finally serve the revolution. Robbe-Grillet became a public figure in other ways as well. As we noted, he wrote the script for the film directed by Alain Resnais, *L'Année dernière à Marienbad* (1960), a great success in France and a cult film abroad, winner of the 1961 Golden Lion at Venice. Demonstrating an almost Sartrean commitment, he signed a manifesto against the continuation of the Algerian War, and in favour of independence for the Algerians, the *Manifeste des 12*. More films followed: *L'Immortelle* of 1963, which won the Prix Louis Delluc; *Trans-Europe-Express* in 1966; and *L'Homme qui ment* in 1968.[7]

That Robbe-Grillet and the other new novelists had great literary gifts cannot possibly be denied: the effects they produced, exhilarating or tedious (at one extreme was *choisisme*, the exclusive concentration on inanimate things, in preference to human beings), were the results they very deliberately and skilfully aimed to produce. Robbe-Grillet's *La Maison de rendez-vous* (*The House of Assignation*, 1965), again a novel reflective of the arbitrary workings of the mind, is certainly not tedious, being loaded with all the ingredients of the classic exploitation novel: Lady Ava's *Villa Bleu* in Hong Kong, trafficking in drugs and girls, murder, espionage, sensual musings. *La Route de Flandres* by Claude Simon, based on his experiences as an escaped French soldier of the time of the fall of France, is an intensely rich novel but deliberately restricted to what the central character could have been aware of (the omniscient narrator of the bourgeois novel was anathema to the *nouveau roman* novelists). Yet so complex were the themes that in the final stages of the writing Simon used coloured threads to represent each one,

'weaving them together to make the design visible to his own eyes'.[8] But Sollers is the man we have to watch. His novel *Parc* (*Park*, 1961), which won the Prix Medici, was reckoned to be in the *nouveau roman* mode. Then in 1964 and 1965—after escaping military service in Algeria thanks to the personal intervention of de Gaulle's minister of culture, André Malraux—he violently attacked first Robbe-Grillet then the *nouveau roman* itself, accusing it of 'academicism' and 'false avant-gardism'.[9] His allegiance, and that of *Tel quel*, was with Foucault, Barthes, Lacan, Althusser, and thoroughly Marxist poststructuralism. He developed the theory of the 'revolutionary text', a mode of production that subverts bourgeois ideology by attacking the conventions of realism. Sollers experimented with drugs, then in 1968 showed his solidarity with Mao by beginning to learn Chinese.

While the French 'new novel' and the early ideas of Barthes were taking shape in the 1950s, the dominant literary mode in Italy was still 'new realism'. Thus in the world of ideas there was an even sharper break at the beginning of the 1960s in Italy than in France, with the appearance of 'neo-avant gardism', 'experimental modernism', 'the new poetics'. The preoccupations are very much those of the French figures I have been discussing: semiology, the 'decentring' (or death) of the individual subject, a complete break with commercialism and bourgeois traditionalism (with regard to the last point, the Italians acknowledged a debt to the German writers, who in setting up Gruppe 47 immediately after the war had sought a total rupture with the past). Among the major new figures were Umberto Eco (b. 1932), philosophy graduate, author of a dissertation on medieval society and thought, deviser of a tape in homage to James Joyce, interpreter of modernism, student of contemporary popular culture, and Italy's major semiologist, and Nanni Balestrini (b. 1935), contributor to the 1961 anthology of poetry, *I novissimi*. One of the most prestigious figures of the older generation, Italo Calvino (1923–85), was already in the 1950s delving in his novels into the worlds of fantasy, myth, and allegory: but it was only in the 1960s that he turned to novels dealing with the creation of the cosmos—*Cosmicomici* (*Cosmic-comics*, 1965) and *Ti con zero* (*You from the Beginning of Time*,

1967—somewhat absurdly translated into English as *Time and the Hunter*)—works that seemed to echo Foucault's ideas about the insignificance of humanity in the total history of the universe. Eco began to receive something of the same attention attracted in France by his contemporaries there, with the publication of *Opera aperta: Forma e indeterminazione nelle poetiche contemporanee* (*Open Work: Form and Indetermination in Contemporary Poetics*, 1962), whose basic thesis was that modernist works are characterized by 'openness'—that is to say, their meaning is very much open to the individual interpretation of the individual reader. Eco, who became a considerable celebrity, is the most directly influential figure, perhaps second only to Barthes, in popularizing the idea of the systematic scholarly analysis of the many different aspects of popular culture. The two major works developing his structuralist and semiological interests were *La struttura assente* (*The Absent Structure*, 1968) and *Le forme del contenuto* (*The Forms of the Content*, 1971).[10]

Balestrini was born into a prosperous Milan family; his mother was German, and the family avoided the worst of the war on Lake Como, where Balestrini went to a private school. He refused to follow his father into engineering, becoming instead a poet and publisher, a member of the new avant-garde, dedicated to a literature that, in rupturing the accepted relationship between language and meaning, forswearing narrative content, and abandoning literary craftsmanship, would in itself embody a comment on the (as he saw it) nakedly commercial conditions of all production in late capitalist society; the echo of the intentions of the new novelists in France is strong. Along with Eco, Balestrini was active in founding Gruppo 63, which, apart from the conscious echo of the German Gruppe 47, kept in close touch with the *Tel quel* group in Paris. Balestrini programmed his computer to produce poetry—the ultimate in literature as commodity. His first novel, *Tristano* (1966), consists of ten chapters of ten paragraphs, each of twenty-four lines; the paragraphs are culled either from romances or from technical handbooks. There is formal perfection, but interpretation, as Eco argued should be the case, is in the hands of the reader.

The Appeal of Poststructuralism and Postmodernism

Poststructuralism developed into postmodernism, which, looking beyond the period covered by this chapter, became the single most powerful intellectual system—and belief system—in the 1980s. As we have seen, postmodernism (through its founding figures Foucault, Barthes, Althusser) inherited a strong radical Marxist constituency, which greatly increased as traditional Marxism suffered blow after blow. Many aspects of postmodernist theory had a liberating feel about them: the insistence on plurality and difference; the abandonment of 'grand narratives', of which, of course, traditional Marxism was the grandest; the recognition of the insecurities of language and the lack of a direct correspondence between language and reality, if not the whole-hog position of everything being constructed within language.

Geraldine Finn spoke for a substantial element in an entire generation when she wrote that postmodernism seemed 'to open up spaces in culture and consciousness where we can speak, hear, and recognise other and heretofore subordinated histories, realities, reasons, subjectivities, knowledges and values which have been silenced and suppressed and certainly excluded from the formulations and determinations of the old modernist project'.[11]

7　The Élite Arts

Art Music

The first three chapters of Part Two have been largely concerned with the more obvious and direct artistic manifestations of cultural, social, and intellectual change. I return now to those art forms that, superficially at least, are furthest removed from the marketplace, least obviously embody responses and reactions to the social and political environment: music, painting, sculpture, poetry, experimental theatre, and architecture. In fact, these apparently more remote art forms provide some of the most persuasive evidence of the all-embracing nature of change in the long Sixties. Before coming to architecture—which certainly impinges massively on everyone's environment, and which, like the other subjects discussed, was affected by a strong current of political commitment—I insert a comment on the mixing of history (including genuine primary sources) and fiction.

In my earlier discussion of art music I highlighted the notion of the Second World War requiring a complete break in musical tradition, with Pierre Boulez as the prime protagonist of this position. There were developments in a more ruthless, more mathematical, serial music, in electronic music, in *musique concrète*, and in aleatoric music. The post-war avant-garde musicians eschewed the melodies and harmonies of the past; what they wrote did not make for comfortable listening and, while certainly sounding radical and revolutionary, did not otherwise convey anything in the way of an emotional or political programme. Yet the composers I am about to discuss did have strong political commitments, generally to the radicalism and utopianism that characterized the protest movements of the 1960s. There is a desire to take art music beyond its tiny audiences, and a concern with the relationships between élite culture

and popular culture. There is the stern, unbending modernism of Boulez; but there is also the playfulness, the mixing of genres, the blending of historical periods, the rejection of grand programmes, all elements of postmodernist style. Apart from John Cage, who, anyway, is more important as a theoretician than as a composer, the most radical figures were all European. Yet America, and the patronage it offered, were very important to them. Luciano Berio (b. 1925), after remarking that 'Music doesn't escape the law of the marketplace', described the United States as undoubtedly

the most musical country in the world (in the sense that the majority of people have a direct and real contact with music making), has a very high standard of performance, a staggering number of orchestras—and an American orchestral musician earns in a week what his Italian equivalent earns in a month . . . The most lively, authentic and interesting forms of American creativity are to be found in commercial music and, perhaps, in the really advanced research on music created with computers or synthesizers (linked to the electronics and computer industries). In the middle, between these two extremes—rock, pop, disco and jazz on the one hand, and 'technological' and digital music on the other (extremes which in America often overlap and influence each other on the level of pure *sound*)—there's the music of serious composers which naturally has no market . . .

Such composers, he says, do well materially, but their music has 'nobody really to address itself to . . . it is fundamentally a music of solitude'.[1]

Karl Heinz Stockhausen (b. 1928) studied music in Cologne and then in 1952–3 with Messiaen and Milhaud in Paris, where he made his first experiments with electronic music. On his return to Cologne he co-founded the pioneering Electronic Music Studios of the West German State Radio in 1953. He produced various works experimenting with electronics, synthesized sounds, children's voices, and serial techniques. In 1958 he went to the United States, where he absorbed John Cage's ideas about aleatoric music. In *Aus den sieben Tagen* (*Out of the Seven Days*, 1968) the 'score' consists of an instruction to the players to fast in silence for four days and then to improvise without conscious thought. Stockhausen's world philosophy comes out clearly in his 'Manifesto for the Young', originally

published in the *Journal Musical* of Paris on 16 June 1968 (when the famous Parisian 'events' of 1968 were still at high intensity):

Once again we are revolutionizing—but throughout the entire world this time. We are now setting ourselves the highest possible goal: a development of consciousness where the whole of humanity is at stake . . .

The higher self should provide reason with something to think about, receiving its impulse from the intuitive consciousness which is in turn fed by the higher and higher consciousness, linking every individual consciousness with supra-personal cosmic consciousness.[2]

These ideas, and the aleatoric, were embodied in *Hymnen* (1966–7), for orchestra and electronic sounds, which was a recomposition of several national anthems into a single universal anthem. *Stimmung* (*Tuning*), played at the 1970 World's Fair in Japan, scored for six vocalists with microphone, contains texts consisting of names, words, days of the week, in German and English, and excerpts from German and Japanese poetry.

By the 1960s Boulez was becoming the great impresario and celebrity of ultra-modern music, composing less and less, but entering on a sparkling career as a conductor, with much time spent in the United States. In 1966 he was the specially featured composer at the Edinburgh Festival, and in 1971 he became Director of the New York Philharmonic Orchestra. Subscriptions, however, fell off as he tried to introduce audiences to contemporary music. France summoned him back and in 1976 he founded, and the French government funded, the computer-based Institut de Recherche et de Coordination Accoustique-Musique (IRCAM) attached to the Pompidou Centre in Paris, directed by Boulez himself. Opening in 1977 the Institut had its own performance group, the Ensemble Intercontemporain. Boulez appointed Luciano Berio as Director of the Institut's Electronic Music section. Europe, one might say, was reclaiming its own.

Berio was a much less austere figure than Boulez. His *Circles* (1960) is a setting of three poems by e.e. cummings, where the attempt is made to create in sound an analogue of the experimental nature of the poetry. Room is left for the performers to make some of their own choices in performing the music.

Sinfonia (1969) may be thought of as postmodernist because of the way it incorporates quotations from other composers such as Mahler and Richard Strauss. The real hard-line Marxist among musicians was Berio's fellow Italian Luigi Nono (1924–90). Nono's equal commitment to everything that was most advanced in music was sealed by his marriage to Schoenberg's daughter Nuria in 1955. His chamber opera *Intolleranza 1960*, premièred in his home town of Venice in 1961, attacked Fascism, racial segregation, and the atom bomb, and ends with the world being flooded and destroyed. Marxist revolution with a vengeance! The performance was stormed by neo-Fascists, and a riot ensued between them and the Communists. The work survived, and reappeared ten years later as *Intolleranza 1970*. World political concerns are again obvious in the dramatic cantata of 1962, *Su le ponte di Hiroshima* (*On the Bridge of Hiroshima*). Nono's enthusiasm for the Chinese 'cultural revolution' led to him giving his daughter a Chinese name, and composing in honour of her birth *Per Bastiana Tai-yang Cheng* (1967); this aleatoric work required magnetic tape and three instrumental groups playing in quarter tones.[3]

Steve Reich, born in New York in October 1936, is usually labelled a 'minimalist', since his emphases were on repetition and extreme reduction of musical means. Experimenting in 1965 with tape loops, he noticed that two tape recorders did not run at the same speed, thus producing a time shift between the two loops. 'Phase shifting' was employed in the first half of *It's Gonna Rain*, a tape piece of 1965, based mainly on excerpts recorded by Reich from a black minister preaching about the Deluge. *Melodica* (1966), instead of words, used the children's toy instrument, the melodica. *Come Out* was performed in New York City Hall in 1966 as part of a benefit conference on behalf of imprisoned black activists, the 'Harlem Six'. *Pendulum Music* (1968) was composed for microphones, amplifiers, speakers, and performers—in effect an electronic, multimedia event.[4] The development whereby Reich had his own 'group' to play his own music mirrored the similar trend in rock/pop initiated, the other way round, by the Beatles, who had moved rapidly from playing the black rhythm and blues classics to composing their own numbers.

The puristic avant-garde composers contributed to the expanding repertoire of musical languages, but it was the more eclectic composers who won over audiences. Britten's older rival, Michael Tippett (1909–98), achieved a belated recognition in the 1960s. His opera *The Knot Garden* (1966–9), which focused on the resolution of amorous difficulties through play-acting, included both jazz and blues, and references to Mozart's *Cosi fan tutte*. The *Third Symphony* (1970) included a soprano blues in the finale.

Paintings and Assemblages

We have noted the triumphs of Abstract Expressionism and post-painterly abstraction. In the mid-1950s a rather different type of art, associated particularly with Jasper Johns (b. 1930) and Robert Rauschenberg (b. 1925), began to emerge, initially referred to as neo-Dada or, in some of its aspects, as Junk Art. Johns's illusionistic painting of such familiar objects as the American flag or his bronze replicas of beer cans conjured up memories of Marcel Duchamp and his ready-mades. Rauschenberg produced what he called 'combine painting' in which a painted surface is combined with various found objects; sometimes these became three-dimensional structures. He had long been associated with the Merce Cunningham Dance Company, and also with our old friend John Cage. A number of 'happenings' were organized in the 1950s, culminating in Allan Kaprow's *18 Happenings in 6 Parts*, presented in 1959 in New York.

British Pop Art sprang from two very different sources, the one organized and intellectual, the other personal and inspirational. The intellectual element came from a coterie of artists and critics, including Eduardo Paolozzi (b. 1924 to an Edinburgh/Italian family), Reyner Banham (architectural historian, critic, and journalist, 1922–88), Lawrence Alloway (art critic, 1926–90), and Peter (b. 1923) and Alison (1928–93) Smithson (both architects), who, calling themselves the Independent Group, were from 1952 holding meetings at the recently formed Institute of Contemporary Art. The pre-occupation of the group was with consumer goods, mass

communications, and urban lifestyles so manifest in the America of the time, though scarcely yet present in Britain. In 1956 the group organized an exhibition at the Whitechapel Art Gallery entitled 'This is Tomorrow', an exhibition as much about the artefacts of American urban culture (which is what the organizers meant by 'pop') as it was about representations of, or artistic references to, that culture (what came to be known as 'Pop Art'). In the entrance, however, was what is often regarded as the prototype British Pop Art painting, reproduced also as a catalogue illustration and poster for the exhibition: *Just what is it that makes today's homes so different, so appealing?* by Richard Hamilton (b. 1922). The new art, Hamilton declared a year later, should be characterized by 'popularity, transience, expandability, wit, sexiness, gimmickry and glamour; it must be low-cost, mass produced, young and Big Business'.[5]

The spontaneous, and much more youthful, element came from a group of students at the Royal College of Art. At the time of the 'This is Tomorrow' exhibition, Peter Blake (b. 1932) was in the final year of his postgraduate studies when he painted *Children Reading Comics*, described in the guide to Royal Academy Pop Art exhibition of 1991 as 'typical of his approach in its affectionate acceptance of popular art forms and its nostalgic recreation of a moment from his own youth'. Meantime, older fellow student Joe Tillson (b. 1928) was beginning to produce his distinctive toylike painted constructions. A third RCA student, Richard Smith (b. 1931), shared a studio with Blake during 1957–9. Smith went to America in 1959, thus coming directly into contact with such artists as Jasper Johns.

In the movements and 'isms' of modern art, critics and publicists have often played conspicuous roles (the analytical, the explicit, the reflexive are noteworthy characteristics of cultural movements in the 1960s, from the French *nouvelle vague* at the beginning of the decade to 'art and language' at the end of it). On 27 October 1960 the critic Pierre Restany brought together a number of established artists in Paris to form the *nouveaux réalistes* (new realists). The founder members of the group were Arman (b. 1928), Raymond Hains (b. 1926), Yves Klein (1928–62), Martial Raysse (b. 1936), Daniel Spoerri (b. 1930), Jean Tinguely (1925–91), Jacques de la Villeglé (b. 1926), and the

Italian Mimmo Rotella (b. 1918); these were subsequently joined by César (b. 1921), Niki de Saint-Phalle (b. 1930), and Christo (b. 1935). Restany declared the aims of the group to be purely sociological (an interesting anticipation of one of the things Georges Perec was to say about *Things*); theirs was an art concerned with the reality of the new urban environment. The works were not, of course, 'realistic' in the sense in which that term is commonly understood. *Crucifixion* (1963), by Niki de Saint-Phalle is a vast, vulgar doll, suspended in crucifixion position, revealing a great mass of pubic hair. The fascinating and wittily eccentric sculptures of Jean Tinguely are contrived out of all sorts of junk.

Yves Klein died in 1962 at the age of 34. Jazz musician and judo expert as well as painter, he is most important as publicist, as creator of some dramatic action paintings, and as sponsor of some highly distinctive happenings. His most famous creations were the *Anthropométries* (1959–61), when he had twenty musicians play his own *Monotone Symphony*, a single note held for ten minutes, alternating with ten minutes' silence, while naked girls smeared with blue paint flung themselves on a canvas spread on the floor. Rivalling Klein in extremism was the Italian Piero Manzoni (1929–68). Manzoni, who experimented with body art, performance art, and conceptual art, is most notorious for his series of tins of his own excrement, *Merda d'artista* (1961),[6] making quite a pungent point about the commodification of art.

Early in 1961 the 'Young Contemporaries' exhibition of student art in London introduced what should really be called post-Pop Art: much more varied than the original 'Pop Art' and much more open to influences outside Pop strictly defined. Among the artists were Derek Boshier and David Hockney, both born in 1937, and Patrick Caulfield, born in 1936. In the main Caulfield and Boshier, in slightly different ways, took their images from contemporary consumer society, but in a manner that is both witty and clearly deeply critical of that society. Hockney's freshly playful paintings, combining abstract and figurative elements, contain strongly personal and autobiographical elements, his own homosexuality being strongly hinted at in *Going to be a Queen Tonight* (1960), *Bertha Alias*

Bernie (1961), and *We Two Boys Together Clinging* (1961). Hockney, with 'his dyed blonde hair, owlish glasses, and gold lamé jacket',[7] became a symbol of the new, more approachable art, as the Beatles were the symbol of the new popular music (and, like them, moved into the celebrity category).

In 1963 the Whitechapel Gallery held the first public exhibition of the brightly painted welded metal constructions of Anthony Caro (b. 1924), followed by the exhibition in Battersea Park: 'Sculpture: open air exhibition of contemporary British and American works'. The Battersea exhibition featured most notably the American David Smith (1906–65), as well as Caro and some of those British sculptors who were soon to be known as the 'new-generation' group (Barry Flanagan (b. 1941), Richard Long (b. 1945), and Tony Cragg (b. 1949)). Caro's apprenticeship as a sculptor was served between 1951 and 1953 as an assistant to Henry Moore (1898–1986). He visited the United States in 1959, where he was deeply influenced in particular by the colour-field abstractions of Kenneth Noland (b. 1924), by the abstract metal constructions of David Smith, and by the theories of the critic we have already met, Clement Greenberg. Striking early examples of the new welded metal sculptures, painted in brilliant colours, that Caro now began to produce are *Twenty-Four Hours* (1960) and *Early One Morning* (1962).

The Museum of Modern Art in New York in 1961 held a significant exhibition, 'The Art of Assemblage'. In essence, assemblage abolishes the distinction between painting and sculpture. Pop Art in America now entered what is usually described as its classic phase, involving on the one side assemblages of many kinds, though most often created from the junk of contemporary society, or meticulous replicas thereof, and, on the other, two-dimensional works featuring advertising images, strip cartoons, and representations of the idols of popular culture. Leading figures of the latter tendency are Andy Warhol (1928–87), with his silk-screen productions of such stars as Marilyn Monroe, Roy Lichtenstein (1923–97), with his painted simulations of the heroes and heroines from newspaper comic strips, James Rosenquist (b. 1933), using glossy billboard advertising images, and Tom Wesselman (b. 1931), with his still

lifes featuring such products as Coca Cola and Lucky Strike cigarettes. The leading figure in the assemblage tendency is Claes Oldenburg (b. 1929), whose subjects ranged from junk food to consumer durables, often in gigantic scale and made of vinyl stuffed with kapok. Jim Dine (b. 1935) staged *Car Crash* (1959–60) both as a happening and then as a permanent assemblage. Ed Kienholz (b. 1927), in California, produced multiple assemblages, sometimes referred to as 'funk art', art with such a bizarre, sick quality that it suggested overt criticism of contemporary society. One of the most alarming of the early pieces of funk art was the American assemblage *Couch* (1963) by Bruce Conner (b. 1933), a decaying Victorian sofa on which there appears to be a rotting and dismembered corpse.[8]

The artist who commanded attention, who embodied spectacle, who became a celebrity, was Andy Warhol. In the 1950s he was an extremely prosperous designer and illustrator. At the very end of 1963 he moved to a spacious fourth-floor loft at 231 East 47th Street, between 2nd and 3rd Avenues, not far from Grand Central Station. Redecorated mainly in silver, this was named 'The Factory'. Warhol perceived that with conceptual art (and here the term 'art' includes his films) you could outrage people and gain enormous publicity through people simply being made aware of the concept, without ever having actually to view the painting, sculpture, or film. The Warhol exhibition that opened at the Stable Gallery, New York, on 21 April 1964, was in itself a concept. It was his first exhibition of his three-dimensional grocery carton 'sculptures'—carefully made and carefully silk-screened boxes purporting to be for Kellogg's corn flakes, Heinz ketchup, Brillo Pads, and so on. The Gallery took on the appearance of a wholesaler's warehouse. The link between Warhol's first multi-reel film, *Sleep*, an eight-hour study from fixed camera positions of a male friend of Warhol's asleep in his bed at nights, and painting, as traditionally understood, is relatively clear: there is a long tradition in Western art of paintings of sleeping subjects. Two more 'motionless' films followed, each about half an hour in length: *Eat*, which showed a fellow artist eating a mushroom, and *Blow Job*, which is fixed entirely on the face of the young man who is having this sexual

act performed on him by a number of other males. Two sound films followed: *The Life of Juanita Castro*, satirizing the Cuban Communist leader Fidel Castro, and *Vinyl*, a spoof on British novelist Anthony Burgess's novel about excessively violent youth in a future society, *A Clockwork Orange*. In 1966 there came a film that was considerably more sophisticated than anything that had gone before, *Chelsea Girls*. This is a slow film, featuring drugged and drug-taking drop-outs and snatches of desultory conversation. With respect to explicit sex and full frontal nudity, Warhol's films so far had been rather coy. He now moved on to two much more explicit films, *Lonesome Cowboys* and *Blue Movie*: the central sexual act in *Blue Movie* was not simulated. This film played for a week before, on 31 July 1969, New York City Police seized it; shortly after it was declared to be obscene.[9]

In terms of publicity value, Warhol's nearest rivals on the European continent were Michelangelo Pistoletto (b. 1933) in Italy and Joseph Beuys (1921–86) in Germany. Pistoletto's early work was in the form of assemblages of mirrors and life-size photographic figures, the mirrors amplifying the composition in various ways, not least of which was the incorporation of the spectator himself or herself. Pistoletto quickly diversified to a range of stunning sculptures and assemblages, still sometimes employing optical effects, usually with a title indicating some deep conceptual problem. Beuys had been a pilot in the German Air Force during the Second World War, and was severely injured in an air crash. In his 1960s assemblages he took to making particular use of felt and fat, which for him had particular symbolic significance, as well as (frequently) bottles and instruments reminiscent of a hospital. Beuys was an impresario and an activist, being a founder of the German Green Party. Saying that 'everybody is an artist', he aimed to shift attention away from what the artist produces to the 'artistic' being, a 'personality', famous for his actions and opinions. Both Pistoletto and Beuys were included in an exhibition mounted at Genoa in 1967 by the Italian art critic Germano Celant (b. 1940). Celant coined the term 'art povera' (poor art—note Celant used the English 'art' in preference to the Italian 'arte') to cover the work of Pistoletto, Beuys, and a considerable range of artists

from New York, the Netherlands, three English cities, West Germany, and Italy.

One of the Americans featured by Celant was Carl André (b. 1935), who (again sign of the times) actually did most of his work in Europe. André became most noted for his installations consisting of basic materials placed on the floor, timbers, or building bricks. Such 'art', in a rather obvious way, poses general questions about what 'art' is; it is also, in an obvious way, 'minimalist'. Among British artists, Celant included Barry Flanagan and Richard Long, both strongly influenced by Anthony Caro. Looking back on Caro's protégés a quarter of a century later, traditionalist art critic Peter Fuller put matters sourly, if wittily: 'Caro had declared that sculpture could be anything; but his rebellious pupils took him more literally than he intended. Barry Flanagan and Nicholas Pope reduced the art to placement of barely worked materials. Others started digging holes, taking photographs, and even walks, and calling that sculpture too.'¹⁰ Flanagan's work was certainly highly distinctive, and is always immediately recognizable, basically consisting of coloured hessian sacks filled with paper, foam, or sand: this was variously described as Process Art, Anti-Form, or Post-minimalist. Flanagan then moved into Temporal Art, constructions that are dismantled after being viewed. Long was an Earth Art man: he presented maps and photographs of landscape as well as arrangements of stones. Leading American figures in Environmental and Earth Art were Michael Heizer (b. 1944) and Robert Smithson (1938–73).

The succeeding fashions were for Performance Art and Superrealism. If we wanted to look at early 1970s art as representing 1960s innovations overstated and then made banal, an appropriate place to start would be with Gilbert (b. 1943) and George (b. 1942). Gilbert and George were still sculpture students at the St Martin's School of Art when they attracted international attention for a peculiar and highly personal twist on the notions of art as 'performance' and as being 'temporal': in what was first called 'Our New Sculpture', then 'Underneath the Arches', and finally 'The Singing Sculpture', they themselves posed as their own 'sculptures'. The next stage was to seek a permanent form for these 'living sculptures': 'they began

to use the traditional media of painting and drawing, in a novel and witty way', creating numerous 'drawing pieces', 'charcoal on paper sculptures', and one huge 'painting sculpture', in all of which the posed image of the artists appeared life-size.[11] In 1971 Gilbert and George turned to photography, creating the 'photo-piece' that was henceforth to be the basic form of their art. Words and phrases often appear on these photo-pieces, seeming to maintain a link with Conceptual Art: but Gilbert and George saw themselves as 'New Realists'. From 1973 there was an emphasis on urban settings: many appeared to be about drinking and drunkenness. The Nature photo-pieces of the early 1970s seemed to have much in common with Earth Art. But Gilbert and George were great self-publicists, and very soon they began to insist that they were not of the narrow world of conceptualism: theirs was an art of the people. To many critics it seemed merely simplistic and meretricious. The *Life of the People* seemed to be the life of the lavatory wall: titles ran from *Prostitutes Poof*, *Shag Stiff*, and *Wanker* to the less and less printable, the photo-pieces often incorporating photographs of male sex organs. The unmediated photographs of Robert Mapplethorpe (1946–89), who had his first exhibition in New York in 1972, aroused not dissimilar reactions, many being of male genitalia (black and white) or of sadomasochistic male homosexual encounters.

The driving forces behind Superrealism, as well as the label itself, were American, but in fact many Europeans were independently going in the same direction, and the label was very easily adapted into the European languages. In Italy the hyper-inventive Pistoletto, with his life-size photographs pasted onto sheets of steel that reflected the spectator, was already developing his own type of Superrealism. The leading figure in France was Jacques Monory (b. 1934), and in Germany Gerhardt Richter (b. 1932). In Britain Lucien Freud (b. 1922) had long been producing meticulous warts-and-all nudes, which, as has been said, appear naked rather than nude. The arrival of Superrealism as a main trend in European art was signalled by the Documenta V exhibition in Kassel in West Germany in 1972. The leading Superrealists are the Americans Duane Hanson (1925–96), Ralph Goings (b. 1928), Richard

Estes (b. 1936), Chuck Close (b. 1940), and John De Anviea (b. 1941). Malcolm Morley (b. 1931) was English, but had worked from New York since 1964. At its best Superrealism was exploring the nature of reality; most Superrealist paintings (though not all) were based on photographs, not directly on reality. They present a very intense, cold, distant, version of life, totally without sentiment or rhetoric.

Sculptor Duane Hanson did go beyond neutrality, seemingly commenting on the emptiness of materialist society. Referring to such works as *Couple with Shopping Bags* (1976), he has said: 'My most successful pieces are naturalistic or illusionistic, which results in an element of shock, surprise or psychological impact for the viewer. The subject matter that I like best deals with the familiar lower- and middle-class American types of today.' This work, he adds, reveals 'the emptiness and loneliness of their existence'.[12] However, 'empty', 'brutal', and 'frozen' are adjectives that readily suggest themselves to describe most Superrealistic art. The Italian art critic Lea Vergine has a marvellous description: 'il rigurgito reazionario' (the reactionary regurgitation).[13]

Let me conclude this section on a more inspiring note—for the powerfully realized, though far from exactly representational, warrior heads, male nudes, and horses with rider by English sculptor Elizabeth Frink (1930–93), toughly and uncompromisingly female (rather than feminist), are truly inspiring. Her imaginative world, her obituarist Bryan Robertson (*Independent*, 20 April 1993) told us, was 'quite radically affected, if not fully formed, by the war'.

Her father was at Dunkirk as a professional soldier, and saw much action elsewhere; the family at home lived near an airfield in Suffolk where bombers often returned to base in flames. As a very young schoolgirl, Frink had to hide in the hedges from the machine-gun attack of a German fighter plane. As a 15-year-old schoolgirl, she watched on her local cinema screen the first appalling news pictures of Belsen. Her earliest drawings, even before she went to Chelsea School of Art in 1949, were powerful but grim in tone: wounded birds, apocalyptic horses and riders, falling men.

Poetry

Andy Warhol went beyond mere assemblages, Earth Art, Conceptual Art, etc., and into film and light shows. All through the later 1960s there were examples of happenings and performance art. Such art moves across the boundaries towards theatre. But it is now time to turn in the direction of poetry, a possible bridge being provided by the London Institute of Contemporary Arts Exhibition of 1965, 'Between Poetry and Painting', which, among other things, demonstrated how poetry could form into distinctive shapes, like some paintings. Such poetry attracted to itself one of these adjectives which we keep finding in different contexts in the 1960s: hence, 'Concrete Poetry'. Actually, what claimed to be 'the first international exhibition of concrete and kinetic poetry' had taken place the previous year not all that far away, in Cambridge, organized by Michael Weaver. Weaver distinguished between three kinds of concrete poetry: visual (or optic), phonetic (or sound), and kinetic (moving in a visual succession), and argued that concrete poetry was related either to the constructivist or to the expressionist tradition in art. The constructivist poem results from an arrangement of materials according to a scheme or system set up by the poet that must be adhered to on its own terms (permutational poems). In the expressionist poem, the poet arranges the material according to an intuitive structure.[14]

Some authorities credit a 21-year-old Italian aristocrat, Carlo Belloli, with producing the first concrete poems, though in fact a sort of concrete poetry was being produced in the United States in the 1930s by e.e. cummings. Belloli wrote and displayed his TESTI-POEMI MURALI (mural poetic texts), and in 1959 enunciated his theory of audio-visualism (which sounds pretty like concrete poetry, through Belloli declared that his work was something different). The actual term 'concrete poetry' had been coined in the 1950s by poets working in two different locations, one far out on the periphery of the intellectual world I am concerned with in this book, one much nearer to home: the Brazilian brothers, Agusto and Haraldo de Campos, and the Swiss Eugen Gomringer. Towards the end of the 1950s, it was Germany that emerged as the most important centre of this

poetry. From being an avant-garde movement for those in the know, concrete poetry, in a way we have seen so often, became in the 1960s *the* most modish form of poetry. The leader of the concrete poetry movement in Italy, typically an artist as well as a poet, was Arrigo Lora Totino, who directed the poetry review *Modulo*, and helped Carlo Belloli to establish the Museum of Contemporary Poetry in Turin. Only the Italian language could offer the perfect title for the way in which the poets contributing to the anthology saw themselves, I NOVISSIMI (the very newest), edited by Nanni Balestrini and Alfredo Guidini. Another poet associated with Gruppo 63, Lamberto Pignotti, put forward the concept of 'technological poetry', which would use the mass media to get poetry to the masses.[15]

Pierre Garnier, French school teacher (he taught German at a lycée in Amiens, where he had been born in 1928) and leading international protagonist of concrete poetry, preferred the term *spatialisme*. *Spatiale* and *spatialisme* are words that crop up with respect to many different art forms in the 1960s—assemblages and floor displays took up space in a way that traditional paintings did not. In January 1963 Garnier issued his first 'Manifesto for new poetry, visual and acoustic (*phonique*)'. The ideas are similar to those put forward by various artists of the time, by McLuhan and Warhol: wanting a poetry that will 'reach people', Garnier also remarked that 'now the medium creates poetry as much as the poem does'. His second manifesto showed the same concern with slippages and changes in the meaning of words found in Barthes and Derrida: 'The art of visual poetry consists of getting the word to no longer coincide with the word. Drawn out, deformed by the other words nearby, the word sometimes gets quite noticeably out of adjustment with itself.'[16]

Both the determined effort to blur boundaries between different art forms, and the rejoicing in the possibilities of the machine can be seen in the 'action poetry' of Bernard Heidsieck, which in some respects moves towards performance art or happenings. With the familiar mixture of exciting clarity, mysticism, and sheer mud, Heidsieck explained: 'places of "actions" or auditions take the place of the written page: stage, street, listening room, studio.' The action poem 'is made from anything that the poem authorises to take . . . the voice,

the cry, the gesture, the act, the noise, the sound, the silence, everything and anything'. The use of the tape recorder gives 'a certain angle more exact, perhaps, of reality, which the machine authorizes'.[17]

It was a fundamental feature of the arts in the 1960s that no particular literary or artistic movement came anywhere near establishing a monopoly. Recurring preoccupations were the nature of words, and, as in Pop Art and the early *nouveau roman*, the 'thingness of things'. The first tendency may be seen in the poetry of Yves Bonnefoy (b. 1923), for whom a certain restricted list of words were felt as 'essences': the second by Francis Ponge (1899–1988), who 'will spend three pages getting inside the skin of an apricot, or twenty or so describing "the prawn in all its states"'.[18]

A central irony of the 1960s strongly affected many poets: they wanted to be, and boasted of being, 'underground' poets, yet they also wanted to establish maximum contact with 'the masses'—not easy to do if you are literally out of sight. The 1950s Beat tradition of poetry readings and of combined poetry and jazz sessions developed throughout the 1960s in the form of poetry and light shows, and poetry and happenings. Underground poetry could scarcely have found a more visible venue than the massive Albert Hall in London for the 1965 'International Poetry Incarnation', seen as the grand climax of underground poetry by its anthologist, Michael Horovitz (b. 1935). Some poetry was openly political (American racism and American policy in Vietnam being frequent targets), some was consciously savage (in Britain, George MacBeth (1932–92) represented the former and Ted Hughes (1930–98) the latter). Poetry became international and cosmopolitan as never before. Poets, like others, raised questions about who was really mad, about how insanity is defined in society; out of the five quotations from various authors that preface *Delusions, etc.* (1972) by the alcoholic American poet John Berryman (1914–72), one concludes: 'the most mentally deranged people are certainly those who see in others indications of insanity they do not notice in themselves.'

There was a vogue in the English-speaking countries for translations from the German. The pre-Hitler poet Rainer

Maria Rilke (1875–1926) enjoyed a burst of popularity, the specialist English Hogarth Press followed up *Poems 1906–1926* (1957) with *New Poems* (1964) which presented the originals as well as translations. English poet Matthew Mead (b. 1924) produced translations of works by the East German poet Johannes Nobrowski.

Already in the post-war years a high critical reputation was being enjoyed by a group of Scottish poets: Hugh MacDiarmid (1892–1978), Robert Garioch (1909–81), Norman MacCaig (b. 1910), and Edwin Morgan (b. 1920), all active figures in a clearly visible Scottish bohemia. What happened in the 1960s was that the wider Scottish society (traditionally governed by strongly Puritan tenets), or at least parts of it, was brought into a closer alignment with this bohemia, while the poets themselves developed a new self-awareness and confidence. Edwin Morgan, in discussing the 1960s, speaks of 'the sort of seriousness or awareness that Scottish poetry has been jolted into (as opposed to certain stereotypes of "entertainment" and "character" which have always been available)'.[19] Morgan and Ian Hamilton Finlay (b. 1925) were important figures in the concrete poetry movement.

Analogous developments, involving such poets as Dannie Abse (b. 1923), took place in Wales. Writing in the poetry magazine *Agenda*, the English poet Kathleen Raine (b. 1908) stated: 'Much fine verse is being written in Scotland and for a like density of good poets one would have to go to Wales.'[20] Poetry magazines proliferated throughout the provinces and nationalities of the British Isles. In 1967 one of these, *Phoenix*, moved to Belfast in Northern Ireland: among the local poets published by *Phoenix*, one was very quickly to rise to international fame: Seamus Heaney (b. 1939), of whom much more in Chapter 9.

In the British Library catalogue of post-1975 publications there are ninety-one entries relating to the American poet Sylvia Plath (1932–63); she is one of only three recent American poets to have her *Collected Poems* (1981) on the open shelves there; the volume of poems about her by her husband, the poet Ted Hughes, *The Birthday Letters* (1998), is listed as 'missing' (i.e. stolen). Plath is another of our artists to have met an untimely death, and no doubt something of the intense,

possessive even, interest in her poetry is due to her experience of love for, and marriage to Hughes, his involvement with another woman, and her suicide on 11 February 1963. Her poetry, also, bears testimony to the continuing creation, amongst all the experimentation, of thoroughly accessible, yet entirely fresh poetry. And from its production we can learn something of the artistic process. As many others have done, Plath looked for models among older poets. As her twenty-seventh birthday (22 October 1959) approached she set out to write a series of short poems modelled on the highly intro-spective poetry, about nature, about greenhouses, of the Ameri-can Theodore Roethke (1908–63). But in the event, the poems took off with a life of their own.[21] On 20 October she noted in her journal: 'Ambitious seeds of a long poem made up of separ-ate sections. Poem on her birthday. To be a dwelling on mad-house, nature: meanings of tools, greenhouses, florists' shops, tunnels vivid and disjointed, An adventure. Never over. Devel-oping. Rebirth. Despair. Old women. Block it out.' On 4 November she was celebrating: 'Miraculously, I wrote seven poems in my "Poem for a Birthday" sequence.'

The first of these, 'Who', begins:

> The month of flowering's finished. The fruit's in,
> Eaten or rotten. I am all mouth.
> October's the month for storage.

The great moment of achievement led almost directly to the publication of her first book of poems, *The Colossus and Other Poems* (London, 1960; New York, 1962). For anyone who knows the place, the poem, 'Parliament Hill Fields', which she herself broadcast on BBC radio, has a perfect precision:

> On this bald hill the new year hones its edge.
> Faceless and pale as china
> The round sky goes on minding its business.

The first lines of her last poem, written on 5 February 1963, have become very famous:

> The woman is perfected
> Her dead
> Body wears the smile of accomplishment.

Experimental Theatre

Marxist political theatre—'agitprop'—was a recognized 'tool of world revolution' (so to speak), but everywhere unsuccessful, and dead on its feet by the mid-1960s: practically everyone found it as boring as many people found Warhol's films. Experimental theatre, though limited to tiny and usually élite audiences, was different. Across the Western world, there were 'alternative theatre', 'underground theatre', 'street theatre'; less menacingly, there was 'fringe theatre'. There was also travelling theatre, most admirably in Free Southern Theater, an inter-racial company loosely associated with the voter registration campaign in the American 'Freedom Summer' of 1964. Experimental theatre suggests theatre 'in the open' or 'in the round', without the traditional proscenium arch dividing actors from audience. The Royal Court Theatre, some way from London's West End, at the London end of the King's Road, Chelsea, was actually a traditional theatre in miniature, but location for many of the most avant-garde plays, including, in the 1950s, both Osborne's *Look Back in Anger* and the plays of Samuel Beckett; however, the Royal Court also opened during the 1960s a 'Theatre Upstairs', a club theatre in the round.

Intriguingly, the experimental theatre of the 1960s was in large measure an invention of the Americans, with the further twist, however, that American experimental theatre received far more acclaim in Europe (above all France) than it did in its home country. The most important pioneering groups were Living Theatre (founded 1946), Playwrights' Theatre Inc., San Francisco (founded 1958), Café La Mama (founded 1961), Open Theatre (founded 1963), and Bread and Puppet Theatre (founded 1963–4); in addition there was Joseph Papp's New York Shakespeare Festival Public Theater (founded 1967). The single greatest intellectual influence was that of Jerzy Grotowski (1933–99), with his Polish Laboratory Theatre and the notion of 'poor theatre', that is theatre stripped down and bare, without the conventional scenery and props—'minimalist' theatre, you could say. Behind Grotowski were a French director and a German playwright: Antonin Artaud (1896–1948), who had called for a return to the primitive and the ritualistic in drama, a

conception sometimes represented by the term 'theatre of cruelty', and Bertolt Brecht (1898–1956), whom I discussed in Chapter 2. A fourth influence from within the world of theatre was Samuel Beckett (1906–89).

It is a fact that the experience of the Second World War did give a stimulus to the setting-up of local theatres in various countries. Thus it is not entirely fortuitous that the married couple Judith Malina (b. 1926) and Julian Beck (1925–85) should have set up Living Theatre in New York in 1946. For years it played to a minority of a minority of a minority, then, within a few weeks of the opening on 15 July 1959, it achieved national notoriety and international acclaim with a classic play of drug-dealing by Jack Gelber (b. 1932), in the presentation of which jazz was an integral feature: *The Connection*. The next attention-focusing production was *Brig*, set in a beyond-hope military prison. On 17 October 1963, the Inland Revenue Service (nemesis also for Al Capone) closed down not just *Brig* but the entire company. Between 1964 and 1968 Living Theatre was in exile, travelling around Europe. Their *Frankenstein*—a four-to-five-hour 'collage of Grand Guignol, shadow-play, Yoga, meditation, gymnastics, howls, grunts and groans'[22]—opened in Venice in September 1965; shortly afterwards the company was deported from Italy. In 1969 Living Theatre was in London, based at the Roundhouse, once an engine shed, converted by socialist playwright Arnold Wesker (b. 1932) into a theatre. *Paradise Now*, in which the actors roamed among the audience, often abusing them, was as lively and sensational as anything else produced by the company.[23]

The first ever black play (black author, black characters, black director) to be produced on Broadway was Lorraine Hanbury's *A Raisin in the Sun* (1959). Though the ambience was very much that of the prospering black middle class, this was an important event in black cultural history. Just as important is the fact that the person who founded and inspired Café La Mama, set up in a basement in New York's East Village, was a black woman, Ellen Stewart. Café La Mama existed to provide opportunity for new talent of all types, including director Tom O'Horgan and the writers James Rado and Gerome Ragni (1942–91), all later famous because of their association with the

musical *Hair*, and specialized in the total integration of music and dance with drama. One of its greatest public successes was *America Hurrah* by Jean-Claude van Itallie (b. 1936)—a satire on American imperialism. Open Theatre employed many women directors and writers, including Megan Terry (b. 1932), whose *Viet Rock* was first presented, in the spring of 1966, at Café La Mama. Barbara Gerrson's *MacBird* presented President Johnson as the murderer of J. F. Kennedy. As small venues multiplied so did performances featuring violence, drug-taking, nudity, simulated sex, and, in Greenwich Village in 1968, an actual act of homosexual fellatio.[24]

The early training of Peter Schumann (b. 1934) was in the sculptural arts. He did his first theatrical work at the Living Theatre, then he came across the material Celastic, which made possible the fourteen-foot-tall puppets, held aloft on a stick, that were to be the performers in what he now created as the Bread and Puppet Theatre, based at a loft in Delancey Street, Lower Manhattan. Schumann explained: 'We named our theatre the Bread and Puppet because we felt that the theatre should be as basic as bread.'[25] Bread and Puppet took part in many anti-Vietnam war demonstrations, and put on a number of plays about Vietnam. It was highly successful in France, where it was treated as something of a 1960s icon; less so in Britain. The great figures who provided the intellectual and on-the-ground drive behind French experimental theatre were all active well before 1960: Jean Vilar, Roger Planchon, Maurice Sarrazin, Jean Dasté. Sarrazin put on contemporary plays in Toulouse; Dasté radical ones in Saint Etienne; Vilar directed the Avignon Festival from its foundation in 1947 to his death at the age of 59 in 1971.

The 1950s renaissance in German-language theatre expanded greatly in the 1960s.[26] An important veteran was Erwin Piscator (1893–1966), a theatre director who had worked closely with Brecht, experimenting in the use of photographs, film clips, and so on. During the Second World War Piscator taught drama in New York, returning to Germany in 1951 and becoming director of the important experimental theatre, the West Berlin Volksbühne, in 1962. He strongly influenced three of the playwrights I am about to discuss, Peter Weiss (1916–82), Heinar Kipphardt (1922–82), and Rolf Hochhuth (b. 1931). Piscator

also had an impact on Britain's Joan Littlewood. The new generation produced a brilliant young director, Peter Stein (b. 1937), who powerfully and thrillingly developed the tradition of meticulously researched productions with strongly left-wing political messages. He directed *Vietnam Discourse* (1969) and in 1970 became director of another important avant-garde theatre, the Schaubühne. Weiss, though born in Germany, was actually Swedish. He wrote in English a play with the longest title ever: *The Persecution and Assassination of Jean-Paul Marat as performed by the inmates of the Asylum of Charenton under the direction of the Marquis de Sade*. This was presented in London (1964) by the Royal Shakespeare Company under the direction of Britain's most brilliant young director, Peter Brook (b. 1925). *The Investigation* (1965), a dramatization of events during a recent war crimes trial, was staged simultaneously in fourteen German theatres.

Heinar Kipphardt was resident playwright for the Deutsches Theater in Berlin. *In the Matter of J. Robert Oppenheimer* (1964) employed documentary techniques and was originally intended for television. However, Piscator turned the work, concerned with the US nuclear physicist and McCarthyite intrigues against him, into a multimedia stage event. Rolf Hochhuth was another Swiss writing for German audiences. Two of his plays achieved international notoriety, not through any wild stylistic experimentation, but through making highly controversial claims about recent history. *The Representative* (1963) was actually written in the verse style of the eighteenth-century dramatist Schiller: but it was in effect a condemnation of the failure of the Roman Catholic Church to do anything to halt the Holocaust during the Second World War. There was some justification for this, of course, as there was for the focus upon Churchill's role in the firebombing of Dresden in *Soldiers* (1967), but the allegation in the same play that Churchill had been responsible for the death in an air crash of the Polish leader Sikorski really was absurd. Austrian Peter Handke (b. 1942) caused even more offence to audiences than Hochhuth, but he did this entirely through the extremism of his experimentalism. *Offending the Audience* (1966) is aptly titled. His explorations of communication and language, and his attempts to replace

conventional dialogue, place him on the far side of a certain kind of postmodernism. The central character in *Kaspar* (1968) is unable to speak, while the text in *The Ride across Lake Constance* (1971) consists entirely of clichés. Handke has also written novels in similar vein, leading him to be compared with Robbe-Grillet. His best-known novel (with one of the best-known titles in contemporary literature), *The Goalie's Anxiety at the Penalty Kick* (1970), is a bizarre thriller about a footballer who commits a pointless murder.

Britain offered a paradigm of the way in which theatrical innovation advanced across a broad front in the new civic theatres which were essentially a legacy of the war, in the slightly older proscenium-arch experimental theatres, in certain of the big subsidized companies (especially Peter Brook's Royal Shakespeare Company), and in the new spaces, such as the Traverse in Edinburgh, the Open Space (founded by the American sponsor of the Theatre of Cruelty, Charles Marowitz), and the Arts Lab (Texan Jim Haynes was associated first with the Traverse, then with the Arts Lab). Joan Littlewood's Theatre Workshop, very much in the older agitprop tradition, achieved a permanent home in the traditional suburban theatre in working-class East London, the Theatre Royal, Stratford East. *Oh! What a Lovely War* (1963) brought music-hall techniques to a bitterly satirical critique of the inefficiency and corruption of generals and politicians in the First World War. In 1964, Peter Brook put on a 'Theatre of Cruelty' season; then in February 1968 he put on *US*, using influential contacts to prevent this highly emotive play about Vietnam being banned by the Lord Chamberlain.

The name of Edward Bond (b. 1934) is one to note for a number of reasons. If any work deserves to be called Theatre of Cruelty, Bond's certainly does; it also reflected his deep commitment to Marxism. Censorship troubles over *Saved* (1967), which included a scene of a baby being stoned in its pram, and *Early Morning* (1968), both performed at the Royal Court, led directly to the Lord Chamberlain's censorship powers being abolished. *Saved* was taken up almost immediately by Peter Stein and performed in Berlin. *Early Morning* put historical personages—Victoria and Albert, Disraeli and Florence

Nightingale—into non-historical situations to suggest the sadism and corruption of Britain's ruling class. In scene xii Florence is dressed up as a man; in the background are six dead bodies—three hanged, three shot:

VICTORIA. If they knew you were a woman there'd be a scandal, but if they believe you're a man they'll think I'm just a normal lonely widow . . .

FLORENCE. I'm the first hangwoman in history—public hangwoman, that is. It's part of our war effort. And if we are being emancipated we must be consistent. So we take over any man's job that's suitable.

Bond's career was fully established as that of David Hare (b. 1947) was just beginning. Hare was co-founder of two of the tiny, travelling, experimental theatre groups that were so important in 1960s drama: Portable Theatre and Joint Stock Company. By the end of the century Hare had been canonized as one of the greats, to be ranked, say, with Bernard Shaw, his newest plays being performed side by side with revivals of older ones. He perhaps had an element of the luck that also touched the Beatles, Hockney, and others in the decade of golden opportunities for youth. He was taken up both by the Royal Court and then, a really major step, by the newly created National Theatre, where he became resident playwright. His plays are both comic and politically deeply serious. Hare is also remarkably prolific. After *Slag* (1970), *Lay By* (1971), and several others came *Plenty* (1978), composed like a film screenplay, in which the post-war collapse of political idealism is represented by the long nervous decline of a former British Resistance heroine. Hare's foregrounding of female characters is a final point worthy of special note.

Documentary and Faction

Television, I have said, gave a great stimulus to the merging of fact and fiction. Experimental theatre introduced documentary elements into drama. Novelists, too, in the 1960s began to mix fact with fiction, hence the term, coined around 1970, though now rather fallen into disuse, 'faction'. The prime figures were both American: Truman Capote (1924–84) and Norman Mailer

(b. 1923). Capote made his name with the light-hearted story of playgirl Holly Golightly in *Breakfast at Tiffany's* (1958)—subsequently an exquisitely amusing film—and then in 1966 published *In Cold Blood*, a recreation of the brutal multiple murder of a whole Kansas family by two ex-convicts and the lives of the murderers right up to their execution. Important works by Mailer are *The Armies of the Night* (1968), about the anti-war demonstrations at the Pentagon in October 1967 and the brutal suppression of the hippy element that stayed right to the bitter end, and *The Executioner's Song* (1979), about the life and death of Gary Gilmore, who, when he went before a firing squad in Utah on 17 January 1977, was the first person to be executed in the United States in over a decade. *The Armies of the Night* contains useful primary source material and has the value to historians of an account by an able, but imaginative, journalist.

Architecture

The 1960s do not stand out as a golden age in architecture, nor as a unique one, nor as one of dazzling innovation. In general, trends that had become well established in the 1950s continued into the 1960s, which often meant ugly and unfriendly public buildings and shoddily built workers' flats, isolated and lacking in basic amenities. But if there were no signs at the beginning of the decade of the sorts of striking changes taking place in other spheres, by the end of it there had been enough in the way of protest to ensure the beginnings of a radical change in planning and architectural policies; and there had been some successes in both public and domestic building.[27]

There can be no question about American primacy in public architecture, created by the multiplicity of affluent corporations, public bodies, and individuals eager to memorialize themselves in conspicuous and stylish buildings. The great German architects of earlier in the century, Mies van der Rohe (1886–1969) and Walter Gropius (1883–1969), both came to live and work in America. Mies was responsible, among many other buildings, for the stark Chicago Lake Shore Apartments of 1949–51, and the New York Seagram Building (designed by

Mies with his principal American disciple, Philip Johnson (b. 1906)). A much-quoted aphorism from the German master was 'Less is more'. The inventive Philadelphia architect Robert Venturi (b. 1925) responded with 'Less is a bore'. Venturi's reaction against Puritanism, and his inclusion in his buildings of the widest range of elements, can be seen in his Football Hall of Fame (1968), which incorporates a Las Vegas-style illumin-ated billboard, and his Liedhouse, Long Beach Island, New Jersey (1966–9), where the painted house number nine is five feet high; both have very strong Pop Art elements, and can safely be labelled 'postmodernist'.

Walter Gropius made his mark both as a teacher at Harvard and as the architect of such buildings as the massive one domin-ating Park Avenue in New York, the Pan Am Building of 1958. Among his pupils was I. M. Pei (b. 1917), responsible for a number of striking high-tech buildings, from the Mile High Center at Denver, Colorado, to the Hancock Tower, Boston (1969), using reflecting glass and a slender steel mullion system. Eero Saarinnen (1910–61) was responsible for Dulles Inter-national Airport, near Washington, for the TWA Terminal at Kennedy International Airport, near New York, for the famous Arch at St Louis, and for the CBS Building in New York with its vertical-striped science-fiction character. The unhappy story of public housing for the poor is symbolized in the well-known history of the low-cost Pruitt-Igoe housing scheme in St Louis by Minoru Yamasaki (1912–87). Poorly constructed with shoddy materials, this unlovely and unloved complex was by the end of the decade being subject to vandalism and arson attacks; in 1972 the authorities dynamited it.

Italy has never needed lessons in architecture from anyone, and remained remarkably insulated from the least desirable leg-acies of the international movement in architecture. There were, however, a number of shoddy and structurally unsound housing developments. Still, in general, Italian Marxist architects were more genuinely in contact with the needs of the Italian people than were idealistic followers of Le Corbusier (1887–1965) in the other countries. The blocks of flats laid out in the Tiburtino district of Rome on an irregular plan and crowned with tiled, sloping roofs, were a great achievement.

Two of Italy's most significant skyscrapers had been completed in Milan before the end of the 1950s. The first, the Pirelli Building by Gio Ponti (1891–1979), also involved the most important figure in Italian public architecture of the 1960s, the engineer Pier Luigi Nervi (1891–1978). The other was the twenty-six-storey Torre Velasca by Ernesto Rogers and Enrico Peressutti: the top six storeys, which, in a fine Italian affirmation of the value of urban life, were devoted to family accommodation, were supported on buttresses and overhung the rest of the building, thus echoing the contours of such medieval predecessors as Florence's Palazzo Vecchio. Other Italian architects of particular note were Carlo Scarpa (1906–78) and Giancarlo de Carlo. The latter somehow managed to echo, in a completely modern idiom, the Renaissance jewel of Urbino with his student residences for the university of that city, built between 1962 and 1969.

French architectural history of the 1960s is pretty dismal. The housing estates (*grands ensembles*) from 1954 onwards, built, as in Italy, as rapidly as possible, have been much criticized. There was then a phase, from the mid-1950s onwards, of the building of more imaginative suburban developments and new towns, though often to lamentably low standards of materials and workmanship. French administrators were, on the whole, notable for their clear-headed recognition of economic needs. Between 1957 and 1963 the main Paris airport at Orly, just south of the city, was completely reconstructed. In the mid-1960s attention began to be given to the inefficiencies inherent in the location of the main food market, Les Halles, in the centre of Paris. After many vicissitudes, and the aversion of some nearly fatal errors, this central area was reconstructed in a stylish and tasteful way.

In Britain the story of public housing in the 1960s was largely that of 'redevelopment'—that is to say, the destruction of close-knit older communities for the poor trade-off of disruptive urban motorways and badly designed and shoddily built high-rise housing. Some sensitively conceived, family-friendly estates were built, a good example being the carefully integrated Byker development in Newcastle by Ralph Erskine (b. 1914). The Lillington Street Estate in Pimlico, London, built by

Darbourne and Darke between 1967 and 1973, was widely recognized as sensitive and successful. The cultural expansion of the 1960s also created demands for the building and extending of universities, and for the construction of theatres. Stylistically, one could make a rough distinction between the monumental terrace style of Sir Denys Lasdun (b. 1914), as seen in the University of East Anglia and the National Theatre, London, and the gentler, more flexible style of, say, Sir Basil Spence with his Sussex University, strongly influenced by Le Corbusier's Jaoul Houses in Paris and discreetly blending echoes of a Roman colosseum into a magnificent landscape. There had, of course, to be something going on in Liverpool, and that was the construction, between 1960 and 1967, of the Roman Catholic cathedral by Frederick Gibberd (1908–84): this striking building unfortunately suffered, like so many ambitious housing schemes, from financial constraints, and the impressive 'crown of thorns' that surmounts the circular building became the butt of local jokes as 'the Mersey funnel'. The first custom-built open stage theatre was that for the Chichester Festival, completed in 1961 by the firm of Powell & Moya.

Less noted at the time were a number of buildings designed by the Scottish-born, Liverpool-educated James Stirling (b. 1926), within the partnership he had formed with James Gowan: the Engineering Building at Leicester University (completed 1964), the Cambridge University History Faculty (finished 1968), and the student residences at Oxford, the Florey Building (1966–71), characteristic of Stirling's 'uncanny fragmented geometry'[28]—here five-eighths of an octagon, which is stretched round the public rooms and given a strong sense of enclosure. Those who had to inhabit Stirling's buildings often complained that they were uncomfortable or impractical.

Bad buildings and ruined urban environments were a legacy of the 1960s. But at the same time new thinking about architectural problems came into being, having some strikingly positive effects in the final decades of the century, as we shall see in Part Three.

Part Three

German Metamorphosis and
Global Capitalism, 1980–2000

Introduction to Part Three

Just as the starting point for Part One was the full emergence of America as the West's dominant power, the starting point for Part Three is the full emergence of Germany as Europe's dominant power, relaxed, mature, and, ultimately, unified. Germany now gets fully to grips with its past and its present, producing a rich cultural efflorescence, particularly in cinema and in art. The first of my cluster points for Part Three is the way in which, first in Germany, then in America, then in the other European countries, the new societies of sophisticated global capitalism, advanced information technology, and extreme environmental hazards, are put under scrutiny. As always, the foremost art form for sociological and philosophical analysis is the novel, and, apart from the exceptional and crucially important case of Germany, it is on the novel that I concentrate in Chapter 8. The second cluster point is provided by the arrival in the 1980s, from its origins in the 1960s, of postmodernism as a dominant system of ideas. Arguably, this is seen in its strongest and purest form in architecture, poetry, and music. Yet, once again, we find that the holistic approach is inappropriate. Up to a point, we can say that, in both architecture and music, postmodernism was a reactive phenomenon. Modern architecture, austere, brutal, minimalist, seemed to have come to a dead end, and was widely resented; avant-garde music, whose development I trace from the end of the war through the 1960s, had reached a stage of such abstract purity that even some of the most dedicated music lovers found difficulties in engaging with it. So both architecture and music turned to eclecticism, to bring in exuberant and even light-hearted elements, though these were more obvious in architecture than in music. Music, however, was particularly affected by revivals in religion and nationalism, and by new influences emanating from the former Soviet Union. Architecture was, above all, affected by the boom

in building development associated with the new phase in international capitalism. In poetry the postmodernist turn was much more heavily theoretical: the fundamental drive was to demonstrate that words are completely divorced from what was once thought of as their 'meanings'.

At the end of the war the divide between élite culture and popular culture was still a rigid one, most obviously in Europe, less so in America. By the final decades of the century, the blurring of the divide, for good or ill, had gone far. This is reflected in the organization of Part Three. In Chapter 9, art music and popular music are taken successively. At the same time the point is picked up that, while back at the end of the war new ballets were still being created, by this era of intensive globalization and postmodernism it is now proper to talk of 'dance', the quintessence of crossover. Élite and popular arts, and again, perhaps, crossover arts, are brought together in Chapter 10, whose cluster point is the notion that, since the 1960s, one consistent aim in several different art forms has been to be as absolutely shocking as possible. I start with the plastic arts, which can be interpreted as containing strong popular elements in the form of video or digital art. Throughout this book, combating the simplistic notion of 'the global village', I stress the importance of experimental theatre as a powerful means of transmitting new ideas and attitudes. There is in fact a very easy transition from the dramatic, sexy, and violent installations of Britart and its analogues in other countries to the plays of Sarah Cane or the theatrical productions of Romeo Castelluci. One form of art that bridged the gap between the 1960s and the *fin de siècle* was given the label 'Superrealism'. As, still analysing the tradition of the shocking, I return to a subtheme that I introduced in Chapter 1, that of the way in which novels become films, it seems entirely appropriate to introduce the category of the 'super-thriller'. Having started with the two great post-war intellectual/cultural developments, Abstract Expressionism and Existentialism, my book concludes with what (for people of all ages) were the dominant popular art forms at the beginning of the new century: novels of a particular type, films, television. Then, looking to the future, I add a small coda on the books being read by children.

8 Past and Present: Sociology and Philosophy

Grasping the German Past

There are times when certain cultural products, together with their reception and impact, become historical events. This happened in Germany, beginning in the late 1970s, and running right through the 1980s and, following unification in 1989, into the 1990s, the period of the *Aufarbeitung der Vergangenheit* and the *Historikerstreit*—the former meaning 'getting to grips with the past', and the latter the 'historical debate'— that is, the debate over Nazism, the period of what is usually called the 'New German Cinema' and associated television series, and the reactions they evoked.[1] There was, actually, an American contribution as well as a purely German one, but I think one can make a valid comparison between the post-war America with which I started this book, a place where one can perceive a vibrant interaction between the arts and America's full emergence as the world's most powerful nation, and this Germany of the late twentieth century, still agonizing over the past, but thoroughly endowed with restless creative spirits as the liberating legacies of the 1960s merged into the puzzling outcomes of reunification. Historians played a part, obviously, though the most important intellectual protagonist was the philosopher and sociologist Jürgen Habermas (b. 1929). Had ordinary Germans of the time been complicit in Nazism? Was there some inherent illiberalism in German society? Or was Nazism simply a natural totalitarian response to the revolutionary threat of Russian totalitarianism? Eventually newspapers, and the ordinary viewing and reading public, became involved. Earlier works had, we have seen, sought to engage with the Nazi past, but usually in a rather limited, leftist way, alleging continuing Nazi influence in high places, and indicting the German people as a whole for complacency about their past. In this period of intense creative

activity it was not just Nazism and the war that were put under scrutiny, but also the terrorism of the early 1970s, with questions being asked about possible links between that and the state terrorism of the Hitler period. Questions were also asked about the new feminism, about the role of women, particularly since two of the leading terrorists in the recent period had been women, Ulrike Meinhoff and Gudrun Ensslin. The films, in particular, but also some of the television programmes, are of additional importance for practising the fashionable post-modernist techniques, the absence of linear narrative, bricolage, and the modalities of documentary fiction or faction.

The movement begins in 1977 and 1978. In the former year there was Hans Jürgen Syerberg's *Hitler—ein Film aus Deutschland* (*Hitler—a Film out of Germany*, 1977), which focused on the private lives of Hitler and, in particular, of Himmler. Thomas Elsaesser has argued that one of the central arguments of Syerberg's film

is that the Nazi deployment of radio broadcasts, live transmissions, mass rallies, and civil mobilisation campaigns turned the State into a twelve year state-of-emergency, experienced by many Germans as communality, participation, and direct address. Syerberg's polemical point is that Hollywood cinema and more recently television, in the name of democracy and the right to consume, have made the Riefenstahl aesthetic of *Triumph of the Will* (1935) the international television norm: politics has become a series of photo opportunities, public life a perpetual festival of presence, action, liveness, where spectacles of destruction, or feats of prowess and the body beautiful are feeding national or individual fantasies of omnipotence.[2]

Hitler was followed in 1978 by the film that is often seen as the real launch of 'The New German Cinema', *Deutschland im Herbst* (*Germany in Autumn*), for which Alexander Kluge (b. 1932) brought together a sparkling group of young film-makers, including Fassbinder (1946–82) and Edgar Reitz (b. 1932). This omnibus film combined discursive and argumentative sections with dramatizations; it was the most reflexive treatment yet of the Nazi legacy and its impact on the present. At the centre, linking the different sections of the film, was a female teacher, played by Gabi Teichert. Although important immediately in

the arguments and discussions among German intellectuals, these films did not have any great popular impact.

That was provided by an American television series. NBC had already had great success, national and international, with a series based on Alex Haley's best-selling work *Roots*, a novel with documentary elements, about the history of black Americans, and particularly Haley's own ancestors, from tribal life in Africa through slavery on the American plantations. The follow-up was *Holocaust* (1979, screenplay by Gerald Green, directed by Marvin J. Chomsky). Again this was a kind of docudrama, the horrific historical facts being integrated with the stories of the fictional Weiss and Dorf families. Naturally, the series was marketed in Europe, and German audiences, in particular, were moved in a way that no previous work on the Nazi past had succeeded in doing. As one academic put it in the important German colour magazine *Der Spiegel*: 'An American television series . . . accomplished what hundreds of books, plays, films, and television programmes, thousands of documents, and all the concentration camp trials have failed to do in the more than three decades since the end of the War: to inform Germans about crimes against Jews committed in their name, so that millions were emotionally touched and moved.'[3] The moment was now propitious for the production and then international release on American television of the Goodrich and Hackett play, *The Diary of Anne Frank* (Boris Sagal, 1980).

A whole flood of German-made films, and then television programmes, followed, presenting quite sharply varying perspectives on the Hitler years, and also on the more recent terrorist past. Women directors (particularly Margarethe von Trotta (b. 1942) and Marianne Rosenbaum) were prominent. Films included *Die Verlorene Ehre der Katharina Blum* (*The Lost Honour of Katharina Blum*, from the 1975 Heinrich Böll novel of the same name), *Germany Pale Mother* (Helma Sanders-Brahms, 1979), Rainer Werner Fassbinder's *The Marriage of Maria Braun* (1978) and *Lili Marleen* (1980), and Volker Schlöndorff's *The Tin Drum* (1979—actually a truncated travesty of Grass's novel, confined to the pre-war period). Kluge's *Die Patriotin* (*The Female Patriot*, 1979) again featured Gabi Teichert. Margarethe von Trotta's *Die Deutsche Schwesterin*

(*The German Sisters*, 1981) was based on the lives of Ulrike Meinhoff and Gudrun Ensslin. The reflexive, intellectualizing note is very pronounced. *The Female Patriot* presents the notion of history 'as obstinacy, as having a will of its own', incorporates popular sources, 'sources from below', and suggests a notion of 'popular memory'.[4]

Edgar Reitz began working on the massive television series *Heimat* (*Homeland*) in 1979. The series, covering the lives of the fictitious Simon family from 1918 to 1982 in a total of sixteen hours, was transmitted in 1982. *Heimat* is set in Reitz's own native district of the Hunsrück, in the fictional village of Schabbach. Maria, born in 1900, married to Paul Simon, spends her whole life in the village. We encounter four generations of three large families assembled around hers. Suddenly, in 1928, Paul departs. Maria raises her sons alone, falls in love with an engineer, and has a son by him. A letter arrives from Detroit, sent from 'Simon Electrics, Inc.'. Now a 'rich American', Paul Simon returns in 1947. The inclusion of mythical America is something I have referred to many times, though here it is obviously specifically intended to symbolize the wide world, the opposite to Heimat. The series ends with the death of Maria, lonely and worn, aged 82.

Reitz and his co-author, Peter Steinbach, spent more than a year researching in the Hunsrück and collecting oral testimony. Local farmers loaned Reitz everyday artefacts used in the film to intensify the sense of authenticity. More than 150 amateur actors, all speaking the local dialect, and 4,000 extras from the region took part.

Women sing at the spinning wheel, grouped in a painterly composition; the village smith stands at his anvil, pounding a wheel as sparks fly; Marian kneads dough: the film lingers over such genre scenes . . . The elaborate reconstruction of country life and work produced many scenes that contribute to the nostalgic atmosphere of the film while slowing down the narrative pace . . .[5]

Heimat fitted into an interpretation of the German past that maintained that, whatever the atrocities of the Nazis, ordinary life continued to be lived, largely unaffected. Reitz made no mention of the death camps, arguing that these were not

something people were aware of. Thus he was severely criticized for evading, and covering up, the atrocities of Nazism. What Reitz does show, like Syerberg (b. 1935)—and of course many other creative workers in other contexts—is how consumerism and technology disrupted rural life in the period under review:

Reitz shows no rural, pre-industrial idyll, and instead his characters' lives and histories are transformed by modern communications technologies: the women go to the movies (to see a film called *Heimat*) and the men either spend their time with ham-radio sets, or busy with precision optics, or have a passion for still photography—when not on active duty as newsreel cinematographers on the Eastern front.[6]

Both the American *Holocaust* and the German *Heimat* used fictional characters. The Jewish director Claude Lanzmann (b. 1925) attempted, somewhat in the manner of Ophuls, to put together genuine testimony from those who had lived through the Holocaust, including survivors of both Auschwitz and Maidanek, creating the six-hour-long *Shoah*. Lanzmann deliberately adopted a non-emotional, alienated, and potentially alienating approach. This too played an important part in the great ongoing debate, but inevitably, perhaps, it was probably more written about than actually viewed, its distribution being confined to minority television channels and art cinemas (abroad as well as in Germany).

Then—from America once again—came a completely antithetical treatment. Stephen Spielberg (b. 1947) was already very famous for his spectacular films with mass popular appeal—for example *Jaws* and *ET*. There can be no doubt about his very genuine belief in the importance of studying the past, not just the Jewish past, though as a Jewish American he had a particular interest in this, thoroughly demonstrated through his efforts in setting up the Holocaust Archive. *Schindler's List* (1993) is an important phenomenon in our enquiries into the relationships between the past, history, novels, and film. Schindler, a German industrialist, had actually existed, and had managed to save the lives of many Jews who would otherwise have been consumed in the Holocaust. Thomas Kenneally (b. 1935), an Australian of Irish descent, wrote a novel, *Schindler's Ark*, dramatizing, but basically true to, the basic outlines of Schindler's life. Spielberg

further dramatized the life, trying, through the cinematic arts, to give a graphic sense of the horror of the Holocaust; yet, in the end, through the inevitable personalization of the story, he conveyed heroism and hope more effectively than he did the unutterable horror of the Holocaust. *Schindler's List*, naturally, was seen by far more people in Germany than was *Shoah*. Many German intellectuals had been outraged by *Holocaust*, seeing it as stealing and trivializing the German past; the same arguments were made, and even more outrage expressed, over *Schindler's List*. However, the English critic John Gross probably put the matter most fairly in an article about the film in the *New York Times*: 'As a contribution to popular culture, it can only do good. Holocaust denial may or may not be a major problem in the future, but Holocaust ignorance, Holocaust forgetfulness and Holocaust indifference are bound to be, and *Schindler's List* is likely to do as much as any single work can to dispel them'.[7]

There was a change of direction of at least forty-five degrees in another celebrated treatment of Germany's past. From Lothar Gunter Buccheim's important novel, Wolfgang Petersen (b. 1941) produced the six-part television series, *Das Boot*, about a German submarine and its crew in 1941. One is immediately reminded of the great literary evocations of trench life in the First World War: as there was then contempt for generals and politicians and those at home consumed with war lust, here there is contempt for the Nazi hierarchy and for Nazi enthusiasts. The enemy is the British, the Americans not yet being in the war, and for them a kind of wry admiration is expressed from time to time. Twice we have the submariners singing, in English, 'It's a Long Way to Tipperary'. Conditions aboard are foul, as they were in the trenches. Fear of destruction by British destroyers with depth charges, or British aircraft, is very real. There are a number of near escapes, then the absurd order is given to sail through the thoroughly defended Straits of Gibraltar, in order to help secure the supply lines to Rommel in North Africa. The boat is attacked and sinks right to the bottom. But a brave and dramatic escape is made. There is a triumphant return to base at La Rochelle. Then at the height of the celebrations the RAF swoops in, killing everyone save for

the war correspondent and the naval lieutenant who has been telling the story. This classic TV drama is a powerful and poignant evocation of the ironies and horrors of war, from the side of an entirely sympathetic and very brave group of German combatants.

There was also a film director who stood rather apart from the *Historikerstreit*. Wim Wenders (b. 1945) was in fact in Hollywood for most of that period, making the acclaimed film *Paris, Texas* (1984). What might be called the American–German axis of this time (I return to this in a moment) is palpably demonstrated in the film Wenders made on his return to Germany: *Der Himmel über Berlin* (*Sky [or Heaven] over Berlin*, 1987, given the English title *Wings of Desire*), which gives a key role to the American actor Peter Falk, who plays himself, as a director in Berlin to make a film. *Wings of Desire* is one of those films that holds you enthralled at the time, but that you find difficulty in explaining afterwards.

In *Sky over Berlin*, angels hover unseen by human adults (but not by children or the film's spectators) and descend to mingle with people, hearing their inner thoughts. Falling in love with a trapeze artist in a circus, an angel portrayed by Swiss actor Bruno Ganz (b. 1941) gives up his angel-hood to share the human condition—the Director's symbolic return to Europe from the sky over the mid-Atlantic.[8]

By 1999 it was becoming possible to laugh over Germany's recent past: the film *Sonnenallee* (*Sunshine Alley*—screenplay by Thomas Brussig) makes light of teenagers in 1970s East Berlin taking home-made hallucinogenic drugs and dancing to *T-Rex*.

The great controversies over the 'historical debate' and 'getting to grips with the past', coinciding with the period of 'New German Cinema', provide the greatest single example in the entire period covered by this book of a close interrelationship between cultural artefacts, and philosophical and historical ones. History, for reasons given in the Introduction, I exclude from this book, but it is important to mention the role of philosopher and sociologist Jürgen Habermas in bringing out the significance of what was happening in the cultural and intellectual world, in particularly in his essay 'On the Public Use of History'. Habermas was a Marxist who had

supported the student activists in the 1960s. His *Knowledge and Human Interests* (1968) argued that scientific and technological rationality was tending to displace ethical argument from social decision making.

If we turn to art, which of course had endogenous imperatives of its own, we do see that much of it was affected by the 'attempt to get to grips with the past'. Georg Baselitz (b. 1938), Markus Lupertz (b. 1941), Anselm Kiefer (b. 1945), and Martin Kippenberger (1953–97) must be seen, first and last, as belonging to the school of 1960s and post-1960s artistic expression of which Josef Beuys was undisputed head, but the opportunity to make cross-references to film and television is too good to miss. They belong to that branch of the European revival of neo-expressionism known as the *Neue Wilder* (New Wild Group), dealt with more fully in Chapter 10. Here I make a few quick points. Kiefer used straw in a series of 1981 entitled *Margarethe*, each canvas incorporating one or more words from lines from the Jewish poet Paul Celan: 'Your golden hair Margarethe / Your ashen hair Sulamith', referring to the victims of the Holocaust. Many of his paintings mock the architectural plans of Nazi architect Albert Speer, and his *Shulamite* (1983), a painting of a vast, fire-blackened crypt, clearly refers to the Holocaust. Kippenberger's painting of jumbled angular forms (1984) is titled *With the Best Intentions I Cannot Find a Swastika*. Baselitz's *Model for a Sculpture* (1981) has a Hitler-figure emerging from a block of wood, giving the Nazi salute. Gerhard Richter, engaging with the more recent past, put together a sequence of images of members of the Baader-Meinhof gang titled *18 Oktober 1977*, exhibited in 1988. As these artists followed Beuys in developing an international reputation, Cologne became a centre of international art dealing, establishing an artistic axis with New York.[9]

The American Present

In discussing an important and wide-ranging debate in Germany, I have deliberately brought in certain American cultural products. The enormity of the German past and the importance of the German debates over it were such that American moguls

of the mass media were bound to get involved, even if slightly adventitiously. But, of course, for most creative workers in America *the* subject was America itself. If Germany is, for a short period, the primary location for experimental film, America is the major home of the new super-thrillers that appear as both novels and films. These I turn to in Chapter 10. But here I want to concentrate on those more nuanced novels that more or less consciously analysed America as it was in the 1980s and the 1990s.

The notion that we live in 'a postmodern era' or, what is essentially the same thing, in 'a condition of postmodernity' appeals to those who take a metaphysical, epochal, view of societies and their history. Its two leading protagonists are both French, Jean-François Lyotard (1924–98) and Jean Baudrillard (b. 1929). The absolute essence of their arguments is that we live in a period of late capitalism, out of which springs the 'condition of postmodernity'. Lyotard claims that we no longer have the certainty of what he calls 'grand narratives' explaining history and society, but that the possibilities are unlimited of producing narratives that explain history and society in a multiplicity of different ways, with no one narrative being intrinsically more valid, more true, than another. Baudrillard stresses the crucial importance of modern electronic technology, to the extent that distinctions between the real and the unreal, between substance and appearance, are no longer meaningful: we begin to *perceive* things as real only once they have been mediated through television or other means of mass communication. The strange ideas spouted by Baudrillard are best exemplified by his infamous claim that the Gulf War of 1991 did not actually take place outside its media representation. We have to appreciate, too, that for these theorists the modern era, and modernity, began as far back as the French Revolution of 1789.[10] Thus some of the characteristics attributed to postmodernity may seem better described as elements of radical modernity if, as I do, you see modernism as a movement *in the arts*, appearing only in the later nineteenth century and reaching full flood in the twentieth. Obviously, the post-1960s period of new information technology, of privatization, of glorification of market economics, did have distinctive characteristics, and, in this section

and the next, I shall discuss novelists who, 'postmodern' or not, did present a kind of sociological commentary on it (a classic function of the novelist throughout the ages). The notions of a postmodern era and of postmodernity have far more to do with the political ideology of the extreme Left than with dispassionate observation: however, the label 'postmodern' is useful as precisely that, a *label* (analogous to 'baroque' or 'mannerist') for identifying a *style* that in some ways takes the tenets of modernism to their furthest extremes, and in others is a reaction against modernism's most austere tenets, a style that is eclectic, referential, and obsessed with the dangers and difficulties of language. We can expect postmodernist works to be full of bits and pieces (*bricolage* in French): in novels this can be insertions of newspaper items, documents, cartoons, advertisements.

In turning to European novelists in the final section, I shall, in addition to social commentaries, be discussing works deliberately inflected with postmodernist philosophy. Quite unambiguously, there *is* a self-declared postmodernist style in architecture: it is with architecture that I shall begin Chapter 9, before going on to music, and then poetry—a sphere in which there was a deliberate conflation between postmodernist theory and poetic practice.

Starting with the social rather than the philosophical we should, I believe, spend a good deal of time over the two massive novels by Tom Wolfe (b. 1930), *The Bonfire of the Vanities* (1987) and *A Man in Full* (1998), which really are of great value to historians. The earlier Tom Wolfe, the journalist with the exaggeratedly hip style, the writer of the particularly American type of documentary book verging on faction, is well represented by the titles of the two most famous of these works, *The Kandy-Colored Tangerine-Flake Streamline Baby* (1965) and *Electronic Kool Aid Acid Test* (1968). The first is a series of studies of the fashionable figures of the early 1960s, including the Beatles and Andy Warhol; the latter is a colourful, perhaps even psychedelic, tour through the excesses of the hippie scene, and, in particular, the role of Ken Kesey in that. As a star journalist, Wolfe was well qualified to write a couple of novels upon whose sociological qualities almost all reviewers remarked. With regard to *The Bonfire of the Vanities*, *Publishers Weekly* spoke of

a 'brilliant evocation of New York's class, racial, and political structure in the 1980s'. Whether *A Man in Full*, also brilliant in its sociological analysis, focused this time on the city Atlanta, presents society in the 1990s as being distinctly different from that of the 1980s, or of Atlanta being distinctively different from New York, I shall consider in a moment. Both books, like so many novels featured in this study, present meticulous, and almost voluptuous, topographies of the cities they are concerned with. To British readers the language of the two journalistic works of the 1960s can (as the titles suggest) seem hyperbolic and undisciplined. The colour, the up-to-the-minute slang is there in the novels, but kept under perfect control. The wit, and the economy of phrase, are often stunning. Are we then dealing with postmodern, or even modern, novels? The fact that the novelist with whom Wolfe was most often compared was Charles Dickens would suggest a strong qualification even to the second part of that question.

In *The Bonfire of the Vanities* we are introduced first to Sherman McCoy, a whizz-kid, filthy rich, trader in bonds on Wall Street. Then, quite separately, we become acquainted with Larry Kramer, poorly paid Assistant District Attorney in the appallingly deprived and desperately dangerous New York borough, the Bronx. The moment when we become aware that the two lives are indeed going to intertwine (Kramer will be prosecuting McCoy for a hit-and-run car accident) is the moment when we realize that this is a traditional, well-made novel—but an absolutely up-to-the-minute novel, set in a context, and raising issues that would have been unimaginable to Dickens. Lust is an emotion dominating most of the characters—female as well as male—most of the time, though, demonstrating that we are definitely in a post-1960s era, there are no explicit accounts of sexual activity. This culmination of a discussion between Sherman, terrified over his impending prosecution, and Maria, his girlfriend and wife of another man, is graphic, frank, witty, yet leaves it all to the imagination: 'She took his face in both hands and kissed him. They ended up on the bed, but this time it took some doing on his part. It wasn't the same when you were scared half to death.'

So, the novel is contemporary, but not modern. Does that

matter? Does the traditional quality of Wolfe's international bestsellers merely indicate that the novel is indeed well on its way to an overdue death? Or is not the very rapidity of historical change, the need to anatomize society's upheavals and transformations, the very best guarantee for the continuing existence of the traditional novel? It is hard to see that Wolfe could convey so much—and he surely conveys a lot, every page in getting on for a thousand contributing its share—otherwise than in a traditional novel. We may note, with reference to one of my major themes, that nothing in either of these novels is in any way connected to the Second World War; however, Charlie Croker, who becomes 'a man in full' in the second of them, is a veteran of the Vietnam War. Trendy characters do refer knowingly to the postmodern: Fallow, the English journalist in *Bonfire*, says it is 'more Post-modern for a painter to have the eyes of a paedophile than the eyes of a child'.

McCoy, and his fellow bond-dealers, are unambiguously upper class: McCoy's father had been chief executive officer of a patrician firm of lawyers: his colleagues had all been at the élite universities, Yale, Harvard, Stanford.

How these sons of the great universities, these legatees of Jefferson, Emerson, Thoreau, William James, Frederick Jackson Turner, William Lyons Phelps, Samuel Flagg Bemis and the other three-name giants of American scholarship—how these inheritors of the *lux* and the *veritas* now flocked to Wall Street. . . . How this story circulated on every campus! If you weren't making $250,000 a year within five years, then you were either grossly stupid or grossly lazy . . .

What great wealth brings McCoy is 'insulation', the ability to separate himself completely from the dangerous classes. McCoy thinks of himself as a 'Master of the Universe' and exults in living on the most expensive street, Park Avenue, in the most exciting city in the world, New York. But Wolfe is a ruthless analyst of his characters' fears and vulnerabilities: to keep up his mighty lifestyle, McCoy needs his massive income—if anything goes wrong with that, as it does, he plunges immediately into an abyss.

The self-indulgent life of McCoy and the socialites he and his wife mix with is contrasted with the scrimping existence of

Larry Kramer, existing on under $40,000 a year. He lusts after a juror in one of his cases, but then finds he cannot afford the restaurants he takes her out to. The third class of people identified in the book are the denizens of the Bronx, though we scarcely meet any of them as individuals. What we do get are vivid evocations of their dreadful urban jungle. The court house where Kramer works sports fine sculptures of Commerce, Justice, and so on, noble Romans wearing togas.

Today, if one of those lovely classical lads ever came down from up there, he wouldn't survive long enough to make it to 162nd Street . . . they'd whack him just to get his toga . . . Just last week some poor devil was stabbed to death at 10.00 a.m. The bench was ten feet inside the park; someone killed the man for his portable radio . . .

Later we have a description of a high-rise housing estate:

The idea had been to build apartment towers upon a grassy landscape where the young might gambol and the old might sit beneath the shady trees, along sinuous footpaths. In fact, the gamboling youth broke off, cut down, or uprooted the shade-tree seedlings during the first month, and any old person fool enough to set along the sinuous footpath was in for the same treatment.

McCoy picks up his lover Maria at the airport, takes a wrong turning, and finds himself lost in the Bronx. Trying to turn off up a ramp he runs into a trap made of tyres. Both the hardened planner of the intended robbery, and the innocent neighbour who happens to be with him, are black, and live in the housing estate just described. In reversing away from the scene, Maria having taken over the driving seat, the car accidently runs over the innocent man.

The people Kramer prosecutes come exclusively from racial minorities. There are so many of them that there is no time for proper trials, and almost all cases are resolved through a process of plea-bargaining. What everyone wants is a genuine prosperous white person to prosecute. Particularly is this the case with the District Attorney himself, Weiss, who is planning to run for mayor and who needs the support of the black and other minority groups who make up the majority of his constituency. The innocent young black run over by Maria goes into a terminal coma. All evidence of the attempted robbery is erased and

McCoy is represented as having himself been a hit-and-run driver. At the prospect of being able to prosecute this wealthy white man, 'Weiss sank back in his chair and smiled, the way one smiles over impossible dreams. That sure would put an end to this shit about white justice.' A manipulative and charismatic black preacher, Reverend Bacon, also has an interest in the prosecution of McCoy. A drunken free-loading British journalist, Peter Fallow, perhaps the most fully realized and certainly the most obnoxious character in the book, is brought in to expose McCoy in the tabloid he works for. (Wolfe, incidentally, is very good on the appeal all things English have for New York snobs and very good on the ungracious contempt Englishmen in New York have for most things American, such as saying 'Pardon?' instead of 'What?')

The story of the pursuit and humiliation of McCoy is a gripping one, with some nice twists. Using tapes of conversations with Maria, McCoy is able to persuade the ferocious, but decent, Jewish judge Kovitsky to strike down the charges against him. But there is an epilogue to the novel. A little, perhaps, in postmodernist style, we have a document, an article from the *New York Times*, a year later. Kovitsky has failed to secure re-election as a judge. McCoy is being arraigned again, and it is clear that he will not escape this time. Fallow has won a Pulitzer Prize for his coverage of the case. There is in the novel, I shall finally add, something of that reflexive quality that, while, in my view, not specifically postmodernist, is characteristic of post-1960s artistic (and academic) endeavour. Wolfe pays great attention to the accents and language of his characters: Maria's Southern speech is reproduced phonetically; Kramer, who is well educated, naturally speaks correct English, but in 'a room with three people who said *She don't*', he couldn't get a 'doesn't' out of his mouth, and himself says 'she don't'. The sitting mayor sets out to do a shady deal with a black bishop: 'No black accent at all, thought the Mayor. He seemed to run into black people with no accent all the time now. The fact that he noticed it made him feel guilty, but he noticed it all the same.'

Bonfire of the Vanities is a magnificent literary artefact, a work of social criticism, a study of character, a moral fable, just like

the great ninetenth-century novels. Could it—to explore one of my subthemes—have been turned into a successful film? We shall never know, since it was in fact turned into a quite abysmally awful one. Fallow becomes an American journalist, though admittedly still a drunken one, played by Bruce Willis. The film starts with him, drunk, being fêted after his winning of the Pulitzer Prize. He then takes up the role, for much of the film, of a voice-over narrator, and a banal and stilted narration it is too. From being on the brink of total failure as a journalist he is rescued through his fate being entertwined with that of Sherman McCoy—Tom Hanks is utterly miscast in this part. Of course, to turn a long novel into even quite a long film (two hours) much has to be cut. But Wolfe's wit and characterization simply disappear. Weiss and Bacon become cardboard villains, while the Jewish judge, Kovitsky, becomes the standard black judge of so many American television series. McCoy (of course) is triumphantly acquitted at the end. The director, strangely, was the respected Brian De Palma.

For all its subtlety, *Bonfire of the Vanities* has essentially only one story line. There are several in *A Man in Full*. Charlie Croker is a 60-year-old real-estate speculator living the life of a white patrician; having divorced his first wife he now has a young and sexy one. Croker's speculations have gone disastrously wrong and Planners Bank, to whom Croker owes getting on for a billion dollars, is about to cast him adrift. One of the bank's underpaid employees, eager to play his part in the ruining of Croker, himself has the terrible problem of a paternity suit from a Finnish woman. Roger White II, a well-educated, self-effacing, conciliatory black lawyer, known as Roger too White, is summoned in by his old schoolfriend, now the black mayor of Atlanta, to help solve a problem that could blow Atlanta apart: although nothing has been made public yet, the daughter of the most important businessman in town ('Inman Armholster was one of the first five names you would think of if the subject was the White Establishment in Atlanta') is accusing the local black football hero of raping her.

Croker owns a processed foods empire with a frozen food warehouse on the Oakland side of San Francisco Bay. There we encounter white working-class America, and in particular

Conrad Hensley, desperately trying to support a wife and child. In an act of bravery, Hensley saves a fellow worker from certain death in an accident in the warehouse. But shortly he is declared redundant by the Croker organization. Very much the doomed, put-upon low-grade American worker, he ends up in prison, but then, much later, escapes when the San Francisco earthquake of 1992 splits open the walls of his jail. Back in Atlanta Roger mediates a deal whereby Croker will speak up on behalf of the young footballer, in return for the bank releasing him from his debts. But Hensley, technically an escaped convict, comes to work for Croker as a medical attendant, and begins to interest him in Stoic philosophy and the gospel of Zeus. Croker, now become 'A man in full | He had a back like a Jersey bull' (or has he simply gone mad?), decides that the honourable thing for him to do is to reject material salvation from the bank and refuse to fulfil his side of the deal. In front of the assembled press and television crews, instead of making a speech in support of the black footballer, he criticizes that hero's arrogant, predatory nature.

Everything (Wolfe brilliantly sets out the irony of the situation) works out to the advantage of the mayor and his little scheme. He is helped, it transpires, because there is unassailable evidence that Armholster's daughter is very promiscuous and, in effect, had seduced the black footballer. Questions of honour, questions of identity, supreme wit, delicious irony, and exciting storylines: has Croker become a full man, an honest man? Certainly he loses all his investments, becoming a successful preacher in the cause of Stoicism. Are we being told that there is no difference between a real-estate speculator and a hot-gospeller (in this case the gospel of Zeus)? The sociological and, indeed, geographical and historical elements are vivid. As we had a tour of New York in the earlier novel so in this one we have a tour of Atlanta, encountering the basic class divide formed by Ponce de Leon Street running east to west: 70 per cent of the population, black, live to the south of this line, the other 30 per cent, white, to the north. We learn of the very distinct, and very libertarian, Black High Society.

Was 1990s society, as portrayed in *A Man in Full*, significantly different from 1980s society as portrayed in *Bonfire*? The

ambience of real-estate speculators and bankers in Atlanta is not very different from that of bond dealers in New York. But White High Society in Atlanta, in cultural matters, has a definite inferiority complex with respect to New York. Two of the leading characters in the second novel are black; we have evocations of both Black High Society, and a successful black upper-middle class. Does this mean that nationally certain blacks have progressed since the 1980s, or that certain opportunities for blacks are greater in Atlanta, than in New York? Historically, the truth is surely that prosperous black groups have continued to consolidate in both Atlanta and New York (and Wolfe alerts us to this). In *Bonfire*, New York is the place to be; it has totally taken over the qualities of Paris, Rome, and London. In *Man in Full* Atlanta is presented as having aspirations to take over, not just from the European capitals, but from New York itself. This comes over as a slightly absurd aspiration, rather than a statement of objective fact. Both novels are unkind about the undesirability and dispensability of middle-aged women—hints, perhaps, of a vestigial male chauvinism daring to speak its name in a post-feminist world.

Perhaps Wolfe, in presenting novels that to all appearances were in the traditional mould, had, after all, just been lightly caressed by postmodernist fashion. *Generation X* (1991) by Douglas Coupland (b. 1961) definitely requires attention to its actual *physical* format. After thirty-one very short, titled chapters (the whole book is short, little over 50,000 words), there is a three-page section headed 'Numbers'. These are social statistics, relating to the end of the 1980s and the beginning of the 1990s, cited with their sources. They indicate the increasing numbers of young people not getting married and, indeed, living alone; they demonstrate the growth both of poverty, and of the numbers of over-65s; they show that a majority of 18–29 year olds agree that 'there is no point in staying at a job unless you are completely satisfied'. Throughout the book there are little graphics looking as if they have been taken from the comics pages of newspapers: 'don't worry, mother ... If the marriage doesn't work out, we can always get divorced', says the bubble coming out of the mouth of one young woman. At the foot of many pages there are definitions of technical or

slang terms relevant to the content of the book itself—for example, '*Bleeding Ponytail:* an elderly sold-out babyboomer who pines for hippie or pre-sellout days'. There are also mottos and slogans of various sorts, with boxes, heavy leading, and some bare drawings creating the feeling of a technical textbook.

The narrator, Andrew Palmer, 'almost thirty', is an expert in Japanese language, ever ready with quotations from Rilke and other evidences of a top-class education, who is doing a 'McJob' in a bar in Palm Springs. He lives with Dag, who does the same job, and Claire, who peddles 'five-thousand-dollar purses to old bags'. These three members of the 'Generation X'—as defined in the statistics I have just quoted—tell each other stories, and each little story forms a chapter of the book. Though it is scarcely made explicit, there is a strong sociological statement behind the fact that the three are simply friends, totally without sexual interrelationships. Although the dialogue can be stilted, the language pretentious, and the little stories tiresome, points about both American society as a whole, and about this generation of young people rejecting the concerns of their parents and doing dead-end jobs in order to be able to think and talk untrammelled, are made with great wit and economy, using a language that contributed to the book's cult status. Recurrent horrors for Generation X are, apparently, the threat of nuclear annihilation (from America's own nuclear installations, if no longer from Russia), celebrities, and shopping malls. Along with sociology, we get some geography and some recent history. Buffalo, New York, once a great steel-making centre, is 'north America's first "ghost city" since a sizeable chunk of its core businesses had just up and left one fine 1970s day'. We have the customs and incomprehension of the older generation, and the explications of the younger:

Mr MacArthur who, with his wife, clips coupons, shops in bulk, and fails to understand the concept of moist microheated terrytowels given before meals on airline flights. Dag once tried to explain 'the terrytowel concept' to Mr M.: 'Another ploy dreamed up by the marketing department, you know—let the peons wipe the ink of thriller and romance novels from their fingers before digging into the grub. *Très swank*. Wows the yokels.' But Dag, for all of his efforts, might as well have been talking to a cat. Our parents' generation seems neither able

nor interested in understanding how marketers exploit them. They take shopping at face value.

But, of course, even members of Generation X cannot escape the amenities of contemporary society: 'Claire puts scientifically enhanced popcorn in the microwave oven. "I never feel like I'm putting food in one of these things" she says, entering with beeps, the time-set into the LED, "it feels more like I'm inserting fuel rods into a core. She slams the door hard."' Back home with his parents in Oregon, our narrator climbs up the hill to 'A Garden of Solace', a Vietnam memorial. The impact of war, at whatever remove, on life, and therefore on art, simply cannot be gainsaid. He reflects:

Growing up, Vietnam was a background color in life, like red or blue or gold—it tinted everything . . .
 . . . they *were* ugly times. But they were also the only times I'll ever get, genuine *History* times, before *history* was turned into a press release, a marketing strategy, and a cynical campaign tool . . .

The book proper ends with a chapter entitled 'Jan. 01, 2000'. The narrator, driving towards the Mexican border, thinks he sees a thermonuclear mushroom cloud ahead of him. Eventually he realizes that what he is seeing is smoke caused by farmers burning off the stubble of their fields. This event becomes 'something of a chance tourist attraction': cars pile up as people stop to watch. A 'cocaine-white egret' flies overhead, then dives down and rips the scalp of our narrator with one of its claws. Among the spectators are a group of mentally retarded teen-agers. One after another they rush over to hug and heal him: 'this crush of love was unlike anything I had ever known.' These four, final, poetic pages are magnificent.

The novelist that all students of contemporary history should put first on their reading list is Don DeLillo, who, in November 1936, was born to Italian immigrant parents in the Bronx, New York City. He grew up in the same mean streets as Lee Harvey Oswald, later assassin of President J. F. Kennedy. DeLillo set out to be a writer, interpreting the world in its many contemporary facets, not to be a celebrity. He took a degree in communication arts in 1958 and began work as an advertising copywriter in 1959, devoting himself full-time to writing from 1964. In 1966,

subsisting on a very low income, he began his first novel, *Americana*. Halfway through, in 1968, it came to him almost 'in a flash' that 'he was a writer'. The strongest influences on him, he felt, were the 'paintings in the Museum of Modern Art, the music at the Jazz Gallery and the Village Vanguard, and the movies of Fellini and Godard and Howard Hawks'.[11] DeLillo's novels begin as if simultaneously exploring the different genres of American fiction *and* the different media of communication. *Americana* (1971—accepted by the first publisher the author sent it to, though, like his other early novels, not particularly successful) is a kind of road novel, focusing on film and television, and tells the story of a TV executive seeking the real America behind the commercial images. *End Zone* (1972) we could summarize as a sports novel featuring language, *Great Jones Street* (1973) as a rock novel featuring music, *Ratner's Star* (1976) as science fiction focusing on mathematics, and *Running Dog* (1978) as a thriller featuring literature and film. Receiving a Guggenheim Fellowship in 1979, DeLillo used it to travel to Greece, where he wrote *The Names* (1982), about a series of cult murders, and an American innocent in an alien context becoming aware of his own complicity. The author has commented: 'the simple fact that I was confronting new languages and fresh languages made me feel almost duty bound to get it right!'

DeLillo traverses many themes, some of which we have already become familiar with, including a fascination with the evil of Hitler. In *Running Dog* there is a search during Hitler's last days for a supposedly pornographic film about him. In *White Noise* (1985) Professor Jack Godley of the College-on-the-Hill is chairman of the Department of Hitler Studies, a subject area he created in March 1968—though he is still struggling to learn the German language. With this novel, centred on the American family (Godley has had many wives and he and his ex-wives have many sets of children), and featuring a poisonous gas cloud made worse by media exaggeration and the dubious technology used to combat it, DeLillo moved into a highly innovative satirical style, in itself devastatingly funny. He also moved towards unsought-for fame. This move was consummated with *Libra* (1988), a bestseller, which, on the surface at least, appeared to be a 'factional' account of the Kennedy

assassination modelled on works I have already mentioned by Capote and Mailer; DeLillo, however, is trying to bring out the responsibility of the media in creating Oswald's sense of himself as a man of violence. *Mao II* (1991) was prompted by the Salman Rushdie affair and is a protest against the condition of the serious writer today. *Underworld* (1997) is DeLillo's 'great American novel', 800 pages long. It starts in the 1950s, jumps to 1992, then to the 1980s, then to the summer of 1974, then to the 1950s and 1960s, then to 1951–2, before, in the Epilogue, entitled *Das Kapital*, taking us first to post-Soviet Russia, then back to contemporary America.

They are trading garbage in the commodity pits in Chicago. They are making synthetic faeces in Dallas. You can sell your testicles to a firm in Russia that will give you four thousand dollars and then remove the items surgically and mash them up and extract the vital substances and market the resulting syrupy stuff as rejuvenating beauty cream, for a profit that is awesome.

British Variations

There are many worthy competitors for the position, formerly occupied by Kingsley Amis, of novelist presenting the shrewdest commentaries on changing British society, but David Lodge (b. 1935), Professor of English at Birmingham University, emerged as winner by a short head. *Nice Work* (1988) is *the* novel of life in Thatcherite Britain: 1986 is 'Industry Year', and universities are encouraged to appoint an 'Industry Year Shadow', who, by following a local industrialist around, will learn about the vital importance of making money. Robyn Penrose is the 'Shadow', Vic Wilcox the industrialist. Here is part of their first conversation:

'My field is the nineteenth-century novel,' said Robyn. 'And women's studies.'

 'Women's studies?' Wilcox echoed with a frown. 'What are they?'

 'Oh, women's writing. The representation of women in literature. Feminist critical theory.'

 Wilcox sniffed. 'You give degrees for that?'

 'It's one part of the course,' said Robyn stiffly. 'It's an option.'

 'A soft one, if you ask me,' said Wilcox. 'Still, I suppose it's alright for girls.'

'Boys take it too,' said Robyn. 'And the reading load is very heavy, as a matter of fact.'

'Boys?' Wilcox curled a lip. 'Nancy boys?'

'Perfectly normal, decent, intelligent young men,' said Robyn, struggling to control her temper.

In *Therapy* (1995) the wealthy narrator is the writer of a popular television comedy series. In hospital he encounters a National Health Service patient admitted three days previously: 'nobody had come near him since'; 'he seemed to have dropped into some kind of black hole in the system'. Some words also on 'recession-depression': 'People get depressed because they can't get a job, or their business collapses, or their houses are repossessed.'

Many other British writers produced accounts, often highly inventive, of the manners and morals of the age. Fay Weldon (b. 1931) remained an exuberant guide to post-feminist sensibilities: *Leader of the Band* (1988) portrays the sexpot musician out of lust for whom the narrator, Starlady Sandra, has given up her work as a brilliant astronomer. In the 1990s there came the post-feminist Generation X novels, mostly about the travails of 'thirty-something' single women. In Britain, Helen Fielding (b. 1959) led the pack with her hilarious *Bridget Jones's Diary* (1996), which first appeared as a newspaper series, and its sequel *The Edge of Reason* (1999). In the first novel there are cunning echoes of Jane Austen's *Pride and Prejudice*, a spectacular version of which was being presented at that time on British television. Each diary entry begins with something along the following lines:

9st (better), alcohol units 5 (but special occasion), cigarettes 16, calories 2456, minutes spent thinking about Mr. Darcy 245.

The film *Bridget Jones's Diary* (2001) achieved great acclaim in America, being described as 'funnier than *Four Weddings and a Funeral* and *Notting Hill*'. It was not as funny as either of these, and it was not as funny as the original column or novel. But it was an effective translation from the two original media into a very different one. It focused firmly on the triangle of one personable, slightly plumpish young woman (brilliantly played by the American Renee Zellweger) and two very beautiful men

(Hugh Grant and Colin Firth). For American audiences Bridget counted her weight in pounds (which sounded very wrong) and replaced the word singleton with single. Slightly odd, also, is the way in which Bridget Jones keeps her bra on in bed.

America had its own variant, of which perhaps the most successful example was *Sex and the City* by Candace Bushnell (subsequently a TV series). The boys (in Britain) got into the act too, two novels by Nick Hornby (b. 1957), *Fever Pitch* (1992), and *About A Boy* (1997) achieving considerable national and international success.

An elegant bridge between the novel as social, geographical, and historical commentary and the novel as postmodernist experiment is provided by the works of Martin Amis (b. 1949). Amis (son of Kingsley) had burst on the literary scene in the 1970s with *The Rachel Papers* (1973), a sort of last fling of 1960s' youth, and *Dead Babies* (1975), a vicious drug-laden binge set in a future whose super-rich, arrogant characters marvellously anticipate the nastiest acolytes of Thatcherism. In *Money* (1984), which is narrated in a highly personal and sometimes dishonest way by yuppy advertising agent and pornographic film-maker John Self, Martin Amis introduces *himself* as a minor character. Self, who has all the crude cynicism and jealousy of you and me, remarks to M. Amis: 'Your dad is a writer too, isn't he? Bet that made it easier.' To this M. Amis replies: 'Oh, sure. It's just like taking over the family pub.' To say that *Money* is set within the Thatcherite world would be ludicrously limiting, though there is contemporary relevance in the manner in which the action is divided between London, New York, and California. The novel is subtitled 'A Suicide Note', addressed, says the author, in a brief preface (but 'there are more suicide notes than there are suicides'), to 'you out there the dear, the gentle'. Feminists declared Amis a sexist, but may have been falling into the elementary error of confusing author with character. In late 1989 London buses were carrying massive advertisements for *London Fields*: Amis was one of the first Britons to enjoy the fat-cat advances that were becoming a feature of the international literary industry. *London Fields* (1989) is as powerful, and witty, an excoriation of urban decay and social decadence within a perilously threatened world as you

could find: 'It takes all kinds to make a world. It takes only one kind to unmake it.' *Time's Arrow* (1991) is experimentation at its extreme, the story being told backwards. It concerns the life and moral choices of a Nazi concentration camp doctor—that war again! *The Information* (1995) is a gloriously funny evocation of rivalries and jealousies among literary figures, and a judicious condemnation of incomprehensible, meaningless experimental novels:

Richard Tull published his first novel, *Aforethought*, in Britain and America. If you homogenised all the reviews (still kept, somewhere, in a withered envelope), allowing for many grades of generosity and IQ, then the verdict on *Aforethought* was as follows: nobody understood it, or even finished it but, equally, nobody was sure it was shit. Richard flourished.

For 'the extraordinary amalgam of Dickensian richness', the 'quirky circumlocutions', the 'grim realism, extravagant farce, fantasy, magic, and symbolism' of Salman Rushdie, born in 1947 in Bombay, we have to resort to the label 'magic realism'.

Magic realist novels and stories have, typically, a strong narrative drive, in which the recognisably realistic mingles with the unexpected and the inexplicable and in which elements of dream, fairy-story, or mythology combine with the everyday, often in a mosaic or kaleidoscopic pattern of refraction and recurrence.[12]

When it comes to *The Satanic Verses* (1988), dream and symbolism are the words that immediately jump out at the reader. When I first read this novel I certainly did not think that it was 'shit', but so erudite was the symbolism (one is almost put in mind of Eliot's *The Wasteland*) that many passages were incomprehensible; only when I got Rushdie's own guide to the symbolism was I able fully to appreciate the novel.[13] At heart, *The Satanic Verses* is exploring the experiences encountered by Muslims living in the West. The treatment of one character, apparently the prophet Muhammad, brought to Rushdie a peculiar and unwanted fame. The book was burned—terrible sign of the times!—by incensed Muslims in Bradford, and a death sentence was pronounced on him by the Iranian Ayatollah Khomeini. Earlier novels, also in some way or another concerned with the tensions between Muslim origins and

subsequent life in the British intelligensia, are *Grimus* (1974), *Midnight's Children* (1981), and *Shame* (1983). In 1999 there appeared *The Ground Beneath her Feet*, Rushie's most accessible, affecting, and, in places, hilarious novel. Evoking myths both oriental and occidental, it is the story of the immortal love between wondrous singer and popular idol Vina Apsara, half-Indian, half-American, and Ormus Cama, an Indian with a miraculous gift for writing pop music. The story is told by Indian photographer Rai, who has an earthier love affair with Vina. A photograph Rai takes of her after their last meeting, some time before she actually perishes in an earthquake (the ground beneath her feet is catastrophically insecure), becomes mythologized as a shot of her at the moment when the earth swallows her up. Public reactions after her death are reminiscent of those following the death of Diana, Princess of Wales. The novel starts in India in the 1930s and 1940s and pauses for a time in the pop world of 1960s London before moving to the contrasting world of the 1980s and 1990s, beset by earthquakes, when 'the times were not a-changing'. The magic realism, tightly controlled, the dreams, the nightmares, are there, names are subtly changed—rock 'n' roll star Jesse Parker, his manager 'Colonel' Tom Presley—Kennedy survives the assassination attempt, there are touches of P. G. Wodehouse. In the 1960s, Ormus, employed on a pirate radio station, mixes with the 'dying, drifting, broken generation, which has told itself a great lie—that it represents hope and beauty'. He visits a boutique on the King's Road, *The Witch Flies High*, run by the malevolent Antionette Corinth and backed by the 'waistcoated dandy' Tommy Gin, both of whom cut him dead. But, after Ormus has encountered the skinny, pallid resident model, 'She'—'Half love child, half zombie, She is a sign of the times'—Tommy Gin comes rushing in:

Listen man, I'm sorry, man, Gin expostulates, clasping both of Ormus Cama's hands. It's the Witch, man, she like her joke. I mean, you're Indian, I love India. The Maharishi, man. And the Buddha, and Lord Krishna. Beautiful.

And Ravi Shanker, offers Ormus, trying to be friendly. But Tommy Gin has run out of Indians and can only nod furiously. Right, right, he nods, beaming . . .

. . . Gin returns to his embarrassed apology . . . I mean, if you can believe it, she told me you were *Jewish* . . . But you're not, man, you're just not. Oh, wow.

Ormus proceeds to have a great time with 'the girls in their false eyelashes and high boots', being 'taken for an Italian, a Spaniard, a Romany, a Frenchman, a Latin American, a "Red" Indian, a Greek'.

One branch of postmodernist thinking challenges the fundamental historical notion of society's changing over time, of there being (fairly) distinctive historical periods different from each other—the nineteenth century, for instance, being different from the twentieth, and both from the era of the ancient Greeks and Romans: to use the jargon, a synchronic approach is posited as against the historian's diachronic approach. A master of this approach (provided one is always clear that he is writing fiction and not in any sense history) is Peter Ackroyd (b. 1949), whose eponymous subjects *Hawksmoor* and *Chatterton* had real historical existences, in the eighteenth and early nineteenth centuries, and in the early nineteenth century, respectively: but we flit back and forwards across the centuries, highly effectively, though in a manner that, to historians, involves unacceptable anachronisms. *Dan Leno and the Limehouse Golem* is to a large extent built up of diary entries, although we do not know who the diarist is. Dan Leno was a historical character, a stage performer, and other historical personages appear, including Karl Marx and Oscar Wilde.

The novel begins with the death-by-hanging of Elizabeth Cree for the murder of her husband. Later we start reading the journal of her husband, which begins: 'It was a fine bright morning and I could feel a murder coming on.' This is a macabre and mesmerizing novel that, as the *Daily Mail* put it, 'pervades the midnight movies of the mind and makes the blood run chilly'.[14]

Postmodernist theory denies the distinction, which I have been at pains to stress, between fiction and history. From fictions involving real historical persons, Ackroyd moved to full-scale 'biographies' with strong fictional elements—notably, *Blake* (1996) and *The Life of Thomas More* (1998). Novelists are not tied by the principles that govern the production of history.

Unfortunately some historians, eager to be in the height of fashion, and at the centre of media attention, have used postmodernist theory—any narrative is just as good as another—to abandon these principles. Most notorious is Simon Schama (b. 1945), who moved from being a true historian to making the post-modernist case in *Dead Certainties* (*Unwarranted Speculations*, 1991), to being presenter of the BBC's sixteen-part series on British history in 2000. In reviewing Schama's *Rembrandt's Eyes* (1999), Jonathan Israel, Professor of Dutch History at London University, raised some issues central to this book of mine:

Schama's strategy appears to be to omit as far as possible everything that is intellectually demanding, historically complex and which requires any effort from the reader. He seems almost deliberately to be trying to reduce historical writing to vivid impressions, appealing unabashedly to the senses instead of to the mind . . .

. . . Schama's rhetoric, and the supporting media fanfare, raise compelling questions about the character of today's learned and literary culture, as well as what currently makes successful historical writing. Increasingly, the power of commercial factors and the media generates cultural trends in society. More and more, what is valued is the packaging, the glossy surface and pungent image-creation, with less and less emphasis on intellectual content.[15]

Personally, I think Israel overstates the importance of 'commercial factors and the media'. The real villain is the conflation of history and fiction, the elevation of rhetoric over evidence.

Fortunately, there are still writers of true historical novels, illuminating about the past without pretending to be history. Most noteworthy is Sebastian Faulks (b. 1953), who has written two books set in the Second World War, and, in between, a masterpiece (and worldwide bestseller) about the First World War and its implications, *Birdsong* (1994), which really does earn a place among great novels about that war. And there are still writers too who are marvellously inventive in the creation of character, and the situations that arise out of character. For *Sacred Country* (1992), Rose Tremain (b. 1943) created a little girl in a deprived farming family who realizes at the age of 6 that she is really a boy, and the restrained, funny, but overwhelmingly moving story of her determination to rectify her sex. For

The Way I Found Her (1997) she created a precocious 13-year-old boy who tells of his infatuation for a beautiful Russian novelist, of her disappearance, and of his quest to find her.

Continental Variations

A perfect specimen of the postmodernist genre was provided by one of the few Austrian novels to enter the international book market, *Die Letze Welt* (1988; published in English as *The Last World*, 1990) by Christoph Ransmayr (b. 1954). To help those unfamiliar with the classics, the English translation had an 'Ovidian repertory' added to it, giving potted accounts of both the fictional characters of Ovid's *Metamorphoses* and certain real historical characters such as the poet Ovid himself, and the Roman emperors of his era (about fifty years before the birth of Christ to some years after it). We are in the time of Ovid, yet the people have a cinema and watch films. Ancient Rome, you could say, meets the twentieth century: from out of this there emerges a political and cultural fable, deeply philosophical about the end of time, the last world. Ransmayr, whose *Morbus Kitahara* (1995; rendered in English as *Dog King*, 1997) was about a deindustrialized future, was indeed a student of philosophy.

Philosophy, too, was a fundamental interest of the Czech novelist, Milan Kundera (b. 1929), whose titles I shall render here solely in English. In the 1960s and 1970s he wrote a number of plays and novels that combined black comedy and erotic farce. He was a teacher at the Institute for Advanced Cinematographic Studies in Prague, but lost his professional standing after the Russian invasion in 1968; in 1975 he settled in Paris. *The Unbearable Lightness of Being* (1984) is ostensibly about the Czech surgeon Tomas, his wife Tereza, and one of his many lovers, Sabina, about life under Communist rule and the events of 1968, but is afflicted by a scarcely bearable heaviness of philosophizing, about human existence, responsibility, and the relationships between the public and the private. Franz (Sabina's long-time boyfriend)

felt his book life to be unreal. He yearned for real life, for the touch of people walking side by side with him, for their shouts. It never occurred to him that what he considered unreal (the work he did in the

solitude of the office or library) was in fact his real life, whereas the parades he imagined to be reality were nothing but theatre, dance, carnival—in other words, a dream.

Choices, it would seem, are irrevocable and, in combination with external events, determine our lives: in that sense we are relieved of any weight bearing down upon us, but at the same time such a state of affairs is unbearable.

As we have seen, it was not altogether unusual for books published in French, Italian, or German to be translated into English and achieve substantial international sales. There were perhaps specific historical reasons why one or two books written in Czech should also achieve this accolade. For a book written in one of the Scandinavian languages, to do so was a much rarer event. *Sophie's World* (1985), written by a Norwegian philosophy teacher, Jostein Gaarder (b. 1952), did become a sensational world seller. It is perhaps worth noting that translation into English did not come until 1994—for publication in America, with British publication following in 1995. The British paperback, published in 1996, then went through twenty-three further impressions, meantime being translated into forty other languages. The English-language version carries a subtitle: *A Novel about the History of Philosophy*, and, indeed, the novel does very largely consist of a series of potted accounts of major philosophers, fifteen of the thirty-five chapters having simple titles like 'Aristotle', 'Kant', 'Kierkegaard', and so on. Critics recently have singled out this book as having, they claim, played a part in a general intellectual dumbing-down taking place towards the end of the twentieth century, on the grounds that philosophy should not be learned through little potted summaries. Indeed, a good deal of the interest of the book attaches to its reception, rather than to its production. Since the book was written in Norwegian, one can presume that it was not deliberately constructed as an international bestseller. The critical comments quoted in the British paperback edition in themselves make interesting reading. The *Guardian* referred to 'Gaarder's gift for communicating ideas', and the *Independent on Sunday* said that the book was 'packed with easily grasped and imitable ways of thinking about difficult ideas'. The *Daily Mail's*

comment goes wider: 'A terrifically entertaining and imaginative story wrapped round its tough, thought-provoking, philosophical heart.' The most wide-ranging claim appears in the quotation from the *Daily Telegraph*, though the phrase 'talked up' may suggest that the claim is not one that the paper itself necessarily endorses: 'An *Alice in Wonderland* for the 90s . . . already *Sophie's World* is being talked up as philosophy's answer to Stephen Hawking's *A Brief History of Time* . . . this is a simply wonderful irresistible book.'

The apparent pattern of the book is quickly established in the mind of the reader. Sophie, a schoolgirl on the verge of her fifteenth birthday, first receives unexpected letters, each one a lesson in philosophy, then meets the mystery author Alberto Knox, with whom she thereafter has what could reasonably be described as a series of tutorials. But from the start there is an element of mystery: Sophie also receives cards addressed to an unknown girl of exactly her own age, Hilde, and apparently written by her father, a UN officer in the Lebanon. There are a number of non-naturalistic happenings: a dog talks, a sudden storm blows up in a lake. The attractions for the vast readership, one presumes, are the combination of useful information and the eternal desire to have mysteries explained. Just over halfway through the novel we learn that Sophie and Knox are actually characters in a novel by Hilde's father, which he is sending to her in instalments. It is suggested that this author is a kind of godlike figure and the question arises as to whether his characters, Sophie and Knox, can exercise some free will of their own.

We encountered Umberto Eco as one of the protagonists of the 'intellectual revolution', putting forward new ideas about the nature of life, art, and language, ideas that became central elements in postmodernist theory. Eco's two magnificent novels, entitling him to be identified as one of the giant cultural figures of the whole of the second half of the twentieth century (perhaps even a celebrity), cannot be constrained by the label 'postmodernist': Eco is an electrifying storyteller, setting puzzles and creating mysteries, but never going beyond the rational understanding of the attentive reader; he is immensely knowledgeable, yet the learning transfers itself lightly, because of the

reader's enthusiastic involvement; the ideological issues—predominant in *Il nome della rosa* (*The Name of the Rose*, 1980)—and the political ones—in *Il pendolo di Foucault* (*Foucault's Pendulum*, 1988)—are always intriguing. Eco had originally been a student of medieval history and philosophy and this informs *The Name of the Rose*, actually a complex, subtle, and very thrilling murder mystery set in the year 1375 in a monastery in northern Italy. Unlike some of the postmodernist writers I have discussed, Eco fully understands the differences between the medieval world and our own. However, the interplay between past and present, the use of the past in exploring contemporary theoretical issues, is very characteristic of much of the literature of the last two decades of the century. The Foucault in the title of the second novel has nothing to do with the poststructuralist philosopher, though, since some association of ideas is unavoidable, the book is enriched thereby. Eco's Foucault was a scientist whose Pendulum demonstrated the rotation of the earth. It was invented in 1851 and exhibited in a couple of places in Paris before, in 1855, a reduced version was installed at Saint-Martin-des-Champs.

Some of the action takes place in this rather spooky church. We go far back beyond the nineteenth century in investigating the origins, in secretive medieval orders and societies, of what begins to emerge as a worldwide conspiratorial movement. Once more: a thriller, full of learning, full of issues, enchanting reading.

Among Italians Eco's greatest rival for media attention was the glamorous journalist/novelist, Oriana Fallaci, born in Florence in 1930 and, as a child, involved with her father's Resistance activities. Fallaci made her name in the 1960s as, in particular, the author of published interviews with famous people: according to the *Washington Post* at the time, she 'wants to be more than a brilliant interviewer, she wants to be an avenging angel'.[16] In the preface to a book about the status of women in India and China, she stated her position with regard to feminism:

Whenever I possibly can, I always avoid writing about women, or about problems concerning women ... God Almighty created men and women to live together, and since this can be very agreeable, in spite of

what certain outsiders may have to say, I find it quite senseless that women should be regarded as if they live on another planet and reproduce the species by pathogenesis.[17]

She produced one novel at this time, *Penelope all guerra* (*Penelope Goes to War*, 1962). The blurb on the 1966 paperback English translation gives this summary: 'Instead of sitting demurely at home with her loom, the modern Penelope goes off to war, just like Ulysses.' After this gross hyperbole, the novel is somewhat of a disappointment. Penelope is Giovanina, a 26-year-old Italian writer of film scripts who travels across the Atlantic to seek her fortune in New York. With her she carries the memory of an American soldier sheltered by her family during the war. She encounters him in New York and finds him irresistible. In the main the book is a study of American women embarking on liberation. Fallaci really did go to war (as a war correspondent) for her major 1960s work, *Niente e così sia* (*Nothing and Thus It Was*, 1969; translated in 1972 as *Nothing and Amen*). Fallaci explained: 'There was a war in Vietnam, and, if you were a journalist, you were bound to go there. Either because they sent you or because you asked to go. I asked to go.'[18]

Her great novel, to return to the time period under discussion, is set in war-torn Beirut. *Insciallah* (1990; English version, *Inshallah*, 1992) is a gutsy, colourful account of an episode in the seemingly eternal conflict between Christians and Muslims. The novel is dedicated 'to the four hundred American and French soldiers slaughtered in the Beirut massacre by the Sons of God sect', and 'to the men, the women, the old, the children slaughtered in the other massacres of that city and in all the massacres of the eternal massacre called war.' The novel, Fallaci explains, 'is meant to be an act of love for them and for Life'. Reviewers evoked *Catch-22*, Proust, Tolstoy, Boccaccio, Fellini, Goya, and a few others.[19] A bit much: but then Fallaci always inspired hyperbole.

Three novelists dominating the French literary scene in the 1980s and 1990s were: Hélène Cixous (whom I have mentioned in Chapter 4 in connection with the feminist writing of the 1960s and 1970s), J. M. G. (Jean-Marie) Le Clézio (b. 1940), and Patrick Modiano (b. 1945). Then came Michel Houellebecq and his international bestseller, *Les Particules élémentaires*

(*Elementary Particles*, 1999, but published in English as *Atom-ised*, 2000). Cixous is straightforwardly postmodernist in her alle-giances and preoccupations: she is fascinated by language and by Derrida's exploration of it, and immersed in philosophical dis-putation, while, mercifully, insisting on the difference between being a writer of philosophy and a writer of novels (though not on the difference between philosophy and poetry—an issue to which I refer in the next chapter). As she herself puts it:

To live language, inhabit language, what luck and what adventure . . .

If one can speak of a 'personal tradition', in my own tradition I have never conceived of poetic writing as separate from philosophy.

To me writing is the fastest and most efficient vehicle for thought: it may be winged, galloping, four-wheeled, jet-propelled etc.—according to the urgency.

The difference with philosophical discourse is that I never dream of mastering or ordering or inventing concepts. Moreover I am incapable of this. I am overtaken. All I want is to illustrate, depict fragments, events of human life and death, each unique and yet at the same time exchangeable. Not the law, the exception.[20]

The works of Cixous are not for every taste but (to touch on one of my constant refrains) there can be no doubt about the genuine compulsions that lie behind her production of them. She talks of having 'never been without writing', of ' having writing in my body, at my throat, on my lips . . . '. Within postmodernist thought there has been a growing interest in the nature of 'boundaries'—between concepts, activities, setting the limits of what it is conventionally proper for people to do. This is an area of philosophy to which Cixous has herself greatly contributed, particularly with reference to human relationships and sexual love. Of one of her most recent novels, *La Bataille d'Archachon* (*The Battle of Archachon*, 1987), critic Verena Andermatt Conley has written that it 'extends and experiments with new ways of writing about love, of linking absence and presence, self and other'.[21] Cixous has taken an interest in the travails of for-mer French colonial countries in the Far East, as seen particu-larly in some of her plays—for example *L'Histoire terrible mais inachevée de Norodom Sihanouk roi du Camboge* (*The Terrible but Unfinished History of Norodom Sihanouk King of Cambodia*, 1984).

This interest in the former colonial world is shared by Le Clézio, who spent three of his childhood years (1947–50) in Africa. Though he was born in France to a French mother, his father was actually an English medical officer in Nigeria who retired to Nice. In 1958 he taught for a year at Bath Grammar School while attending Bristol University. Publication of the novel *Le Procès-verbal* (*The Verbatim Report*, 1963; always inaccurately translated as *The Interrogation*) brought him— another 1960s youthful genius!—a certain fame. In fulfilment of his military service obligation, he chose, during 1966, to teach at the Buddhist University in Bangkok; he spent 1967 at the University of Mexico. His national service over, he took up residence for four years among the Embera Indians in the forest of Panama, not returning to France until 1973. Many protracted visits to Central America followed. Like others we have encountered, Le Clézio despised city life, the advertising industry, department stores, consumerism; he sought an inner spiritual serenity. Much of this is implicit in his translations of Mayan texts and his explorations of Mayan and Buddhist spirituality. Critics have noted in Le Clézio's novels—top bestsellers have been *Le Chercheur d'or* (*The Seeker of Gold*, 1985), *Le Rêve mexicain* (*The Mexican Dream*, 1988), and *Onitsha* (1991—Onitsha is the name of an African port)—distinctively postmodern attitudes to language, and to the 'foregrounding of spatial elements'. Anthony Levi writes

To rebel against society . . . the first step has . . . to be the dislocation of language, which appears in Le Clézio's work ambiguously as a weapon, a shield, and an instrument. For him language is 'not a harmony, but an explosion'. Each person, particularly each writer, by constructing his own language, affirms himself and his attitude to the rules which govern not only the grammar of his language, but also the values of his society.[22]

Bronwen Martin declares that Le Clézio's

Fictional writings are characterised by a foregrounding of spatial elements—whether they be urban, cosmic or natural—and a slackening of what is traditionally recognised as the anecdote or story line . . . spatial figures (images) play a key role in the production of meaning in

his texts: they not only serve to create a sense of place, they also fulfil functions traditionally associated with the characters and the narrative. And, at the same time, they become vehicles of an abstract discourse.[23]

Onitsha features three characters, their dreams, their revolts, seeking inner tranquillity, within a juxtaposition of an oppressive colonial regime against African myths. The first chapter of the final part, part four, is 'Bath Boys' Grammar School, automne 1968', recalling his early life. Le Clézio has offered his own recipe for his writing: 80 per cent pure imagination, 10 per cent personal experience, 2 per cent remembrance of things read, 0.5 per cent premeditated recourse to traditional themes, 6 per cent miscellaneous news items (*faits divers*) and elements of actuality, 1.5 per cent relating to the great problems of the time. He seems to have been fairly serious.[24]

Atomised, by Michel Houellebecq, is perhaps the first significant post-postmodernist, or, even, neo-traditional novel. Set mainly in the period before, during, and after the Cultural Revolution of the long Sixties, it is a moral fable condemning that era of excess and abandonment of religion and family values as entailing the destruction of humanity: the two protagonists, Michel and Bruno, are half-brothers, the dysfunctional products of promiscuity. It is easy to understand the appeal of the book. All of the characters have fixed identities, jobs, parents, and grandparents, giving the endearing quality of a family saga. There are lashings of sex, some penetrative, most not. But there are also erudite lessons in science (most notably), history, philosophy, and politics, with a series of sparkling aphorisms on the human condition—is it not our unalterable nature, rather than our personal defects, that makes us so awful? The Epilogue takes us into the future, where Michel's brilliantly original scientific work leads to the creation of a super-species of decent beings (one is put in mind of George Bernard Shaw's *Man and Superman*). *Atomised* is an enthralling, uncompromising, breath-taking work: it may be the beginning of the renewal of the novel for the new century. With Patrick Modiano we again encounter the all-pervasive influence of the Second World War. For non-francophones probably the most meaningful, if not the most subtle, way of introducing Modiano is as the screen-writer for the Louis Malle film, *Lacombe*

Lucien. In the French manner, he has quite a long list of novels, all very short. They feature that fashionable topic, memory, mostly memories of the war, and often concerned with the way in which French Jews coped with the war. They range from *La Place de l'étoile* (1984) to *Des Inconnues* (1999).

Multiculturalism and Postcolonial Literature

Racism is still very apparent in all Western societies, yet there can be no doubt about the transformations in race relations everywhere since the 1960s. Given the nature of population movements, all countries are in some sense becoming multi-cultural, often grudgingly, sometimes with signs of enthusiasm; rock music, inherently a mix of black and white influences, has been a potent agent. Already, as prize-winning literary spokes-persons of black America, I have mentioned James Baldwin and Toni Morrison. I have also already discussed Salman Rushdie: born in Bombay just at the time when India was achieving independence from the United Kingdom, he could well be, and often is, considered the quintessential postcolonial writer, and, given that he was educated at one of England's most privileged public schools, Rugby, and at one of the most exclusive colleges, King's Cambridge, a most intriguing one.

Postcolonial literature was hot property at the end of the twentieth century, for a least two reasons. First, it is the newest and most fashionable field within Anglo-Saxon literary studies, attracting much po-faced analysis from postmodernist critics. Secondly, writers generally identified as postcolonial were at that time very successful in Britain, managing to carry off a number of Booker prizes, to the extent that they are often cited in support of the contention that the native English novel is dead. Familiar names are those of Timothy Mo (b. 1950), Arundhati Roy (b. 1960), Vikram Seth (b. 1952), Ben Okri (b. 1959), Anita Desai (b. 1937), Caryl Phillips (b. 1958), and Diran Adebayo (b. 1968).

In this section, of course, I am not talking about European writers such as Etcherelli, Cixous, or Le Clézio who have engaged with Third World themes, but about writers born in the Third World. This literature has perhaps three branches: there

are writers who, like Rushdie, deal with the encounter between Third World and Western traditions; there are writers who want to restore authentic accounts of their own native countries, sweeping aside the encrustation of imperial values and attitudes; and there are those who deal with domestic life in the West, addressing the issues of racism and multiculturalism.

The most revered figure in the first branch is Sir V. S. Naipaul (b. 1932), who is a hero to at least two traditions, since, though born in Trinidad in the West Indies, he belonged to a Brahmin family of Indian origin. After education in Port of Spain and then University College, Oxford, he settled in Britain, his Knighthood being a fairly persuasive indication of his acceptance there. He achieved fame with *A House for Mr Biswas* (1961) and *The Mimic Men* (1967). *In a Free State* (1971) features three stories of cultural displacement, those of a Bombay servant suddenly uprooted to Washington, of a West Indian youth in London, and of two Europeans in a Black African state.

The second branch is well represented by two contrasting Nigerian writers, Chinua Achebe (b. 1930) and Wole Soyinka (b. 1934). In *Things Fall Apart* (1958), Achebe set out deliberately to challenge the representations of Africa given by such English novelists as Joyce Cary, telling a story of a colonial encounter from the African point of view. Soyinka has declared that his work has been aimed at overcoming limited eurocentric views of Africa, striving to present his 'own world in its full complexity'. Soyinka has himself been subject to attack from a more recent generation of Nigerian critics who, echoing points made earlier from Achebe, have described him as 'Euro-assimulationist'. A warning, simply, that one should not generalize too wildly about postcolonial literature.

To date, the most interesting example of the third branch has come in the form of a film. *My Beautiful Laundrette* (1985) by Hanif Kureishi (b. 1954) is, in some elements at least, multicultural, in that it focuses on British Asians, one white, one Afro-Caribbean, and on a gay sexual relationship. Just to tie up the complexities of this general topic, the most vigorous denouncer of white supremacist policies in South Africa was the white South African novelist J. M. Coetzee (b. 1940), winner of the Booker Prize in 1999, with *Disgrace*.

In the broad historical perspective, there can be no question that the most intriguing development in the last twenty years of the twentieth century was the return of Germany as Europe's most powerful country, with the many repercussions in the arts that I identified at the beginning of the chapter. Yet, as the prototype of post-industrial society on the threshold of the twenty-first century, America continued to exercise its magnetic attraction, producing some fine novels of social and historical analysis. In the final section we touched on some of the literary implications of globalization. All that said, there was still a case for Paris as the intellectual centre of the world. Certainly, at the beginning of the new century, Houellebecq was carrying all before him.

9 The Real Postmodernism?

Architecture

There is general consensus that an architectural style exists that is exactly described as 'postmodernist'. And, if the notion of a postmodern world has any validity at all, it would be in its application to the urban environment, or at least to those areas of the urban environment where there was much new building in the 1980s and 1990s. In Britain: extensions to the National and Tate galleries and to the Victoria and Albert Museum; De Montfort University, Leicester; the Inland Revenue offices in Nottingham; the Waterloo international terminal; various buildings along the Thames and in the City of London. In France: the Lyons TGV station; the Departmental Offices, Marseilles; the Crédit Lyonnais bank, in the Lille satellite town, Euralille; Disneyland near Paris; the La Villette development on the northern borders of Paris. In Germany, the Hamburg Ferry Terminal and the headquarters of the various banks in Frankfurt. In the late 1990s a vast area at the heart of reunited Berlin was the world's biggest building site, from which many postmodernist constructions would arise, and over which loomed the Daimler Benz Building, and the new glass bubble atop the old Reichstag. There are the Z-Bank in Vienna, the Groninger Museum, and the Erasmus Bridge, Rotterdam; the buildings of Expo 92, Seville, Eco House, County Cork, and many, many other buildings everywhere in Europe, run up by developers rather than architects. In America: the Los Angeles County Museum of Art, the Children's Museum, Houston, Texas, the AT&T Building, New York; loads of buildings in Las Vegas and Los Angeles, and in every state touched by the Disney Corporation with its hotels and theme parks.[1]

Purists would describe some of the buildings included within that quick tour as High Tech, New Expressionist, Ecological

Architecture, Populist Architecture, or Megastructures, though 'postmodernist' remains permissible as a blanket term, postmodernist architecture being essentially characterized by its obvious and very conscious reaction against the austerity and brutalism of the modernist international style as it had developed through the 1950s and 1960s. The most blatantly postmodernist buildings deliberately make use of styles of earlier periods, sometimes mixing them up together; particularly favoured is the art-deco style of the inter-war period, and sometimes a pastiche of the classical styles of the eighteenth century. There is usually something of a fantasy element, called 'architecture of fiction' by the leading Italian postmodernist architect, Paulo Portoghesi (b. 1931). It is where this fantasy quality permeates High-Tech buildings and the Megastructures (the postmodern successors to skyscrapers) that they are most obviously postmodernist. Postmodernism could be exciting, amusing; it could bring a lift to the spirits; it could also be the trademark of the shoddy developer—this was particularly so in Britain. It gained full recognition as a major international style at the Venice Biennale of 1980, though its origins, as we saw, went back to the 1960s, springing from the challenges mounted then by Robert Venturi (b. 1925), Louis Kahn (1901–74), and Charles Moore (1925–83).

In *Complexity and Contradiction in Architecture* (1966) Robert Venturi had called for the development of 'an architecture that promotes richness and ambiguity over unity and clarity, contradiction and redundancy over harmony and simplicity'. Louis Kahn, Professor of Architecture at the University of Pennsylvania, 1957–74, called for an architecture that was in tune with the rules of nature, for houses that conformed to the spirit of those who lived in them. Against the solemnity of modernism there should be the opportunity for wit and fantasy. Charles Moore brought in the element of populism, the idea that in mass, multicultural society you had to appeal directly to people, and could not expect them to respond to the austerities and abstractions of modernism.

Venturi's later work is well exemplified by the Gordon Wu Hall at Princeton University (1983) and the Sainsbury Wing at the National Gallery, London (1986–91), the design for which

was submitted jointly with Denise Scott Brown (b. 1931), Venturi's partner in the firm of Venturi, Scott Brown, and Associates. The former building was set amid the neo-Gothic buildings of the Princeton campus; the latter was juxtaposed to the classical façade of the National Gallery. The Gothic element is replicated in the red walls and two large bay windows of the Gordon Wu Hall, while over the entrance there is a dominating panel of white marble patterned with geometric shapes in grey, which lifts the whole tone of the building into that of almost childish exuberance. The monumental staircase inside the National Gallery extension is both modern and classical. The exterior, however, is playfully postmodern, being 'animated by a series of classical pilasters, in various orders, moving across the limestone surface like so many superimposed, moving, neon images on a billboard in Times Square. The columns eventually crowd together and appear to slide behind, or crash into, each other at the main entrance . . .'.[2]

Most playful and irreverent of the American postmodernist architects was Charles Moore, yet he was entirely serious in his statements that he was never intentionally a postmodernist, as is illustrated by a delightful story. Lecturing at a university in Brazil, he was criticizing postmodernism for having become superficial and banal, when he was interrupted by one of the organizers of the lecture, who took him backstage and told him how disturbed the students and staff were to hear this: he had been specifically invited as one of the founders of postmodernism in the hope that he would give encouragement to those who had doubts about the style. The lesson bears repeating once more: great artists do not set out to exemplify a particular style. Influenced (inevitably) by the specific conditions of production, they fulfil their own vision in resolving the problems that they perceive. Labels are nearly always applied retrospectively. Moore was an iconoclast, a humorous defier of tradition and convention. What more suitable challenge for him, then, than to design an Episcopal church? But what more suitable venue for his outlook and talents than Pacific Palisades, Los Angeles? What Moore produced was a work of the complexity demanded by Venturi, forcing together several ancient traditions of church building, 'a kaleidoscope of colour, light and surface'.[3] If

fantasy is the key word for Moore's Beverly Hills Civic Center, there are also strange elements of the liturgical in the white and pink building, while environmentalist principles are exemplified by the integration of palm trees with the building.

Fourth of the great quartet of American postmodernists is Michael Graves (b. 1934), among many other things a principal architect for the Walt Disney Corporation. Graves, one could almost say, developed a kind of Disneyesque conception of classicism and the use of columns: he then added colour, and a great variety of decorative 'add-ons'. The Portland Building, Portland, Oregon (1980–3) is often seen as marking the entry of postmodernism into the realm of major public buildings, just as the Humana Corporation Medical Headquarters, Louisville, Kentucky (1983–6) is seen as the first postmodern skyscraper, or 'megastructure'. Philip Johnson (b. 1906) was a very late and perhaps reluctant convert. With John Burgee (b. 1933), he was responsible for the AT&T Building, New York (1979).

The adoption by James Stirling (1926–92) (with his partner Michael Wilford) of postmodernist approaches is most strikingly seen in two buildings in Stuttgart, the Neue Staatsgalerie (1977–84), and the Music School and Theatre Academy (1986–95). The former, through its veneered sandstone and travertine walls and natural stone paving, achieves a 'casual monumental effect', making a convincing statement about the dichotomy between the traditional formality of museums and the more populist, informal approach of the end of the century.[4] Externally similar, the latter building forms an integral part of a massive urban-planning project by the city of Stuttgart. In his native Britain, Stirling's most important postmodernist works are the new Tate Gallery in Liverpool (1984–8), and the Clore Gallery at the London Tate (1985–6).

The most consistent and confirmed exponent of postmodernism in Britain is Terry Farrell (b. 1938), whose buildings at TV AM (1981–2), Charing Cross Station (1987–90), just across the river from Waterloo, and Vauxhall Cross, just over the river from the Tate, have become prominent London landmarks. Some of the equally attention-grabbing works of Sir Michael Hopkins (b. 1935) and of the Edinburgh-educated exponent of

High Tech, Nicholas Grimshaw (b. 1939) were mentioned in Chapter 7.

From time to time I have questioned whether the, often incoherent, manifestos that some artists issue are truly helpful in understanding their work. In 1988 yet another 'ism' was launched at a Museum of Modern Art exhibition, when the ubiquitous Philip Johnson, who had moved from 'ism' to 'ism', and the younger Mark Wigley organized a display of 'Deconstructivist' architecture. While the two sponsors disavowed any connection with Derrida's theory of 'deconstruction' (it is difficult to see how this could possibly relate to architecture), one architect, Peter Eisenman (b. 1932), took up the fashionable notions of texts being subject to ever-changing interpretations and of the decentring of the human subject. Deconstructivist architecture can be seen as a stage in the development of postmodernist architecture towards expressionist architecture. Among Eisenman's larger works are the Columbus Convention Center, Ohio (1992). To convey his preoccupation with the information age (very much a preoccupation of the postmodernist philosophers Lyotard and Baudrillard, as well as Derrida), Eisenman divided the plan of the building into curved, barlike strands intended to suggest train sheds and fibre-optic cables.[5]

Let me now add some names to the buildings I lumped together at the beginning of this section: La Villette, master plan, and most buildings by Bernard Tshumi, a French-Swiss architect born in 1944, and usually labelled a deconstructivist; the Boilerhouse extension to the Victoria and Albert (1996), designed by Daniel Libeskind, an American architect born in 1945 in Poland, and again labelled a deconstructivist; Groninger Museum (1990–4), built by the Cooperative Himmelblau, the partnership of two young Austrians, one of whom had been born in Poland; the Erasus Bridge (1996), designed by the young Dutch architect Ben van Berkel (b. 1957); Los Angeles County Museum of Art, built by the American expressionist architect Bart Prince (b. 1947); Hamburg Ferry Terminal (1988–91), designed by Euro-Partnership of British William Alsop and German Jan Stormer, both born in 1947; Lyon TGV station (1988–94), designed by Spanish architect Santigo Calatrava (b. 1951); Z-Bank, Vienna (1974–9), designed by the

Austrian Gunter Domenig (b. 1934); De Montfort University (1993), designed by Short, Ford and Associates, headed by Alan Short (b. 1955); Eco House, Cork, designed by Gaia Associates, headed by Irish Architect Paul Leech (b. 1950).

At their best, postmodernist, expressionist, and High-Tech buildings were both striking in their own right and redolent of their time; many could be just as boring as, and much more irritating than, the much criticized failures of the modern style. Postmodernism attempted to incorporate a selection, often conflicting, of older styles. Many projects, particularly residential ones, reverted back to traditional styles: a prime exponent in Britain was Quinlan Terry (b. 1937). However, Britain often seemed to get the worst of everything: the modernist, high-rise post-war redevelopment around St Pauls in central London came to be seen as a ghastly mistake; it was to be replaced by the more restful, but tediously traditional Paternoster Square development (1990) by John Simpson.

A renewed 'New Modernism' continued, unfussy but spectacular, as in the work of the American Richard Meier (b. 1934), celebrated for his shining white buildings, such as the High Museum of Art, Atlanta (1980–3), and the Barcelona Art Museum (1996). There was also a gentle, welcoming, modernism, nicely represented by the new British Library (1963–97) designed by Colin St John Wilson (b. 1922). And the great moderns of the early post-war period marched on. I. M. Pei (b. 1917) attracted enormous attention for his Louvre Pyramid in Paris (1983–93). His Rock and Roll Hall of Fame in Cleveland, Ohio (1993–5), a wonderful expression of the coming together of high-art architecture and popular culture, is a complex building incorporating a huge triangular glass wall, as well as solid pink shapes. According to Pei himself, 'I wanted the building to express music. But what is this music? It has a sense of rebellion, of breaking away from tradition. It has a dimension of energy. The generation that made rock music was much more transparent about its ideas than my generation. Everything is up front, whether you like it or not'.[6]

Art Music

Advanced technology was affecting the distribution of art music from the end of the Second World War onwards. By the 1960s the production of music was also being strongly affected—and the development of the Moog synthesizer in 1965 gave a great stimulus to electronic composition. Then with the advent of the compact disc in 1986 there was another powerful boost to distribution. Yet, while production of classical music for consumption in the home became ever bigger business, *fin-de-siècle* marketing techniques were also applied to live performance, with a special stress on the glamour of performers. Much new music presented analogies with postmodernist architecture, in its eclecticism and self-conscious borrowings from both the past and from popular music, though formally the dominant styles were Minimalism and New Complexity, the latter reviving the principles of rigour and control insisted on earlier by Boulez.[7]

The trouble with the most innovative art music after 1945 had been that only those who understood its intellectual premisses could engage with it. There are two questions that can be asked about contemporary music. Can we educate audiences so that they appreciate it, making them realize that what they take as 'normal' in the matter of harmony and melody is simply the Western tradition in which they have grown up? Or can we persuade composers to forsake their intellectual preoccupations and produce compositions that appeal to what most audiences look for in music? The most informed commentators do not give clear answers about where music stood at the end of the twentieth century. According to musicologist Mark Morris, 'the conglomeration' of various musical developments in the twentieth century, and particularly after 1945, 'made the avant-garde period of the late 1950s and the 1960s the most experimental, the most fertile and most exciting since the 1920s', yet he recognizes the absence of audience appreciation, before going on to dismiss the period that followed 'as the most regressive and disappointing twentieth-century period in Western culture and intellect', speaking of the most recent developments as having 'reached a musical impasse'. Then, in a thought well worth pondering deeply, he declares: 'The experience and

development of the avant-garde period remains a sleeping giant, perhaps waiting for the right genius of a composer to reawaken it.'[8] Geniuses do not turn up on a regular basis; instant recognizability is not a quality that usually pertains to them.

Since the late nineteenth century, concert programmes have tended to be filled more with composers who are already dead than with contemporary ones. Any art form does have to be refreshed with new work, but as long as works are being enjoyed, or touching the emotions, or being interpreted and reinterpreted, the art form is not dead. What is crucial, to return to a question raised at the very beginning of this book, is that people should have choices. Choices, certainly, can be curtailed through material, and particularly educational, deprivation and by the undue influence of commercial considerations. But I think Morris is simplistic and wrong when he makes a scapegoat of the United States, though, as always, there are elements of truth in what he says and particularly in the opening words of this quotation:

Western European cultures have traditionally valued the arts beyond their immediate financial rewards as essential to the health of those cultures; North American culture since World War II has not. Increasingly, North American thinking has been dominated by financial considerations and controlled by accountants. Consequently, in the search for large audiences, the culture has aimed at a lower and lower common denominator. In terms of classical music, this has meant an increasing reliance on the standard 'classics' that will bring in audiences. New works are increasingly aimed at entertainment as much as challenge; this is one of the reasons the United States has produced so comparatively few composers of stature.[9]

That final statement really does seem to be contradicted in other parts of his magnificent *A Guide to 20th-Century Composers*. In fact, Morris cannot resolve the problem. Music needs to renew itself, needs to be for and of its own time. But, it would seem, the more the music of today is of its time, the less people want to listen to it. Morris brilliantly expresses the paradox, but that is what it remains: 'There is a very real danger that classical music will be relegated in its contemporary manifestations to the ivory tower, and in the wider world to musics of the past. These cannot speak to those needs, or foster new ideas, except in the most

general way, and classical music is in danger of becoming a medium to entertain, rather than to expand our horizons.'[10]

These are the issues; let me now try to summarize the good news and the bad, in so far as these can actually be separated from each other. On the whole, from the later 1970s onwards the more arid experimentation of the post-war generation was abandoned. Composers allowed themselves to be affected by extra-musical influences: nationalism, religion, a kind of neo-romanticism—but saying, according to Morris, 'very little new and rarely saying it well'.[11] An important geographical and national influence was that emanating from some of the East European countries formerly under Russian and Communist domination (and thus truly culturally dead). A lesser one was that emanating from the Scandinavian countries. National and religious emotions also affected certain composers in the United Kingdom, which, to a greater extent than any other country, benefited from the continuing, though diminishing, patronage of the BBC.

The Polish composer who made the biggest impact in the West was Henryk Górecki (b. 1933). His Symphony No. 3 (*Symphony of Sorrowful Songs*) actually dated back to 1976, but it was only in the 1990s that a recording of it began to be widely played in the West. Górecki's work had gone through a long and determined experimental phase. In it, national and religious influences have full rein. Both the Symphony No. 2 (1972), written for a huge orchestra with a battery of percussion instruments, and works of the 1980s and 1990s for small groups of instruments are more challenging, but there can be no doubting the emotional power of the Third Symphony. Bernard Jacobson's notes for the Philips CD with the Warsaw Philharmonic Orchestra conducted by Kazimierz Kord explain: 'The three "Sorrowful Songs" . . . are settings respectively of a fifteenth-century lament from the Holy Cross Monastery, a prayer written on the wall of a Gestapo cell in Zakopane by an 18-year-old girl imprisoned there, and a folk song in the dialect of the Opole region in South-west Poland'. Jacobson here points out that (once more) we certainly do have a connection to the Second World War, but warns against regarding the work too specifically as a 'war symphony', adding that in an interview Górecki,

having spoken of the horrific events of the war period, added: 'Those things are too immense—you can't write music about them.' Jacobson continues: 'Philosophically, the work is a confrontation with the universal theme of suffering. Musically, in addition to purely Góreckian inventions like the thematic material of the second movement, it draws both on folk sources . . . and some of the composers he admires most (including Chopin, whose A minor Mazurka . . . furnishes other thematic ideas in the same movement)'. Jacobson concludes that it is 'ironic' that in this work 'Polish music found a universal language by rejecting the facile orthodoxies of either modish modernism or dogmatically inspired "social realism". Ironic, but not surprising, for the way to the heart is through individual thought and feeling, not through the collectivism of either artistic schools or political structures'.

The three most important composers to emerge from the former Soviet Union are the Estonian Arvo Pärt (b. 1935) and the Russians Alfred Schnittke (1934–98) and Sofuja Gubaydulina (b. 1931), both of whom settled in Hamburg in Germany. Pärt is formally a Minimalist, but, as a practising member of the Russian Orthodox Church, subject to profound liturgical influences. Referring to the mystical significance of the tones he uses, Pärt has described these as 'tintinnabulation'. His grandest work is *Passio Domini Nostri* (1981): 'Deliberately antidramatic, a 70-minute bleak setting of the Passion, severe, detached, stubbornly repetitive and monochrome.'[12] Other religious works are the *Stabat Mater* (1985) and the *Te Deum* (1984–6). In Schnittke, most performed of contemporary musicians, strong religious influences are apparent, as well as that of Shostakovich. Even when not formally producing a concerto, Schnittke tends to favour the concerto line-up of solo instrument, pitted against an orchestra. Symphony No. 4 (1984), for piano, vocal soloists, choir, and chamber orchestra, is described by Morris as a 'strange but moving work', which 'one feels, belongs in the cathedral rather than the concert hall'. There is a tendency to mawkishness, apparent in places in the generally lyrical and sometimes hymnlike Cello Concerto No. 1 (1985–6). Also religious, and considered a trouble-maker under the Soviets, Gubaydulina, in common with many other modern and

postmodern artists, was obsessed by the problems and concept of time. Of *Figures of Time* (1994) she said that in it she was converting the vertical time of inspiration into the linear time of actual process.[13]

German radio stations come close to the BBC in encouraging new music, and Germany far outdoes Britain in the support provided by federal and state authorities. But the giants, Stockhausen and Hans Werner Henze (b. 1927) have scarcely been replaced. As a socialist idealist Henze had produced spare, non-avant-garde music. With the fall of the Berlin Wall, there was a return of rich harmony and lyricism:

His Opera *Das verratene Meer* ('The treacherous sea') of 1990 and his Eighth Symphony of 1993 grind no political axes. He calls this symphony 'a summer piece' and says it relates to three episodes in *A Midsummer Night's Dream* . . . The music may lack the focus of the earlier scores, but it reveals that he is at his happiest when writing in the voluptuous, romantic idiom so admired by his one-time enemies, the bourgeoisie.[14]

From Aribert Reimann (b. 1936) one might note his fourth opera, *Die Gespenster Sonate* (*Ghost Sonata*, 1984), based on a Strindberg play, and *Requiem* (1982). Konrad Beohmer's (b. 1941) opera *Docteur Faustus* (1985) combines electronics with live instruments, and Hans-Järgen von Bose (b. 1953) introduces elements of Berlin cabaret jazz into his stylistically fragmented compositions. Wolfgang Rihm (b. 1952), a pupil of both Stockhausen and Nono, can be labelled 'post-avant-garde Expressionist'. His opera *The Conquest of Mexico* (1992) is based on an outline by Artaud (of Theatre of Cruelty fame).

With more than a flavour of postmodernist identity theory, Rihm turned the Aztec leader Montezuma into a woman. The Aztecs and their Spanish conquerors under Cortez are contrasted musically: for the latter, 'pungent, abrasive music'; for the former, music that is 'soft-grained and lyrical'.[15] After Montezuma's death Cortez dreams that he has become her, and on waking begins to sing in her style.

For advanced technology in music, Boulez's Institut at the Pompidou Centre has been of prime importance, and leading French composers of electronic music are François Bayle (b.

1932) and François-Bernard Mâche (b. 1935), who have increasingly 'left the sound sources as natural as possible', creating what has been called 'anecdotal music', which in turn has merged with 'New Age' ideas about privileging the environment.[16] From Michäel Levinas (b. 1949) has come *La Conférence des oiseaux* (*The Meeting of the Birds*), definitely postmodernist in its turning to the ancient tradition of *commedia dell'arte* and applying avant-garde music to it; the first performance was directed by British protagonist of Theatre of Cruelty, Peter Brooke.[17] Among the most interesting of the new Scandinavians is the Finnish female composer Kaija Saariaho (b. 1952). *Jardin secret I* (*Secret Garden I*, 1984–5) is a computer-generated work for tape, while *Lichtbogen*, described by Brian Morton as her 'hymn to the northern "arches of light"' (the environment again), used a computer to compose a work for flute (the principal instrument), percussion, piano, harp, and string quartet with double bass.[18] In America, Ellen Taaffe Zwilich (b. 1939) was the first woman to win a Pulitzer Prize in music, awarded in 1983 for her *Symphony No 1: Three Movements for Orchestra* (1982), which incorporated bell sounds and both tuned and unpitched percussion; according to Morton, it 'balances modernity and classicism in about exactly equal proportions'.[19]

However, as Morris tells us uncompromisingly, Philip Glass (b. 1937) 'is unquestionably the most successful serious American composer of the present day, at least in terms of contemporary public reaction, commanding an international audience that includes lovers of pop and jazz as well as classical music. He is also the popular leader of the reaction to post-serialism, and the 1960s avant-garde, known as minimalism . . .'.[20] Glass has created a trilogy of operas based on historical figures, exploring, respectively, the concept of the scientist, the humanist, and the religious thinker: *Einstein on the Beach* (1975), *Satyagraha* (1979–80), and *Akhnaten* (1982–3). The younger composer, John Adams (b. 1948), composer-in-residence with the San Francisco Symphony Orchestra, and to some extent a Minimalist follower of Glass, is famous for composing the grand-scale opera *Nixon in China* (1987), in which one can also detect the influence of the Leonard Bernstein of *West Side Story*. Morton is a little unkind:

The opera deals in a rather uncomfortably surrealistic way with Nixon's trip to China and his meetings with Chairman Mao. Much of the orchestra texture is pared down, the fascination of detail lost, and in spite of some marvellous climactic moments (especially where ecstatic choral texture joins rich orchestral colour), the banality resurfaces, partly caused by the ugly and whitewashing libretto which makes some sections seem a minimalist parody of Gilbert and Sullivan.[21]

The great, if tiny, American public of intellectuals also gave a rapturous reception to the opera *Emmeline*, by Tobias Picker, which had its world premiere at the Santa Fe Opera on 27 July 1996. The basis of the opera is the true, and tragic, American story of the much-abused Massachusetts factory worker Emmeline Mosher, which unfolded between 1841 and 1861. The immediate source was the novel of the same name published in 1980 by Judith Rossner. The outstanding symphonic work of recent years, in terms of audience appeal at any rate, is the Symphony No. 1 (1990) by John Corigliano (b. 1938), a teacher at the City University of New York, and, subsequently, at the Julliard School of Music. The symphony was inspired by the exhibition 'The Quilt' commemorating AIDS victims, with three of the four movements being in memory of individual friends who had died from AIDS. Piano playing and dances are heard in the distance as if through nostalgic memory; there are dark marches with climactic interjections and hushed sad passages. Corigliano's opera buffa *The Ghosts of Versailles* (completed 1991) was actually commissioned by the New York Metropolitan Opera for the 1983 celebrations of its centenary. This is certainly a celebratory opera, presenting spectacle in the manner of contemporary musicals. Again, Morris's criticisms are redolent of the paradox of *fin de siècle* would-be art music: 'the opera answered an American vogue for entertainment on a lavish scale, but it was a pity that the Met could not have chosen a composer of greater musical depth for their first new opera in a quarter of a century'.[22] What would have constituted 'greater depth', and would audiences have responded to it?

One answer perhaps lies in the work of the British composer Brian Ferneyhough (b. 1943), whose total serialism has developed into the 'New Complexity' and who has stated uncompromisingly that he composes for 'active collaborative

listeners, who are prepared to jump between levels of texture and tolerate multiple meanings'.[23] He is certainly not a darling of British audiences, and has lived and taught in Germany since 1973. His works include the song cycle *Études transcendentales* (*Transcendental Studies*, 1982–5) for soprano and small ensemble, and *Mnemosyne* (1986) for bass flute and tape. Michael Nyman (b. 1944) is the leading English Minimalist: like Reich before him, he formed his own instrumental group to perform his music. At the end of the century he was the most distinguished composer of film music, beginning with such minority works as Peter Greenaway's *The Draughtsman's Contract* (1982) and *Prospero's Books* (1991), and moving on to popular successes like *The Piano* (1993) and *American Beauty* (1999). Suites drawn from the scores for the earlier films have been published as independent works. His opera *The Man who Mistook his Wife for a Hat* (1986) is a courageous work engaging with the case of a man suffering from Alzheimer's disease. Nigel Osborne (b. 1948) has shown a particular interest in contemporary poetry, particularly Russian, this interest culminating in the opera *The Electrification of the Soviet Union* (1987), based on a story by Boris Pasternak, and using a chamber orchestra with electronic tape. The libretto was by the contemporary English poet, Craig Raine (b. 1944). The older composer Harrison Birtwhistle (b. 1934), flourishing from the 1970s onwards, developed into Britain's leading composer of postmodernist opera (and was knighted in 1988). The central work was *The Mask of Orpheus*, premièred at the English National Opera in 1986, and, according to Paul Griffiths, giving 'a late twentieth-century view' of 'the most venerable operatic myth',

in which different accounts of events are sung, mimed and acted in a complex of simultaneous alternatives, successive changes and interleaved allusions. Each of the central characters has three incarnations on stage, and sometimes all three are present; there are also mimed enactments of other, related myths, taking place to the electronic music that is one of the most inventive features of abundantly rich score that otherwise emphasises wind and percussion.[24]

John Tavener (b. 1944) is often seen as standing at the opposite pole to the austere Ferneyhough. His *The Protecting Veil*

(1987) is probably rivalled in popularity among contemporary works only by Górecki's Third Symphony, and one or two pieces by Pärt. A deeply religious man, Tavener converted from the Catholic to the Greek Orthodox church in 1972. He called *The Protecting Veil*, whose title refers to a vision of the Virgin Mary in Constantinople in which she held out her veil to protect the Christians against the Saracens, 'a lyrical icon in sound'. The Virgin is represented by the solo cello playing a lament of great beauty throughout this forty-two-minute work for cello and strings. His opera *Mary of Egypt* followed in 1992. Mark-Anthony Turnage (b. 1960) has much of the appeal of his teacher Henze. His *Drowned Out* (1994) is based on the William Golding novel *Pincher Martin*, while *Greek*, commissioned by Henze, was based on the play by British writer, actor, and director Steven Berkoff (b. 1937) of the same name: the Oedipus myth is given a feminist twist and set in East London in the 1970s. On Christmas Day 1999, a contemporary opera (in all senses) of a rather shocking sexual character was broadcast in Britain on Channel Four television. The opera *Powder her Face*, by Adès (b. 1971), had been completed and first produced when the composer was only 24. The libretto by Philip Hensher was based on the life of the notorious Duchess of Argyll, whose maxim, apparently, was 'go to bed early and often'. The opera opens in 1990, where, after flashing back to 1934, it closes. Postmodernist eclecticism comes over highly amusingly as the music touches on the idioms of such earlier twentieth-century composers as Berg, Britten, Poulenc, Strauss, and Stravinsky, as well as those of popular music. Much hope for the future is placed on the shoulders of Adès, at the turn of the century artistic director of the Aldeburgh Festival. Critics point knowingly to his string quartet of 1994, *Arcadiana*. The slow movement, reminding us of the forces of nationalism again coming to the fore, is subtitled 'O Albion'.

The music of Oliver Knussen (b. 1952) is sometimes described as 'expressionist' or 'fantastical': Knussen was Coordinator of Contemporary Activities at the Berkshire Music Centre from 1986 to 1990, and has been Co-Artistic Director of the Aldeburgh Festival since 1983. He is probably now best known for his fantastical operas based on the illustrated

children's books by Maurice Sendak: *Where The Wild Things Are* (1979–83), and *Higglety Pigglety Pop!* (1984–90).

Specifically Scottish influences are strongly apparent in some of the work of Judith Weir (b. 1954)—for example, *Airs from Another Planet* (1986) for chamber ensemble, and *The Vanishing Bridegroom* (1990), which deploys Scottish folk themes. However, the opera *A Night at the Chinese Opera* (1987) manifestly draws on a very different culture. The work of James MacMillan (b. 1959) is very markedly affected by both his Scottish Nationalism and his Roman Catholicism. So far expression of the Welsh national revival in art music has been left largely in the hands of older composers such as Alun Hoddinott (b. 1929) and William Mathias (1934–92).

The dominance of canonized classical music continued into the new century. However, traditional operas could often be presented in startling ways. During the 1999 Summer Festival season in Italy there were presented: a technological *Madame Butterfly* (at Verona) where the abstract *mise-en-scène* was entirely computer generated, and a postmodernist one (at Macerata) where Cio-cio-san changed her identity from Japanese to American and back to Japanese, all in a Japan destroyed by the atomic attacks of 1945; a space-age *Otello* (Macerata); a *Tosca* (Verona) with changing film sets, computer operated (with musical direction by the American female conductor, Wilson); and *Il viaggio a Rheims* (Pesaro) with a miraculous display of puppets strung out high above the stage.

Popular Music

Nothing very new here. Of the two main branches, the stage musical had originated in the inter-war years, and rock/pop had originated in the rock revolution consummated in the 1960s. There was interaction between the two, and there was further absorption of elements from art music. Some performers achieved high levels of individuality and idiosyncrasy, and there was a notable intrusion upon the 'Anglo-Saxon' monopoly by performers from continental Europe. But much of what was most striking was of social, and even political, significance, rather than musical. Originating in particular from ethnic

minorities, there were new sounds and new rhythms and, above all, new dance forms. Of course, the apparent absence of striking musical innovation was not a matter for agonizing concern in the world of popular music in the way that it was among serious music critics. The essence of popular music is that it should be popular, and all the evidence was that it was, more than ever; there is not a lot of point in criticizing popular music for being popular. One criticism that came from outside that world was that musicals were taking up too many theatres, and thus squeezing out serious drama. There is no doubt that commercial conglomerates were exerting an ever-increasing, and certainly not beneficial, influence on theatres, but the fact was that most innovative work in theatre originated from the small and specialist theatres, which were never likely to mount musical productions. With regard to what becomes a main theme of my next chapter, one significant development among successful popular music groups was that it became almost obligatory for them to issue videos of their most important numbers, some of these videos being quite inventive. Pop musicians have a separate importance, too, as providers of often very fitting scores for some of the best films of the time.

Pop music was coming in a much greater variety of subgenres; and it was a profoundly *involving* and *participatory* activity: each subgenre had its knowledgeable enthusiasts, ranging in age from pre-teen to post-retirement. Influences from the recent past were Soul (a leading British group was Simply Red), Country (the leading group in America in the 1980s was Alabama), Hard Rock (important groups were the New Jersey's, Bon Jovi, and Scotland's Almighty, interesting for the song 'All Sussed Out', urging their fans not to vote Conservative in the 1997 general election), Heavy Metal, and Punk—subdivided into Hardcore and Gothic (one of the first Punk groups was the British group Alien Sex Fiend). From ethnic minorities came Rap (strong in France, as well as in Britain and America—a big name was MC Solaar), Hiphop (one of a number of specialities of the American group Beck), and Reggae (originating in Jamaica; the groups Clint Eastwood and General Saint were largely responsible for bringing reggae to wider audiences; the most famous multiracial reggae band was UB40, the name deriving from the card you

were given when you became unemployed). Technology, obviously, was a big influence; techno-music, at the most extreme, incorporated developments that had been going on for some time in art music, and there were more moderate variants such as semi-acoustic rock and electro-synth.[25] Continental bands excelled in techno-music, Kraftwerk making quite an impact in the British and American markets, their fellow German group Rammstein slightly less so; attention focused on the 'French Touch' of such groups as Mr Oizo.

New forms that emerged were New Romantic pop (prime British exponents, dating back to 1979, being Spandau Ballet) and 'Indie', a term applied to what was seen as non-commercial rock (the British 1990s band Verve is a good example). Music specially designed for disco-dancing and for 'acid-house dancing' at those private occasions in old barns and garages pervaded by drugs (particularly ecstasy) was usually put in a separate category: a prime exponent was the North of England group Chemical Brothers. Non-musical influences were: the post-feminist phenomenon of girlpower (the American singer Madonna was the prototype, followed by the British group the Spice Girls, and such groups as the Californian Go-Gos, Hole, the British Girlsschool, and the American pioneers of the 1990s radical feminist musical movement, Bikini Kill); the demand among the very young for teenage boy bands (in Britain, first Take That, then the Irish group Boyzone); the removal of the prejudice against homosexuality together with the positive fashion for androgyny (Boy George led the way in the 1980s with his deliberately feminized appearance; American black singer Michael Jackson, who seemed increasingly to promote a white image, attempted to rebut media speculation about his sexual identity; and something of the same aura attached to Freddie Mercury, lead singer with the brilliant Queen, many of whose productions were inflected with art music). Apart perhaps from techno-music, crossover was much less in evidence than might have been expected from the predictions being made in the 1960s. British rock star Elvis Costello attempted a brave collaboration in *The Juliet Letters* (1993) with the classical Brodsky Quartet, but this was commercially not a success.

Socially, the most successful pop performers were celebrities

on a par with film and television stars, best-selling artists, block-busting novelists, and film directors: albums instantly rated as 'classic' were discussed seriously in the music columns of the press, while other sections of the same newspapers paid great attention to the break-up of groups and to the love affairs of their members.

Only one non-Anglo-Saxon group achieved the fame and wealth of the top American and British groups, the Swedish ABBA, back in the second half of the 1970s. 'Dancing Queen' reached number one in the United States, and ABBA achieved sales unmatched since the golden age of the Beatles. When the group dissolved in 1982 it had had nine UK number ones in just over six years, and it continued for several years to eclipse car manufacturers Volvo as Sweden's largest earners of foreign currency. Only one other non-Anglo-Saxon group has come anywhere near: A-Ha from neighbouring Norway, formed in 1982. The weird nature of the pop industry is driven home by the appearance, and considerable success, from 1989, of an Australian group of ABBA impressionists, with a name based on that of one of the ABBA singers, Bjorn Again. In the summer of 1999 the French weekly *Les Inrockuptibles* featured 'MADE IN FRANCE' on its cover, claiming that French pop music was now 'one of the most highly rated in the world'.[26] Biggest star was the aristocratic Isabelle de Truchis de Varenne, the ultra-cool singer Zazie, whose hit of 1997 was 'Homme sweet Homme'.

The only British artist to rival the success of the Beatles and the Rolling Stones is Elton John, whose high status was confirmed when he sang 'Candle in the Wind 97' at the funeral of Diana, Princess of Wales. On the continent the only singer to enjoy anything like the same kind of status (despite the advent of the likes of Zazie) was the ageing Johnny Halliday in France, though the death of Domenico Modugno ('Mimmo') in 1998 was a cause of mourning in Italy.

One part of postmodernist fashion was that popular culture was taken so seriously, and, indeed, a good deal of serious attention was given to the musical, which was certainly beginning to show a penchant for *bricolage*. Revivals from the classical period, roughly the 1930s–1960s, were directed by leading theatrical figures. *42nd Street* (1980) was based on the 1933

Warner Brothers film, featuring the original songs, fortified by imports from other films, including 'Lullaby of Broadway': this I suppose was, in its eclecticism, a sort of postmodernist musical. Some new productions were both spectacular and relatively challenging, breaking from the sentimentality and the 'homeyness' of the traditional American production. *Chicago* by Kander and Ebb was bold and sinister, the story of two jailbirds who are constructed into celebrities by a dubious Chicago lawyer.[27] *The Lion King* was a complete reconception of the Walt Disney feature-length cartoon of the same name. It used ritualized puppetry, mask, and movement, and featured music by Elton John and Tim Rice, with contributions by Hans Zimmer and LeboM, resulting in a fusion of pop and the rhythms of Africa. Britain mounted a very powerful challenge to American supremacy in this art form through the composer Andrew Lloyd Webber (b. 1948) and the extraordinary impresario Cameron McIntosh. Lloyd Webber, in fact, was something of an impresario himself. What perhaps most distinguished the latter's musicals was the distinction of the sources they drew on, middle-brow or even high-brow writings or, in the case of *Evita*, historical events. The notion of using Victor Hugo's mighty novel *Les Misérables* did not at first seem a good one from the commercial point of view, and, when the show opened at the Barbican Theatre in London in 1985, it received mixed reviews. However, with a book by Alain Boublil and Claude-Michel Schoenberg and music by Herbert Kretzmer (all French), production by the celebrated director Trevor Nunn, and Cameron McIntosh behind the whole thing, it became, on a worldwide basis, the most successful musical ever. The music of Andrew Lloyd Webber no doubt owed much to Puccini and it did retain, in an easy-to-listen-to way, some of the appeal of the master. Particularly inspired was the choice of T. S. Eliot's humorous poems *Old Possum's Book of Practical Cats* (1953) for *Cats* (1981). Gaston Leroux's novel about a disfigured man who haunts the Paris opera and falls in love with a young singer had been the basis for many adaptations. *The Phantom of the Opera* (1986) certainly made a convincing musical, aided (as musicals generally had to be these days) by a fine array of spectacular special effects. *Evita* (1978) and *Sunset Boulevard* (1993)

were historical in different ways, while *The Witches of Eastwick* (2000) was based on the novel by John Updike. Schoenberg provided the music and Boublil the book for a rip-off (the slang phrase is fully justified) from *Madame Butterfly*, *Miss Saigon* (opening at the Theatre Royal, Drury Lane on 20 September 1989, and on Broadway on 11 April 1991).[28]

Dance

There is classical ballet and there is modern dance, and then there is postmodernist dance, which usually turns out to signify the most extreme forms of modern dance, developing from the 1960s onwards, involving complete disruptions of any linear or chronological order, spoken text (utterly taboo in classical ballet), and elements drawn from multimedia events. Modern (and postmodern) dance has been dominated by the United States, and, apart from that grievous and grieving dead period between the rise of Nazism and the middle 1960s, Germany, and in the most recent period, Japan. The greatest early American figure in modern dance was Martha Graham (1894–1991), who formed her first dance company in 1926; the greatest German was Kurt Jooss (1901–79), whose company settled in England in 1934. The greatest period of innovation in modern dance was that of the cultural revolution, the pioneering figure being Merce Cunningham (b. 1919), collaborator of John Cage and founder of the Merce Cunningham Dance Company in North Carolina in 1953.

Two little histories indicate something of the relationships between classical ballet and classical music, and between classical ballet and modern dance. In March 1954 the Martha Graham Dance Company performed in Britain for the first time. The dancers were looking forward to a warm welcome in what they thought of as a great cultural capital, London. But, as dancer and choreographer Robert Cohan (b. 1925) recorded:

We were totally devastated to be completely rejected here—but completely. Almost all the critics, one after another, said that this was an absurd way to move, an absurd idea of dance, there was no technique to start with, it was boring, it was ugly, it was stupid—one review after

another. There was one evening [in the Saville Theatre] when there were only thirty people in the audience.

However, among those who perceived the life-enhancing qualities of this total antithesis of classical ballet was Richard Buckle, *Observer* ballet critic, who wrote: 'Now I conjure every idle, habit-formed fellow, in need of a third eye to see new beauty, that he should visit the Saville Theatre and watch Martha Graham. She is one of the great creators of our time . . . I hope all thoughtful people will see her, for she has enlarged the language of the soul.'[29] In 1967 Cohan was appointed Director of the London Contemporary Dance Trust: in 1960s Britain, modern dance became highly successful.

My second history is set in the 1960s, but begins in that august home of classical ballet, the Royal Opera House Covent Garden. There, in 1964, the imaginative choreographer Kenneth Macmillan expressed the intention of creating a ballet to Mahler's *Das Lied von der Erde* (*Song from the Earth*). The establishment view, of directors and musicians, was that this would be to impair the integrity of a classic work of classical music. Macmillan took his project to the Stuttgart Ballet, classical but, under the inspiration of the Australian-born choreographer John Cranko (1927–73), very forward-looking. It was a 'colossal success' in Germany; then, thus validated, it returned in 1966 to a warm welcome in London.[30]

The most celebrated representatives of German *Tanztheater* (specializing in modern dance) are Pina Bausch (b. 1940), a pupil of Jooss, and her *Wuppertaler Tanztheater*, presenters of dramatic happenings, strongly feminist, and a million miles away from classical ballet. In *Auf dem Gebirge hat Man ein Geschrei Gehört* (*On the Mountains a Cry was Heard*, 1984), a group of men, possibly representing bullies in a playground, hotly pursue a man and a woman in order to force them to kiss one another.[31] The sudden blossoming of modern dance in France is closely related to the institutional developments, particularly the sponsorship of provincial ventures by the Ministry of Culture, that we noted in Chapter 7 in discussing experimental theatre. One outstanding example is the Compagnie Maguy Marin in Créteil, responsible for the shambling,

muttering (but still dancing, just) *May B* (1981) based on plays by Samuel Beckett, including *Waiting for Godot*.

America continued to be the liveliest centre of avant-garde dance. We should note: the Judson Dance Theatre, New York, set up in 1962 by Cunningham, Cage, and Robert Dunn, 'whose experimentation', according to the *International Dictionary of Modern Dance*, 'is widely recognized as the beginning of post-modern dance'; the 'ballet' (really a multimedia production) *Einstein on the Beach* (1976), produced by Robert Wilson, choreographed by Lucinda Childs, with music by Philip Glass; the works of Twyla Tharp (dancer, choreographer, and director, b. 1941), including *When We Were Very Young* (1980), incorporating the poems by A. A. Milne, and *The Catherine Wheel* (1981), 'filled with lust and strife';[32] and *Still/Here* by Bill T. Jones, a tribute to his partner, Arnie Zane, who died of AIDS, and to all those who live with terminal illness.[33]

The dance (or could it possibly be ballet?) sensation of 2000 was Mathew Bourne's *Swan Lake* danced entirely by men.

Poetry

In introducing a collection of essays on *Contemporary Poetry and Poetics* by American poet and theorist John Taggart, published in 1994, Marjorie Perloff wrote:

John Taggart belongs to that memorable generation of poet-theorists who came of age in the seventies and eighties. I say poet-theorists (rather than poet critics) advisedly, for unlike the poets of the previous generation—Robert Lowell, Robert Duncan, Robert Creeley, to name just three—who regarded the production of critical essays as a kind of left-handed activity, a holiday from their 'real' poetic creation, today such poets as David Austin, Charles Bernstein, Susan Howe, Steve McCaffery, Leslie Scalapino, and Rosemarie Waldrop don't always distinguish between the writing of theoretically informed poetry and a poetically inspired theory.[34]

On the basis of that testimony it would be fair to generalize that the fit between postmodernist theory and artists' practice has been closest in poetry. The most important new self-declared school of poetry appearing (in America) in the mid-1970s, with which most of those whose names have just been listed were

associated, declared themselves $L = A = N = G = U = A = G = E$ poets: their basic principle was doubt as to whether the written word can fully and adequately express the human state, so that their poetry was marked by a deconstructionist attitude towards language, and a disregard for conventional literary formalities.

Let us consider Susan Howe (b. 1937), not a member of the original literary group, and a painter before she turned to poetry. A clearly identifiable theme is the uniqueness of the female. But her work, in the manner of postmodernist 'writing', is certainly not immediately intelligible. Among her characteristics are: placing her verse upside down; leaving parts of it crossed out; playing on words that have phonetic similarities; infrequent use of punctuation marks; carrying over the last letter of a word onto a new line of verse. 'Some critics have likened her poems to paintings on the page, the large gaps between words providing white spaces that are meant to convey as much meaning as the words themselves.'[35] The assimilation of poetry to the visual arts links some of these postmodernist poets both to the concrete poets of the 1960s, and to the major individual American poets of the age.

From the publication in 1976, to great acclaim, of *Self-Portrait in a Convex Mirror*, the American John Ashberry (b. 1927) has been the most influential poet in the English-speaking world, hailed by the theorists as a postmodernist and 'dismantlar of bourgeois discourse'. For five years in the 1960s, Ashberry was an art critic. *Self-Portrait* is inspired by a work by the Italian Renaissance painter Francesco Parmigianino; many critics have seen Ashberry's work as the print analogy of Abstract Expressionist painting; others again have detected devices inspired by film: crosscut, flashback, montage, close-ups, fade-out. Certainly his poems are full of dislocated language and twisted syntax. The effects can be powerful and haunting—and have been much imitated. Deliberately the poems lack themes or clear external reference points; for some readers they are simply unintelligible.[36]

Poetry can, like music, make an immediate sensuous impact. But (if it is to be taken seriously) it is not intended to be easy. Difficulties of language, apparent obscurities, draw the reader in, make him or her think. Observance of the disciplines of

metre or form (sonnet form, for instance) contribute to meaning as well as effect. Postmodernists sometimes put me in mind of the cat circling round several times before settling down to sleep, though actually there is no tall grass to be flattened, no contact, therefore, with current reality. But many poets at the end of the century, happily unconcerned about 'bourgeois' (that is 'intelligible') language buttressing 'bourgeois' hegemony, were producing work inflected (though never naively) with external referentiality. In accepting his Nobel Prize in 1995 Seamus Heaney made a speech in which he 'credited' poetry— that is, explained, as he saw it, its nature and significance. This wonderful exposition calls for extensive quotation.[37]

Heaney begins by describing his sensations as a child growing up in the three rooms of a traditional thatched farmstead in County Derry, Northern Ireland: 'Ahistorical, pre-sexual, in suspension between the archaic and the modern, we were as susceptible and impressionable as the drinking water that stood in a bucket in our scullery: every time a passing train made the earth shake, the surface of that water used to ripple delicately, concentrically, and in utter silence.' The 'little pandemonium of bubbles and squeaks' on their wireless set would give way to a BBC newsreader reporting on the progress of the war against Germany. But the news did not really interest him and after the war it was the BBC stories about Dick Barton, 'special agent', or RAF flying ace Biggles that thrilled him (the external call of 'the arts', however simplistic, once more!). The radio also offered short bursts of foreign languages—which led to 'a journey into the wideness of language', a journey through poetry: 'poetry can make an order as true to the impact of external reality and as sensitive to the inner laws of the poet's being as the ripples that rippled in and rippled out across the water in that scullery bucket fifty years ago.'

Heaney quotes American poet Archibald MacLeish's affirmation that 'Poetry should be equal to/not true', continuing:

As a defiant statement of poetry's gift for telling truth but telling it slant, this is both cogent and corrective. Yet there are times when a deeper need enters, when we want the poem to be not only pleasurably right but compellingly wise, not only a surprising variation played

upon the world, but a returning of the world itself. We want the surprise to be transitive, like the impatient kick which unexpectedly restores the picture to the television set . . .

Returning to his definition of poetry 'as an order "true to the impact of external reality and . . . sensitive to the inner ears of the poet's being"', Heaney moves to the external reality of events in Northern Ireland:

aware of the minority citizen in oneself, the one who had grown up conscious that his group was distrusted and discriminated against in all kinds of official and unofficial ways, this citizen's perception was at one with the poetic truth of the situation in recognising that if life in Northern Ireland were ever really to flourish, change had to take place.

What of those under the far more severe constraints of life in pre-1989 Eastern Europe? 'How would you like it', a Polish writer once asked the British poet and critic A. Alvarez, 'if you had to submit every word you wrote to the literary editor of the *Daily Mirror*?' Czech poet Miroslav Holub (b. 1923) declared: 'Authenticity, living everyday authenticity, plain human speech, and the most ordinary human situation of these years were not only poetically viable but also the most telling argument.'[38] In 'The Prague of Jan Palach' (the student who burnt himself to death in protest at the Russian invasion of 1968), Holub invokes great artists of earlier in the century:

> And here stomp Picasso's bulls
> And here march Dali's elephants on spidery legs
> And here beat Schönberg's drums.[39]

Yes, poetry continues to memorialize and to celebrate elements from that mix of present, myth, and past that is so often the raw material of the arts. In 1985 Nigerian-born and Leeds University-educated poet Wole Soyinka retrospectively celebrated Mohammed Ali regaining his world title from George Foreman in 'Mohammed Ali at the Ringside':

> Cassius Marcellus, Warrior, Mohammed, Prophet,
> Flesh is clay, all, all too brutal mould.

Thom Gunn wrote about AIDS in 'The Missing' in August 1987:

> Now as I watch the progress of the plague,
> The friends surrounding me fall sick, grow thin . . .

James Fenton wrote of the Chinese government's massacre of students in Tiananmem Square in his poem, 'Tiananmem':

> The cruel men
> Are old and deaf
> Ready to kill
> But short of breath

What better way to end this chapter than with reference to the witty conceit of Carol Ann Duffy and a book of poems about *The World's Wife*, including Queen Herod, Pilate's wife, Anne Hathaway, Queen Kong, Pygmalion's Bride, Frau Freud, The Kray Sisters, Elvis's Twin Sister, and Pope Joan. Here is Mrs Darwin:

> *7 April 1852*
> Went to the Zoo
> I said to Him—
> Something about that Chimpanzee over there reminds me of you.[40]

10 King Video, Shockers, and Super-Thrillers

Art

As with so many other innovations, video art, in both single-screen and multiple-screen formats, and in the form of video installations, had first appeared during the cultural revolution of the 1960s. Standard chronology has it that, while there was a revival of painting in the 1980s, by the 1990s video was the dominant mode of artistic expression, with computer-based art becoming important at the end of the century.[1] As is well known, four of the short-listed candidates for the British Turner Prize in 1999 submitted video art; and, while Tracey Emin's main entry was her *Bed*, complete with stained sheets and soiled underwear, she also had on show a video of herself commenting on her life and abuse by men (a rather common topic). The winner was black British artist Steve McQueen, with a video in which we see the artist himself, immobile and resolute, as the side of a house appears to fall on him—the film material has been appropriated from a Buster Keaton film, *Steamboat Bill, Jr.* (1928).

In the 1960s and early 1970s, video was something that artists dabbled in, untidily, and operating primarily in other modes. As so often happens, it was technological change that brought full control and enabled them to be video artists and nothing else: cheap video-editing methods in the mid-1970s, followed by ever-more-affordable cameras, especially colour ones, and by better processing techniques. Nam June Paik, who was himself responsible for developing the Paik/AbeS synthesizer, used for image manipulation and colourization, was quick to take advantage. In 1986 he produced *Butterfly*, vibrantly colourful abstract images combined with music. Paik moved on to video installation: his *Electronic Super Highway: Bill Clinton Stole My Idea*, a massive assemblage of television monitors filled with images of

every possible kind that one might find on television news and documentary programmes, was the main German entry at the 1993 Venice Biennale. Paik is almost a symbol of both internationalism/multiculturalism and the melding of different art forms. Born in Korea, he studied aesthetics and music in Japan in the 1950s, then became a student in West Germany in the early 1960s; while there he met John Cage and other Fluxus artists, participating in the first Fluxus Festival, the Fluxus International Festival of Very New Music at Wiesbaden. He moved to New York in 1964.[2]

The American Bill Viola (b. 1951) is often seen as the leading figure of the new generation of video artists. Paik gave his seal of approval, saying that Viola knew how to 'sublimate his work in the camera', while Viola himself said: 'My work is centred on a process of personal discovery and realization. Video is a part of my body; it's intuitive and unconscious'.[3] Viola had been a student of both music and audio design, and his total serious-ness and dedication to his art cannot be doubted. He drew inspiration from the Koran, Buddhist texts, and Sufi mysticism. Understanding the body is fundamental to Viola's art, its spirit-ual and corporal nature in its journey from cradle to grave: it is 'the neglected key of our contemporary lives'.[4] Michael Rush counts Viola as among the most lyrical of video artists. In *Nantes Triptich* (1992), a man floats in a pool on the central screen, on the left screen Viola's wife gives birth to their son, and on the right screen his mother is on her deathbed. *Stations* (1994) is to be understood as referring to the Stations of the Cross. In this computer-controlled, five-channel video/sound installation, images are projected onto vertical slabs of granite and in turn, reflected on mirrored slabs placed on the floor perpendicular to the granite ones. Again we have bodies in water, floating and tumbling. Another even more cerebral Amer-ican was Gary Hill (b. 1951), a student of Heidegger, Wittgen-stein, and postmodernist theory, particularly with reference to language. *Tall Ships* (1992) is a blacked-out corridor from the ceiling of which videos project images of viewers as they enter the installation. This is the quintessence of interactive art: viewers appear to be approached by figures they themselves have triggered, murmuring barely audible sentences.

Pipilotti Rist (b. 1962) produced a colourful and rather fren-
zied feminist statement in *I'm not the Girl who Misses Much*
(1986). She profited from advanced digital techniques in her
Ever Is Over All, which she exhibited at the 1997 Venice
Biennale. On two large screens on adjacent walls we see slowly
changing shots of beautiful flowers in a peaceful garden, juxta-
posed with shots of a woman moving down an equally peaceful
street in Switzerland, then suddenly, violently, smashing car
windows. The American Dara Birnbaum (b. 1946) produced a
rather stereotyped 'deconstruction' of television and its presen-
tation of women, *Technology Transformation: Wonderwoman*
(1978–9), in which she re-edited and manipulated single frames
from the popular American television show *Wonderwoman*,
reducing it to spinning and whirling nonsense. In 1989 she was
one of the first to create a massive outdoor installation: her *Rio
Videowall*, set up in a shopping mall in Atlanta, Georgia, brought
a kind of union of architecture and video images. The single-
channel format continued to be used, and television commercials
continued to make a good target. Using women of different ages
and ethnic origins making music by blowing into Coca Cola
bottles, British artist Gillian Wearing (b. 1963) made *I'd Like
to Teach the World To Sing* (1996), a delightfully exuberant
alternative advertisement for the famous American drink.

For some artists, video art was genuinely a culmination and
consolidation of the experiments they had been carrying out in
the many different modes that had developed during the cul-
tural revolution of the 1960s. Adrian Piper (b. 1948), an
American black woman, had worked in both minimalist sculp-
ture and performance art. In the various versions of *I Am the
Locus*, performed in the mid-1970s, she dressed herself up, with
whitened face, false moustache, Afro hairstyle, and mirrored
shades, as 'an anonymous third world young boy, wandering
through the crowd . . . both hostile to and removed from the
presence of others'.[5] In a famous series, started in 1991, *What
It's Like, What It Is*, Piper created a complete minimalist
environment of white walls onto which benches were built for
viewers (like the Romans watching the lions devouring Chris-
tians, Piper said[6]), with a tall white box in the middle containing
video monitors. On these a black man routinely rebuts racial

stereotypes: 'I'm not lazy', 'I'm not vulgar', 'I'm not horny', and so on. *Out of the Corner* had male and female talking heads addressing questions, relating to racial issues, directly to viewers.

Raising questions of black and female identity had seemed obvious enough in the 1960s and 1970s: with postmodernist interventions came questioning about male identities. After various videos of himself in the nude, Matthew Barney (b. 1967), in 1994, began his series of *Cremastre* videos and installations (the 'cremastre' being the thin suspensory muscle of the testicles). Michael Rush provides this summary:

elaborately costumed fairies, satyrs and other assorted creatures enact private scenarios that spring from Barney's preoccupations with body parts and fluids, hetero- and homosexual relations, athletics and alchemy . . . With Barney, explorations of the body in late twentieth-century art reach Baroque proportions in production values of costumes, make-up, prosthetic devices, fantastical camera images, and sculptural oddities that suggest a breathless search for identity and pleasure under the constant eye of encroaching death.[7]

Whatever one thinks, only video could do this, and Barney certainly makes the fullest use of its possibilities.

National and regional identities were also coming under scrutiny, though there is perhaps nothing particularly Scottish about the joint work of Stephanie Smith and Edward Stewart: *Intercourse* (1993) and *Sustain* (1995) are video tapes of the couple enacting their own sexual rituals—the shocking in the art of the time is a theme I shall return to shortly. There was, of course, no war in Scotland. Irishman Willie Doherty used projections of burnt-out cars and looped voice-overs of phrases like 'At the end of the day there's no going back' to produce, in *At the End of the Day* (1994) and *Somewhere Else* (1998), powerful evocations of the war in Northern Ireland. Incorporation of the latest horrors from national and international news was a commonplace of much video art. The most imaginative installation was that of French artist Fabrice Hybert (a former participant in the films of Andy Warhol), who, for the 1997 Venice Biennale, constructed an entire television studio, with, in a combination of installation, video, and performance art, both

broadcasts and simulated interviews and production meetings taking place.

Art (or some of it) follows technology. After videos come computers, and what is usually termed 'digital art'. Computers can be used to create images or designs, which can then be printed off as 'hard copy'. They can be used to modify or manipulate existing images that have been scanned into the computer. A famous example is *Mona/Rio* (1987) by Lillian Schwartz, in which the right half of the face of the Mona Lisa is exactly matched up with the left half of the face of her creator Leonardo Da Vinci. Another American, Keith Cottingham (b. 1965), has produced a series of photographs exclusively produced by digital manipulations. Then, of course, through use of the World Wide Web, images can be communicated to everyone with a computer terminal. This may lead to the ultimate in viewer participation in art. Or are we simply down at the level of video games? It certainly seems far too early to state that: 'an irrefutable change has occurred in the experiencing of art (to say nothing of its creation). Interactivity is a new form of visual experience. In fact, it is a new form of experiencing art that extends beyond the visual to the tactile. Viewers are essential, active participants in this art. No longer mere viewers, they are now users.'[8] The most prestigious of established artists to become involved in artistic commissions for the web is Tony Oursler (b. 1957), a highly inventive creator of video installations. In 1995 the Dia Center sponsored its first commission, *Fantastic Prayers*, in which Oursler collaborated with writer Constance DeJong and musician Stephen Vitiello.

'Installation', 'video', 'video installation', and 'assimilation'—the latest, Anglo-Saxon, version of *bricolage*, the picking-up and incorporation of bits and pieces from anywhere: these were the key words. For the other side of the street there was the label 'neoexpressionism', applied generically to almost all of those who persisted in the age-old proclivity for shoving paint—or whatever came to hand—onto canvas—or whatever came to hand.

The major figures in neoexpressionism were the German artists we have already encountered, Baselitz, Kiefer, and Lüpertz. To some critics Baselitz is the greatest living European artist; he

is certainly one of the most financially successful.[9] Born Georg Kern in 1938 in Deutschbaselitz in East Germany, he crossed to West Germany in 1957 and in 1961 adopted the substantive part of the name of his native town. His *Die grosse Nacht im Eimer* (*The Great Piss-Up*, 1962–3), featuring a masturbating male figure, was seized by the police as obscene and Baselitz was prosecuted. At the end of the 1960s he began rendering all the subjects of his paintings upside down. After 1979 he began producing a stunning range of expressionist (and sometimes overtly political) works, sculptures as well as paintings. The most noteworthy younger German figure was Julian Schnabel (b. 1951), who gave intensity to his work in the early 1980s by lining his canvasses with a surface of broken crockery. Typically, his works embrace both figurative and abstract elements, and he went on to paint on all kinds of surfaces, including metal, velvet, and old tarpaulin—on a grimy piece of the latter he painted a bold blue shape and entitled it *Portrait of God* (1981). Such works as *Oar: For the One who Comes out to Know Fear* (1981) are a form of Abstract Expressionism, with the surface broken up by crockery and other objects. *Vita* (1983) contained a female crucified Christ. *Second Crown from the Sun* (1991), oil and plaster on canvas, is largely abstract, but with recognizable elements, and also letters printed across it.

In Italy, neoexpressionism was often known as *transavantgardia internazionale*. Important exponents were Francesco Clemente (b. 1952), Sandro Chia (b. 1946), and Mimmo Paladino (b. 1948). They were noted for heavily painted, often grotesque, figures, both human and animal. Paladino went on to produce assemblages of strange, self-standing stone figures. The label *transavantgardia* may be as boring, pompous, and devoid of meaning as the writings of many Italian academics; but the work being shown in exhibitions of contemporary art in Italy throughout the 1980s and 1990s had an inexhaustible inventiveness, taking the form of paintings, sculptures, assemblages, and installations—but with little in the way of video art.

Neoexpressionist art, in the hands at least of a certain favoured few, was highly saleable in New York in the 1980s. Clemente installed himself there from 1981, working with the 1960s figures Allen Ginsberg and Andy Warhol and also with

the black artist Jean-Michel Basquiat (1960–88), a master of self-advertisement whose branch of expressionism falls into the category known as graffiti art (because of the line drawings and scribbles incorporated in it). To his early works Basquiat appended the signature SAMO (which stood for SAMe Old shit), but by 1980 he had given up the name and was taken up successively by two of the most prosperous New York galleries. The fact that he became very rich and very self-indulgent, wearing Armani suits and dying of an overdose, does not, of course, stop him from being one of the greats (as well as a celebrity) of the end of the twentieth century. What might he have done had he lived beyond 28 years? Not video, I surmise. The magnificent 'Basquiat a Venezia' exhibition in the summer of 1999 suggested that the art of painting at the end of the twentieth century was far from dead (even if Basquiat, alas, was). *The* masterpiece was perhaps the triptych *El Gran Espectaculo* (*History of Black People*, 1983). Acrylic on canvas, this consists mainly of black figures, with written messages, part scored out in Basquiat's characteristic way. One wing, boldly labelled 'Memphis Tennessee', has this explanation of the clearly recognizable black shapes: 'A dog guarding the Pharoh'—the last word in white, 'corrected' in yellow, deliberately misspelt. According to Basquiat: 'I just look at the words I like, and copy them over and over again, or use diagrams. I like to have information, rather than just have a brush stroke. Just to have these words to put in these feelings underneath, you know.' 'Cumulatively', Michael Archer writes, 'Basquiat's paintings conduct a harsh critique of contemporary America and of the position of black people within it'.[10] True, but that is to miss the humour, the directly appealing quirkiness, the irresistible mix of apparently childish naivety with deep wisdom.

If we need labels, Basquiat mixed neoexpressionism (graffiti branch) with a form of conceptualism. With white American Jeff Koons (b. 1955) we are firmly in the world of neoconceptualism; he specialized in presenting objects, made for him by skilled workers, which, in the manner of Warhol, imitated objects available in the shops. In the words of Michael Archer:

The displays of upright and wet/dry vacuum cleaners in spotless, fluorescent-lit Perspex cases he began in 1980 are perhaps another homage to Duchamp. Bulbous containers, long floppy tubes, rigid upright forms and the tension between dirt and pristine purity rework the Dadaist's eroticism and his admiration for American plumbing as the country's one great art work for a new era. In the mid-1980s, a number of stainless steel casts of a plastic inflatable bunny and a Bourbon decanter shaped like the train on the Jim Beam Bourbon label among other things, reaffirmed the distance between the usefulness of ordinary artefacts and the reflective value of art.[11]

One Ball Total Equilibrium Tank (1985) consists of a metal stand on the top of which a sealed glass tank filled with a salt solution holds a basketball at the exact centre of the container, because of the carefully calculated balance between the weight of the ball and the density of the solution. A beautiful illusion, a minimalist expression of the striving of art towards perfection and the ideal. With reference to *Two Ball 50/50 Tank* (1985), Andrew Causey declares that 'Koons conserves pristine and desirable consumer objects behind Perspex, where the possibility of their use is remote and their value relates to their status as signs'.[12]

Many other artists practised the 'commodity sculpture' of Koons. The German sculptor Katharina Fritsch (b. 1956) created what looked like cheap commercial reproductions, but of figures, animal or increasingly human, that carried emotional resonances. She got a great deal of attention with her *Elephant* (1987), which was a green plastic model, full size, cast from a specimen in the Bonn Natural History Museum, and placed on a tall plinth. Cloned human figures sit on either side of a long table covered in a cloth patterned with a computer-generated design in *Tischgesellschaft* (*Company at Table*, 1988). *Madonna of Lourdes* (1987), based on a small commercial effigy, is life size, made of plastic, and painted a garish yellow. Placed originally in a street in Münster, this work demonstrated Fritsch's concern 'with the way in which images travel and how their implications change in different situations'.[13] Her compatriot Reinhard Mucha (b. 1950) used discarded pieces of industrial machinery to create works that he saw as both monumental and dramatic, such as the massive work with the massive title *Das Figur-Grund Problem in der Architektur des Barock* (*Für Dich*

allein bleibt nur das Grab) (*The Underlying Figure-Ground Problem in Baroque Architecture* (*For you Alone Only the Grave Remains*), 1985).

The work of Sophie Calle (b. 1953) involves both black-and-white photographs and textual extracts. Her themes are very much those of memory and autobiography. For her first work, *Les Dormeurs* (*The Sleepers*, 1979), she photographed forty-five people whom she had asked to sleep in her bed for eight hours and then respond to her questions. *Suite Vénitienne* (*Venetian Suite*, 1980), with texts and photographs, narrates how she stalks a chance acquaintance whom she has overheard planning a trip to Venice. *Last Seen: A Lady and Gentleman in Black by Rembrandt* (1991) was an evocation through texts and photographs of thirteen works of art, including ones by Vermeer and Rembrandt, that were stolen from a Boston museum in 1990. Calle, rather refreshingly, refuses to give interviews, saying that everything that she has to say is conveyed in her art.

Any familiarity at all with developments on the continent of Europe and in North America should dispel the illusion that there was a distinctive 'Britart' in the 1990s. Britain had its neoexpressionists (sometimes referred to as the London school), older painters like Howard Hodgkin (b. 1932), Frank Auerbach (b. 1931, who represented Britain at the 1986 Venice Biennale), Leon Kossoff (b. 1926), Lucien Freud (b. 1922), Portuguese-born Paula Rego (b. 1934) (described by Germaine Greer as having a power that is 'undeniably, obviously, triumphantly female'[14]), and Patrick Caulfield (b. 1936). Caulfield's show at the Hayward Gallery (all painting) was another exhilarating experience of 1999. In the words of the catalogue:

Caulfield is the great entertainer of contemporary British painting. But, as with all classic comedians . . . there is an underlying melancholy, and the performance, poised and impeccable, consummate in its imitations of real and known things, seems to hint at something unspoken, something not in the picture . . . Caulfield's laconic juxtapositions of pictorial effects and visual styles, the games he plays with contrasting idioms—popular, highbrow, realistic, decorative—have more to them than meet the eye. They are aspects of a presentation replete with references to art and to life. They intimate with an extreme

economy the social, psychological and emotional conditions that shape and colour our lives in the spaces we inhabit. Caulfield's paintings are composed with cunning, predetermined to disconcert as well as delight. They are pictures about picturing, enigmatically reconciling the statement of the visually obvious with the impossibility of our being certain of its meaning.

These were pictures that were very much of their time, in fact, but also with something of a universal appeal. There was also a group of young Scottish painters, following in the traditions of Sir Robin Philipson and John Bellany: Steven Campbell (b. 1954), Adrian Viszniewski (b. 1958), Stephen Conroy (b. 1964), and Ken Currie (b. 1960), whose highly expressive work was clearly influenced by the social and industrial plight of Glasgow.

What is usually referred to as the 'New British Sculpture' was linked, too, to expressionism. In 1981 the Whitechapel Gallery hosted an exhibition by Tony Cragg, whose bas-relief *Britain Seen from the North* of 1981, now in the Tate, 'a deconstructed school-atlas image made up of colourful plastic fragments',[15] was one of the most publicized works of art of the decade. The exhibition 'Objects and Sculpture', held jointly at the ICA, London, and the Arnolfini Gallery, Bristol, later in the same year, comprised works by Richard Deacon (b. 1949), Anthony Gormley (b. 1950), Anish Kapoor (b. 1954), and Bill Woodrow (b. 1948). The catalogue 'stressed that the referential had gained precedence over the formalist, and that associational rather than didactic or interrogative means were employed to elicit this content . . .', while Kapoor declared: 'I have no formal concerns. I don't wish to make sculpture about form—it doesn't really interest me. I wish to make sculpture about belief, or about passion, about experience, that is, outside of material concern.' Richard Deacon's often humorous constructions made of banal materials with the joins deliberately obvious, and with clichéd, or sometimes punning titles, took two directions. On the one hand were solidly built objects with openings into them—for example, *If the Shoe Fits* (1981) and *Out of the House* (1983); on the other were 'skin-like hollow shells pierced by one or more openings',[16] such as *The Eye Has It* (1984), or *Listening to Reason* (1986).

Some avant-garde art had always caused shock. The notion that there was something specially shocking about 'Britart' painting was phoney, initiated by the ever-prurient British tabloid press, but probably fostered for commercial purposes. The most important patron of Britart was Charles Saatchi, of the wealthy public-relations firm and master-minders of Conservative election victories, who had set up a gallery in a former paint factory in St Johns Wood, northwest London. Forty-two artists from the Saatchi Gallery made up an exhibition under the establishment auspices of the Royal Academy, cleverly given the title of 'Sensation'. The objective was fully achieved when Mayor Giuliani of New York expressed his outrage at the same exhibition being mounted in the Brooklyn Museum, and moved to cut the city's grant to that museum. Most notorious of the artists was Damien Hurst (b. 1965), entrepreneur (Hurst had mounted an exhibition of works by himself and fellow students from Goldsmiths College, London, in a disused Docklands warehouse in 1988), and self-promoted 'celeb' *par excellence*. His best-known works consisted of specimens from the animal kingdom, whole or in parts, preserved in formaldehyde in glass tanks. But only a jaded Tory or a tedious cultural theorist could have failed to have been exhilarated by much of the exhibition. Among the exhibits were *Self* (1991) by Marc Quinn (b. 1964), eight pints of his own blood poured into a cast of his head, which was then frozen and placed in a perspex cube attached to a refrigeration unit—doubtless a would-be profound statement with something to do with AIDS; two paintings by black artist Chris Ofili, *Afrodizzia* and *Holy Virgin Mary* (both 1996), psychedelic paintings incorporating elephant dung, raising questions about physical stereotypes of 'blackness'; *Zygotic Acceleration, Biogenic, De-Sublimated Libidinal Model (Enlarged x 1000)* (1995) by Jake and Dinos Chapman, 'a ring of mutant child mannequins with convulsive displaced genitalia which portrays the underside of psycho-sexual energy'; *Au naturel* (1994) by Sarah Lucas (b. 1962), a mattress on which two melons and a bucket are carefully placed so as to represent a woman lying on her back, the man apparently lying beside her being represented by an erect cucumber and a couple of oranges; and *Everyone I have ever Slept with (1963 to 1995)* by

Tracey Emin (b. 1963) is a portable tent appliquéd with the names of all of her lovers—'the tent', according to the catalogue, 'becomes a monument to the variousness of physical and emotional intimacy'.

The Theatre of Shock

The new experimental theatre of the 1960s had had a wonderful youthful exuberance about it; youthful writers, youthful directors, youthful actors, youthful *audiences*. Much of the best theatre of the 1980s and 1990s was little more than a continuation of what had been started in the 1960s. Probably the audiences were not the same, but they were certainly older. Many of the playwrights and directors *were* the same. In general, theatre just seemed not to be a youthful activity. There was an atrocious symbolism about the suicide in 1999 of the young British playwright Sarah Kane, author of the two most shockingly controversial plays of the late 1990s. Gloom was most profound on Broadway, where there was little or no investment in new American dramatic productions. British theatrical successes (many of them far from being masterpieces) had a fairly easy passage to New York, since the theatre bosses preferred to buy in ready-made successes carrying the snob British cachet (satirized in Tom Wolfe's *Bonfire of the Vanities* (see Chapter 8)). Much of the shock tactics and trickery, special effects, multimedia and musical devices had been absorbed by mainstream theatre, including musicals. It often seemed that experimental theatres were reduced to being more and more shocking, and nothing but shocking. French avant-garde theatre, intellectually rigorous, was in the healthiest state at the end of the century, in part at least because of state subsidies developed in the 1960s and extended into the 1980s. But audiences were very much minority ones, and certainly not youthful. (It should be noted, however, that a British Council tour of contemporary British plays—all rather shocking—in early 2000 was enthusiastically received in Paris.) Italy's great burst of activity had long since subsided. Theatrical life was healthy in Germany, but not especially exciting.

There was, however, one titanic qualification to my comment

about Italy. In 1981 Romeo Castellucci (b. 1960) founded the Societas Raffaello Sanzio, whose productions were to make the writings of Antonin Artaud seem like the gentle visions of a benign nutter, and the most violent plays of the 1960s like drawing-room comedies. His *Julius Caesar* was first presented at Avignon in 1998. Most of his productions were based on myths, because these 'describe a primal world which erupts into being and is sustained by donations of human blood'. But he has also used fairy tales, being attracted by their 'freaky irrationality'; he cast his own children in a version of *Hansel and Gretel*. In *Julius Caesar*, Antony has throat cancer, Cicero is played as a naked sumo wrestler, and Brutus and Cassius undergo sex changes and reappear as anorexic women. Caesar is old and emaciated; Brutus strips off all of Caesar's clothes, washes him all over, then obsequiously uses his own hair to dry Caesar's feet. Portia dies by swallowing fire. The final sentence of this short quotation from Peter Conrad lets us know what philosophical territory we are in:

Antony . . . has had his larynx removed. Sometimes he croaks with the aid of a voice box; but he also does without this aid, and we are required to watch as the hole in his throat gulps open and shut like an alternative, inarticulate mouth. While the Italian actor pitifully wheezes and burps his way through 'Friends, Romans, countrymen', Castellucci's soundtrack allows us to hear Marlon Brando slurring his way through the same monologue in an excerpt from Joseph Mankiewicz's Hollywood film of *Julius Caesar*. The aim is to lame and incapacitate speech, to rid Shakespeare of the easy fluency which turns classics into anthologies of clichés.

Conrad remarks that he got through the production in Strasbourg in the summer of 1999, 'more or less intact, but only by periodically averting my eyes'. He offered this warning to those intending to go to the London production: 'If you have eaten dinner, before you go, be prepared to up-chuck it.'

The plays of Hélène Cixous have already been mentioned; the great protagonists of experimental theatre continued to be Jean-Pierre Vincent and Michel Vinavar. French theatre's greatest international success, however, was something entirely distinctive (indicating, among other things, that one can no more predict the end of theatre than one can predict the end of a

novel or of art music), and was written by the daughter of a Polish father and a Hungarian mother living in Paris. There have been many plays drawing ponderous humour from the apparent absurdities of modern art, but *Art* (Paris, 1994; English translation by Christopher Hampton (b. 1929), London, 1996) by Yasmina Reza, starting from the purchase of a pure white painting by one of the three male characters, branches out into a series of running arguments about art, value, intellectualism, and friendship. The bluff, common-sense member of the trio has a nice hit at the fashionable postmodernist concept 'deconstruction': 'You pick a word from *Builders' Weekly*,' he says scathingly. And, of course, Avignon was chosen as the venue for the première of Castellucci's *Julius Caesar*.

What word but 'shocking' should be applied to the works of Edinburgh-born, ex-drug addict Irvine Welsh (b. 1958). He first came to attention with his loose assemblage of tales fashioned together as the novel, *Trainspotting* (1993), and is not immediately associated with the theatre. However, it is the case that, at the same time as the paperback of the novel was selling well and the sentimentalized film version (1996) was on the way to grossing £23 million, an early dramatized form, first produced in Scotland, was being performed in London. This intense theatrical experience demonstrated that the stage, not requiring illusionism or contrived links, still has a unique and special place among the arts. All that needs to be done is to let young people in on the secret.

The most controversial play to emerge from America was shocking because of its perceived political incorrectness, its anti-feminism. Actually *Oleanna* (1991), by David Mamet (b. 1947), in which the two characters are a middle-aged male professor and a female student, is perhaps a little more open-ended than feminist critics maintained. The title derives from two lines of an American folksong:

> Oh, to be in Oleanna—that's where I would rather be.
> Than be bound in Norway and drag the chains of slavery.

Much of the dialogue is about the politically incorrect books the student wants to have banned. Then at the end it becomes apparent that she has lodged a claim of attempted rape against

him: 'you "pressed" yourself into me. You "pressed" your body into me.' Then, suddenly, he shows an appalling violent side to his character:

'You vicious little bitch. You think you can come in here with your political correctness and destroy my life?
(*He knocks her to the floor.*)
After how I treated you . . .?
You should be . . . *rape you* . . .?
Are you kidding me . . .?
(*He picks up a chair, raises it above his head, and advances on her*).
I wouldn't touch you with a ten-foot pole. You little *cunt* . . .

Whom do we sympathize with?

Mamet is the author of a number of deservedly famous plays, including *American Buffalo* (1975) and *Glengarry Glen Ross* (1984), subsequently a film, with Mamet writing the screenplay. The production history of *Oleanna* illustrates neatly the relationship that was now fairly firmly established between experimental theatre and straight commercial theatre. It was first performed at the small Hasty Pudding (lovely title!), in Cambridge, Massachusetts, on 1 May 1992, but quickly transferred to the Orpheum Theatre, in New York, where it was first performed on 11 October 1992. The first British production was given at the Royal Court Theatre on 24 June 1993, but again there was a quick transfer, with a first performance at the Duke of York's Theatre on 15 September 1993.

There is a touch of political incorrectness, or even fogeyism, about some of the later plays of Tom Stoppard, who is also another example of a veteran of the 1960s: his *The Real Thing* was first presented in November 1982, then revived in 1999. The play is rather dependent on being spiced up with pop music: the cheerfulness of the audience at the end partly derives from the playing of 'I'm a Believer'. The main character, Henry, is a snobbish writer, whose sentiments (in 1999) are loudly applauded by the audience of elderly Americans. In mocking the lefty ex-convict, Broadie, who aspires also to write, he uses (of all things!) a cricket bat as an analogy for words: if the cricket bat is correctly used it 'works as words correctly used work'.

Copenhagen (1998) by Michael Frayn (b. 1933) was performed to much the same audiences, at least after it transferred from the National Theatre (where it was first presented on 21 May 1998) to the West End. The play is historical in a very particular way, focusing on a meeting that very definitely did take place in Copenhagen in 1941, between the Danish atomic physicist Niels Bohr and the German one, Werner Heisenberg, with Frayn drawing some of his initial inspiration from the biography of Heisenberg, *Uncertainty* by David Cassidy. Why did they meet, what did they discuss? Heisenberg did actually go back again in 1947 in the (vain) hope of settling this. Frayn's play is set much later, with both men in reality dead: the set is suitably abstract. The third character is Margrethe, Bohr's wife. Frayn's handling of time, and the presentation of different possible versions of the truth, are brilliant. Some of the discussions are of the nature of scientific discovery, and also of possible political influences on outcomes: did Heisenberg in fact collude in denying Germany the bomb, in making sure that the West had it? But, in bringing out the human and political elements, Frayn is certainly not taking a relativist position: indeed, the play can be seen as a very firm rebuttal of postmodernist polemic about science merely being bourgeois ideology.

In Britain, Caryl Churchill (b. 1938), not utterly unlike Cixous, continued to explore feminist themes and poststructuralist modes, particularly ideas of the non-existence of personal identity. In *Cloud Nine*, presented by Joint Stock at the Royal Court in 1982, she again had actors changing roles, men playing women, and women playing men. *Top Girls* (1982) had an all-female cast, *Softcops* (1984) had an all-male one. Commercial success came with *Serious Money* (1987), a satire on the stock market of 1980s yuppydom, which, however, made absolutely no concessions to its audiences (which included guffawing yuppies), employing the fluid notions of sexuality and the other non-naturalistic devices of her earlier plays.

Blasted, first full-length play by Sarah Kane (1971–99), was first performed at the Royal Court Theatre upstairs in January 1995. The play featured rape, buggery, masturbation, and cannibalism. A tabloid hack eats a baby, and is himself raped by a

soldier, who then sucks out his eyes and eats them. The following morning the *Daily Mail* critic reported: 'Until last night I thought I was immune from shock in any theatre. I am not.' He also described the play as 'a festival of filth'. The *Daily Telegraph*'s critic claimed that the play had almost made hardened critics throw up. The London *Evening Standard* spoke of 'sheer, unadulterated brutalism'. Given that the play is about civil war, the horror and violence were perhaps not so gratuitous as the critics suggested. Kane followed with *Phaedra's Love*, a reworking of Seneca's tragedy of incest and unrequited lust. *Cleansed* was put on at the Royal Court Theatre downstairs in April 1998. That Kane was both a serious and an extraordinarily talented artist cannot be doubted. In order to avoid the wrong kind of publicity, she originally wrote the short play *Crave* under the pseudonym 'Marie Kelvedon'. The public première, under her own name, came at the Traverse Theatre, in Edinburgh, on 13 August 1998. This is an entirely different kind of play, exploring the rhythm and music of language, with the speakers simply identified by a single capital letter, C, M, B, and A. Kane's plays have been performed in Germany, Austria, Belgium, Italy, Australia, France, and the United States: her loss is a terrible one.

Super-Thrillers: Novels and Films

The thriller as literary (and later filmic) genre is nothing new. What helped to create the super-thrillers of the 1980s and 1990s was the sophisticated integration of plots into present or (often) past political debates and the introduction, frequently, of elements of the macabre. Film learned from art and from theatres; the deliberately shocking motifs, apparent in the cinema of the early 1970s, were enlarged and deepened. The authors I shall refer to are those whose books, at the end of the century and in translation if appropriate, commanded the windows of bookshops and dominated the newspaper bestseller lists across Europe and North America. Several found their novels regularly turned into films.

The characters in the books by John Grisham (b. 1955) are thin and clichéd, as if waiting for famous film actors to fill them

out, a failing not entirely compensated for by the liberal senti-
ments and social concerns of the author. Lawyers and court
cases figure prominently. The novels—such as *The Firm* (1991),
The Client (1993), and *The Partner* (1997)—are certainly, as the
Daily Telegraph put it, 'hard to put down'. James Ellroy (b.
1948) produced a series of crime thrillers set in the 1950s in his
native city of Los Angeles, a place of corruption, mobsters,
drugs, whores, and brutally racist cops. *LA Confidential* (1990)
has a typically labyrinthine plot, but the central event is a mys-
terious massacre at a coffee shop called the Nite Owl, which in
turn leads to a search for three black men, and then a further
heinous crime. *LA Confidential*, shorn of some of its complex-
ities, but generally faithful to the original, became a successful
film (1997), directed by Curtis Hanson and starring Kevin
Spacey. Meantime, Ellroy had published *White Jazz* (1992), set
in Los Angeles, 1958, and narrated, in Ellroy's brilliant staccato
prose, by the central character, a corrupt murdering cop, and
American Tabloid (1995). Los Angeles is also the field of action
for policeman Harry Bosch in the novels of Michael Connelly
(b. 1956), a former police reporter on the *Los Angeles Times*.
Angel's Flight (1999) features a funicular railway of that name in
downtown Los Angeles; inside one of the cars is found the dead
body of a black lawyer, who had specialized in cases of police
brutality, corruption, and racism, and had been trying to
expose the influential person guilty of the rape and murder of a
12-year-old girl. Another former crime reporter, Patricia
Cornwell (b. 1956), had also been a volunteer police officer and
a computer analyst in the Chief Medical Examiner's office. In
a series of novels set in the American South she created Dr
Kay Scarpetta, and then, in *Hornet's Nest* (1997), Deputy
Chief Virginia West. Here was the thriller writer for the
post-feminist era.

Thriller moves towards horror in the novels of Thomas
Harris (b. 1940) and Stephen King (b. 1947). Harris published
Red Dragon, the novel that in 1981 introduced the sinister flesh-
eating Dr Hannibal Lector, and became the basis of the film
Man Hunter (1986). In *The Silence of the Lambs* (1988) psych-
iatrist Hannibal Lector is now in a maximum-security jail, while
outside a new serial killer, known as Buffalo Bill, whose habit is

skinning his victims, is on the rampage. Out of all this came, in 1990, one of the most sensational films of the time, directed by Jonathan Demme, with Jodie Foster as the young police officer, Clarice, who manages to get Hannibal Lector, played by Anthony Hopkins, to cooperate in finding the new serial killer. As the *New York Times* put it: 'The final confrontation between Clarice and the man she has been pursuing is a knockout—a scene set in pitch dark, with Clarice being stalked by a killer who wears night-vision glasses'.[17] To well-orchestrated publicity, in 1999 Harris published a third book about the evil doctor, simply titled *Hannibal*. Sales were enormous, and a popular, money-making film was confidently expected, and duly appeared under the same title. But this proved a rather dull example of the super-thriller genre although some critics found witty touches in the direction of Briton Ridley Scott, who had recently made the blockbuster *Gladiator*. The immensely prolific Stephen King, writer of screenplays as well as novels, brings the super-natural into his horror/thrillers. He had immediate success with his first novel, *Carrie* (1974), and it, and two of his subsequent titles, *The Shining* (1977) and *Misery* (1987), were made into films. In the film of *The Shining* (1980), directed by Stanley Kubrick (1928–99)—and for many critics a considerable enhancement of the novel—the Torrance family (with Jack Nicholson starring as Jack Torrance) spend the winter as care-takers in an isolated hotel that turns out to be haunted. The *New York Times* described all this as 'gloriously diabolical' and a 'spellbinding foray into the realm of the horror film'. *The Green Mile* (1996), told by a prison officer who has presided over seventy or eighty executions in 'Old Sparky' or 'the Big Juicy', concerns a prisoner sentenced to death for raping and murdering two young girls, who may or may not be a devil in human form. To assist the reader, the novel has illustrations, gothick (*sic*) in character, of the electric chair, the prison, and so on. This too, became a film (1999).

The film *Fatal Attraction* (1987), directed by Adrian Lyne, has a rather banal storyline, but one that is brilliantly manipulated by the director in order to create maximum horrific effect. The habitually faithful husband (played by Michael Douglas) is seduced by a business acquaintance (Glenn Close), then returns

to his wife, whereupon the spurned woman sets out to destroy husband, wife, and daughter by ever more terrifying means. *Goodfellas* (1990) had its origins in the novel *Wiseguy* (1985) by Nicholas Pileggi, who wrote the screenplay for the film directed by Martin Scorsese (b. 1942). The story is of a long-time Mafia member in New York who turns FBI informer. Scorsese received much praise for his inspired direction of this violent film, using freeze frames, fast cutting, and the occasional long tracking shot; the immense attention to detail builds up a tremendous feeling of authenticity. Quentin Tarantino originated his own screenplays for *Reservoir Dogs* (1992) and *Pulp Fiction* (1994). *Reservoir Dogs* is about a Los Angeles jewellery store robbery, which goes wrong because of a traitor among the gangsters. The identity of the traitor becomes apparent about halfway through, but that only increases the tension in this intricately structured and beautifully ironic film, whose images remain with one for years. *Pulp Fiction* was even more highly praised (it won the Palm d'Or at the Cannes Film Festival of 1994): there are three linked stories taking place, as the *New York Times* put it, 'in a milieu of obscenity-spouting, petty hoodlums, the small-timers and big babies Mr Tarrantino brings to life with such exhilarating gusto'.[18] Both films are brutally violent, the torture of the captured cop in *Reservoir Dogs* being almost impossible to watch. Slightly more restrained, immensely stylish, beautifully acted, and difficult to follow, *The Usual Suspects* (1995), directed by Bryan Singer, became a cult film.

The master of shock-horror films of a different sort was Steven Spielberg—for example, *Jaws* (1976), from a novel by Peter Benchley (b. 1942) about a monster shark, and *Jurassic Park* (1993), from a novel by Michael Crichton (b. 1942) about prehistoric monsters alive and well in a contemporary theme park. David Pesci's book about the celebrated early nineteenth-century historical episode in which a boatload of slaves destined for America made a break for freedom, *Amistad* (1992), was said by the *New York Times* to read 'like a thriller'. Steven Spielberg, ever interested in history, seized the opportunity, though inevitably the film *Amistad* was very far from being an accurate historical reconstruction.

As the blurb on every paperback of the ten Ken Follett novels tells us, he 'was only 27 when he wrote *Eye of the Needle*, the award-winning novel which became an international bestseller and a distinguished film', and previously he had been a newspaper reporter and a publishing executive after studying philosophy at University College, London. Follett sets his thrillers in distinctive historical periods, that of the Nazis, that of international tension on the eve of the First World War, the distant Middle Ages. He puts his university training to good use in doing the necessary background research—today's readers (and viewers) have a great appetite for facts. For *The Hammer of Eden* (1988), Follett had to mug up earth sciences, since the story is about a terrorist group threatening to trigger earthquakes.

Two British female practitioners of the more cerebral type of whodunnits with long-established reputations were P. D. James (b. 1920) and Ruth Rendell (b. 1930). The journalist and author of serious books on current events Robert Harris (b. 1955) gave his thrillers a strong historical dimension. His first novel, *Fatherland* (1992), was postulated on the premiss that the Germans had won the battle of Stalingrad and that Britain, having got rid of Churchill, had accepted peace within a general German hegemony. While not officially at war, the United States was supporting a Russian Resistance behind the Urals. The murder mystery is set in the imagined (but far from unrealistic) Germany of the 1960s, and concerns a desperate attempt to prevent the Americans from obtaining clear evidence about German policies towards the Jews. *Enigma* (1995) is set among the decipherers of the German Enigma code at Bletchley Park: it seems that a spy among them has given away the Allies' most precious secret, which would, of course, clear the way for a German victory.

Authors writing in English always have a big initial advantage in the international market. However, the fashion for the new types of thriller was genuinely Europe-wide. Authors who might not necessarily be translated into English were translated into the different European languages. Leading figures were: in Germany, Pieka Biermann—whose *Violetta*, which opens with the discovery of a series of corpses, mostly of women, published

in Berlin in 1989, came out in Italian ten years later; in France, Jean-Claud Izzo—whose latest novel at the time of writing was *Chourmo*, about murder in Marseilles, amid racists and Mafiosi; and in Italy, Renato Olivieri, long-established creator of Commissioner Ambrosio, and the up-to-the-minute Carlo Lucarelli (said by some critics to be the true successor to Sciascia), with his brutal stories featuring the foul-mouthed Inspector Coliandro—the latest example being *Il giorno del lupo* (*The Day of the Wolf*, 1998).

Other Film Genres

What I want to focus on first is the emergence, in *fin-de-siècle* Hollywood, of some very young directors of remarkable originality and talent. Steven Soderbergh (b. 1963), writer, editor, and director of *sex, lies and videotape* (1989), a film of the manners and (very loose) morals of the video generation, was 26 when this, his first film, was completed; the *New York Times* praised 'The bright wit, sinister undertone, and smooth layered style'. One of the characters carries a video camera everywhere, which 'is the perfect matter for these people, who can only respond to one another as images and objects'.[19] The Coen brothers—Joel Coen (b. 1955), Ethan Coel (b. 1956)—had already made three films in the 1980s, when *Barton Fink* (1991) swept all the main prizes at Cannes. The film is set in 1940 or 1941, before America's entry into the Second World War. When a pompous dramatist, hired to work on a Hollywood film, puts up in a seedy downtown hotel, he suffers from paralysing writer's block and encounters some weird characters. Warming to the occupant of the adjacent hotel room as a 'simple working stiff', he confides in him (thus revealing the essence of the film) about the terrors and mysteries of the territory called the mind: 'There's no road map for it.' The Coen brothers went on to make a very funny, but also menacing, satire on American corporate life, *The Hudsucker Proxy*.

Boogie Nights (1997) was the second film of 27-year-old Paul Thomas Anderson. Set in sleazy southern California, this is an absolutely matter-of-fact account of an enterprise that, in a

drug-sodden atmosphere, makes hard-porn films; California leads, but the film really could have been set anywhere in the West. The central character Eddie, who takes the professional name of Dirk Diggler, is treated with the kind of exploitative reverence that in the films of an innocent past would have been addressed to an emerging football star. Eddie has an incredibly long penis. *The Opposite of Sex* (1998), written and directed by newcomer Dawn Roos, is a comedy of the (sometimes atrocious) manners and sexual morals of the late 1990s, of brothers and sisters, lovers and friends, heterosexuals, homosexuals, and bisexuals. The wit is that of the best and most sophisticated American comedy:

'He made his bed, he can lie in it.'
'If there's room.'

A major commercial force behind some of the most interest-ing new films of the last decade of the twentieth century was the American distribution company Miramax, which operated on an international scale. Australian director Jane Campion (b. 1954) had made one greatly admired film, *Sweetie* (1989), when *The Piano*, an Australian/French co-production of 1992, was released by Miramax in 1993. Written as well as directed by Campion, the film tells of how Ada (Holly Hunter), a young Scots widow who is mute but not deaf, comes out to New Zea-land with her 9-year-old daughter to marry a man she has never met. The husband-to-be refuses to give house-room to her piano, and this becomes the centrepiece in a strange, passionate romance between Ada and a rough, illiterate settler, Baines (Harvey Keitel). In a scene as horrific as any I have already referred to in this chapter, the husband exacts revenge by chop-ping off one of Ada's fingers. When Baines, Ada, and her daughter (a wonderful realization by Anna Paquin) set out for a return to Britain, the piano goes to the bottom of the seabed, Ada almost with it. But in this film of humanity and triumphant resolution, Baines succeeds in rescuing her. Music is by Michael Nyman.

None of the more established directors quite equalled the originality of the newcomers, but veteran Mike Nichols (b. 1931), and the two British expatriots Alan Parker (b. 1944) and

Ridley Scott (b. 1939), in particular, did create films somewhat apart from the by now conventional stereotypes. Nichol's *Silkwood* (1983), based on the true story of Karen Silkwood who worked for a year in a plutonium recycling facility in Oklahoma, was a bold attack on America's nuclear power industry. His *Working Girl* (1988) had no similar target but is acute on American class differences between, for example, Tess (Melanie Griffith), the working girl on the way up and Katherine (Sigourney Weaver), who becomes her rival; it is even more acute on the commercial ambience of the time, in which business success and sex were treated as almost interchangeable pursuits, with life's greatest happiness to be achieved by combining the two. Alan Parker's *Mississippi Burning* (1988) is set back in 1964 and concerns the brutal murder of three civil-rights workers in Mississippi. Much of the film focuses on the relationship between the two investigators, an eager, progressive FBI man from the north, and an apparent Mississippi redneck. By focusing on two white men, it fails to do justice to the achievements of black civil-rights workers, but it is a gripping and noble film, with some of the qualities of the violent thrillers I have already discussed. *Thelma and Louise* (1991), directed by Ridley Scott, is a road movie, but this time the daring anti-heroes are two women, one a bored housewife who hates her husband, the other a bright and witty single woman who has shot a would-be rapist.

Titanic (1997), written and directed by James Cameron (b. 1954), was, in all senses, the biggest film yet made—a big film with a big target. But the snide comments from the critics missed the point. Certainly, the film has a completely invented romantic storyline; few films do not; and in this case the performances by Leonardo DiCaprio and Kate Winslett, as the young couple, are entirely persuasive. True, the appalling class distinctions so carefully delineated belong to 1912 and the film does not open up any discussion of whether such distinctions still exist today, though Cameron did joke that he himself could almost be suspected of being Marxist.[20] The reconstruction of the ship and of its sinking are meticulous, the drive to achieve authenticity relentless. The classic formula for high entertainment, a private story set against a public event, is perfectly

realized. The sinking of the ship, taking place in front of us in what is practically real time, is tragedy pushed to the limits.

The British film industry, in which Britain's wealthy resolutely refused to invest (Miramax making the investment, and taking the profit in the case of most recent successes), swings constantly between revival (as in the 1960s) and decline. The new revival that seemed to be heralded by *Chariots of Fire* (1981), directed by Hugh Hudson, was not sustained, but there have been a number of decent films of a distinctively British character, and, in the 1990s, some thundering commercial successes.

Chariots of Fire very effectively recreates the era of the Paris Olympic games of 1922. The film is about winners (which always appeals to audiences). It is also about three highly individualistic athletes, a Jew, a Scot, and an English aristocrat; yet, at a time when Britain was just entering the Thatcher era of aggressive and divisive economic individualism, it was a reminder of the stuttering but nonetheless genuine British sense of team spirit and national unity. The great end-of-the-century run of British success embraced *Four Weddings and a Funeral* (1994), *The Full Monty* (1997), *Shakespeare in Love* (1998), *Notting Hill* (1999), and, on the European continent (though much less so in English-speaking territories) *Bean* (1999). Writer for both *Four Weddings and a Funeral* and *Notting Hill* was Richard Curtis (b. 1956)—Czech-born, but fully assimilated into British ways, author also of some of Britain's funniest television programmes. Each film featured the very diffident, very English, Hugh Grant, and in each film he has a romance with an American woman, Andie McDowell in the first one, Julia Roberts (essentially playing herself as a very famous American film star) in the second. Both films are set in, or on the fringes of, the still very much alive British upper class (an important scene in *Four Weddings* takes place in a Scottish castle). The director of the first film was the experienced Mike Newell, associated with a succession of very British films; the second was directed by relatively unknown Roger Michell. The funding, of course, was American, as were the two biggest stars (to ensure transatlantic distribution and sales), but the characters, idiosyncratically human, and the episodes, quietly, or

outrageously, entertaining, belonged to no country but Britain. If these two films suggested the continuing existence of an upper class, *The Full Monty* (1997) indicated the continuance of the traditional working class, even if fallen upon near-terminal hard times—so hard that the unglamorous group of unemployed Sheffield steel workers embark on a new career as male strippers. The debut work of director Peter Cattaneo and writer Simon Beaufoy, it was turned down by two leading British film-making television groups, Film Four and Granada, before being picked up by the American conglomerate, Fox, who are said to have made more profit out of it than they did from *Titanic*.[21] *Shakespeare in Love* (1998) is a very funny post-modernist comedy, speculating fantastically on the sources of Shakespeare's inspiration, and including deliberate anachronisms. The influence on the script of playwright Tom Stoppard is very evident, direction was by John Madden (b. 1949), who had already established a reputation with his sensitive *Mrs Brown* (1997), about Queen Victoria's relationship with John Brown. *Bean* was a vehicle for Rowan Atkinson in his chosen role as mime (in his other persona as a sardonic, and loquacious, actor he is brilliant). America's Polygram provided the money and continental Europe provided the audiences; of the clutch of British films discussed here, *Bean* made the most money.

The late stage designer and avant-garde film-maker Derek Jarman (1942–94) claimed that, compared with such films as his own *The Last of England* (1987), Peter Greenaway's films 'pale into conformity'.[22] Sometimes obscure, Greenaway's films are in fact superrealist to surrealist fables that repay very close attention, beautifully filmed by French cameraman Sacha Vierny, and to be experienced as much as thought about. Most stunning to date is *The Cook, the Thief, his Wife and her Lover* (1989), a modernist morality play if ever there was one.

Irish-born Neil Jordan (b. 1950) has produced a range of arresting films. *The Company of Wolves* (1984), a truly captivating and imaginative compilation of dream sequences and scenes set in the contemporary world and in the Middle Ages, drawn from stories by magic-realist novelist Angela Carter, with a screenplay by her and Jordan, demonstrates how wonderfully liberating postmodernism as a creative force, as distinct from

critical and sociological pontification, can be. *The Crying Game* (1992) is in part an anti-imperialist insight into the troubles in Northern Ireland—the British soldier captured and shot by the IRA is black. The main IRA protagonist goes off to London in search of the black soldier's girlfriend; in a famous moment of *shock*, 'she' turns out to have perfectly formed male genitals. Most consistently acute in recording British fancies and foibles is Mike Leigh (b. 1943): *Secrets and Lies* (1996) concerns the search of a successful young black professional woman for her mother and the repercussions, warm and human, among various relatives and friends when the mother is discovered to be a poorly educated, working-class white woman.

Strikingly, given the reputation of French avant-garde and postmodernist films during and after the New Wave, the French productions enjoying greatest international success have all been period films. For historians, the accounts of the two trials held in the second half of the sixteenth century of the French peasant Martin Guerre by the parliamentary councillor who handled the case, Jean de Coras, are invaluable primary documents. Apparently the notoriously difficult and unpleasant Martin Guerre disappeared from his family and village in 1549, then returned, eight years later, a pleasanter and more loving man. But was he really the same man? That was the basis of the court cases that have fascinated writers ever since, not least those of the postmodernist inclination, preoccupied with questions of identity and memory. In the film *La Retour de Martin Guerre* (*The Return of Martin Guerre*, 1983), director and writer Daniel Vigne focuses on the two trials, with Gerard Depardieu, in full medieval peasant garb, as the later Guerre (the earlier Guerre is played by a different actor). This is a compelling film, the issues addressed, for all the medieval setting, being insistently contemporary ones. Of course, it strays far from the historical record. American historian Natalie Zemon Davis, who helped with the film, independently published the meticulous, and exciting, work of scholarship, *The Return of Martin Guerre* (1983).

The two linked films, *Jean de Florette* and *Manon des Sources* (both 1996), both directed by Claude Berri (b. 1934), based on a 1930s two-part novel about Provençal peasant life by Marcel

Pagnol, could well be considered to represent everything that the *nouvelle vague* had reacted against—that is, sheer literary escapism. But the escape is into an irresistible invented world of the 1920s, a world of duplicity, greed, and violence—the first film ends with the eponymous hunchback, Jean (Depardieu once more), being blown up as he tries to blast open a spring to fertilize his arid land—though the second is pervaded by innocent love and remorse.

One period that artists cannot keep away from is that of the Second World War. Louis Malle's *Lacombe Lucien* has been mentioned previously. *Au revoir les enfants* (*Goodbye Children*, 1988) is based on events that took place during January 1944, when the 12-year-old Malle was at a Jesuit boarding school. It is a story, taking place over just three weeks, of young Malle slowly befriending a Jewish boy and then of that boy, with two others, and also the headmaster, a priest, being taken away by the Germans. But the earlier war continues to linger in artists' consciousness as well. *La Vie et rien d'autre* (*Life and Nothing Else*, 1989), by Bertrand Tavernier (b. 1941), is a highly contrived film designed to bring out the differences between personal memories and the official version of events in the First World War. Further back in time again, in fact to the pre-revolutionary eighteenth century, is the setting for *Ridicule* (Patrice Leconte, 1996), a beautiful costume piece with present-day resonances. Social intercourse at the court of Louis XVI is based on the cruel sport of ridicule: there is fierce competition in the coining of brutal put-downs, ones that can destroy the lower-status, less-secure members of the court circle. The story is of a local notable who has to come to the court to secure royal permission for the drainage scheme he wishes to carry out on his own land, a scheme with long-term benefits, but one that in the short term affects the livelihoods of those who trap the animals and fish living in the marshes.

The sensation at Cannes in 1998 was *La Vie rêvée des anges* (*The Dream Life of Angels*) about a lesbian relationship, directed by newcomer Erick Zonca. Then came *Romance* (1999) by Elizabeth Breillat (b. 1948). This shockingly serious exploration of one woman's sexuality featured an enormous tuft of black pubic hair and a selection of erect male members. The female

protagonist, played by Caroline Ducey, finds a submissive older man to tie her up according to her instructions.

Italy produced a trio of international successes. *Cinema Paradiso* (*Paradise Cinema*, 1989, directed by Guiseppe Tornatore), about the friendship that develops between the elderly projectionist in the only cinema in a small southern Italian town and a small boy who is fanatical about films, just stops short, in a perfectly Italian way, of sentimentality. *Il postino* (1994), directed by Michael Radford (b. 1950), the English director who had made a highly praised film about Italian prisoners of war in Scotland during the Second World War, *Another Time, Another Place* (1983), is based on the exile in Italy during the 1970s of the left-wing Chilean poet Neruda—though the exile was not on a remote island like the one featured in the film. The sad, inarticulate, nearly unemployable local figure Mario (played by Massimo Troisi) is given a pittance as a temporary postman hired solely to deliver Neruda's extensive fan mail. A relationship builds up (not altogether unreminiscent of the one in *Cinema Paradiso*) and Mario becomes entranced by the power of poetry. Neruda is played by the distinguished French actor Philippe Noiret, whose French was, in accordance with the venerable Italian post-production tradition, dubbed into Italian. *La vita è bella* (*Life is Beautiful*, 1998) is another film about the Second World War, one that was smothered in praises and prizes, but also severely criticized for seeming to take the Holocaust lightly. Roberto Benigni (b. 1952) not himself Jewish, directed, shared in the writing, and played the principal role of Guido, a Jewish-Italian bookseller. The first half of the film is brilliant comedy, full of inspired clowning by Benigni. Then, when he and his son Giosue are placed in a concentration camp, Guido, ostensibly to shield his son from the horrors all around, continues to treat everything as a joke. That this defies all reality should have alerted critics to the obvious fact that we are watching a fable. What the fable *is* criticizing, of course, is the whole blundering absurdity of the Nazi enterprise. Near the end full brutal reality breaks in, and Guido is shot down running away from German soldiers. His son survives and is reunited with Guido's wife: not, in the long historical view, an inaccurate ending; people did survive, Nazism was defeated; and the character

audiences have identified with most closely throughout the film has been hunted down and shot dead.

Television

The overriding factor in television was technology. With satellite, cable, and the digital revolution, the number of channels available to viewers multiplied. Given the immense investment required, and given that, where they had existed, government monopolies were being weakened even while the number of channels remained limited, it was almost inevitable that commercial interests would predominate in the new situation, as, of course, had long been the case in the United States. Commercial interests, obviously, wanted to secure the largest audiences at which to direct their advertising. European governments continued to feel, and to try to exercise, some responsibility towards television being used for educational purposes and in support of maintaining high standards in the arts. But there was a tension between what politicians and intellectuals interested in these matters felt was right, and what audiences made it clear they wanted: public television could not totally ignore audience ratings and it had to justify the expenditure of money raised through viewers' licence fees or taxes. With regard to quality, more did not necessarily mean less, but it almost certainly did not mean more. Faced with the example of the Soviet Union and its satellites, one could not argue that direct state control was best; faced with examples of political manipulation in France, one could not even argue that public corporations were always best. On the other hand, the American free-enterprise model had long produced low-quality output, and programmes that, even when reasonably good, were interrupted too frequently and for too long by the crassest possible advertising. The nearest we have to a test case is that of Italy: thanks in large part to the political and economic pressures generated by Silvio Berlusconi, Italian television was decontrolled in 1987. The widely held view is that advertising ran riot, and standards slumped, with a daytime diet characterized by striptease shows performed by ordinary housewives. The widely held view is correct.

This concluding discussion of television, by the late twentieth century the central medium for the provision of entertainment, as well as of news and all kinds of information, offers a convenient opportunity for returning to some fundamental principles. The works of art (prose, poetry, painting, music, film) that affect us most profoundly—if given the chance—are, in the last analysis, created by individual people with special talents. We have no need to invent the myth of the isolated individual genius—conditions of artistic production can often be extremely complex—but, in the end, that touch of individual genius, or, at the very least, of talent, is a fundamental requirement. We judge societies by many criteria, but over time we would expect a healthy society to produce at least the occasional outstanding work of art. Quite certainly, we would expect outstanding works of art, wherever produced, to be available to the citizenry. Even more certainly, to get closer to the point, we would expect books to be available that were not all merely pulp fiction, we would expect television programmes to be available that were not all lowest-common-denominator trash. We have to be concerned if most television output is exploitative, mindshrinking, and pandering to the lowest tastes, but we have to remember that a continuous supply of material of the highest artistic quality is scarcely feasible and perhaps not even desirable. Genius is rare and talent scarce. Genius starving in the proverbial garret is of little use to the rest of humanity. Genius needs audiences. Even allowing for the use of the video recorder, there are times—the breakfast exodus, or the evening return, for instance—not best suited for the broadcast of an opera, or even one of the more subtle comedy sitcoms. Most material on television originates outside television, either in its entirety (films, obviously, which at most are subject to conversion into electronic format, scarcely perceptible to the viewer), or in its raw form (the news, current events, programmes of information and instruction—building a house, making a garden, appraising antiques), though the latter examples, certainly, are subject to a great deal of processing and shaping. External material floods in, and the best talent tends to flow out (even if not permanently). Television has bred many star actors and directors: on the whole, the ablest do not tend to stay continuously

with television. The best television films are made with the intention of securing theatrical distribution: they will then, indeed, return to their makers, but it is fully understood that the kind of viewer-attracting prestige that the makers are after can be obtained only through the international cinema box office and the verdicts of the film critics.

The greatest critical praise is attracted by adaptations of the great literary classics of the past. Clearly these successes depend heavily on acting and directorial talent. But whose is the genius? Dickens, Jane Austen? Don't misunderstand me: these productions are among the most valuable parts of television output, and they set the standards against which the most ambitious television is judged. Their value is multifold: they bring audiences into contact, however indirect, with great works of the past, and, up to a point, with the distinctive world of that past, with its different attitudes and values and different ways of using language. For the well educated they provide the opportunity to compare the television version with the original, to criticize production values and role interpretations; for everyone they provide entertainment, and suspense, at a rather higher intellectual level than is to be found in standard television fare. The highest basis on which to judge television would be on that of new dramas, specially created for television: one thinks of *Marty* and some of the American drama of the 1950s, of some of the series created in Britain by Denis Potter, and of the German *Das Boot* of 1984. Such ventures were not very apparent at the end of the century, but there were whispers in the winds and we must not give up hope yet. The point I am making is that if television, for all the inevitability of some of its lesser products, is to continue to be rated of artistic value, such productions must continue to appear. The reason for not giving up hope is that the television corporations know this too, and they actually do want plaudits and prestige as well as megabucks.

That said, our basic judgements have to be based on the routine drama series (based on the police station, hospital, law firm, and so on), then on the situation comedies and the comedy variety shows (still going strong in Britain and the continent of Europe, practically unknown now in the United States), and finally, the soap operas.

It is well known that the games children play, taken very seriously by them, are part of an almost instinctive educational process (there are parallels in the animal kingdom). Human beings develop through their contacts in the family and their experiences of the world outside. There have long been comics and stories for girls and boys, to stimulate the imagination but also to introduce their readers to different kinds of relationships and to ways of coping with problems. Something of this function may now be served by even the most mundane of soaps. A responsibility lies with education and social policy as well as with the television companies. An exclusive viewing diet of soaps is not to be recommended, nor is an unwillingness to separate fictions from real life, while, at the same time, an ability to relate certain fictional situations to that life may be beneficial. Trite, sentimental, stereotyped, and ultimately utterly unrealistic soaps continue. But a general conclusion must be that among certain series standards have risen considerably. Critics have frequently noted the harsh realism that intrudes on the British soaps *EastEnders* and *Brookside*. These are domestic soaps, set in the working-class and lower-middle-class reaches of English society (East London and suburban Liverpool, respectively). American soaps have tended to be set in more affluent contexts and with many aspiring to be regarded as dramatic series rather than soaps.

The soap of all soaps was *Dallas*, which from its beginnings in 1978 exercised a kind of international monopoly over the first part of the period under review, fading a bit in the late 1980s.[23] An absurd melodrama, featuring lengthy time-wasting (but money-making) reaction shots, about oil-rich, self-indulgent, and generally nasty people, it expressed for domestic and (particularly) foreign viewers a certain myth of ruthless go-getting, filthy-rich America. The arrival of *Hill Street Blues*, broadcast in America from 1981 to 1989, marked a significant change: the characters were sleazy and idiosyncratic, including the police officers; there was little affluence around, and persons apprehended were beset by real problems, such as poverty. High living returned with *LA Law*, a bit too smooth, a bit suspect in its liberalism, but very watchable, very professionally done.

Comparable changes in the world of sitcom took place with

the arrival of two very original, though very different shows, *Cheers* in 1983 and *Roseanne* in 1989. The latter really did represent a daring break with tradition in that the setting was working class, Roseanne being a factory worker and her husband a builder: both were, and intended to be, fat, physically unattractive, and slovenly. Both sitcoms and soaps tend not to enjoy longevity: their initial novelty (if there ever was one) wears off and they become stereotyped, or they take a sudden change of direction that totally dispels the original appeal. Wise producers take good ones off while they are still working. Having become a celebrity, the actress Roseanne Barr decided to have a makeover in her physical appearance, with the character she was playing inevitably doing the same: the whole point of this unconventional, hard-hitting, and often quite funny comedy was lost. The producers of *Cheers* were wise: after a dozen years the greatly loved comedy, set in a Boston pub where the inadequate regulars tried to live vicariously through the sexual exploits of the handsome barman played by Ted Danson (b. 1947), was axed. *Cheers* well illustrates American professionalism in the matter of comedy writing, with a highly paid team of writers working away until they really have produced something that is genuinely funny. Comedy in Europe tends to depend on individual writers, or partnerships, or sometimes on comic actors themselves. Where true humour is achieved, this may depend more upon the actual situation than upon the sort of one-liners Americans excel in. A classic example at the end of the century was the British sitcom *The Royle Family*, an unimaginative, inarticulate, ill-educated Liverpool working-class family whose little rituals and glaring misapprehensions rang very true and very funny.

That can be compared with the almost exactly contemporaneous American sitcoms *Friends*, and also *Ally McBeal*, comedies about thiry-somethings in the contemporary city scene. Again the brilliant professionalism of the team beating their brains over the scripts is very evident. No doubt slickness and professionalism are more evident than inspiration, but one has only to compare some of the commercial and critical successes at the end of the century with their predecessors and a point is made: the hospital soap (or drama series) *ER* with *Dr Kildare*,

or the series about the criminally inclined New York Italian family *Sopranos* with even *Dallas*. There were a number of decent 'blue flashing lights series' in Britain, some, unlike their American counterparts, turning on incidents or crimes that did not involve murder or great violence. But here bad news predominated: the schedules were being sustained by repeats, and there was little sign of new developments. The Scottish television series *Taggart* managed to come up with new productions from time to time, maintaining its unique power to shock with elements of ingenious gothic horror.

American television did have one unique critical success with the cartoon series, *The Simpsons*, created by Matt Groening, starting in 1991, for Twentieth Century Fox. This is a retelling, in brilliantly distinctive drawings, of the eternal story of the little man, conniving, self-centred, dishonest, hypocritical, abusive when he can get away with it, sycophantic when he cannot, updated to *fin-de-siècle* corporate America: the compromises with dubious politics and social injustice are the compromises of late-twentieth-century America. Like all cult shows this has detractors as well as fanatical followers. But there can be no doubt that the satire is powerful and uncompromising. This show makes lots of money for its owners; it is certainly no agent of bourgeois hegemony.

Critically acclaimed programmes usually drew large audiences, but large audiences wanted other things as well—the great popularity everywhere in the West of public lotteries is a good indication of the natural inclinations of ordinary human beings. The story of *Who Wants To Be A Millionaire?* is very instructive. The conceivers of the basic concept—contestants are helped by having a choice of four answers from which to choose, and can seek further help either from the audience or from phoning a friend; at each stage they can go off with their winnings, or they can hazard them on moving towards the final goal of winning a million pounds—had great difficulty in persuading any television company to adopt the idea. But creative talent (if that is what it is), and British talent at that, won out in the end, with the show being adopted in the United States and a large number of other countries, and becoming the world's most popular television show. With audiences showing their

preferences so convincingly, one can see the problems facing programme-makers with high ideals. It would seem that audiences like docusoaps as well. These began in Britain and have proliferated, one Italian critic actually hailing them as the television style of the future.[24] Docusoaps film a group of people going about their everyday life or business. They involve no creative writing in the production of a story, and all that goes with that, such as revelation of character, humour, surprise, structured reflection on life and its mysteries, and are very cheap to make. They are the biggest single threat to the continuing production of programmes of some artistic quality.

Children's Books

Children, we know, are more at home with the Web than many adults. Is the habit of reading dying out? As with so many other messages of gloom, this one is not thoroughly substantiated by the evidence. Indeed, if after tending to suggest that the record at the end of the century is contradictory, with negative developments in conflict with positive ones, I am on the whole optimistic that the human craving for the arts will continue to insist on being provided for, part of that optimism derives from the production and sale of books for children that are original and challenging. A few names and titles will illustrate the point I am making.

Actually we have already met the American Maurice Sendak (b. 1928) in connection with the operas of Oliver Knussen. Sendak, who, like so many of the heroes of this book, came to the fore during the cultural revolution, is one of the few geniuses of the illustrated children's book, his works ranging from *Kenny's Window* (1965), through *Where the Wild Things Are* (1965), and *Higglety Pigglety Pop! or, There Must Be More to Life* (1967), to *We Are All in the Dumps with Jack and Guy* (1993). Sendak claimed, very reasonably: 'I remember things other people don't recall: the sounds and feelings and images— the emotional quality—of particular moments in childhood.'[25]

No one would rest hopes for the cultural future of the human race on the popularity of comics. However, two highly sophisticated series, both francophone, have become justly famous.

Belgian Georges Remi (1907–83), under the name Hergé, created the far-flung adventures of boy reporter Tintin, his dog Snowy, and their companions Captain Haddock, Professor Calculus, and detectives Dion and Dion. Declaring 'Tintin, c'est moi', Hergé insisted that no one should continue the comic strip after his death. The non-profit-making Hergé Foundation in Brussels, which continues to reprint the books for each new generation, has rigorously respected this wish.[26] With the cultural revolution came the second series, *Asterix le Gaulois* (*Asterix the Gaul*, first appearing in the comic magazine *Pilote* in 1959, and in book form in 1961), written by René Goscinny (1926–77), and illustrated by Albert Uderzo.

Petra Mathers, born in West Germany in 1945, became a New York-based writer of illustrated books with a delightful surrealist quality, starting with *Maria Theresa* (1985) about an adventurous hen, living in New York with her owner Signora Rinaldo, and including, most recently, *Lottie's New Beach Towel* (1998).[27] More sophisticated fare has come from the amazingly successful, Edinburgh-based author J. K. Rowling (b. 1965), whose Harry Potter stories have the sinister edge that enthralls children (against the wishes of *bien-pensant* educators) and from, for older children, Sue Townsend (b. 1946), whose *The Secret Diary of Adrian Mole aged 13¾* first appeared in 1982.

There is hope, then, in the way future consumers are being catered for. Obviously, the younger generation will reinforce the trend towards video, and, more particularly, digital art. It cannot be said that the works being produced in this sphere at the end of the twentieth century were very inspiring. And, as we have seen, much of the more traditional production in film and literature had an exploitative, cast to it, going for thrills and shocks, emphasizing sex and violence. Yet what a wonderful variety of artefacts and practices we have encountered in the third, and final, part of this book.

Conclusion: Conflicts and Contradictions

The only conclusion is that there are no conclusions. Achievements, yes; but also conflicts and contradictions. Despite the most destructive war in history and an extended period when the threat of nuclear annihilation was real, the nearly sixty years covered by this book were, across all the arts, élite and popular, as productive as any sixty years in the past. From the standpoint of the beginning of the new century, the last two decades perhaps seem a little disappointing when compared to the post-war wave, and the innovations and new directions associated with the cultural revolution of the long Sixties. But we do not know what will come next and serious evidence for pessimism simply is not there: certainly, talk of 'the death of the novel' or 'the death of painting' is rhetorical nonsense. Art music does give cause for concern to traditionalist music-lovers, but renewal is surely as much in evidence as sterility. The film industry, certainly, has much to answer for. Two excellent films were made from novels by James Ellroy (b. 1948), but, as is almost inevitably the case, Ellroy's brilliant handling of language disappeared. Sometimes, however, there are touches of poetic justice. One of the best-selling novelists of all time is the American, Robert Ludlum (b. 1927), whose works are excoriated by the literary critics. In Britain, the most performed playwright after Shakespeare is Alan Ayckborn (b. 1939), whose works are universally described as 'bourgeois'. Neither, as it happens, has had any great success in film.

Some developments, particularly strong in the United States, but apparent also in Europe from the 1980s onwards, entailing the ultimate commodification of artistic products, the elevation of price, and denigration of value, are unfortunate. Yet the United States has also been the sponsor of major artistic initiatives ('Blessed be America for its catholic *bigness*', Sylvia Plath wrote in her journal, feeling oppressed by the

narrowness of cultural life in Cambridge[1]). Corporations out to *make* money tend to debase; but individuals, and even corporations, who have already *made* money tend, it would seem, to prefer to patronize art of quality. To follow fashion is human; but in the last sixty years of the twentieth century there were almost too many disruptions and changes of direction. At the start of a new century the range of sources feeding into artistic production, from emergent nations and submerged nationalities, has never been wider. The danger then is of a bland internationalization. Local styles need to be protected: it is here, I think, that the case for publicly organized patronage is strongest.

There are no grounds for doubting the sincerity of those contemporary artists who have taken up the most uncompromising postures, following through the logic of their position to the (often bitter, or at least highly abstract) end, without heeding the claims of audiences. The incomprehensible of today may become the basis for widely respected development in the future. However, it does remain the case that art that fails to meet human needs and evoke human responses withers. No one knew this better, nor expressed the point more effectively, than Wolfgang Amadeus Mozart. Writing about his three piano concertos K413, 414, and 415 in the well-known letter to his father of 28 December 1782 he remarked: 'There are passages here and there from which the connoisseur alone can derive satisfaction; but these passages are written in such a way that the less learned cannot fail to be pleased, though without knowing why.' Mozart then continues with a sentence that puts into perspective the mere half-century of this study, the pontifications about postmodernity, capitalist crises, and the end of artistic development, and reminds us that the human craving for the arts (and all the issues that arise therefrom) goes back for centuries: 'In order to win applause one must write stuff which is so inane that a coachman could sing it, or so unintelligible that it pleases precisely because no sensible man can understand it'.[2]

The danger at the beginning of the new century, long to be found in America and now becoming common in Europe, is that all artistic endeavours, élite and popular, are being treated as equal—film music being equated with symphonic, photo-

journalism with painting, sculpture, or installation art. In the currents of the 1960s, much of the old snobbishness was swept away. It may be that the injection of a new snobbishness is now required. Cross-over, cross-referencing, intertextuality, and eclecticism can have all the potency of the art that encourages us to see things in new ways; but postmodernist trickery can also become merely tedious.

The new century opens with an expanding market for entertainments of a documentary sort, firmly based in actual events; there is an appetite for facts, put over in an appealing and simplistic way. As we have seen, much art draws on the past. But artists' *representations* and *evocations* of aspects of the past are very different from the *knowledge* of the past produced by historians, as, indeed, artistic representations of current events should be very different from the reporting of them by journalists. Artists are fully entitled to incorporate in their works all the various materials, primary and secondary, pertaining to the past. Historians (and journalists) who affect to be artists simply produce feeble art and unreliable history. What this book has stressed throughout is the virtues of division of labour, and the need to make distinctions and draw boundaries. The arts are produced by artists, they are not simply the undifferentiated outcomes of processes of 'cultural construction'. Soap operas and sitcoms do minister to basic human needs; but the greater works of art, of which I have tried to discuss a reasonable sample, challenge us, puzzle us, stretch us, and, finally, enhance us. Fully to realize ourselves as humans, we need that challenge, that enhancement.

What do the arts we have been reflecting on tell historians? For responses to, and evaluations of, specific events and specific social changes, television, film, and middlebrow novels are generally most useful. But for the more profound, and more subtle, changes in societies, in beliefs and values, the more complex art forms—painting, poetry, music—can in the end have a special value of their own. Historians (rightly) still argue over the exact significance of the Second World War: the arts in all their variety demonstrate conclusively that the shadow of it, and of the Holocaust, was long and pervasive. They demonstrate also the power of modernism as an intellectual and aesthetic mode, and

help to pin down the emergence and development of post-modernism. Unprecedentedly rapid technological advance, globalization in all senses of the term, and what, for convenience, we call consumerism can all be perceived in a very precise way in the different art forms I have been discussing.

Notes

Introduction: Assumptions, Themes, Contexts

1. *Independent*, 16 Oct. 1999.
2. Thoughts roughly along those lines are well expressed in John Ellis, *Seeing Things: Television in the Age of Uncertainty* (2000), *passim*.
3. Edward Lucie-Smith (ed.), *British Poetry since 1945* (1985), 79.
4. Quoted by Augustus Pallotta, *Italian Novelists since World War II 1946–1965* (1997), p. xi.
5. Milton C. Cummings, Jr., and Richard S. Katz (eds.), *The Patron State: Government and the Arts in Europe, North America, and Japan* (1987), *passim*.
6. My latest thoughts on the influence on the arts in Britain of the Second World War can be found in Arthur Marwick, *A History of the Modern British Isles, 1914–1999: Circumstances, Events and Outcomes* (2000), 194–7.
7. See Cummings and Katz, *The Patron State*, esp. 21, 47–9, 69.
8. See my *The Sixties: Cultural Revolution in Britain, France, Italy, and the United States, c.1958–c.1974* (1998).
9. Arthur Marwick, 'Die 68er Revolution', in Peter Wende (ed.), *Grosse Revolutionen der Geschichte* (2000), 312–32.
10. 'Entretien avec Michel Foucault', *Cahiers du cinéma*, 251–2 (July–Aug. 1974), 5–15.
11. I have examined those issues in 'War and the Arts—Is There a Connection?: The Case of the Two Total Wars', in *War in History*, 2/1 (1995), 65–86, and 'Painting and Music during and after the Great War: The Art of Total War', in R. Chickering and S. Förster (eds.), *Great War, Total War* (2000), 501–17.
12. *San Francisco Chronicle*, 3 Sept. 1944. Quoted by Stephen A. Nash, 'Introduction: Picasso, War and Art', in Steven A. Nash with Robert Rosenblum, *Picasso and the War Years, 1937–1945* (1998), 13.
13. Brassaï, *Picasso & Co.* (1967), 53.
14. The judgement is my own. For full details, see: David Barnouwv and Gerald Van Der Stroom, *The Diary of Anne Frank: The Critical Edition* (1989); Lawrence Graver, *An Obsession with Anne Frank: Meyer Levin and the Diary* (1995).
15. Quoted in Graver, *An Obsession*, 126.

Chapter 1. Ascendant America and Eternal Paris

1. Edward Lucie-Smith, *Movements in Art since 1945* (1984), 32.
2. Ibid.
3. David Piper, *History of Painting and Sculpture: New Horizons* (1981), 215.
4. Ibid. 212.
5. Tate Gallery Pollock Exhibition Guide.
6. Piper, *History*, 217.
7. Ibid.
8. Ibid. 218.
9. Timothy Hilton, *Picasso* (1975), 260–1.
10. For the quotations and their sources, see Arthur Marwick, 'War and the Arts—Is There a Connection?, *War in History*, 211 (1995), 81.
11. Jean Dubuffet, *Prospectus et tous écrits suivants* (1962).
12. Pascale Le Thorel-Daviot, *Petit dictionnaire des arts contemporarains* (1996), 243.
13. Ibid. 46.
14. Ibid. 15.
15. Frances Spalding, *British Art since 1900* (1986), 146, 149.
16. David Sylvester, *The Brutality of Fact: Interviews with Francis Bacon* (1987), 11.
17. Le Thorel-Daviot, *Petit dictionnaire*, 26.
18. e.g. Rob Kroes, Robert W. Rydell, and Doeko F. J. Bosscher (eds.), *Cultural Transmission and Reception: American Mass Culture in Europe* (1993), and Richard F. Kuisel, *Seducing the French: The Dilemma of Americanization* (1993).
19. Richard R. Sklar, *Film: An International History of the Medium* (1996), 314.
20. My account is based on Nicholas Wapshott, *The Man Within: A Biography of Carol Reed* (1990), ch. 8, and Charles Drazin, *In Search of the Third Man* (1999), *passim*.
21. Wapshott, *The Man Within*, 179, 181.
22. Introduction to 1999 edition of *The Naked and the Dead*.
23. Sklar, *Film*, 359.
24. *The Macmillan International Film Encyclopedia* (1998), 364.
25. e.g. Peter Biskind, *Seeing is Believing: How Hollywood Taught us to Stop Worrying and Love the Fifties* (1983), 10–20.
26. Margaret Drabble, *The Oxford Companion to English Literature* (1985), 1070; Marcus Cunliffe, *The Literature of the United States* (1986), 447.

Chapter 2. The Disasters of War and their Repercussions

1. Martin Seymour-Smith, *Funk and Wagnall's Guide to Modern World Literature*, ii (1973), 672, quoted by Peter Beichen, 'German Prose after 1945', in Charles Burdick, Hans-Adolf Jacobson, and Winifred Kudzus (eds.), *Contemporary Germany: Politics and Culture* (1984), 319.

2. Quoted by Anthony Aldgate, 'Italian Neo-Realist Cinema', Units 8–9 of Open University Course, *Liberation and Reconstruction* (1990), 10.

3. There is an excellent synopsis in ibid. 21–3.

4. Vittorio de Sica, *Bicycle Thieves*, trans. Simon Hartog (1968), 96.

5. Gian Piero Brunetta, *Cent'anni di cinema italiana, ii. Del 1945 ai giorni nostri* (1985).

6. Ibid. 141.

7. Eric Rhode, *A History of the Cinema: From its Origins to 1970* (1976), 485.

8. Cesare Pavese, *This Business of Living: Diaries*, trans. A.E. Murch (1980), 17 Nov. 1949, 328.

9. Introduction to pocket edition of Carlo Levi, *Cristo si è fermato a Eboli* (1990).

10. Charles B. Johnson, 'Introduction', in Carl Zuckmayer, *Des Teufels General* (1962), 31.

11. Ehrhard Bahr, 'Contemporary Theater and Drama in West Germany', in Burdick, Jacobson, and Kudzus, *Contemporary Germany*, 298.

12. Beichen, 'German Prose after 1945', 322.

Chapter 3. Home Entertainment at the Touch of a Switch

1. Robert Gelatt, *The Fabulous Phonograph, 1877–1977* (1977), 282–3.

2. Ibid. 278–80, 284.

3. Ibid. 286–7.

4. Ibid. 317.

5. John Ellis, *Seeing Things: Television in an Age of Uncertainty* (2000), 39.

6. Christian Brochand, *Histoire générale de la radio et de la télévision en France, ii. 1944–1974* (1994), 29–63, 342–62; Pierre Miquel, *Histoire de la radio et de la télévision* (1984), 147, 167, 178, 215.

7. Paul Jonnet, *Jeux, modes et masses: La Société française et le moderne* (1986), 192.

8. Claudio Ferretti, Umberto Broccoli, and Barbara Scaramucci, *Mama RAI* (1997), 70.

9. Robert L. Hilliard and Michael C. Keith, *The Broadcast Century: A Biography of American Broadcasting* (1992), 104–31.

10. J. Dennis Bounds, *Perry Mason: The Authorship and Reproduction of a Popular Hero* (1996), 3 ff, 83 ff.

11. Francis Wheen, *Television: A History* (1985), 102, 106.

12. Pierre Boulez, *Orientations: Collected Writings*, trans. Martin Cooper (1986), 445. There is a fascinating and highly relevent interview with Boulez in the Open University video 'War and the Arts' (2001).

13. Pierre Boulez, *The Score*, Feb. 1952, printed in Pierre Boulez, *Relevés d'apprenti* (1966), 271–2.

14. Pierre Boulez, *Pierre Boulez: Conversations with Célestin Deliège* (1976), 12–13.

15. Boulez, *Orientations*, 446.

16. Quoted in Robert P. Morgan, *Twentieth-Century Music: A History of Musical Style in Modern Europe and America* (1991).

17. John Cage, *Silence: Lectures and Workings* (1968), 18–19.

18. Ibid. 26.

19. Antione Goléa, *Rencontres avec Olivier Messiaen* (1960), 63.

20. Paul Griffiths, *Olivier Messiaen and the Music of Time* (1985), 90.

21. Claude Samuel, *Conversations with Olivier Messiaen*, trans. Felix Aprahamian (1976), 11.

22. Ibid. 12

23. Olivier Messiaen, *Technique de mon langage musical* (1956), 13, 31, 33, 34.

Chapter 4. Permissiveness, Censorship, Feminism

1. John Sutherland, *Offensive Literature: Decensorship in Britain 1960–1982* (1982), 10.

2. Ibid. 14.

3. Arthur Marwick, *The Sixties: Cultural Revolution in Britain, France, Italy, and the United States, c.1958–c.1974* (1998), 145.

4. Reported in C. H. Rolf, *The Trial of Lady Chatterley* (1961).

5. Quoted in Fred L. Stanley, 'James Baldwin', in Jeffrey Helferman and Richard Layman (eds.), *American Novelists since World War II* (1978), 15.

6. Ibid. 18.

7. Letter from Gore Vidal to the author.
8. Betty Friedan, *The Feminist Mystique* (1963), 43.
9. See Arthur Marwick, 'Three Alison Lurie Novels of the Long Sixties', in Anthony Aldate, James Chapman, and Arthur Marwick (eds.), *Windows on the Sixties: Exploring Key Texts in Media and Culture* (2000).
10. Marwick, *The Sixties*, 159.
11. Marie Cardinal, *Autrement dit* (1977), 86.
12. See Lois Parkinson Zamora and Wendy B. Faris (eds.), *Magical Realism: Theory, History, Community* (1995).
13. Quotation in Gale Group, *Contemporary Authors*, 74 (1999), 424.
14. Germaine Greer, *The Female Eunuch* (1970), 325, 246, 261.
15. Linden Peach, *Toni Morrison* (1995), 3–8.
16. Marwick, *The Sixties*, 404–33.
17. Danielle Taylor-Guthrie (ed.), *Conversation with Toni Morrison* (1994), 49.
18. Peter Beichen, 'German Prose after 1945', in Charles Burdick, Hans-Adolf Jacobson, and Winifred Kudzus (eds.), *Contemporary Germany: Politics and Culture* (1984), 322.
19. Marwick, *The Sixties*, 509–10.
20. Ibid. 166.
21. Ibid. 511.

Chapter 5. The Rock Revolution and the Influence of Youth

1. Francis Rust, *Dance in Society* (1969), 111–15.
2. The literature on rock music is enormous. For preliminary guidance, see Arthur Marwick, *The Sixties: Cultural Revolution in Britain, France, Italy, and the United States, c.1958–c.1974* (1998), 834–5.
3. Barry Miles, *Paul McCartney: Many Years from Now* (1997), ch. 1.
4. Charlie Gillett, *The Sound of the City* (1983), 266; Paul Griffiths, 'Music', in Boris Ford (ed.), *The Cambridge Guide to the Arts in Britain*, ix. *Since the Second World War* (1988), 79.
5. Griffiths, 'Music', 80.
6. Gerald Bordman, *American Musical Theatre: A Chronicle* (1992), 637.
7. Michael Braun, Richard Eckford, and Peter Stimpson, *Jesus Christ Superstar: The Authorised Version* (1972). This book is unpaginated.

8. There are many books on the *nouvelle vague*. A good starting point is Susan Hayward, *French National Cinema* (1993).

9. Robert Sklar, *Film: An International History of the Medium* (1993), 372.

10. Pierre Sorlin, *European Cinemas, European Societies, 1939–1990* (1991), 162–3.

11. Jean-Pierre Jeancolas, *Le Cinéma des français: La Ve République (1958–1978)* (1979), 140.

12. Ibid. 143.

13. Marwick, *The Sixties*, 175.

14. Quoted in Ian Cameron and Robin Wood, *Antonioni* (1968), 25.

15. Michelangelo Antonioni, *L'avventura* (1960), 122.

16. Gian Piero Brunetta, *Cent'anni di cinema italiana, ii. Del 1945 ai giorni nostri* (1995), 283.

17. Pierre Sorlin, *Italian National Cinemas 1896–1996* (1996), 123.

18. Brunetta, *Cent'anni*, 230.

19. My own work, as in '*Room at the Top, Saturday Night and Sunday Morning* and the "Cultural Revolution in Britain"', *Journal of Contemporary History*, 19/1 (1984), and '*Room at the Top*: The Novel and the Film', in Arthur Marwick (ed.), *The Arts, Literature and Society* (1990), 249–79 has been amplified amd modified by Anthony Aldgate, *Censorship and the Permissive Society: British Cinema and Theatre 1955–1965* (1995).

20. Marwick, *The Sixties*, 129.

21. See Anthony Aldgate, 'Defining the Parameters of "Quality Cinema" for the Permissive Society: The British Board of Film Censors and *This Sporting Life*', in Anthony Aldgate, James Chapman, and Arthur Marwick (eds.), *Windows on the Sixties: Exploring Key Texts of Media and Culture* (2000).

22. Marwick, *The Sixties*, 473.

23. Andrew J. Edelstein, *The Swinging Sixties* (New York, 1986), 140–1. Bond has found the perfect biographer in James Chapman, *License to Thrill: A Cultural History of the James Bond Films* (1999).

24. Marwick, *The Sixties*, 173.

25. Thomas Kiernan, *Jane Fonda* (1982), 146.

26. Richard McGuinness, 'Carnal Knowledge', in Thomas R. Atkins (ed.), *Sexuality in the Movies* (1975), 209.

27. Peter M. Nichols (ed.), *The New York Times Guide to the Best 1000 Movies Ever Made* (1999), 337.

28. Jeancolas, *Le Cinéma*, 246.

29. John Sandford, *The New German Cinema* (1980), 13.

30. Ibid.

31. Marwick, *Culture in Britain since 1945*, 86.
32. Quoted in Hilary Kingsley and Geoff Tiballs, *Box of Delights: The Golden Years of Television* (1989), 55.
33. Ibid. 87.
34. James Chapman, 'The Avengers: Television and Popular Culture during the "High Sixties"', in Aldgate, Chapman, and Marwick (eds.), *Windows on the Sixties*.

Chapter 6. Structuralism and After

1. Ted Benton, *The Rise and Fall of Structural Marxism: Althusser and his Influence* (1998), 13.
2. Michel Foucault, 'Man, is he Dead?', in *Arts et loisirs*, quoted in Didier Eribon, *Michel Foucault*, trans. Betsy Wing (1992), 230.
3. Roland Barthes, 'The Death of the Author', in *Image—Music—Text: Essays Selected and Translated by Stephen Heath* (1971), 142–8. See also Sean Burke, *The Death and Return of the Author: Criticism and Subjectivity in Barthes, Foucault, and Derrida* (1992), 9–12, 20, 178.
4. John Fletcher and John Calder (eds.), *The Nouveau Roman Reader* (1986), 20–2, 32, 36; Celia Britton, *The Nouveau Roman: Fiction, Theory and Politics* (New York, 1992), 58–9, 87–8.
5. Philippe Forest, *Philippe Sollers* (1992), 11–14.
6. Alain Robbe-Grillet, *Pour un nouveau roman* (1963), 36–7.
7. Ben Stolzfus, *Alain Robbe-Grillet: Life, Work, and Criticism* (1987).
8. J. A. E. Loubère, *The Novels of Claude Simon* (1975), 92–4.
9. Forest, *Sollers*, 14, 18.
10. Christopher Wagstaff, 'The New-Avantgarde', in Michael Caesar and Peter Hainsworth (eds.), *Writers and Society in Contemporary Italy: A Collection of Essays* (1984), 36–49.
11. Quoted in John McGowan, *Postmodernism and its Critics* (1991), 91.

Chapter 7. The Élite Arts

1. Luciano Berio, *Two Interviews with Rossana Dalmonte and Andrés Varga* (1985), 55.
2. Reprinted in Tim Nevill (ed.), *Towards a Cosmic Music* (1989), 44–7.
3. For Berio and Nono, see Mark Morris, *The Pimlico Dictionary of Twentieth-Century Composers* (1999).

4. Steve Reich, *Writings about Music* (1974), 50–6.

5. Tate Gallery Guide, *Richard Hamilton, 17 June–6 September 1992* (1992).

6. Lea Vergine, *L'arte in trincea: lessico delle tendenze artistiche 1960–1990* (1996), 87, 205; Edward Lucie-Smith, *Movements in European Art since 1945* (1988), 131. For *nouveau réalisme* the critical notes provided in the Beaubourg Gallery, Paris, are particularly helpful.

7. Lucie-Smith, *Movements in European Art*, 139.

8. Much of this comes from the Guide to the Royal Academy of Art, *The Pop Art Show* (1996).

9. David Bourdon, *Warhol* (1989), 14–16, 248–9, 299, 301.

10. Peter Fuller, 'The Visual Arts', in Boris Ford (ed.), *The Cambridge Guide to the Arts in Britain* ix. *Since the Second World War* (1988), 139.

11. *Gilbert and George: The Complete Pictures 1971–1985* (1986).

12. David Piper, *The Mitchell Beazley History of Painting and Sculpture*, iii. *New Horizons* (1981), 252–3.

13. Vergine, *L'arte in trincea*, 187.

14. Mary Ellen Solt, *Concrete Poetry: A World View* (1980), 7.

15. Ibid. 16, 32–49; Lawrence R. Smith, *The New Italian Poetry: 1945 to the Present, a Bilingual Anthology* (1981), 4, 29, 33.

16. Pierre Garnier, *Les Lettres: Poesie Nouvelle*, 30 (May 1963).

17. Solt, *Concrete Poetry*, 35.

18. Graham Dunstan Martin, *Anthology of Contemporary French Poetry* (1972), 2, 6.

19. Edwin Morgan, 'Scottish Poetry in the 1960s', in Michael Schmidt and Grevel Lindop (eds.), *British Poetry since 1960* (1972), 138.

20. Glyn Jones, 'Second Flowering: Poetry in Wales', in ibid. 130.

21. This part is derived from notes by Ted Hughes in Sylvia Plath, *Collected Poems* (1981), 289.

22. James Roose-Evans, *Experimental Theatre from Stanislavsky to Today* (1973), 215.

23. Richard Neville, *Hippie Hippie Shake: The Dreams, the Trips, the Love-ins, the Screw Ups . . . the Sixties* (1996), 155–7.

24. *Village Voice* (18 Oct. 1968), quoted by Donald L. Loeffler, *An Analysis of the Treatment of the Homosexual Character in Drama Produced in New York Theatre from 1950 to 1968* (1988), 185.

25. Stephen Brecht, *Peter Schumann's Bread and Puppet Theatre* (1975), 607.

26. For this paragraph, see Ehrhard Bahr, 'Contemporary Theatre

and Drama in West Germany', in Charles Burdick, Hans-Adolf Jacobson, and Winifred Kudszus (eds.), *Contemporary Germany: Politics and Culture* (1984).

27. See William J. R. Curtis, *Modern Architecture since 1900* (1982), Vincent Scully, *American Architecture and Urbanism* (1969), and Charles Jencks, *Modern Movements in Architecture* (1973).

28. Jencks, *Modern Movements*, 269.

Chapter 8. Past and Present: Sociology and Philosophy

1. John Sandford, *The New German Cinema* (1980); Thomas Elsaesser, *New German Cinema: A History* (1989); Anton Kaes, *From Hitler to Heimat: The Return of History on Film* (1989); Thomas Elsaesser, 'Subject Positions, Speaking Positions: From *Holocaust*, *Our Hitler*, and *Heimat* to *Shoah* and *Schindler's List*', in Vivian Sobchack (ed.), *The Persistence of History: Cinema, Television and the Modern Event* (1996), 140–83.

2. Elsaesser, 'Subject Positions'.

3. Quoted in ibid. 159.

4. Elsaesser, *New German Cinema*, 262–4.

5. Kaes, *From Hitler to Heimat*, 169.

6. Elsaesser, 'Subject Positions', 161.

7. Quoted in ibid. 149.

8. Robert Sklar, *Film: An International History of the Medium* (1993), 459.

9. Michael Archer, *Art since 1960* (1997), 159.

10. This comes through very clearly in the works of Michel Foucault (see Chapter 6) and is echoed in Jean-François Lyotard, *The Postmodern Condition* (1979).

11. Malcolm Bradbury, *The Modern American Novel* (1992).

12. Margaret Drabble, *The Oxford Companion to English Literature* (1985), 606–7.

13. Salman Rushdie, *In Good Faith* (1990).

14. Quoted on cover of British paperback edition (1995).

15. Jonathan Israel, in *Times Literary Supplement*, 5 Nov. 1999.

16. *Contemporary Authors: New Revision Series*, 58: 132.

17. Oriana Fallaci, *The Useless Sex* (1964), 7.

18. Oriana Fallaci, *Nothing and Amen* (1972), 2.

19. *Contemporary Authors: New Revision Series*, 58: 134.

20. Hélène Cixous, 'Introduction', in Susan Setters (ed.), *The Hélène Cixous Reader* (1994). This book has a foreword by Derrida.

21. *Dictionary of Literary Biography*, 83: 60.
22. Anthony Levi, *Guide to French Literature, 1789 to the Present* (1992), 368.
23. Bronwen Martin, *The Search for Gold: Space and Meaning in J. M. G. Le Clézio* (1995), 13.
24. Bart-Moore Gilbert, Gareth Stanton, and Willy Maley (eds.), *Postcolonial Criticism* (1997), Editors' Introduction, 18–21.

Chapter 9. The Real Postmodernism?

1. Most of this section is based on James Steele, *Architecture Today* (1997), esp. chs. 3, 6–10, 12–14.
2. Ibid. 185.
3. Ibid. 177.
4. Ibid. 185.
5. Ibid. 206.
6. Quoted in ibid. 317.
7. Brian Morton, *The Blackwell Guide to Recorded Contemporary Music* (1996), 269.
8. Mark Morris, *A Guide to 20th-Century Composers* (1996), pp. xxxii–xxxiii.
9. Ibid., p. xxxiv.
10. Ibid., p. xxv.
11. Ibid., p. xxxii.
12. Steven J. Pettit, 'Introduction', in David Ewen (ed.), *The World of Twentieth Century Music* (1991), p. xxviii.
13. Michael Hall, *Leaving Home: A Conducted Tour of Twentieth-Century Music with Simon Rattle* (1996), 254–6.
14. Ibid. 239.
15. Ibid. 259.
16. Morris, *A Guide to 20th-Century Composers*, 122.
17. Morton, *The Blackwell Guide*, 313, 316.
18. Ibid. 329.
19. Ibid. 292.
20. Morris, *A Guide to 20th-Century Composers*, 499.
21. Morton, *The Blackwell Guide*, 280.
22. Morris, *A Guide to 20th-Century Composers*, 492.
23. Hall, *Leaving Home*, 243.
24. Paul Griffiths, 'Music', in Boris Ford (ed.), *The Cambridge Guide to the Arts in Britain*, ix. *Since the Second World War* (1988), 74.
25. Details in this section are from *The Virgin Illustrated Encyclopaedia of Rock* (1998).

26. *Independent*, 27 July 1999.

27. Gerald Bordman, *American Musical Theatre: A Chronicle* (1996), 703.

28. E. Behr and M. Steyn, *The Story of Miss Saigon* (1991).

29. Quoted by Richard Mansfield, 'London Contemporary Dance Theatre', in Joan W. White (ed.), *Twentieth-Century Dance in Britain* (1985), 114.

30. John Tooley, *In House: Covent Garden, 50 Years of Opera and Ballet* (1999), 151.

31. Susan Au, *Ballet and Modern Dance* (1988), 201.

32. Ibid. 203.

33. I have drawn heavily on Taryn Benbow-Pfalzgraf (ed.), *International Dictionary of Modern Dance* (1998).

34. Marjorie Perloff, 'Introduction', in John Taggart (ed.), *Songs of Degrees: Essays on Contemporary Poetry and Poetics* (1994), p. vii.

35. Quotations from Scot Peacock (ed.), *Contemporary Authors*, 160 (1998), 177.

36. Daniel Jones and John D. Jorgenson (eds.), *Contemporary Authors, New Revision Series* (1998), 6–14. See also Susan M. Schultz (ed.), *The Tribe of John Ashbery and Contemporary Poetry* (1995).

37. The quotations that follow come from Seamus Heaney, *Crediting Poetry* (1995), 9–17.

38. These two quotations are in A. Alvarez, *The Faber Book of Modern Poetry* (1992), pp. xxiii–xxiv.

39. In ibid. The poems that follow are conveniently located in Peter Forbes (ed.), *Scanning the Century: The Penguin Book of the Twentieth Century in Poetry* (1999).

40. Carol Ann Duffy, *The World's Wife* (2000), 45.

Chapter 10. King Video, Shockers, and Super-Thrillers

1. Edward Lucie-Smith, *Movements in Art Since 1945* (1984); Michael Archer, *Art Since 1960* (1997); Michael Rush, *New Media in Late 20th-Century Art* (1999); Andrew Causey, *Sculpture since 1945* (1998).

2. Rush, *New Media*, 81–6.

3. Pascal Le Thorel-Dariot, *Petit dictionnaire des artistes contemporains* (1996), 265; Rush, *New Media*, 145.

4. Archer, *Art since 1960*, 208.

5. Ibid. 98.

6. Quoted in Rush, *New Media*, 149.

7. Ibid. 151–2.

8. Ibid. 216.

9. Jonathan Law (ed.), *European Culture: A Contemporary Companion* (1993), 33.

10. Archer, *Art since 1960*, 180–1.

11. Ibid. 171.

12. Causey, *Sculpture*, 245.

13. Ibid. 241.

14. Germaine Greer, 'Paula Rego', in *Modern Painters* (Easter 1989).

15. William Feaver, *Observer*, 24 Dec. 1989.

16. Mary Jane Jacob, 'Richard Deacon: The Skin of Sculpture', in Terry A. Neff (ed.), *A Quiet Revolution: British Sculpture since 1965* (1987), 74.

17. Peter M. Nichols (ed.), *The New York Times Guide to the Best 1,000 Movies Ever Made* (1999), 787.

18. Ibid. 681.

19. Ibid.

20. Ibid. 882.

21. Peter Cowie (ed.), *Variety International Film Guide* (1999), 312.

22. Derek Jarman, in David L. Hurst (ed.), *The Last of England: Derek Jarman* (1987), 163.

23. For television presented in Britain, Hilary Kingsley and Geoff Tibballs, *Box of Delights: The Golden Years of Television* (1989), is useful. For a stimulating general discussion, see John Ellis, *Seeing Things: Television in an Age of Uncertainty* (2000).

24. *La Repubblica*, 4 Aug. 1999.

25. Sara Prendergast and Tom Prendergast, *St James Guide to Children's Writers* (1999), 692–3.

26. James G. Lesnick (ed.), *Contemporary Authors* 31 (1990), 366–9.

27. Prendergast and Prendergast, *St James Guide*, 707–8.

Conclusion: Conflicts and Contradictions

1. Sylvia Plath, *Collected Poems* (1981), 289.

2. Emily Anderson (ed.), *The Letters of Mozart and his Family* (1985), 833.

Further Reading

1. General

Aldgate, Anthony, *Censorship and the Permissive Society: British Cinema and Theatre 1955–1965* (Oxford: Oxford University Press, 1995).

—— Chapman, James and Marwick, Arthur (eds.), *Windows on the Sixties: Exploring Key Texts in Media and Culture* (London: I.B. Tauris, 2000).

Bourdon, David, *Warhol* (New York: Abrams, 1989).

Burdick, Charles, Jacobson, Hans-Adolf, and Kudzus, Winifred (eds.), *Contemporary Germany: Politics and Culture* (Boulder: University of Colorado Press, 1984).

Cummings, Milton C. Jr and Katz, Richard S. (eds.), *The Patron State: Government and the Arts in Europe, North America and Japan* (New York: Oxford University Press, 1987).

Ford, Boris (ed.), *The Cambridge Guide to the Arts in Britain*, ix. *Since the Second World War* (Cambridge: Cambridge University Press, 1988).

Freeland, Cynthia, *But is it Art? An Introduction to Art Theory* (Oxford: Oxford University Press, 2001).

Hewison, Robert, *Culture and Consensus: England, Art and Politics since 1940* (London: Methuen, 1997).

Kroes, Rob., Rydell, Robert W., and Bosscher, Doeko F.J, *Cultural Transmission and Reception: American Mass Culture in Europe* (Amsterdam: VU University Press, 1993).

Marwick, Arthur, *Culture in Britain since 1945* (Oxford: Blackwell, 1991).

—— *The Sixties: Cultural Revolution in Britain, France, Italy and the United States, c.1958–c.1974* (Oxford: Oxford University Press, 1998).

Sobchack, Vivian (ed.), *The Persistence of History: Cinema, Television and the Modern Event* (London: Routledge, 1996).

Sutherland, John, *Offensive Literature: Decensorship in Britain 1960–1982* (London: Junction Books, 1982).

2. Painting, Sculpture, Assemblages, etc.

Archer, Michael, *Art since 1960* (London: Thames & Hudson, 1997).

Causey, Andrew, *Sculpture since 1945* (Oxford: Oxford University Press, 1998).

Hilton, Timothy, *Picasso* (London: Thames & Hudson, 1975).

Lucie-Smith, Edward, *Movements in Art since 1945* (London: Thames & Hudson, 1984).

Neff, Terry A. (ed.), *A Quiet Revolution: British Sculpture since 1965* (London: Thames & Hudson, 1987).

Piper, David, *History of Painting and Sculpture: New Horizons* (London: Mitchell Beazley, 1981).

Rush, Michael, *New Media in Late 20th-Century Art* (London: Thames & Hudson, 1999).

Spalding, Frances, *British art since 1900* (London: Thomas & Hudson, 1986).

3. Art Music

Carpenter, Humphrey, *The Envy of the World: Fifty Years of the BBC Third Programme and Radio 3* (London: Weidenfeld & Nicolson, 1996).

Ewen, David (ed.), *The World of Twentieth Century Music*, 2nd edn., rev. Stephen J. Pettit (London: Hale, 1991).

Griffiths, Paul, *Modern Music and After* (Oxford: Oxford University Press, 1995).

Hall, Michael, *Leaving Home: A Conducted Tour of Twentieth-Century Music with Simon Rattle* (London: Faber, 1996).

Morgan, Robert P., *Twentieth-Century Music: A History of Musical Style in Modern Europe and America* (New York: Norton, 1991).

Morris, Mark, *A Guide to 20th-Century Composers* (London: Methuen, 1996).

Morton, Brian, *The Blackwell Guide to Recorded Contemporary Music* (Oxford: Blackwell, 1996).

—— and Collins, Pamela, *Contemporary Composers* (London: St James, 1992).

Thompson, Clifford (ed.), *Contemporary World Musicians* (Chicago: Fitzroy Dearborn, 1999).

4. Dance

Au, Susan, *Ballet and Modern Dance* (London: Thames & Hudson, 1988).

Michael, Marcelle, *La danse au XXe siècle* (Paris: Bordas, 1995).

Steel, Judith A., *A History of Ballet and Modern Dance* (London: Hamlyn, 1982).

White, Jean W., *Twentieth-Century Dance in Britain* (London: Dance, 1985).

5. Architecture

Curtis, William J. R., *Modern Architecture since 1900* (Oxford: Oxford University Press, 1982).

Jencks, Charles, *Modern Movements in Architecture* (Harmondsworth: Penguin, 1985).

Scully, Vincent, *American Architecture and Urbanism* (London: Thames & Hudson, 1969).

Steele, James, *Architecture Today* (London: Phaidon, 1997).

6. Literature and Drama

Alvarez, A., *The Faber Book of Modern Poetry* (London: Faber, 1992).

Bradbury, Malcolm, *The Modern American Novel* (Oxford: Oxford University Press, 1992).

—— *The Modern British Novel* (London: Secker & Warburg, 1993).

Cunliffe, Marcus, *The Literature of the United States* (Harmondswoth: Penguin, 1986).

Forbes, Peter (ed.), *Scanning the Century: The Penguin Book of the Twentieth Century in Poetry* (London: Viking, 1999).

Hunt, Peter (ed.), *Literature for Children: Contemporary Criticism* (London: Routledge, 1992).

Lucie-Smith, Edward (ed.), *British Poetry since 1945* (Harmondsworth: Penguin, 1985).

Moore-Gilbert, Bart, Stanton, Gareth and Maley, Willy (eds.), *Post-colonial Criticism* (Harlow: Longman, 1997).

Roose-Evans, James, *Experimental Theatre from Stanislavsky to Today* (London: Studio Vista, 1970).

Schmidt, Michael and Lindop, Grevel (eds.), *British Poetry since 1960: A Critical Survey* (Oxford: Carcanet Press, 1972).

Shellard, Dominic, *British Theatre since the War* (London: Yale University Press, 1999).

Solt, Mary Ellen, *Concrete Poetry: A World View* (Bloomington, Ind.: University of Indiana Press, 1980).

Taggart, John (ed.), *Songs of Degrees: Essays on Contemporary Poetry and Poetics* (Tuscaloosa, Ala: University of Alabama Press, 1994).

Walder, Denis (ed.), *Literature in the Modern World: Critical Essays and Documents* (Oxford: Oxford University Press, 1990).

7. Film

Armes, Roy, *French Cinema* (London: Secker & Warburg, 1985).

Atkins, Thomas R. (ed.), *Sexuality in the Movies* (Bloomington, Ind: University of Indiana Press, 1975).

Austin, Guy, *Contemporary French Cinema: An Introduction* (Manchester: Manchester University Press, 1996).

Brunetta, Gian Piero, *Cent'anni di cinema italiana*: ii *Del 1945 ai giorni nostri* (Bari: De Donato, 1995).

Chapman, James, *Licensed to Thrill: A Cultural History of the James Bond Films* (London: I. B. Tauris, 1999).

Elsaesser, Thomas, *New German Cinema: A History* (London: BFI, 1989).

Ellwood, David (ed.), *Movies as History: Visions of the Twentieth Century* (Stroud: Sutton Publishing, 2000).

Jeancolas, Jean-Pierre, *Le cinéma des Français: La Ve République (1958-1978)* (Paris: Stock, 1979).

Kaes, Anton, *From Hitler to Heimat: The Return of History as Film* (Cambridge, Mass.: Harvard University Press, 1989).

Nichols, Peter M. (ed.), *The New York Guide to the Best 1,000 Movies Ever Made* (New York: New York Times, 1999).

Sandford, John, *The New German Cinema* (London: Wolff, 1980).

Sklar, Richard R., *Film: An International History of the Medium* (London: Thames & Hudson, 1993).

Sorlin, Pierre, *European Cinemas, European Societies, 1939-1990* (London: Routledge, 1991).

—— *Italian National Cinema 1896-1996* (London: Routledge, 1996).

8. Television, Radio, Gramophone, Popular Music

Bordman, Gerald, *American Musical Theatre: A Chronicle* (New York: Oxford University Press, 1992).

Brochand, Christian, *Histoire générale de la radio et de la télévision en France*, ii. *1944-1974* (Paris: La Documentation Française, 1994).

Ellis, John, *Seeing Things: Television in an Age of Uncertainty* (London: I. B. Tauris, 2000).

Gellett, Robert, *The Fabulous Phonograph, 1877-1977* (London: Cassell, 1977).

Hilliard, Robert L. and Keith, Michael C., *The Broadcast Century: A Biography of American Broadcasting* (Boston: Focal, 1992).

Kingsley, Hilary, and Tibballs, Geoff., *Box of Delights: The Golden Years of Television* (London: Macmillan, 1989).

Miquel, Pierre, *Histoire de la radio et de la télévision* (Paris: Perrin, 1984).

Wheen, Francis, *Television: A History* (London: Century, 1985).

9. Reference Works

Contemporary Authors (Detroit: Gale Publishing).

Contemporary Authors – New Revision Series (Detroit: Gale Publishing).

Contemporary Theatre, Film and Television, 27 vols. so far (Detroit: Gale Publishing).

Dictionary of Literary Biography (Detroit: Gale Publishing).

Law, John, *European Culture: A Contemporary Companion* (London: Cassell, 1993).

Appendix: Websites

www.artchive.com
Fully illustrated directory of artists.

www.artcyclopedia.com
Commercial site with directory of artists, images, information about artists and movements, and listing of museums which hold the work of specific artists (with links).

www.artincontext.org
Extensive directory of artists offering images, exhibitions, information, and international museum links.

www.artnet.com
Directory of artists including images and other information.

www.eai.org
Electronic Arts Intermix website for artists working with video and new media.

www.icom.org/vimp
International Council of Museums website. Useful directory offering links to international museums and libraries, and a search facility.

www.iniva.org
The website of the Institute of International Visual Arts in London, which has a particular interest in new technologies, site-specific work, and artists from diverse cultural backgrounds.

www.lichtensteinfoundation.org
Contains links to Lichtenstein's public sculpture and murals, awards, and exhibitions.

www.marcelduchamp.net
Images, links, and information about the work of Marcel Duchamp.

www.newmedia-arts.org
A guide to new media installation art, cataloguing works from the Pompidou Centre and other European museums.

www.uwrf.edu/history/women
Illustrated directory of 300 women artists from the medieval period to the present day, with links to other relevant websites.

Index